GREAT FRENCH PAINTINGS FROM THE BARNES FOUNDATION

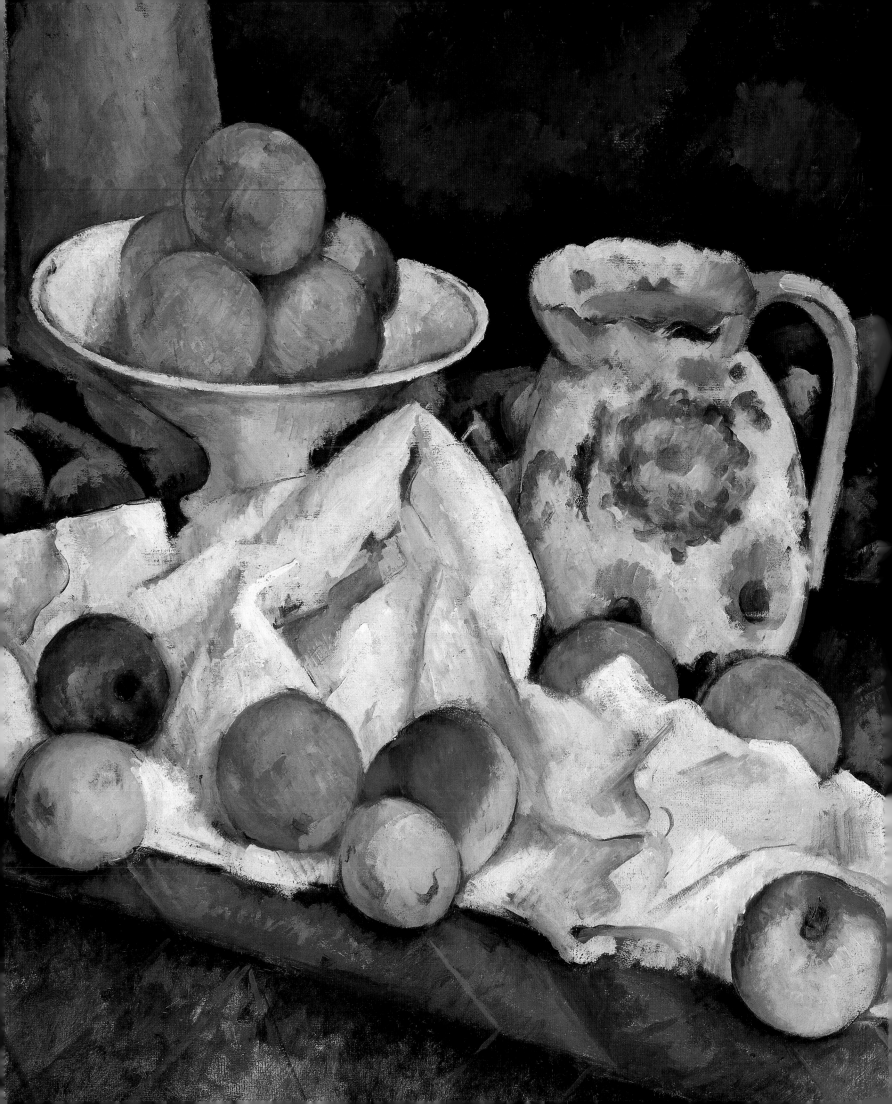

GREAT FRENCH PAINTINGS FROM THE BARNES FOUNDATION

Impressionist, Post-impressionist, and Early Modern

ALFRED A. KNOPF, NEW YORK

in association with

LINCOLN UNIVERSITY PRESS

National Gallery of Art Edition

1993

The exhibition is supported by a grant from GTE Corporation
An indemnity for this exhibition has been granted by the
Federal Council on the Arts and the Humanities
Exhibition dates: May 2–August 15, 1993

THIS IS A BORZOI BOOK
PUBLISHED BY ALFRED A. KNOPF, INC.

Cover: Matisse, *The Red Madras Headdress*, detail.
Frontispiece: Cézanne, *Compotier, Pitcher, and Fruit*, detail.

AUTHORS
Dr. Albert C. Barnes and the Barnes Foundation, *Richard J. Wattenmaker, director,*
Archives of American Art, Smithsonian Institution, Washington
Dr. Barnes in Paris, *Anne Distel, chief curator, Musée d'Orsay, Paris*

CATALOGUE ENTRIES
FC: Françoise Cachin, *director, Musée d'Orsay, Paris*
AD: Anne Distel, *chief curator, Musée d'Orsay, Paris*
JF: Jack Flam, *distinguished professor of art history, Brooklyn College and the Graduate Center, City University of New York*
MH: Michel Hoog: *curator-general in charge of the Musée de l'Orangerie, Paris*
CSM: Charles S. Moffett, *director, The Phillips Collection, Washington, formerly senior curator of paintings,*
National Gallery of Art, Washington
MP: Marla Prather, *assistant curator of twentieth-century art, National Gallery of Art, Washington*
CR: Christopher Riopelle, *associate curator of European paintings and sculpture before 1900, Philadelphia Museum of Art*
JJR: Joseph J. Rishel, *curator of European paintings and sculpture before 1900, Philadelphia Museum of Art*
AR: Anne Roquebert, *Musée d'Orsay, Paris*
HS: Hélène Seckel, *chief curator, Musée Picasso, Paris*
JSW: Jeffrey S. Weiss, *assistant research curator of modern paintings, National Gallery of Art, Washington*

LIBRARY OF CONGRESS CATALOGING-IN-PUBLICATION DATA

Great French paintings from the Barnes Foundation : Impressionist, Post-impressionist, and early Modern.
p. cm.
Essays by Richard J. Wattenmaker and others. Includes bibliographical references and index.
ISBN 0-679-40963-7. — ISBN 0-679-74476-2 (pbk.)
1. Painting, French — Catalogs. 2. Impressionism (Art) — France — Catalogs. 3. Post-impressionism (Art) — France —
Catalogs. 4. Painting, Modern — 19th century — France — Catalogs. 5. Modernism (Art) — France — Catalogs.
6. Painting, Modern — 20th century — France — Catalogs. 7. Painting — Pennsylvania — Merion — Catalogs.
8. Barnes Foundation — Catalogs. 9. Painting — Private collections — Pennsylvania — Merion — Catalogs.
10. Wattenmaker, Richard J.
ND547.5.I4G69 1993
759.4'09'03407474812 — dc20 92-29654
CIP

MANUFACTURED IN ITALY
FIRST EDITION

Contents

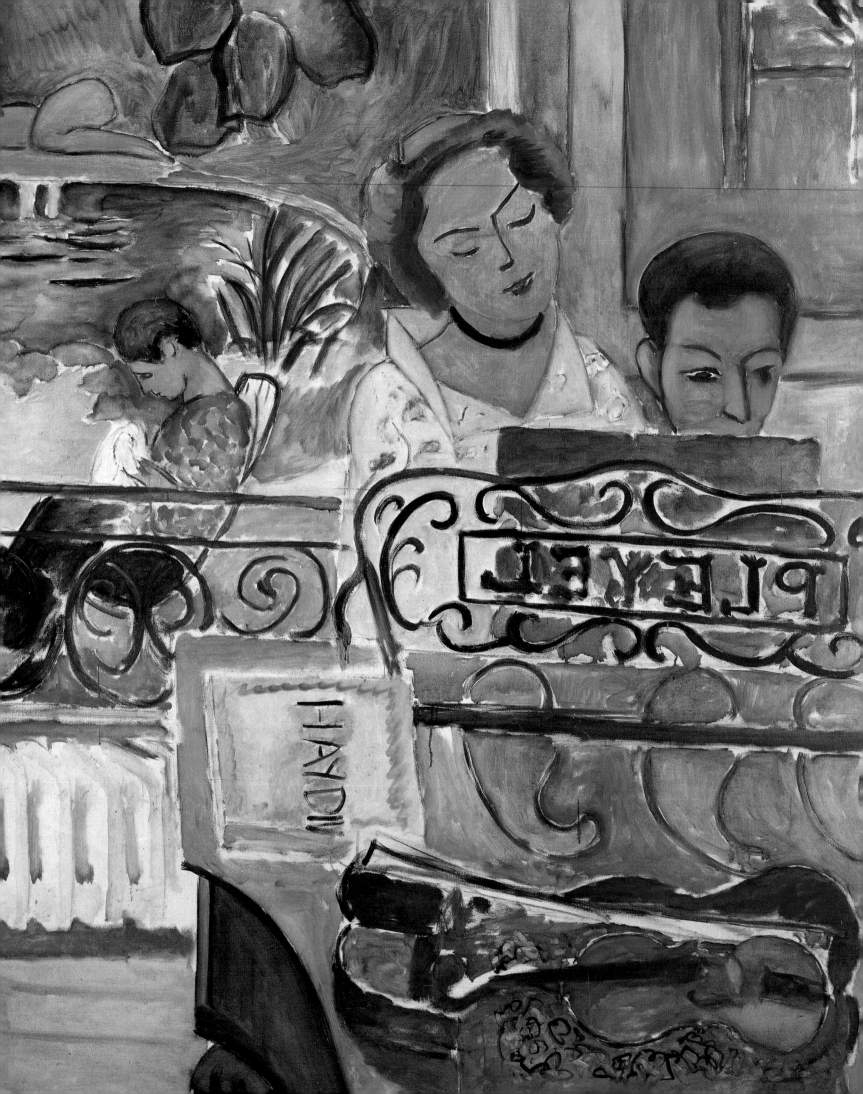

Preface

The international exhibition and this book which accompanies it are historic events for the Barnes Foundation. Since its founding in 1922, Dr. Barnes' collection of incomparable masterpieces has remained a secret to all but a few. The Board of Trustees is proud to present this book as part of our efforts to open the Foundation to a wider public.

This book is also significant because it symbolizes the forward direction the Barnes Foundation is taking as it enters the next century.

When I became President after the death of the Honorable Franklin L. Williams in 1990, the Board of Trustees was not undaunted by the problems that faced the Foundation. We inherited a climate control system that was installed in 1926, defrayed maintenance, and inadequate plant systems coupled with increased costs of security, insufficient endowment funds, and inflation. Consequently, the great works of the collection were at serious risk of long-term damage. To ensure the preservation of the collection and the continuing operation of our art education program, we determined that our first priority had to be the renovation of the Gallery. It was with this in mind that we embraced another first — an exhibition of paintings from the collection. The exhibition and this book are central to our goal to raise the funds necessary to preserve the Foundation in the manner specified by Dr. Barnes, in first-class condition.

Although Dr. Barnes' Indenture prohibited paintings from being loaned, an exhibition was undertaken to secure these desperately needed funds. In the ruling that made the exhibition possible, Judge Louis Stefan states:

> It is difficult to believe that a man of Dr. Barnes' erudition would not have anticipated that the day would come when the structure he had created to house his collection would require such fundamental structural repairs and renovations as would make impossible the uninterrupted display of the collection as mandated by the Indenture. If such were his thought and desire, then history should tell us that an inevitable conflict with reality eventually would occur. The testimony is overwhelming that, after the passage of many decades, a basic overhaul of the Foundation buildings and systems is required if the very reason for their existence — housing and protection of the collection — is not to be frustrated by the ravages of an unfriendly environment.

The exhibition also grants people around the world a historic opportunity to see some of the collection's best paintings, including extraordinary masterpieces by Renoir, Cézanne, and Matisse.

Matisse, *The Music Lesson*, detail.

At the same time, the exhibition ensures the future of the Barnes Foundation. The Board of Trustees is also committed to increasing public access and that of scholars and experts to Dr. Barnes' magnificent collection. The renovation of the Gallery, combined with the determination of the Board to treat the Foundation as a public trust, will allow us to maintain the level of public access befitting the collection.

The uniqueness of the Barnes Foundation's collection of more than two thousand works of art lies not only in the unequalled quality and quantity of the works by Matisse, Cézanne, Renoir, Picasso, and other major artists of the nineteenth and twentieth centuries, but also in their placement in the wall arrangements by Dr. Barnes with ironwork, decorative arts, sculpture, and furniture from a vast array of cultural and ethnic sources including African, Islamic, Chinese, and Native American. Dr. Barnes' method, unique at its time in 1925 and very personal, was a recognition of the unifying form of all art and an understanding of the concept of multiculturalism, before the word — so much in vogue today — was invented.

As President, I have had the opportunity to go through much of the archive left by Dr. Barnes. I have discovered that a great deal remains to be said about this man. In the first part of this century he championed many causes that were unpopular and untried. In particular, he was unwavering in his commitment to education and his belief that an educated society is a key to our democracy. As a lifelong advocate for "those who toil with their hands," he envisioned using education as a means of lifting the working-class and underclass out of illiteracy. His Jeffersonian ideals, more than any other aspect of his life, are at the heart of my deep respect for Dr. Barnes and the Foundation he established.

Dr. Barnes fought against the norm on many fronts. He was a lifelong foe of all forms of prejudice, and a visionary with respect to the power of education to change the lives of African Americans. He held a lifelong conviction that racism would only be conquered when African Americans embraced education and when others became aware of their rich cultural heritage, a heritage that Barnes studied and greatly appreciated.

These strong beliefs led Dr. Barnes to confer the stewardship of the Foundation on Lincoln University, a historically black college in southeastern Pennsylvania. And it is with this commitment in mind that the Board of Trustees seeks to advance his great vision. It is our hope that the Barnes Foundation will promote advanced education among all Americans, including minorities, by combining our resources with those of an accredited institution of higher learning. We hope to support full scholarships to students who qualify and allow students to use the resources of the Foundation to pursue degrees. In this manner the Foundation will truly meet the goals of Dr. Barnes.

From the thousands of archival documents, we get a true picture of Dr. Barnes as a man of incredible energy, intelligence, and artistic vision. A 1926 letter from the art dealer Paul Guil-

laume aptly illustrates the point that some of Dr. Barnes' choices, now recognized as modern masterpieces, were considered odd at the time. Guillaume wrote: "Two weeks ago in Paris I heard a solemn American say to a Frenchman..., 'Dr. Barnes is crazy.'" The Frenchman did not reply to the American. But several days later, the President of France answered this comment in a resounding manner when he conferred on Dr. Barnes the title of Knight of the Legion of Honor, the highest accolade given to civilians by the French republic. This jewel-encrusted medal sits on my desk as a reminder of Dr. Barnes' contributions to his fellow man and of our obligation to keep his collection and his dream alive.

While certain individuals will always fight against change and progress, a large number of people and institutions have shared our commitment to securing a stable and productive future for the Foundation. To all of them, we extend our heartfelt appreciation. Special thanks belong to the late Dr. Franklin Williams; J. Carter Brown, director emeritus of the National Gallery of Art, his successor Earl A. Powell III, and their staff; Irène Bizot and the Réunion des Musées Nationaux; Anne d'Harnoncourt and the Philadelphia Museum of Art; Walter Annenberg; Alfred A. Knopf, Inc.; the staff at the Barnes Foundation; and our families.

Richard H. Glanton
President, The Barnes Foundation

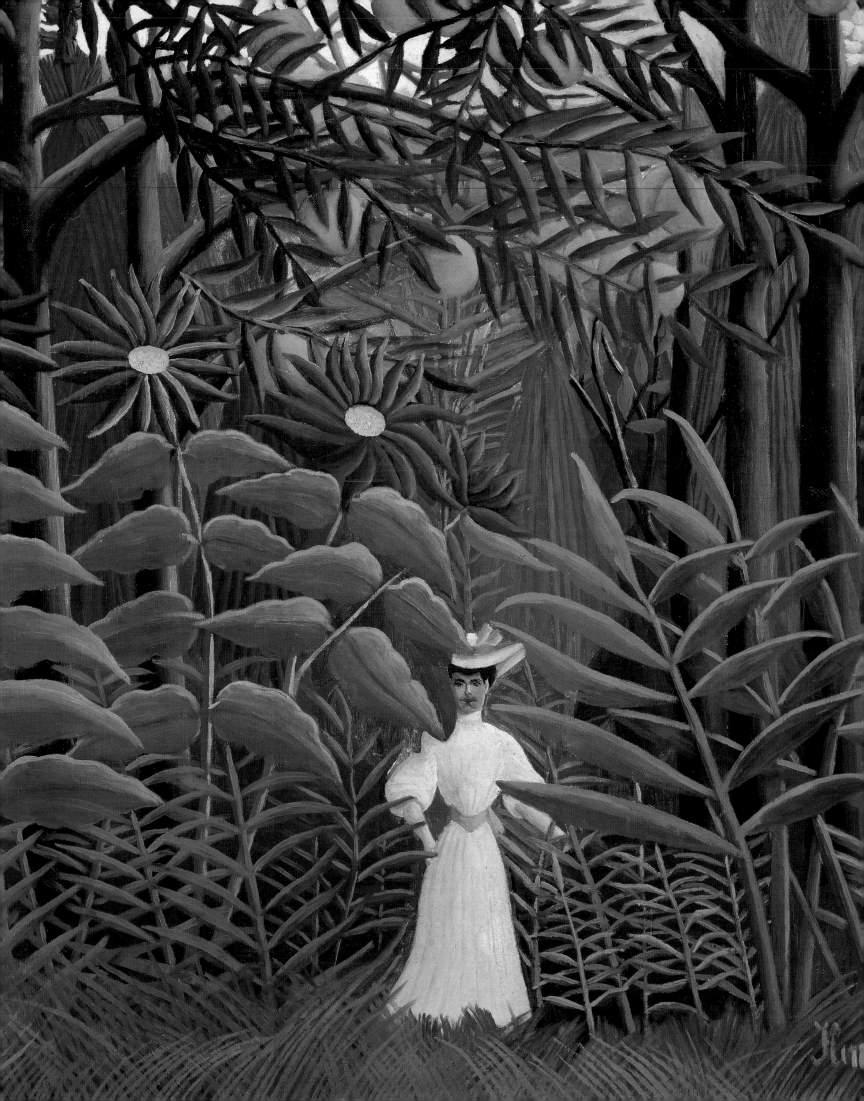

Foreword

We had a memorable experience at Lincoln yesterday — enjoyed the placid contentment that grips one
as soon as the gate is entered. It always seems like home to me.
 — Dr. Albert C. Barnes to Dr. Horace Mann Bond, President, Lincoln University, 17 May 1951

This was a man I discovered to be my friend, and the friend of all the dispossessed of the world. This was
a man of quick and lively sentiments, of love and devotion for the man lowest down.
 — Dr. Horace M. Bond, from a draft document replying to one of Dr. Barnes' critics, February 1952

Those acquainted with Dr. Barnes' life and work know of his self-described childhood "addiction" to "Negro camp-meetings and revivals." This fascination would later develop into a serious study and deep appreciation of the art of Africa and African Americans. With little else to go on, it has become commonplace to cite Dr. Barnes' affinity for "Negro art and culture" as the basis for what many portray as his spontaneous and spiteful decision to bequeath to Lincoln University the responsibility for naming the trustees of the Barnes Foundation.

Quite a different story emerges when one knows the history of Dr. Barnes' relationship with Lincoln University, and particularly with Dr. Horace Mann Bond, Lincoln's president from 1945 to 1957. Off and on, Dr. Barnes had lent his support to various African American artists, including Aaron Douglas, Horace Pippin, and Claude Clark, but no evidence exists to show that he took any sustained interest in higher education of African Americans until he met Dr. Bond. Much of their relationship is revealed in the many unpublished letters and other documents exchanged between the two men over the last five years of Dr. Barnes' life. I have read the correspondence in Lincoln's archives, housed in our Langston Hughes Memorial Library; a study of the Barnes Foundation archives might reveal even more of the story.

Dr. Bond first met Dr. Barnes in Philadelphia on 31 October 1946, at the funeral of a prominent Lincoln graduate. Their chance meeting was punctuated by a typical Barnesian quip that he hoped Dr. Bond would not be as "long-winded" as most "Negro preachers." Dr. Bond disdainfully replied that his remarks would last exactly three minutes, and that he was "not a Negro preacher." This must have piqued Dr. Barnes' interest because after Dr. Bond's brief remarks, he insisted that his new acquaintance join him and his wife for lunch at their residence in Merion. Later, writing to the friend who had introduced him to Dr. Barnes, Dr. Bond

recalled lunching on milk and crackers and receiving a personal tour of the Barnes Foundation gallery as well as a lecture by the collector and one of his colleagues on the philosophy of aesthetics. Dr. Bond also remarked that his host had been very cordial and that he had had a good time. Always on the alert for financial support for Lincoln, Dr. Bond decided that it was "premature" to ask Dr. Barnes for a donation at this first meeting, but he did invite him to come and speak at the university.

Dr. Barnes made his first visit to Lincoln in January 1947, where he met with members of the senior class at Dr. Bond's residence. Shortly thereafter, he made a thousand-dollar donation to the university, which was distributed in varying amounts to needy students from Africa and the Caribbean.

From that point on, the friendship that developed between Dr. Barnes and Dr. Bond was captured in letters that were always cordial, usually candid, but sometimes cautious in tone. Dr. Barnes made a number of visits to the campus, and Dr. Bond visited Merion several times. By 1950, a program had been established to allow Lincoln students to study at the Barnes Foundation. The program continued for some time after Dr. Barnes' death in 1951, but was phased out beginning in 1957.

Dr. Barnes' and Dr. Bond's correspondence included not only their letters to each other, but also copies of letters, memos, and proposals they sent to others. For example, Dr. Bond's files contain copies of letters from Dr. Barnes to the Philadelphia Museum of Art, to John Dewey, to Haverford College, and so on. They also contain memoranda written by Dr. Barnes in 1926 and twenty years later in 1947, explaining the deterioration of his relationship with the University of Pennsylvania. Dr. Bond consulted Dr. Barnes on various matters, such as the proposal he sent to the Ford Foundation in 1951 seeking support for the African Studies Institute he had launched at Lincoln in the fall of 1950.

In October 1950, Dr. Barnes amended his Foundation's Trust Indenture to designate Lincoln University as the institution that would eventually name the Foundation's trustees. He did not immediately inform Dr. Bond of his decision. It was not until 9 January 1951 that Dr. Barnes wrote to Dr. Bond, hinting of "what I have planned for Lincoln in the distant future." On 1 March 1951 Dr. Barnes showed his friend the document, and read to him the language, that gave Lincoln University the role it has today.

That Dr. Barnes had even greater plans for Lincoln and the Barnes Foundation is clear from a letter he wrote to Dr. Bond on 21 May 1951, just two months before his accidental death:

> On Thursday next, I have an engagement with [John] Dewey in New York to lay before him plans to make our resources an integral part of Lincoln's educational program. Since Dr. Fen [a student of Dewey's who was a guest lecturer at Lincoln] expressed a desire to enter a Foundation class next

year, and we want him to, the question came up — for Dewey to answer — [as to] how Fen can serve Lincoln as a catalyst to weld Lincoln and the Foundation in an educational enterprise that has no counterpart elsewhere. And, as a corollary, what outside financial help should be sought to enable Lincoln to carry out the new experiment.

After Dr. Barnes' untimely death, surprisingly little was said about his legacy to Lincoln University. Dr. Bond made some discreet inquiries about the change in the Trust Indenture, but received no concrete information as to whether the wording he heard from Dr. Barnes had been legally incorporated into the document. Not until 1960, three years after Dr. Bond had stepped down from the presidency of Lincoln, did the acting president, Dr. A. O. Grubb, get definitive word that the change of which Dr. Bond had been advised was indeed in effect.

In the meantime, William Schack, author of *Art and Argyrol* (1960), the first biography of Dr. Barnes, had written to Dr. Grubb on 16 December 1959, inquiring about the status of the provision in the Trust Indenture that had conferred on Lincoln University "the power of selecting successor trustees to the [Barnes] Foundation." Mr. Schack continued: "I have just heard a report, however, that shortly before he dies [sic], Dr. Barnes again amended this provision to confer the authority elsewhere. Will you please let me know whether this is true?"

We know, of course, that Dr. Barnes had left the indenture intact. Speculation that Lincoln had "fallen out of favor" with Dr. Barnes may have stemmed from the fact that he did not attend the University's 1951 commencement, at which he was awarded an honorary degree. Apparently, he was peeved because his plans for a special educational program linking the Barnes Foundation with Lincoln were not unfolding precisely as he wanted them to.

Of this incident, Dr. Bond wrote on 11 September 1951:

> . . . following Commencement, we delivered his diploma and hood; and on July 17th, took a party to Merion where we were kindly entertained by Dr. and Mrs. Barnes. At that time I noted he had framed our diploma on his office wall. We discussed plans for our courses at the Barnes Foundation and had a very good visit. Then, [the] next week, Dr. Barnes was killed.

In recent years, speculation that Dr. Barnes had changed his mind about Lincoln has resurfaced in various publications, including Howard Greenfeld's *The Devil and Dr. Barnes* (1987). Citing one of Dr. Barnes' letters to Lincoln's Dean of the College concerning the failures of the first year's experiment to give Lincoln students an art education at the Barnes Foundation, Greenfeld leapt to the conclusion that the only reason Lincoln was "never officially fired" was that "there was no time for Barnes to take this step." Such a conclusion is simply not justified by the documents that give a detailed picture of the relationship between Dr. Barnes and Lincoln University.

Of course, given what Dr. Bond describes as his friend's "mercurial nature," it is not surprising that many have speculated about what Dr. Barnes might have done for or about Lincoln had he not died unexpectedly. But the record shows that shortly before his death, he had turned to John Dewey, his most trusted ally, mentor, and friend, to help him "weld Lincoln and the Foundation [into] an educational enterprise that has no counterpart elsewhere."

The life and legacy of Dr. Barnes are both fascinating and formidable. He is justifiably famous for his role in collecting, interpreting, and promoting the works of some of the most celebrated founders of modern European art. He deserves to be equally well known, as indeed he once was, as a patron and historian of African and African American art. He collected African masterpieces and was one of the first to appreciate the powerful influence of African art on both ancient and modern European art. Two of Dr. Barnes' prominent African American contemporaries, the philosopher Dr. Alain Locke and the sociologist Dr. Charles S. Johnson, each included Dr. Barnes' essays on African art in 1920s publications that have become classic references on the Harlem Renaissance.

Given his lifelong interest in African Americans, it was fortuitous and fitting that Dr. Barnes' respect and regard for Lincoln University's erudite black president would lead him eventually to empower this university to name four of the five trustees of the Barnes Foundation.

At the time of his death, Dr. Barnes' plans for Lincoln University and the Barnes Foundation were just unfolding. One thing is certain: his vision for the two institutions was not a static one; he foresaw the evolution of a great educational alliance. He hoped that together Lincoln and the Barnes Foundation would realize his original dream of educating people from all walks of life through the study of the principles embodied in great art from various periods and different parts of the world.

Lincoln University is excited about the prospect of collaborating with the Barnes Foundation to help bring Dr. Barnes' vision to fruition as we move into the twenty-first century.

Niara Sudarkasa
President, Lincoln University

Director's Foreword

Few exhibitions are likely to appear at once as familiar and surprising as *Great French Paintings from The Barnes Foundation*. With rare exceptions, the artists represented are cherished names in nineteenth- and twentieth-century French painting: Manet, Monet, Renoir, Cézanne, van Gogh, Gauguin, Seurat, Matisse, and Picasso. To many of our visitors, however, the works displayed will be unfamiliar.

Dr. Albert C. Barnes chartered the Barnes Foundation in 1922 as an educational institution. It was his intention that the works of art would serve as objects of study through which instructors could teach his philosophy and psychology of aesthetic form. For many years now, certain restrictions, unusual in the typical art museum, have been observed. Above all, access to the collection has been limited, and since Dr. Barnes' death and that of his wife, loans and reproductions in color have been prohibited. Now, because the facilities are undergoing renovation and repair, a small but extraordinary portion of the collection has been temporarily released — and we are profoundly grateful to the Barnes Foundation for making this long-dreamt-of exhibition come true.

These masterpieces of modern French painting form a vast and exhilarating visual banquet, and reveal Dr. Barnes to have been a bold and original collector of modern art. The selection of works for the exhibition is intended in part to reflect the biases and idiosyncracies of Dr. Barnes' collecting habits, though it should be noted that the collection is rich in areas that we elected not to represent. The choices and omissions of the collection itself, as well as those of the exhibition, set our enterprise apart from any conventional survey of modern art. It offers, among other delights, the opportunity to view works by Renoir, Cézanne, and Matisse in tremendous breadth and depth. Some masterpieces in the Barnes collection have, over the years, attained a high degree of celebrity: thus, Seurat's *Models*, Cézanne's *Card Players*, and Matisse's *Bonheur de vivre* are focal points of the exhibition. Other works are much less familiar, though the pictures by van Gogh, Picasso, Modigliani, and the Douanier Rousseau, for example, all represent those artists at various peaks in their careers. Attention has been paid to the overall achievement of French modernism that Dr. Barnes so admired, while care has also been taken to include some works that stand apart from the mainstream of a given artist's work. Like the exhibition, the catalogue is an unprecedented effort, drawing upon the knowledge of many scholars and specialists in the field. In many cases, this is the first time that paintings from the Barnes

Foundation have received full-dress scholarly treatment. Our authors have applied new research — much of which was conducted in the Barnes Foundation archives — to a discussion of these works in their established art-historical context. In addition to their dazzling appeal, the color reproductions published here will provide a research tool of immense value to students of modern art.

The historic exhibition of *Great French Paintings from The Barnes Foundation* is a remarkable story in its own right, as well as a momentous opportunity to secure the future of this exceptional collection. About two years ago, J. Carter Brown, then director and now director emeritus of the National Gallery, was approached by Richard H. Glanton, Esq., energetic president of the Barnes Foundation, about organizing a brief tour of a selection of masterworks from the collection. This contact was suggested to Mr. Glanton by the Hon. Walter H. Annenberg, a long-time observer of the Barnes Foundation and a considerable judge of French paintings. An incomparable curatorial team was assembled, including Charles S. Moffett, now director of the Phillips Collection, and senior curator of paintings at the National Gallery at the time the exhibition was organized, and Françoise Cachin, director of the Musée d'Orsay in Paris. Throughout our preparations, we have worked closely with the Barnes Foundation; with Irène Bizot, administrator general, Réunion des Musées Nationaux, Paris; and with Anne d'Harnoncourt, director of the Philadelphia Museum of Art, and Joseph J. Rishel, curator of European painting and sculpture there.

The exhibition would not have been possible at the National Gallery without the generous support of GTE Corporation. GTE is one of the Gallery's most eminent corporate patrons, having sponsored eight exhibitions since 1980, including *Art for the Nation: Gifts in Honor of the 50th Anniversary of the National Gallery of Art* in 1991. We are deeply grateful to Charles R. Lee, chairman and chief executive officer, for his longstanding leadership in support of the Gallery's exhibition programs.

We are grateful to the trustees of the Barnes Foundation for their enlightened stewardship of the collection and their unstinting support for the exhibition: Richard H. Glanton, Esq., president; Dr. Niara Sudarkasa, vice-president; Dr. Shirley A. Jackson, secretary; Charles A. Frank III, treasurer; and Cuyler H. Walker, Esq., parliamentarian. We are also indebted to staff members at the Foundation who have provided invaluable service at every stage, particularly Patrick Corcoran, Aminata Diallo, Lynn Fleming, Laura Linton, and Ross Mitchell; special thanks go to Nicolas King for shepherding authors through the Foundation archives.

At the National Gallery, deputy director Roger Mandle played a critical role in the coordination of the exhibition. D. Dodge Thompson, chief of exhibition programs, worked closely with Barnes Foundation trustee Cuyler Walker to develop the guidelines by which the collection would tour. Elizabeth Driscoll Pochter, exhibition officer, oversaw the administration of the exhibition, and the Gallery's associate counsel, Elizabeth A. Croog, provided valuable

legal advice. Elizabeth Weil Perry, corporate relations officer, was responsible for the successful fundraising efforts. In the department of modern painting, Elizabeth P. Streicher, associate research curator, served as coordinating curator of the exhibition. Jeffrey S. Weiss, assistant research curator, brought valuable research and translation skills to the task of preparing the manuscript for the catalogue, and contributed to the general administration, as did Kathryn Calley, research assistant, and Valerie Guffey, former staff assistant. Ross Merrill, head of conservation, and conservators Sarah Fisher, Ann Hoenigswald, Jay Krueger, and Mervin Richard as well as Sally Freitag, Michelle Fondas, Robert Cwiok, Johnnie Mizell, and John Poliszuk of the registrar's office advised on the handling of close to ninety paintings in the Barnes Foundation. We are grateful to Frank Zuccari of the Art Institute of Chicago and Inge-lise Eckmann of the San Francisco Museum of Modern Art for their advice on the conservation of the paintings for the tour. Gaillard F. Ravenel, senior curator and chief of design; Mark A. Leithauser, deputy chief of design; and Gordon Anson, head of lighting design and production; and their staff are responsible for the sensitive design of the exhibition. In the library, reference assistant George T. Dalziel, Jr., and interlibrary loan assistant Thomas F. J. McGill, Jr., were especially helpful.

The editing of the catalogue was overseen from the beginning, with unflagging energy and enthusiasm, by Susan D. Ralston of Alfred A. Knopf, Inc., in collaboration with Frances P. Smyth and Mary Yakush of the National Gallery. Samantha Williams, also of the National Gallery, provided valuable support throughout the project. The volume was designed by Bruce Campbell of Stonington, Connecticut. It was art-directed by Peter A. Andersen and produced by Ellen McNeilly, both of Knopf. The Barnes Foundation paintings were photographed *in situ* by Edward Owen of Washington, D.C.

For their generous assistance in facilitating Jack Flam's research on the *Dance* mural we would like to thank Claude and Barbara Duthuit and Wanda de Guébriant at the Matisse Archives, Paris; Paul Matisse for his help with material from the Pierre Matisse Archives; Lydia Delectorskaya for sharing her unique recollections and insights about Matisse's working procedure; Suzanne Pagé of the Musée d'Art Moderne de la Ville de Paris; and Xavier Girard of the Musée Matisse, Nice, for providing access to works and archival materials in their collections; and John Cauman for his help with archival materials. For sharing information on the history of Dr. Barnes as a collector, we are grateful to Me Aubron, Catherine Chevillot, Guy-Patrice Dauberville, Douglas Druick, Gloria Groom, Jacqueline Henry, Sylvie Maignan, Isabelle du Pasquier, Hans Albert Peters, and Michael Zimmerman.

Earl A. Powell III
Director, National Gallery of Art

GREAT FRENCH PAINTINGS FROM THE BARNES FOUNDATION

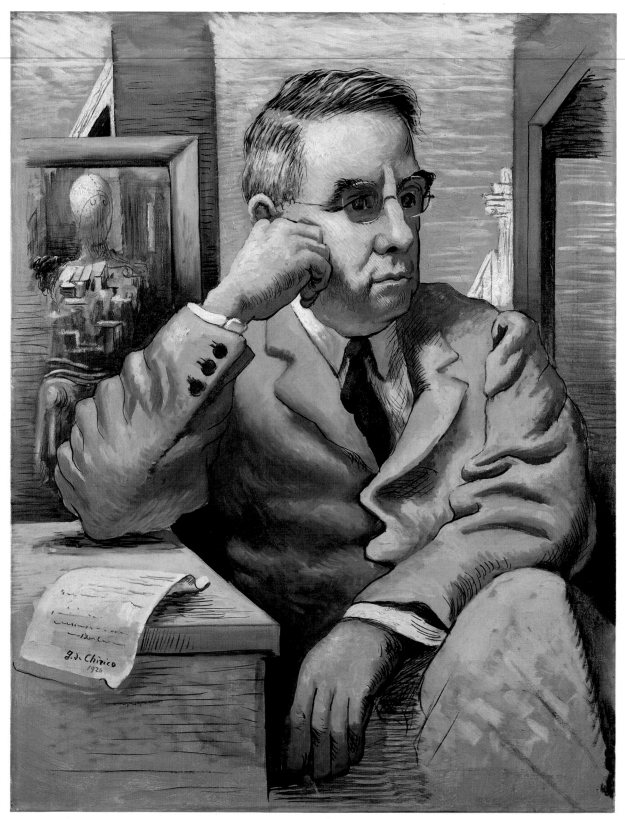

Fig. 1. De Chirico, *Dr. Albert C. Barnes*, 1926. Oil on canvas, 36½ x 29" (92.1 x 73.7 cm). The Barnes Foundation, inv. no. 805.

Dr. Albert C. Barnes and The Barnes Foundation

Objects of art contain myriads of elements of form on different levels, knit together in more and more complex systems, till the feeling which they demand is such as to occupy the whole powers of the greatest mind, and more than these if they were to be had.

— Bernard Bosanquet (1915)

Albert Coombs Barnes (1872–1951) successfully pursued his goal of assembling a collection of modern paintings unrivaled for quality in the twentieth century. What set Barnes apart from other great collectors was his conviction that these works of art could be employed as tools in an educational experiment crystalized in 1922 in the school of the Barnes Foundation. How this great art collection and the systematic teaching program it served were developed by Dr. Barnes to form one of the unique cultural institutions in American life is the subject of this essay.

Barnes was born 2 January 1872 in Kensington, a working-class neighborhood of Philadelphia. In 1867 his father, John, a butcher by trade, had married Lydia Shafer, a devout Methodist of Pennsylvania-German origin who was the motivating influence on the younger of their two surviving sons. During his youth, by his own account, Barnes "tried to paint pictures and to play several musical instruments." That he was obliged to learn boxing in order to defend himself against neighborhood bullies may be one of the many apochryphal stories which have attached themselves to Barnes' life, though combativeness was a prominent component of his psychological makeup. Another important early experience that Barnes stressed in later autobiographical reflections was his contact with African-Americans and the decisive influence their culture had on his life. "My experience with the Negro began when I was eight years old. It was at a camp-meeting in New Jersey and the impression was so vivid and so deep that it has influenced my whole life, not only in learning much about the Negro, but in extending the aesthetic phase of that experience to an extensive study of art in all its phases, and particularly the art of painting." Barnes added: "I became an addict to Negro camp-meetings, baptizings, revivals, and to seeking the company of individual Negroes."

At age thirteen, in June 1885, Barnes entered Central High in Philadelphia, one of the preeminent public secondary schools in the United States, empowered to grant baccalaureate

degrees. The academic program was rigorous; it offered a curriculum oriented toward the sciences or humanities. He attended for eight consecutive terms, was elected vice-president of his senior class and graduated in June 1889, with a B.S. degree.

Barnes and the artist William J. Glackens (1870–1938), who was later to play an important role in Barnes' life, were only once a part of the same class, in February–June 1888. Barnes later wrote: "We became close friends, partly through my interest in his drawing...and because we had the same interest in sports. We were members of the...baseball team for several years."

In the fall of 1889, Barnes matriculated at the University of Pennsylvania Medical School, graduating in 1892 with a cumulative three-year average of 84.5. An M.D. at twenty, he served as an intern at the Polyclinic Hospital, Philadelphia, and in the Mercy Hospital of Pittsburgh. This experience led him to conclude that he was not cut out for the practice of medicine. What interested Barnes most was science, and particularly that branch of chemistry that was related to physiology. In the summer of 1893 Barnes visited hospitals in London and Paris. He saved enough to return to Europe, where in 1894 and 1895 the young physician worked in clinical medicine and experimental physiology at the University of Berlin. He also studied the psychology of insanity for six months at the State Hospital for the Insane at Warren, Pennsylvania.

In the late nineties Barnes was employed as advertising and sales manager for H.K. Mulford and Company, manufacturer of pharmaceuticals, which sent him to Ruprecht-Karls-Universität, Heidelberg, in 1900, where he studied pharmacology. He also attended classes in philosophy. There he recruited a German chemist, Hermann Hille, for the firm. In June 1901 Barnes married Laura Leggett of Brooklyn and their extended honeymoon in Europe took them back to Heidelberg and Berlin where Barnes introduced his bride to his professors. Hille worked independently with Barnes to develop a new silver compound, Argyrol, and in 1902 they established the firm of Barnes and Hille.

Argyrol was effective in the treatment of eye inflamations, especially in newborn infants. Hille oversaw laboratory production and Barnes handled marketing and sales. Argyrol was never patented, for that would have revealed its formula, but the name was registered as a trademark. By 1907 the partnership foundered and was dissolved, and Barnes bought out his partner. Barnes' attorney was John G. Johnson (1841–1917), a graduate of Central High, who had assembled an extensive collection of paintings. Johnson was also Henry Havemeyer's lawyer and a trustee of the Metropolitan Museum of Art.

In 1908 Barnes established the A. C. Barnes Company, which yielded him a considerable fortune. In addition to his training and experience as a physician, chemist, and businessman, Barnes also studied psychology, and was an early exponent of Freud's analytical method, acting as a lay analyst for acquaintances and consulting on cases referred to him by medical colleagues. Above all, he admired the ideas of William James, whose concepts of intelligence applied to the

conduct of everyday life, known as Pragmatism, provided the intellectual underpinnings for Barnes' eventual life's work in education.

Over the next several years Barnes reorganized his business so that the workday required only six hours. Concurrently, he initiated a discussion group for both black and white employees at the factory, in which the first two years were devoted to the study of William James. The curriculum expanded to include Bertrand Russell's "The Free Man's Worship" (1910), John Dewey's *How We Think* (1910), Santayana's *The Sense of Beauty* (1896) and *Reason in Art* (1906). Studying Santayana led Barnes to install in the plant examples of work by the American painters Glackens, Lawson, Maurer, Prendergast, and others he had begun to collect. These paintings were discussed with the workers in the light of ideas derived from their readings. Eventually, as many as a hundred paintings were put on display and offered at cost to interested employees. A circulating library of modern literature was placed at their disposal. The seminars attracted people from outside the company who also wished to enhance their leisure time, and so additional sessions were held. The classes, by that time focused mainly on the systematic study of art, were conducted over a period of a decade by one of Barnes' employees, Mary Mullen (1875–1957), author of the Barnes Foundation's first publication, *An Approach to Art* (1923).

William James' intellectual heir was John Dewey (1859–1952), whose *Democracy and Education* (1916) galvanized Barnes to explore ways to broaden his extensive knowledge of psychology and apply the scientific method to problems in aesthetics. In 1915 Barnes engaged Laurence Buermeyer (1889–1970), who had been a student of Dewey, to read and discuss with him five days a week James' *The Principles of Psychology* and James' philosophical writings, as well as to review with him the tradition of modern Western philosophy. At this time, he also developed friendships with two members of the University of Pennsylvania Philosophy Department, Edgar A. Singer, Jr. and Louis W. Flaccus, the latter a specialist in aesthetics. The tutorial sessions with Buermeyer continued in 1916, at which time the philosophy instructor, subsequently associate director of education of the Barnes Foundation and author of *The Aesthetic Experience* (1924), suggested to Barnes that he enroll in Professor Dewey's weekly seminar at Columbia in the fall of 1917.

Dewey and Barnes rapidly forged a warm friendship that lasted for more than thirty years. Barnes was attracted to the democratic social vision inherent in Dewey's philosophy and its basis in analytical psychological principles. Dewey was impressed by Barnes' comprehensive grasp of complex intellectual matter and his readiness to apply the ideas to situations in the real world. Their relationship was based upon mutual respect and shared values. Dewey was often quoted as saying that in a lifetime spent among scholars he had not met Barnes' equal for "sheer brain power."

Early in 1918, Dewey and his wife Alice accepted Barnes' invitations to visit him and Mrs. Barnes in Philadelphia, where prominent musicians gave recitals at Lauraston, the home that

Barnes built in 1905. The Deweys saw the art collection and they were also introduced to Barnes' artist friends, William Glackens and Maurice Prendergast. Dewey and Barnes shared their thoughts on philosophy, social problems, and political events as well as on matters related to educational method. Their voluminous correspondence, begun in 1917 and continued until 1951, reveals that neither shrank from analyzing and criticizing the other's formulations. Another subject that united them was equal rights under the law and respect for black citizens. Dewey had addressed the first and second National Negro Conference in 1909 and 1910, which led to the founding of the National Association for the Advancement of Colored People, and was a member of its original General Committee.

It was partly as a result of discussions among Barnes and the Deweys that the idea of transforming the informal factory seminars into a formal experiment in education was conceived. Mrs. Dewey, who had been principal of the Laboratory School at the University of Chicago, urged Barnes to consider to what purpose he would devote his collection. She well knew how interested Barnes was in the James–Dewey ideal of self-realization, and the use of the scientific method to guide conduct. Barnes, who was as opposed to inherited privilege as Dewey, shared the philosopher's conviction that the common man, through concerted effort and reflection, could become the dynamic factor by means of which democracy flourishes.

Thus, Barnes' enlightened exercise in industrial relations and self-improvement led to the establishment of the Barnes Foundation in 1922. Barnes saw the Foundation as a force for social action. From its inception he underscored the non-discriminatory conditions underlying the experiment: "We do not convey the impression that we have developed a crowd of savants, or art connoisseurs, but we are sure that we have stirred an intelligent interest in spiritual things created by living people . . . which has been the means of stimulating business life and affording a sensible use of leisure *in a class of people to whom such doors are usually locked*" (*The New Republic*, March 1923, emphasis added).

Around 1911, Dr. Barnes re-established his relationship with William Glackens (fig. 2). The friendship was renewed at Barnes' instigation, as he later wrote, "because I had, in the meantime, become interested in the study of art and especially as it related to education. I spent my days in his studio and he came frequently to my house to visit me and discuss the paintings I had accumulated." Together they looked at the impressionists in the Metropolitan Museum of Art, and Glackens often accompanied Barnes to dealers and artists' studios. Early in 1912, Barnes asked Glackens to go to Paris to purchase modern paintings for him. There, with Alfred Maurer, Glackens visited the galleries to select works for Barnes. Maurer also took Glackens to meet Leo and Gertrude Stein and see their collection. Among the approximately twenty paintings Glackens returned with, which remain today in the collection, are Cézanne's *Toward Mont Sainte-Victoire* (inv. no. 300), van Gogh's *Joseph-Etienne Roulin* (page 169), Picasso's *Woman with a Cigarette* (page

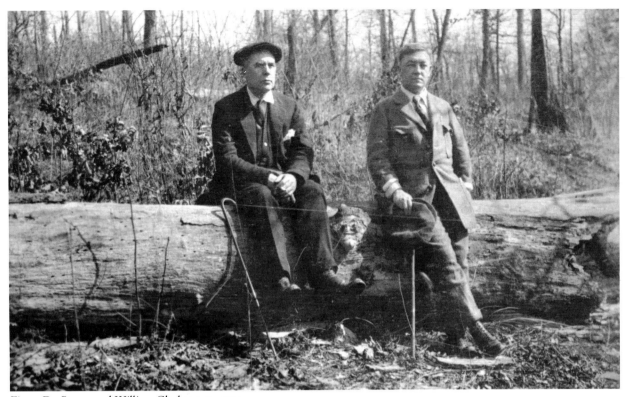

Fig. 2. Dr. Barnes and William Glackens, ca. 1920.

191), Renoir's *Child Reading* (inv. no. 51), Maurice Denis' *Maternity* (inv. no. 335), Pissarro's *Garden* (inv. no. 324) and lithographs by Renoir and Cézanne. While Glackens was in Paris, Barnes purchased Corot's *Landscape* (inv. no. 1035) at auction in New York. Immediately following his return, Glackens arranged for the purchase of Monet's *Madame Monet Embroidering* (page 97), which he had seen in Paris.

Although Glackens had a free hand and the funds with which to buy the paintings, Barnes was sufficiently independent to accept or reject them on the basis of his own judgment of their individual merit, and a number of works were subsequently traded. Glackens never claimed to have had any generative role in the formation of Barnes' collecton. In April 1912, Barnes purchased Renoir's *Reclining Nude* (page 73) and *Girl with Jumping Rope* (inv. no. 137) from Durand-Ruel in New York. By June he was in Paris, where he bought, among others, Gauguin's *Haere Pape* (page 167) of 1892 from Bernheim-Jeune. He corresponded regularly with the major dealers and engaged Alfred Maurer to seek out potential acquisitions. By such means, in September, he got three Bonnards and van Gogh's *Man Smoking* (inv. no. 119).

In December Barnes returned to Paris for a major campaign at the winter auction sales. As a reporter for *The Burlington Magazine* observed:

It was amusing to watch a certain section of those present at the Rouart sale while what they had been accustomed to consider secondary pictures went up to prices hitherto undreamed of. When Cézanne's little *Baigneuses* [page 32], measuring only 16 by 17 inches, was put up to 18,000 (19,800 including charges) [$3960], at which price it was bought by Mr. Barnes, an American collector, there was derisive laughter from some of the worthy dealers and others in my neighborhood. Who, they evidently thought, are the lunatics let loose among us? As the sale proceeded, their derision turned to indignation, for they saw all their standards of value shattered. . . .

A new force had entered the market, a self-made man with substantial financial and intellectual resources, complex, energetic, with a relentlessly curious and disciplined mind, who relished confrontation and controversy and who drove hard bargains in business negotiations. Over the next forty years, the art world learned that to laugh at Albert Barnes of Philadelphia was to provoke an adversarial response of unequalled intensity.

Barnes also bought two other Cézannes (inv. nos. 57 and 241) and Daumier's *Water Carrier* (inv. no. 127) at the Rouart sale, Daumier's *Hypochondriac* (page 32) and two Renoirs, *Woman Crocheting* (page 32) and *Two Women in Park* (inv. no. 289), at the Hirsch sale on 7 December, as well as three additional Cézannes and Emile Bernard's *Self-Portrait* (inv. no. 2004) of 1888 from Vollard. Seven Picassos, six from Kahnweiler and one from Sagot, were acquired on 6 December. Barnes visited Leo and Gertrude Stein on the 9th and purchased his first two paintings by Matisse, *Still-Life with Melon (Collioure)* (inv. no. 64) of 1905 and *View of the Sea, Collioure* (page 237). Following his return Barnes wrote to Robert Henri on Christmas day, "I got some important Cézannes and Renoirs a few days ago in Paris. . . . There are 6 Cézannes . . . and four Renoirs . . . I got also two very typical Daumiers, some early Picassos and the Matisse still life & landscape which I believe you saw at Stein's apartment in Paris."

At once Barnes and Leo Stein found common intellectual ground. Both were Americans of cosmopolitan outlook and neither thought of pictures as mere possessions but rather as embodiments of complex human perceptions and values. Leo, who had studied at Harvard under William James, had an analytical mind and a serious interest in psychology; he was a man with whom Barnes could share ideas, dispute with, and learn from. In 1913, Barnes began a correspondence with Leo that lasted until the latter's death in 1947. He wrote on 30 March 1913: "At New York it [The Armory Show] was the sensation of the generation. . . . Academic art received a blow from which it will never entirely recover I am convinced that I cannot get too many Renoirs"

In June, Barnes returned to Paris where he bought Picasso's *Composition: The Peasants* (page 201) from Vollard. In addition to acquiring more paintings, Barnes was not reticent about expressing his views, refined as a result of his reading — Santayana, Bosanquet, George Moore, Havelock Ellis — sharpened by frequent discussions with artists, and verified by scrutinizing the

pictures in his home and factory as well as in the studios of artists, dealers' showrooms, and museums. By early 1914 he wrote to Leo, "I counted 25 Renoirs, 12 Cézannes and 12 Picassos in my house. I expect to be in Paris about May 1st and surely hope to find you there. Will stay long enough to see what the dealers have and then go to Madrid for the Prado and Florence for the Italians." Barnes, dissatisfied with what he was reading on modern art, urged Leo to write down the ideas which he had been discussing with him: "I hope you'll get busy on the things you can say better than anyone else that I know. You ought to do it. I'll show you how to finance its publication."

Meanwhile, Barnes began to write about art himself. In April 1915, he published "How to Judge a Painting" (*Arts and Decoration*), in which he wrote that the challenge of understanding art "makes worth while getting a collection that is the owner's personal exponent, and especially to the man who, in forming the habit of achieving by his personal efforts, has learned two great lessons of life; the keen pleasure in pursuing an elusive object, and his own judgment based upon sound knowledge as, for him, the court of last resort." He observed that "Havemeyer's is the best and wisest collection in America," and noted "the large number of paintings by the men that make up the greatest movement in the entire history of art — the Frenchmen of about 1860 and later, whose work is so richly expressive of life that means most to the normal man alive today. One could study art and its relations to life to better advantage in the Havemeyer collection than in any single gallery in the world." Barnes acknowledged Glackens' role: "The most valuable single educational factor to me has been my frequent association with a life-long friend who combines greatness as an artist with a big man's mind."

The war interrupted Barnes' travels abroad. In April 1915, Leo Stein returned to New York and intensified his long talks with Barnes. He also published articles in *The New Republic*, which Barnes occasionally criticized in letters to the editor. Leo, whose longstanding predilection for Renoir provided Barnes with an intellectual counterpart to Glackens, likewise encouraged Barnes' enthusiasm for the artist, about whose work he wrote with Barnes in mind, "His pictures so wonderfully supplement and sustain each other, and Renoir lovers are insatiable. Collectors of his pictures have them by the scores and find that each accession adds not itself alone but gives addition also to the life of all the others" (*The New Republic*, 30 March 1918).

Barnes' work with Buermeyer and Dewey, discussions with Glackens and Stein, and his study of psychoanalysis (Freud, Adler, Jung) further reinforced an already secure intellectual framework in which to contextualize the increasing depth of his knowledge. In "Renoir: An Appreciation" (*The Dial*, February 1920), we can discern the general outlines of Barnes' mature aesthetic outlook. "Let us assume the validity of the orthodox statement that all art is automatic, a spontaneous expression of feeling which the artist can neither summon by effort of will nor repress with impunity to his own well-being. If the creative impulse leaves its mark in a material that generates similar feelings in other people, the work of art is a human document

of permanent worth. Its degree of worth is determined by the extent to which the artist has enriched, improved, humanized, the common experience of man in the world in which he lives." In "Cézanne: A Unique Figure Among the Painters of His Time" (*Arts & Decoration*, November 1920), Barnes wrote, "Cézanne stands out as an unique figure among the painters of his time, if not of all time, because of the success of his passionate impulse to penetrate into the forms and structures of things. . . . He was critical and analytical, with a high intensity of mind and spirit in his search of facts to attain to the secret springs of form and structure. . . . His power to fuse thought and feeling, the ability to engraft relevant emotion upon substantial fact, to project himself into objects, made him an artist instead of a scientist."

In 1922, Barnes bought the twelve-acre Wilson Arboretum, one of the finest collections of trees in America. In September he applied for a charter from the Commonwealth of Pennsylvania for an educational institution to be known as The Barnes Foundation. This was granted on 4 December 1922, "To promote the advancement of education and the appreciation of the fine arts." He engaged Paul Philippe Cret, professor of architectural design at the University of Pennsylvania, to draw up plans for a gallery and adjoining residence that were constructed of French limestone in a simplified Renaissance style. The interior, with its subtle monumentality, eschews rich embellishment that would have detracted from the impact of the works of art. Elegant in its layout, it provides an intimate setting for the paintings in Barnes' collection. On the ground level a two-story central gallery with marble floor and three tall French doors is flanked on either side by six interconnected rooms of varying dimensions with high ceilings, burlap-covered walls, and parquet floors. Each room has at least one large window that provides natural light with unobstructed space for pictures on the other three walls. On the second floor, a passage with balcony overlooks the main gallery and across to three lunettes opposite. Five rooms lead off each end of this corridor, two skylit and the other eight flat-ceilinged, with windows similar to those on the ground floor.

Barnes commissioned Jacques Lipchitz to carve seven reliefs to be set in the exterior of both the front and back of the gallery as well as on three sides of his residence. Lipchitz also made a freestanding sculpture for a niche in the front of the house.

A unique feature of the gallery exterior is the decoration in colored ceramic for the entrance portico, designed by Barnes in conjunction with the Enfield Pottery and Tile Works (fig. 3). Barnes specified that Enfield surmount and surround Cret's simple stone entrance and the tablet cartouche above the door reading THE BARNES FOUNDATION MCMXXIII with prominent, three-dimensional terra-cotta and two-dimensional tile adaptations of African sculpture. Six modeled figures are set in the uppermost register, and below on either side, dramatically contrasting with a field of pale yellow tiles of different sizes and tones, are curvilinear and angular patterns of crocodiles, masks, and birds, based upon a carved Baule door from the Ivory Coast in

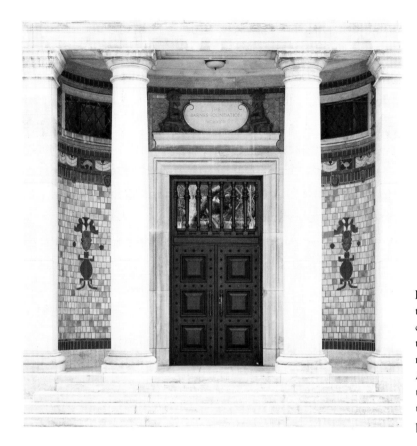

Fig. 3. Main entrance of the Barnes Foundation, 1924. The wall decoration of colored ceramic tiles, manufactured by Enfield Pottery and Tile Works, is modeled after a door relief of a mask and a crocodile made by the Akan peoples of Ivory Coast and Ghana. On the lintel are seated female figures of ceramic tile, modeled after figures made by the Senufo peoples of Ivory Coast and Mali.

the collection. The motifs with their rhythmically balanced shapes and textures welcome visitors as they approach the entrance. The upper frieze surrounding the temple door motif consists of eight different tribal masks. Barnes paid exacting attention to each detail and he wrote to the fabricator "It gives a touch to that part of the building and is worthy of the other works of art which will be its neighbors on the inside. I am sure nothing like it exists anywhere in the world."

In so arranging the entrance Barnes announced his abiding commitment to African art; visitors to the Barnes Foundation are confronted by the central presence of African culture. The juxtapositon of Doric columns and powerful tribal motifs asserts Barnes' point of view. The porch tells us that this is not another conventional grandiloquent monument to classicism. Lipchitz's reliefs underscore the debt owed by modern Western art to the art of black Africa. This theme is further reinforced by the cast iron railings with their Baule mask motif on the interior and exterior of the building.

In the early 1920s, Barnes had begun to collect African tribal sculpture, purchasing large quantities from the Parisian art dealer Paul Guillaume, a pioneer in the study and promotion of these works. Guillaume became Barnes' primary agent in Europe and foreign secretary for the Foundation. At the same time Barnes began to purchase the work of Chaim Soutine, whose exceptionally powerful use of color Barnes recognized as representing a fundamental and

original contribution to the modern tradition (pages 215 and 217). While the gallery was being constructed, a selection of seventy-five works by these School of Paris artists, including nineteen by Soutine, seven by Modigliani, Matisse's *Bonheur de vivre*, and Picasso's *Composition: The Peasants*, was exhibited in April–May 1923 at the Pennsylvania Academy of the Fine Arts, Philadelphia. In his catalogue introduction Barnes called attention to the influence of African sculpture upon artists such as Modigliani, whose "inspiration came from his devotion to the spirit of Negro art," and he urged visitors "to go to the University Museum and look at pieces of ancient African sculpture, so rich in art values." The exhibition met with incomprehension and hostility from the Philadelphia press, which declined Barnes' temperate plea for reasoned consideration: "If one will accord to these artists the simple justice of educated and unbiased attention, one will see the truth of what experienced students of painting all assert: that old art and new art are the same in fundamental principles. The difference lies only in the degrees of greatness, and time alone can gauge that with accuracy."

In 1924, Barnes further prepared for the opening of the Foundation gallery by requesting Guillaume to buy Picasso's *Acrobat and Young Harlequin* (page 195) from Christian Tetzen-Lund in Copenhagen, the same collector from whom he had obtained the *Bonheur de vivre* in December 1922. From Lund he acquired other major works by Matisse, including several that had belonged to the Steins. These included the *Blue Still Life* (page 241), *Red Madras Headdress* (page 239) and *Seated Riffian* (page 247), all bought in January 1925.

At the opening on 19 March 1925, in the main gallery, with masterworks of the French tradition massed in glowing profusion below the border of abstracted African masks, John Dewey gave a dedication address in which he took note of the seminal role played by those who had inspired Barnes:

> Members of the Negro race, of people of African culture, have also taken a large part in the building up of the activity which has culminated in this beautiful and significant enterprise. I know of no more significant, symbolic contribution than that which the work of the members of this institution have made to the solution of what sometimes seems to be not merely a perplexing but a hopeless problem — that of race relations. The demonstration that two races may work together successfully and cooperatively, that the work has the capacity to draw out from our Negro friends something of that artistic interest and taste. . . . We may well rejoice at every demonstration of the artistic capacity of any race which has been in any way repressed or looked upon as inferior. It is the demonstration of this capacity for doing beautiful and significant work which gives the best proof of the fundamental quality, and equality, of all people. It serves . . . the cause of bringing all people from all over the world together in greater harmony.

Dr. Barnes' textbook, *The Art in Painting*, was published just prior to the opening of the Foundation. Alfred H. Barr, Jr., who would become the first director of the Museum of Modern Art when it was founded in 1929, wrote: "This is an important book because it presents a systematic and confident statement of what is central in the 'modern' attitude toward painting. Its five hundred pages are the expression of an energetic critic, of an experimenter in the education of art-appreciation, and of the owner of the finest collection of modern paintings in America." Barr continued: "Modern painting is handled more convincingly and sometimes brilliantly. The plastic developments of Renoir and Cézanne are very thoroughly analysed by the man whose Renoirs and Cézannes should be the envy of every museum in the country — especially the Metropolitan." Barnes' book, a decade in gestation and several years in the writing, articulates a practical approach by which all intelligent individuals may gain for themselves an understanding of the aesthetic aspects of art, a method of attaining a personal vision of those qualities and human values embodied in the traditions.

In a practice that continues to this day at the Barnes Foundation, the galleries were used as a laboratory. Class activity employed pictures and other materials in the collection for a course of instruction. In discussing the paintings, teachers pointed out to students the internal relationships found in the works of art. Based upon ideas outlined in *The Art in Painting*, instructors presented the way an artist uses color, light, line and space — what Barnes termed plastic means — in relationship to each other, fused by the artist's own uniquely personal perceptions of what Barnes referred to as a form, plastic form. This synthesis was not considered a merely mechanical process, what subsequent critics have sometimes dismissed as "formalism." Indeed, Barnes was emphatic in his opposition to formalist aesthetics, wherein the concept of form tended to be reduced to pattern and outline. He stressed the essential affinity of art to nature, whatever creative departures artists may effect by their purposive selection and reorganization of objects and situations in the real world.

What Barnes sought to convey in front of the painting itself, rather than from reproductions, was a means of sorting out the varieties of human experience embodied in a painting. The artist's diverse emotional response to his surroundings, his imaginative formulation of that interaction in terms unique to painting, was foremost in Barnes' method. Barnes emphasized that works of art sum up the broad human values that can be discerned in the world around us and that these are accessible to anyone with a serious interest in learning to see. Delicacy, subtlety, power, surprise — each or many may be the qualities exemplified in an artist's individual work. Thus for Barnes, Renoir's *Artist's Family* (page 77) has as its expressive theme human values of gracefulness, poise, gentleness, coupled with weight, firmness, complexity, power, and drama, each supported by intrinsic relationships of color, light, line, and space. Consequently, Barnes would see in the multiform interconnections of perception, experience, and execution a challenge

to the observer's own understanding and alertness to aesthetic rather than historical, representational, or technical attributes, however legitimate those values may be in human discourse. It was the profound aesthetic values of a picture that absorbed Barnes. As he summed up the problem of appreciation:

> As long as we are really alive, we continue to grow by extending the application of our funded experience, perceiving things more and more precisely and discriminatingly, and at the same time investing them with constantly enriched meanings. The process is exemplified in every activity of life.... As the system of meanings which makes up our minds is amplified and organized, our perceptions become correspondingly richer and more comprehensive.

In the early years of the Foundation's activities, Dr. Barnes attempted to forge a link with the University of Pennsylvania. He proposed to underwrite a comprehensive program of instruction in the philosophy and appreciation of art, with Dr. Buermeyer attached to the philosophy department to teach a course in the aesthetic experience and another Foundation teacher, Dr. Thomas H. Munro, giving instruction in modern art in the galleries of the Foundation. These courses were announced in the School of Fine Arts catalogue but never carried out. Barnes tried for several years to interest the University in collaborating on serious work but the overtures were ignored even though Barnes, in 1926, offered the university's President ultimate control of his Foundation and its collection after his death. In the fall of 1926 Barnes broke off what had never become reciprocal negotiations. The Foundation's classes since that time have attracted students of diverse backgrounds and many painters and teachers at all levels. Its influence has been incalculable.

In 1926, *Primitive Negro Sculpture* by Paul Guillaume and Thomas Munro, illustrated by works in the collection of the Barnes Foundation, was published by Harcourt Brace. The study discussed the aesthetic qualities of African sculpture as well as its chief traditions and its relation to contemporary art. The book and its illustrations became the means by which numerous students, artists, and collectors in the United States were introduced to the subject. Despite the fact that it was ultimately superseded by more detailed and comprehensive studies of African culture and art, the Foundation's publication exercised considerable influence for more than a generation.

In 1929 Barnes sold the A. C. Barnes Company and thereafter devoted himself exclusively to the work of the Foundation. This freedom enabled him to undertake research for a series of monographs, which put into practice the method adumbrated in *The Art in Painting*, the second edition of which had been published in 1928. Together with Violette de Mazia (1899–1988), teacher and subsequently director of education of the art department and vice-president of the Foundation, Barnes published *The French Primitives and Their Forms* (1931), *The Art of Henri Matisse*

Fig. 4. A wall in the Barnes Foundation, 1927.

(1933), *The Art of Renoir* (1935), and *The Art of Cézanne* (1939). A third revised edition of *The Art in Painting* was brought out in 1937. In 1934, John Dewey published *Art as Experience*, which he dedicated to Dr. Barnes. Barnes also wrote numerous introductions for exhibition catalogues, including two for Giorgio de Chirico (1926 and 1936), who painted a portrait of Barnes (fig.1, page 2) in 1926, and one for Soutine in 1943.

Barnes had no qualms about mixing media and intermingling traditions — East and West, tribal and haute epoque. Photographs of installations made in 1927 (fig. 4) show his dynamic groupings of old and new masters, juxtapositions that challenge students to see connections and draw relationships among often seemingly disparate traditions and among works by the same artist. Barnes also took great care to frame the paintings with a selection of richly patinated period frames; he also commissioned frames from such moderns as Charles Prendergast, Robert Laurent, and Max Kuehne. He frequently declined to purchase important works because, he wrote, they would "break up . . . ensembles that are necessary for teaching purposes. The way we hang pictures is not the ordinary way: each picture on a wall has not only to fit in a definite unity but it has to be adapted to our purpose of teaching the traditions."

An explication of the results of this method is found in Barnes' and de Mazia's *Ancient Chinese and Modern European Painting* (1943):

Exclusive interest in the art of our own time and civilization is itself a form of parochialism. The stimulus and illumination which European artists received a few years ago from the work of African sculptures long unknown, widened their horizons and brought them new insight and a new access of energy. The great wealth of resources in oriental art . . . is still a sealed book to most observers. . . . The paintings exhibited here provide a striking demonstration of what ought to be . . . a commonplace of aesthetic criticism — the continuity of great art throughout the ages.

In addition to works by Chinese masters, paintings, watercolors, and drawings by Cézanne, Demuth, Dufy, van Gogh, Goya, Matisse, Modigliani, Renoir, Picasso, Henri Rousseau, Pascin, Jean Hugo, and Glackens, were shown in this exhibition, as they are in the gallery of the Foundation.

Throughout the late 1920s and 1930s, Barnes added to the collection major works that took their place in the challenging wall arrangements. At the end of 1925, Cézanne's majestic *Card Players* (page 123) was acquired from Vollard. In 1926, the year in which Barnes was made an Officer of the Legion of Honor, Seurat's *Models* (page 175), Matisse's *Interior with Goldfish* (page 243), and Courbet's *Nude* (inv. no. 810) were purchased. The following year Renoir's *Artist's Family* (page 77) entered the collection. Late in 1930, during a visit by Henri Matisse to Merion, Dr. Barnes asked the artist to paint a mural to fill the spaces above the windows in the main gallery. Barnes offered Matisse complete freedom in choosing the subject of the commission. Confusion over the measurements led Matisse to compose a mural with the wrong dimensions, but a correctly sized version, *The Merion Dance Mural* (pages 276-278), was completed in May 1933 and installed later that year. Prior to the installation, Barnes fitted the last major element of the main gallery in place when he acquired Cézanne's monumental *Nudes in a Landscape* (page 161), which Barnes and de Mazia described as "Cézanne's greatest imaginative triumph," comparing the powerful composition to the frieze on the Parthenon.

Early in 1932, Barnes obtained Cézanne's pivotal *Bathers at Rest* (page 103). That same year Cézanne's *Red Earth* (inv. no. 909) entered the collection and six months later his *Boy with Skull* (page 151) was acquired from the collection of Dr. G. F. Reber. Manet's *The Laundry* (inv. no. 957) was purchased in 1936. Important works by Renoir were also added: *Jeanne Durand-Ruel* (page 49) and *The Artist and His Model* (inv. no. 949) in 1935 and as late as 1942, *Mussel Fishers at Berneval* (page 28).

In addition to African sculpture and ancient Egyptian, Greek, and Roman carvings, by 1930 Barnes had introduced American Indian pottery, silver jewelry, and dazzling Navajo rugs to intensify further the color and textural impact of the walls and settings. Around 1935, he began acquiring furniture, mainly early American, to render even more complex the wall groupings. The following year, these were further augmented by an array of wrought-iron objects, whose rhythmic punctuations accent and set off the pictures. These comprise a collection in itself of

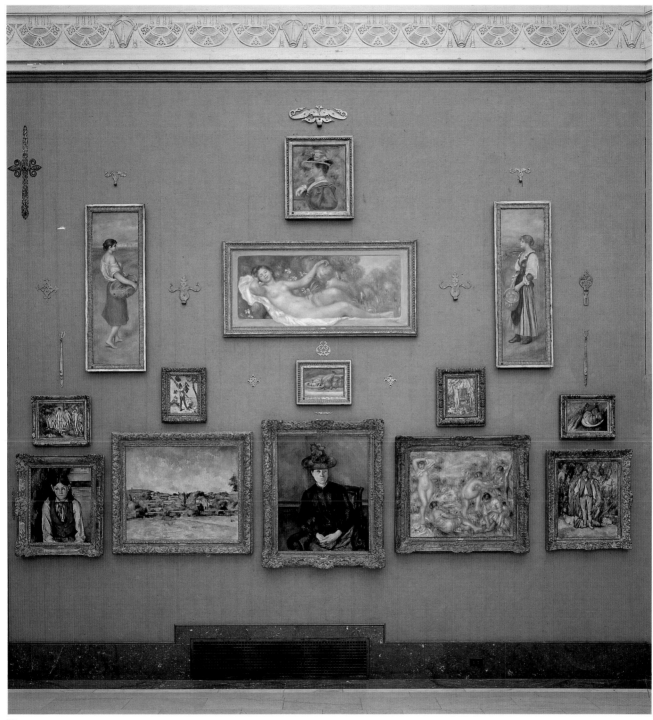

Fig. 5

One of the most striking things in America is the Barnes collection, which is exhibited in a spirit very beneficial for the formation of American artists. There the old master paintings are put beside the modern ones, a Douanier Rousseau next to a Primitive, and this bringing together helps students understand a lot of things that the academics don't teach.

—HENRI MATISSE 1930

17

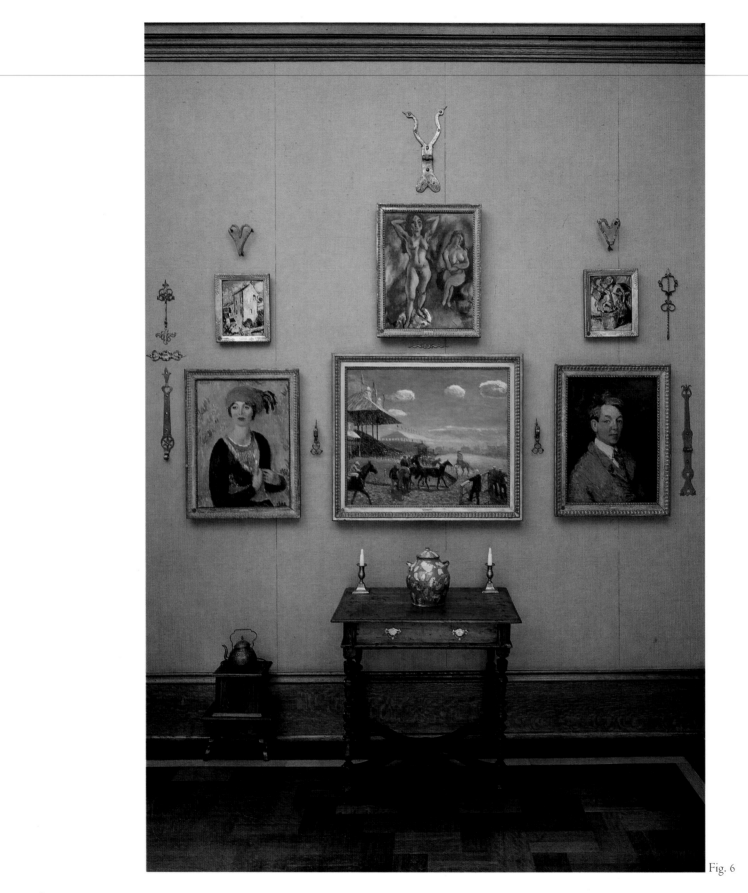

Fig. 6

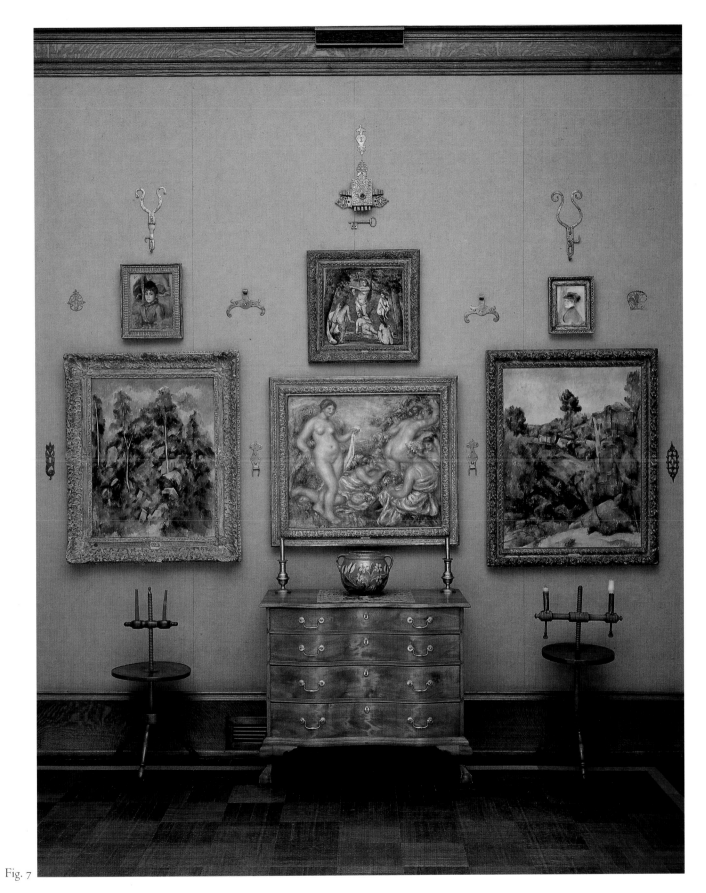

Fig. 7

Fig. 5 (page 17). Eight canvases by Cézanne and six by Renoir, the two central artists of the Barnes Foundation, fill this majestic two-story wall.

The sober monumentality of Cézanne's *Woman in a Green Hat*, 1894–1895, anchors the wall. His glowing, translucent *Red Earth*, c. 1890, to the left, is balanced by Renoir's *Bathers*, c. 1918, whose complex, classically inspired figures are likewise set in a colorful space. The sensuous appeal of color in these two compositions, as well as their recession into space, enframes the dominant purple-blue-gray sculptural power of *Woman in a Green Hat*.

At opposite ends of the first row are Cézanne's *Boy in a Red Vest*, 1888–1890, and *Gardener*, c. 1892, the latter a solid volume set in a mandorlalike niche recalling a figure from a Florentine gothic cathedral. The in-and-out spatial organization of this level of the wall is surmounted by a contrasting layer of small paintings of bathers, figures, and still lifes, which are, in turn, crowned by four Renoirs. This upper level is centered by the large *Reclining Nude*, c. 1895–1897, with graceful, firm volumes and decorative qualities recalling the eighteenth-century French tradition. Its variegated color suffusion and mother-of-pearl surface is an enriched version of Boucher, by way of Titian and Rubens. *Girl with a Basket of Fish* and *Girl with a Basket of Oranges*, both c. 1889, are vertical canvases with single figures that face each other. Their bright, silhouetted volumes join with *Boy in a Red Vest* and *Gardener* in forming a clear perimeter to the wall and with *Woman in a Green Hat* in a V-shaped pattern to unify the upper and lower registers. Renoir's *Girl with Glove*, c. 1893–1895, with its fluid drawing, cool green tapestrylike background, and lustrous white glove, acts as a crowning for the overall architectural organization.

Fig. 6 (page 18). William Glackens' *Race Track* of 1909 is flanked by his *Girl in Green Turban*, c. 1913, and *Self-Portrait* of 1908 and surmounted, left and right, by Alfred Maurer's *House* and *Pot of Flowers*, both c. 1910, and Jules Pascin's *Two Nudes*, 1913.

Bright colors dominate this small wall. *Race Track* conveys the sense of a hot summer day. Objects are not naturalistically rendered; the intense colors, infused with light — pink roof, green infield, reddish-orange track, blue sky — provide a dramatic setting for the horse-and-rider groups and create a sweeping recession into space.

Single figures on either side bracket the *Race Track*. *Girl in Green Turban*'s fluid patterns of dress, hat, and wallpaper create curvilinear shapes that contrast with the angularity of *Race Track*. Colors are applied in thin, loose strokes; the exotic green of the hat and collar echo *Race Track*'s grass and clay. The bold light-dark modeling of *Self-Portrait*, with its broad brushstrokes accentuated by multicolored spots of pigment in the tan coat, is set against a reddish-brown background that clarifies the firm, three-dimensional solidity of the figure. The feathers on the green hat and the almond-shaped bodice play against the shock of hair and lapels in *Self-Portrait*. These sequences are further elaborated by the substantial "Chinese"-shaped Moravian pot (Salem, North Carolina, c. 1800). The spontaneously applied white and green dabs and splotches on a pumpkin-hued ground echo the clouds as well as the color scheme in *Race Track*. A knobbed lid complements the geometric patterns of roofs, and its handles mirror the upraised arms of the Pascin's firmly planted standing figure.

Fig. 7 (page 19). Cézanne's small *Five Nudes* of the late 1870s makes a striking contrast to Renoir's *Bathers*, c. 1918, hanging below it. Its sharp silhouette of mottled ivory figures in a green landscape stands out against Renoir's robust nudes. Cézanne's line is angular and terse, fixing the figures by contour bands and pronounced parallel brushstrokes; their monumental solidity is organized into a blocky pyramid. Renoir's line flows in sweeping arabesques along an inverted pyramid that opens the space around the figures and into the depth beyond.

Renoir's influence on Cézanne's color is seen in the two flanking compositions. These late landscapes, marked by thin, transparent glazes of overlapping color planes, melt and flow in a rich suffusion that Cézanne learned from Renoir as well as from his own experiments with watercolor. This interaction of the two artists is further emphasized by the Renoirs above the landscapes. *Woman in Blue*, c. 1875, on the right above *Bibémus Quarry*, 1898, is lightly brushed in tones of blue and ivory. It was painted before any trace of Cézanne entered Renoir's perceptions. On the left, above *Rocks and Trees*, c. 1900, is Renoir's *Woman in Blue with Bonnet*, c. 1885, painted while Renoir was testing for himself Cézanne's deliberate modeling of volumes and distinct pattern of planes.

This wall surprises in its interlocking patterns. The Renoirs arranged in a V and the Cézannes in a pyramid join with the serpentine-front chest whose blocklike shape echoes *Five Nudes*. Its undulating front reprises the *Bathers* and its blond solidity joins with Cézanne's glowing landscapes. The sweeping floral decoration and curving handles of the Moravian pot continue the flow of the Renoir into the Chippendale bureau.

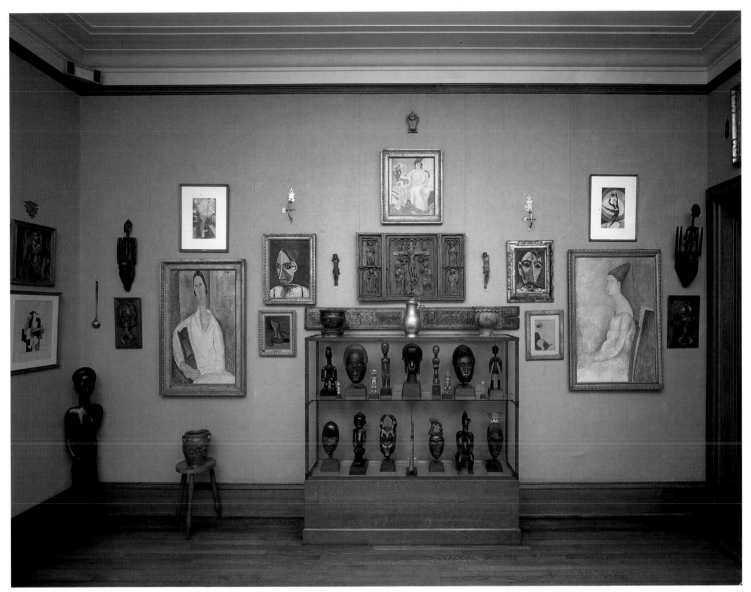

Fig. 8. The focal point of the wall is the cabinet with eighteen African sculptures rhythmically interspersed in two horizontal registers: seven masks, six figures, and five smaller figures in carved bone or ivory. Above is a long horizontal shallow relief from Madagascar, topped by a carved European triptych with eight rough-hewn figures bracketed by two refined wooden crucifixion torsos that tie in with the burnished sheen of the vertical figures, especially the diminutive ivory and bone figures in the case. The interspersion of elegant and rugged, both African and European, obliges us to examine our preconceptions about the traditions of sculpture.

The masks in the showcase and the wood and sheet brass Kota reliquary figures hanging on each end of the wall relate to two small Picasso heads with masklike features. Two canvases by Modigliani, *Portrait of Jeanne Hébuterne (Seated in Profile)*, right, 1918, and *Woman in White*, left, c. 1919, are subdued in color and thinly painted, thereby stressing the linear elongation and distortions derived from African sculptures such as the Bamana masks above the Kota figures. The Modigliani paintings are surmounted by Charles Demuth's watercolors, *In Vaudeville: Two Acrobats*, c. 1917, and *Acrobatic Male Dancer with Top Hat*, 1918. Demuth's resilient line and blotted color connects not only with Modigliani but also with the early Picasso ink drawing hanging below to the right of the cabinet. Matisse's *Seated Odalisque*, 1922, with its pearl-gray woman, pink-rose floor, and striped tablecoverings, tops the arrangement and acts in concert with the translucent oil medium used by Modigliani.

the great tradition of the blacksmith's art. The non-hierarchical arrangements were intentional, as Barnes wrote to *Chicago Daily News* critic C. J. Bulliet early in 1937: "I have introduced a new element in the Gallery which decreases the width of the gap between 'fine art' and 'industrial art.' I mean the 'industrial art' of two or three hundred years ago in America and Europe." African masks, numerous examples of New Mexican painted *retablos*, and ceramics were also interspersed with the paintings; by the 1940s these were joined by the colorfully decorated Pennsylvania-German dower chests that anchor many of the wall organizations throughout the gallery.

Barnes actively maintained his lifelong interest in music, lecturing to students on music as well as painting. As early as 1926, one of the highlights of the class year was the visit of the chorus from the Manual Training School in Bordentown, New Jersey, under the leadership of Frederick J. Work (1880–1942), whose groundbreaking collection and publication of folk songs of the American Negro were responsible for preserving what Barnes considered the greatest creative legacy of the African-American. John W. Work, his brother and collaborator, had written in 1907, "Since [these songs] tell faithfully the Negro's inmost life, both intellectually and spiritually, they are the only true source of our history. If any man would read the Negro's life, let him study his songs. . . . They are sources of great joy as well as sources of history." Dr. Barnes wholeheartedly agreed. The spirituals were sung in the main gallery, with Barnes often joining in. He encouraged the young singers to take pride in the sculpture they could see at the Foundation, work of their ancestors that was central to many of the creative impulses of twentieth-century art (figs. 9 and 10). The space resounded with the deeply felt melodies Barnes so loved, blending with the rich color chords of Renoir, Cézanne, Matisse, Picasso, and their contemporaries, surrounded by the frieze of African masks. Heaven reigned and the doctor's heart's desire was fulfilled.

In April 1936, Barnes returned to Central High, accompanied by the Bordentown Choir and musical director Work, to deliver an address on "The Art of the American Negro." At intervals during the talk the chorus performed and Barnes affirmed: "The Negro spirituals represent the greatest art America has produced, because they came out of the soil and, like the greatest artistic achievements of the Middle Ages — the Cathedrals — they are an outgrowth of community life inspired by religion. . . . Their appeal is universal and they embody the soul of a whole people." Barnes took a keen interest in the collecting and preservation of these treasures. In 1943, at his suggestion and under the auspices of the Barnes Foundation, Ablyne Lockhart, a young African-American contralto and a student in the Foundation's classes, undertook a four-month field trip through Tennessee, Mississippi, Florida, Alabama, and South Carolina to scout for authentic songs. She made recordings on the spot to preserve their pristine form. Miss Lockhart's most interesting discoveries were found among the isolated descendants of slaves on

Fig. 9. *Court Official with Cross Pendant*, sixteenth-seventeenth century. Cast copper alloy. Edo peoples, Benin Kingdom, Nigeria. The Barnes Foundation, inv. no. A230.

Fig. 10. *Primordial Couple*, possibly nineteenth century. Wood. Dogon peoples, Mali. The Barnes Foundation, inv. no. A197.

St. Helena, one of the Sea Islands off the coast of South Carolina where the spirituals retained their original flavor. Barnes observed that some of these St. Helena melodies and harmonies with their slow tempi suggested Gregorian chants.

In November 1936, Ambroise Vollard, legendary Parisian art dealer, accepted Dr. Barnes' invitation to visit America. Following his several days in Merion, both Barnes and Vollard delivered speeches on radio station WINS, New York. In his talk, "America welcomes one of its great Benefactors," Barnes recounted Vollard's discovery of Cézanne and his successful promotion of Renoir, Degas, Gauguin, and Picasso: "It was largely Vollard's knowledge, courage and patience that put their work in the important collections of the world, side by side with the great pictures of all time. This monumental feat entitles Vollard to high esteem as an educator, a leader in moulding intelligent, well-informed public opinon." Vollard responded: "I am still under the spell of the Barnes Foundation, where I saw so many of the paintings which I knew,

defended and loved The great experience of this very short trip to America has been my visit to the Barnes Foundation. With the authority which my age permits me to assume, I assure you that there does not exist and will never exist in the world another collection of masterpieces of the two greatest painters of the nineteenth century, Cézanne and Renoir, comparable to the one assembled there by Dr. Barnes."

During the Great Depression, Barnes was involved in social issues, supporting the Artists Union in Philadelphia and attacking inequities in the administration of the WPA Federal Art Project. He provided generous scholarships to members of his teaching staff and student body to work and study abroad. Artists, college professors, independent scholars, and museum curators consulted him, sent manuscripts for comments, and paid attention to what he said, wrote, and most of all, bought.

Barnes played a pivotal role in the recognition of the African American artist Horace Pippin (1888–1946). In an essay (1940) Barnes wrote: "Pippin's art is distinctly American; its ruggedness, vivid drama, stark simplicity, picturesqueness and accentuated rhythms, have their musical counterparts in the Spirituals of the American Negro." Barnes purchased the artist's work, hanging four of his paintings in the gallery (fig. 11). As a result of Barnes' enthusiastic response, nearly every important museum and private collector eagerly sought to acquire Pippin's pictures.

Barnes customarily made several yearly trips abroad, both to buy and to carry out research for his books. He particularly enjoyed Brittany, where he vacationed in the village of Port-Manech and where the townspeople made him an honorary citizen. There he adopted a dog, whom he named Fidèle. When World War II interrupted his overseas travels, Barnes focused his energies on a 1775 Pennsylvania farmhouse, Ker-Feal — Breton for Fidèle's House — which he purchased in 1940, restored, and filled with early American furniture, pottery, glass, pewter, ironwork, and textiles. Ker-Feal contained no paintings, but the bold arrangements in color, shape, and texture, mainly centered around an extensive collection of Pennsylvania and North Carolina Moravian pottery displayed in lush profusion in open cupboards, on mantels, and on the walls, provided an auxiliary setting for Barnes' experiments in method and organization.

After the war Barnes continued to add to the collection, refining the wall alignments. He traded paintings by Cézanne, Renoir, Soutine, and Degas for old masters such as Chardin and Titian. He bought examples of contemporary artists, Altripp, Wols, Afro, Vieira da Silva, Geer van Velde, Angelo and Biagio Pinto, Barton Church, and Matta, and tried out works by Dubuffet and others he ultimately decided not to acquire. In 1949, Barnes, who was accorded great respect by the French, made what was to be his last trip to Paris. There, Georges Salles, director of the Louvre, accompanied him through the newly rehung galleries.

By the mid-1940s, although in vigorous health, Barnes was eager to arrange for the ulti-

Fig. 11. Pippin, *Supper Time*, c. 1940. Burnt wood panel, 12 x 15″ (30.5 x 38.1 cm). The Barnes Foundation, inv. no. 985.

mate disposition of his life's work. He consulted frequently with Dewey as how best to pass on his legacy. In 1946, Barnes met Horace Mann Bond, President of Lincoln University, a distinguished private and predominantly African-American school founded in 1854, in Oxford, Pennsylvania. They established a cordial working relationship, just the kind of open communication that had proven so elusive in Barnes' dealings with the University of Pennsylvania and representatives of other schools. Their discussions, visits, and frequent exchanges of letters led Barnes to become involved in supporting educational projects at Lincoln to foster leadership among African American and visiting African students. As early as January 1947, after having delivered a lecture at Lincoln, Barnes contributed $1000, as he wrote Bond, "to help the neediest of the foreign students at Lincoln...(to) enable them to advance the education and civilization of their race when they return to their homeland." Barnes concluded, "I enjoyed my stay at Lincoln and was much impressed not only with the friendly and democratic spirit that prevails but with the eager, alive, intelligent group that surrounded me...after my talk."

Long before Gunnar Myrdal, Barnes clearly comprehended "the American dilemma." Concurrent with the opening of the Foundation, Barnes wrote in "Negro Art and America" (*Survey Graphic*, March 1925),

> We have to acknowledge not only that our civilization has done practically nothing to help the Negro create his art but that our unjust oppression has been powerless to prevent the black man from realizing in a rich measure the expressions of his own rare gifts. We have begun to imagine that a better education and a greater social and economic equality for the Negro might produce something of true importance for a richer and fuller American life. . . .
>
> This mystic whom we have treated as a vagrant has proved his possession of a power to create out of his own soul and our own America, moving beauty of an individual character whose existence we never knew. . . . he may consent to form a working alliance with us for the development of a richer American civilization to which he will contribute his full share.

In the summer of 1950, Dr. Bond invited Barnes to join the Lincoln faculty as a lecturer in art for the 1950–1951 year, to deliver four to six lectures, one or two specifically in the field of African art. Barnes made a counterproposal inviting twelve to fifteen Lincoln students to attend a class at the Foundation. Under the administrative aegis of J. Newton Hill, dean of the College, with whom Barnes also developed a friendship, the Lincoln students were enrolled in two courses of study taught by two of the Foundation's teachers in the gallery.

On 20 October 1950, Barnes amended the by-laws of the Barnes Foundation to provide that ultimately the Board of Trustees of Lincoln University would appoint the trustees of the Barnes Foundation. On 5 June 1951, the Lincoln Board awarded an honorary Doctor of Science degree to Dr. Barnes. The citation reads in part: "You have faith in the capacities of the Negro people, and this faith you have demonstrated in many ways throughout your life." Plans for the 1951–1952 scholastic year, with fifteen students enrolled in three classes at the Foundation, were well advanced when Barnes was killed in an automobile accident on 24 July 1951.

Dr. Barnes had left his mark on art and education, as he had on chemistry and business. His original application of the scientific method to art had as one of its tenets the reduction of subjectivity to minimal levels, but this required determined effort and conflicted with standard historical approaches. Barnes took no prisoners in his many disputes with established authority. He could be plainspoken, profane, domineering, even brutal to adversaries, and he had no illusions that the pretense and inertia he found so deeply rooted would disappear. But then, few of those who endowed our most prestigious institutions — universities, libraries, foundations, and museums — were, in their own spheres of activity, gentle and forgiving.

Albert Barnes was, in Horace Bond's words, "a very great American . . . an original American personality." It was Barnes' conviction that ordinary people can understand and share in the

full range of aesthetic experience. His achievements in the realms of art, education, and serious aesthetic scholarship, his optimism about American values, civil rights, and race relations were substantial. As we conclude the twentieth century, technology which was developed to serve humankind is, by its very successes, threatening to undermine our individuality. We strive for fresh, undogmatic solutions to social problems that resist and could overwhelm our democracy and its fragile culture. The essence of Dr. Barnes' legacy, which holds decisively contemporary meaning, is an abiding faith in the common man, the prospect that staunch individualists such as Jefferson, Whitman, and Dewey envisioned for American society.

Richard J. Wattenmaker
Director, Archives of American Art
Smithsonian Institution

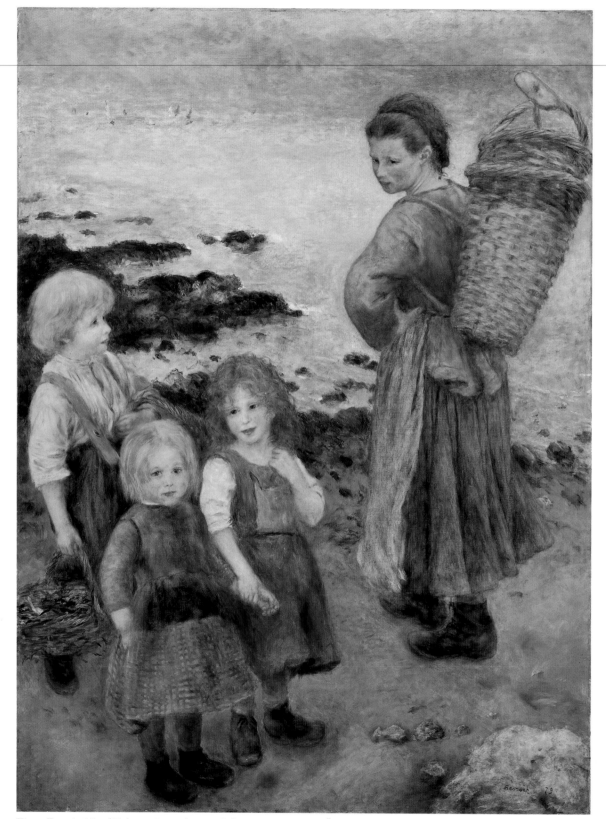

Fig. 1. Renoir, *Mussel Fishers at Berneval*, 1879. Oil on canvas, 69 x 51¼″ (175.3 x 130.2 cm). The Barnes Foundation, inv. no. 989.

Dr. Barnes in Paris

Dr. Barnes just left Paris, after a three-week stay. He spent all of his time not in paying social calls, going to parties and official receptions, but in the way one might expect of this extraordinary, democratic, passionate, inexhaustible, charming, impulsive, generous, unparalleled man. He went everywhere, saw everything that the dealers and the artists and the collectors had to show him. He bought, refused to buy, admired, criticized. He was liked, disliked, made friends and enemies. The auriferous jingle of dollars preceding his steps, covetous desires sprang up before him like apparitions, following him, plaguing him, relentlessly pursuing him like will-o'-the-wisps.

So the young art dealer Paul Guillaume described a recent visit to Paris by the famous collector in his review *Les Arts à Paris* in early 1923.[1]

This fanfare of an introduction does not serve as a prelude to a new study of the life of Albert C. Barnes, whose personality, at the very least eccentric, has already spawned numerous biographies.[2] More modest in scope, this account will recall what it meant, in the period just before and just after World War I, to be a rich American who had come to Paris to buy the paintings of Renoir, Cézanne, Rousseau, Picasso, Matisse, Modigliani, and Soutine.

Paris had been, since the mid-nineteenth century, the undisputed capital of the arts. There one found art schools, museums, major exhibitions of past and contemporary art, dealers large and small who defended the stars of the day and a continually renewed avant-garde, and the important public sales where collections were made and sold. An informed and perceptive collector could, without a great deal of money, enter this market, though the greatest prizes went to those who possessed substantial fortunes.

American collectors had long been part of this system, and were quickly categorized by type: there were the rich collectors who did not know what they were buying and bought fakes; the well-advised rich who, in the eyes of patriots, plundered France of its patrimony, spending fortunes on its masterpieces and carrying them off across the Atlantic. Finally, there were the bold, eccentric rich who did not hesitate to acquire the riskiest examples of contemporary art, those very works which, beginning in the 1880s, accounted for the success of impressionism in the United States. German and Russian collectors, all fabulously wealthy, did not hesitate to join the expanding clientele of the Parisian art dealers.

This does not mean that there were no French collectors in the picture. On the contrary, around 1890, a new generation of native connoisseurs, prepared to pay very high prices to secure

Fig. 2. Cézanne, *Still Life*. Oil on canvas, 7¾ x 14¼″ (19.7 x 36.2 cm). The Barnes Foundation, inv. no. 18.

works by Manet and the impressionists, and even Cézanne, succeeded the first pioneers of the seventies. The competitive buying resulted in even greater competition. Obviously, all these collectors were soon dreaming of "discovering" other less well-known artists: Gauguin, van Gogh, Seurat, the Nabis, and later Picasso and Matisse emerged from obscurity as fellow artists, critics, and dealers advanced their reputations by word of mouth. Since mid-century, shrewd dealers were quick to appreciate the sort of profit to be made by securing exclusive rights to the works of little-known artists. Each new generation of artists had its group of dealers, located at first along the rue Laffitte, moving progressively toward the west of Paris. It was easy enough to make the rounds of the dealers and rapidly inform oneself at a few select addresses of what was going on in Parisian studios. Albert C. Barnes knew how to profit from this. As an impecunious student, Barnes had already been to Europe, especially Germany (see page 4). After the age of thirty-five, when his fortune had been made from the invention of Argyrol, a powerful antiseptic, he traveled regularly to Europe to see and buy works of art. The first of these trips that is of interest occurred in 1912. On 9 December of that year, the famous picture dealer Ambroise Vollard, who "discovered" Cézanne and in 1895 organized the first exhibition devoted entirely to his work, noted in his diary: "Sold to M. Barnes and delivered to him a portrait of Mme Cézanne by Cézanne for 40,000 francs, no. 3809, check rec'd." The next day, Vollard scheduled a meeting with Barnes at his house, rue de Grammont, and on 11 December sold the collector

two more Cézannes for 20,000 francs (figs. 2 and 3), and two Renoirs for 30,000 francs.³ At the same time Barnes was attending public sales in Paris. At a 7 December sale he bought a Daumier (fig. 4), a Pissarro, and two Renoirs (fig. 5), spending altogether more than 50,000 francs.⁴ Two days later he successfully bid for three Cézannes from the collection of a well-known, recently deceased collector of the impressionists, the engineer Henri Rouart, who was also a painter and friend of Degas: "Monsieur Barnes raised the bid to 18,000 francs from a reserve of 10,000 francs for Cézanne's *Bathers* (fig. 6), bidding against MM. Vollard, Bernheim-Jeune, and Druet."⁵ Hence Barnes was brought into the club, in competition with the best-known, most highly esteemed dealers of the period before the war, delighted no doubt to show a newcomer that if it was a Cézanne he wanted, he would have to pay the price. Although Barnes was already an important buyer, he was not yet prepared to outbid Mrs. H. O. Havemeyer who, at the same

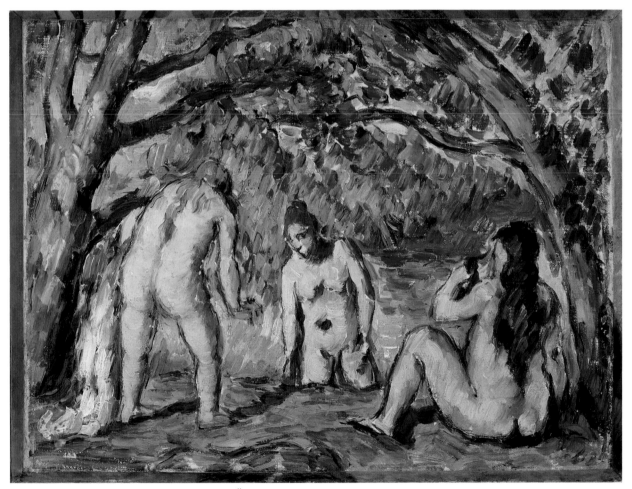

Fig. 3. Cézanne, *Bathers*. Oil on canvas, 9½ x 12½" (24.1 x 31.7 cm). The Barnes Foundation, inv. no. 96.

4.

5.

Fig. 4. Daumier, *The Hypochondriac*, c. 1860/1863. Oil on panel, 9¾ x 12¾″ (24.8 x 32.4 cm). The Barnes Foundation, inv. no. 75.

Fig. 5. Renoir, *Woman Crocheting*, c. 1877. Oil on canvas, 16 x 12¾″ (40.6 x 32.4 cm). The Barnes Foundation, inv. no. 108.

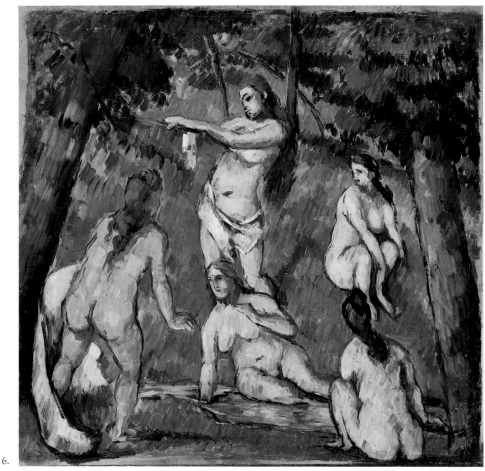

Fig. 6. Cézanne, *Bathers*. Oil on canvas, 15½ x 16½″ (39.4 x 41.9 cm). The Barnes Foundation, inv. no. 93.

6.

sale, did not hesitate to spend almost a half-million francs in gold for a single Degas, thereby setting a record for a work by a living artist. Still, Barnes' purchases were remarkable given that, until then, he was known only as an amateur painter who had been sold a few paintings.[6]

In 1912 the collectors of Renoir, who was still living, and especially of Cézanne, who died in 1906, were not especially numerous, even if their circle had appreciably expanded. By 1911, thanks to the bequest of Isaac de Camondo, the work of the impressionists as well as Cézanne, van Gogh, and Toulouse-Lautrec were accepted for the Louvre, the ultimate sign of official sanction.[7] The list of names of collectors in this field in France at the beginning of the century, still a limited circle, included Maurice Gangnat, collector of Renoir; Auguste Pellerin, who sold his Manets to buy the most extraordinary collection of Cézannes ever assembled before having his portrait painted by Matisse in 1916; state councillor Olivier Sainsère; the Parisian *député* (representative) Henry Cochin; the Prince de Wagram, whose marvelous but short-lived collection would be the source of several important works in the Barnes Foundation such as Renoir's *Reclining Nude*, *Spring*, *Leaving the Conservatoire* (page 51), and *The Luncheon* (page 55).

German, Swiss, Scandinavian, Dutch, and Russian collectors also frequented Parisian dealers such as Durand-Ruel, Bernheim-Jeune, Vollard, Druet, and Barbazanges, who championed not only the impressionists but also the younger generation of artists. Some of them are scarcely known today — the Dutchman Cornelis Hoogendijk, for example, one of Vollard's regular clients, or the Hungarian Marczell von Nêmes, who in bringing together Dutch and Italian old masters, El Greco, and the French impressionists, as well as Cézanne and van Gogh, may have set an example for Albert Barnes.[8] Other collectors, like Count Harry Kessler and especially the Russians — Sergei Shchukin, who in 1910 recognized the genius of Matisse and Picasso, hanging them with his collection of impressionist masters, or Ivan and Mikhail Morosov — have become legendary.

The presence of Durand-Ruel in New York, since 1886, was bearing fruit. Other dealers, such as the photographer Alfred Stieglitz and his friend Edward Steichen, headed in even more venturesome directions. John Rewald has recently shown in detail[9] how Cézanne's reputation, slower to develop in the United States (and in France), than that of his impressionist comrades, grew thanks to a handful of initiates, for the most part clients of Durand-Ruel, Bernheim-Jeune, and Vollard. The "sugar king" H. O. Havemeyer and his wife, Louisine, who were advised by Mary Cassatt, are of course the first names that come to mind, though other younger collectors were already entering the fray. They were Americans living in Europe, neighbors of Bernard Berenson in the countryside around Florence, like Charles Loeser and Egisto Fabbri; or in Paris, Gertrude and Leo Stein who, in 1905, began to buy the work of Picasso and Matisse as well as Cézanne and Renoir. Since 1907 New York's Metropolitan Museum of Art had owned Renoir's *Mme. Charpentier and Her Children*, and in 1913 the museum bought its first Cézanne from the

famous Armory Show in New York. Preparations for that exhibition, which aimed to introduce the American public to the most recent developments in European and American art, were in full swing when Barnes was in Paris in December 1912. The American organizers, a group of artists, dealers, and collectors, included the New York lawyer John Quinn, who knew his way around the Paris art world.

Thus Barnes was not the only one of his kind. His decisions were initially guided by the painter and illustrator William James Glackens (1870–1938), a native of Philadelphia and a school friend of Barnes who settled in New York after visiting Paris in 1895. One of his best-known works, *Chez Mouquin* (1905, The Art Institute of Chicago), is an enthusiastic homage to Manet; somewhat later, perhaps on another trip to France in 1906, Glackens became enamored of Renoir. Barnes appears to have reestablished contact with Glackens around 1911 and engaged him to buy paintings in Paris for the amount of $20,000. Glackens, accompanied by another painter friend, Alfred Maurer, soon expressed his misgivings: "I have been all through the dealers' places and have discovered that Mr. Barnes will not get as much for his money as he expects. You can't touch a Cézanne under $3,000 and that for a little landscape. His portraits and important pictures range from $7,000 to $30,000. I got a fine little Renoir at Durand-Ruel, a little girl reading a book, just the head and arms, in his best period, I paid 7,000 francs for it [$1,400]. They asked eight but came down. I consider it a bargain. This is all I bought so far. Am still looking around."[10] This purchase is recorded in the Durand-Ruel account books, entry for 12 February 1912, and the small painting is still in the Barnes Foundation.[11] Glackens purchased two more small Renoirs at Durand-Ruel, 23 February,[12] then, much more boldly, he bought Picasso's *Woman with a Cigarette* (page 191) at Vollard for 1,000 francs.[13] From a third Parisian dealer, Bernheim-Jeune, Glackens was also able to buy a Sainte-Victoire landscape[14] by Cézanne for 13,200 francs. Glackens probably bought other paintings in his own name but very soon the records of the Parisian dealers began to list the name of Dr. Barnes: Durand-Ruel (Renoir, *Torso*, page 47); Bernheim-Jeune, where he purchased works by Delacroix, Gauguin, van Gogh, Vallotton, and Bonnard;[15] and Vollard, referred to above. Barnes was by nature too wary of dealers and concerned with being duped to place complete confidence in an agent. Bargaining for the acquisitions seems to have been part of the pleasure of collecting for him. He was also spending increasingly large sums of money for paintings. Besides Glackens and Maurer, from 1912 on Barnes was assisted by Leo Stein, who, while confirming Barnes' penchant for Cézanne and Renoir, also encouraged him to buy precubist Picasso and, particularly, Matisse, advice for which Barnes would remain grateful (see page 8).[16] He also counted on Leo Stein to introduce him to collectors, thus furthering his contacts in the Paris art world.[17] By the end of 1912, back in Philadelphia, Dr. Barnes could justly consider himself one of the most "advanced" collectors of contemporary French art, but he lent nothing to the Armory Show. Unlike his peers, Barnes

bought only one work at the Armory Show, a Vlaminck, clearly demonstrating his determination to develop an interest in artists newly arrived on the Paris art scene.[18]

Barnes was as actively involved in acquisitions in 1913 as he was the preceding year. John Rewald recently unearthed a correspondence between Barnes and Durand-Ruel on the purchase of a Cézanne still life [19] (fig. 7) which shows how exasperating a bargainer Barnes could be, playing off Durand-Ruel's patient commercial stoicism in an attempt to avoid Vollard, also a formidable businessman. After visiting Vollard's gallery on 2 June, with Durand-Ruel acting as intermediary, Barnes bought one Cézanne and two Picassos, *Blue Child* and *Boeufs* (Vollard's title exhibited here as *Composition: The Peasants*) (page 201), and a *Head of a Child* by Renoir,[20] continuing to haggle over prices before yielding to Vollard. No doubt investing the money just received from Barnes, Vollard bought "the large painting *Card Players*" (page 123) several days later from Cézanne's son, for the considerable sum of 100,000 francs.[21] That painting, bought by Barnes after the war, would become one of the major works in the Barnes Foundation.

However, Barnes did not do business exclusively with these dealers. He also bought from Roger Levesque de Blives, a young dealer in Faubourg Saint-Honoré, who specialized in im-

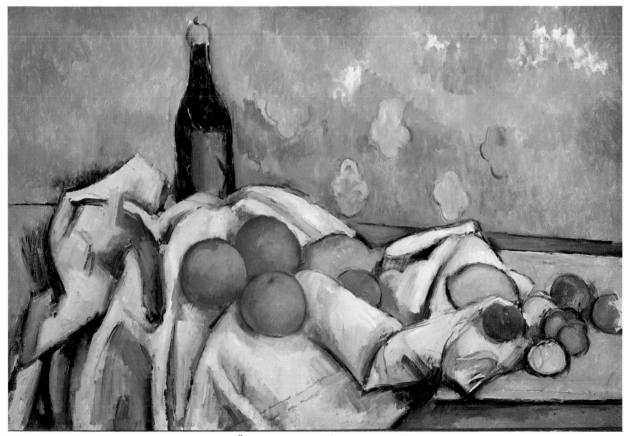

Fig. 7. Cézanne, *Still Life*. Oil on canvas, 18¾ x 28″ (47.6 x 71.1 cm). The Barnes Foundation, inv. no. 7.

pressionist masters (see Renoir, *The Luncheon*, page 55) and young artists like Dunoyer de Segonzac; Levesque even exhibited the work of the Americans Bryson Burroughs and Ernest Lawson in 1914.[22]

In the spring of 1914 Barnes returned to Paris to buy more paintings, especially by Renoir (fig. 8 and 9), which he purchased primarily at Durand-Ruel.[23] On 16 May 1914 he bought, still with Durand-Ruel as agent but this time at public auction, a large *Nude in Brook* (fig. 10) by Renoir.[24] Included in the same sale was Henri Rousseau's superb *Scout Attacked by a Tiger* (page 187), which Barnes bought much later. Also in May 1914 Barnes bought from Durand-Ruel "his" El Greco, a *Saint Francis of Assisi*, adding to his collection the old master most revered by the modernists (he would want to return it a short time later, believing it to be a forgery).[25]

Although the war interrupted Dr. Barnes' transatlantic travel, it did not put an end to his purchases. In 1915, for example, he acquired one of his most beautiful Cézannes, *Woman in a Green Hat*[26] (page 141). In short, by this time, he could already boast of fifty Renoirs and fifteen Cézannes — a remarkable accomplishment not only in the United States but also in Europe — something he recounted with obvious pleasure and without reserve for the readers of *Arts & Decoration* magazine in April 1915.[27] He also reminded readers that he was probably the first person in America to hang next to those works the paintings of Matisse and Picasso, before the latter started to "laugh at everyone with his cubes." Though such a claim may be open to debate, Barnes remains one of the most serious contenders for that distinction. For the first time, the collector took up the sword against academicism in any form, with all his characteristic vehemence.

About 1915 Dr. Barnes seems to have been aware of having covered a certain amount of ground: he planned to publish an illustrated book of the works in his collection[28] and let it be known that he intended to give the collection to the city of Philadelphia.[29] Neither plan was carried out immediately. It must be added that Barnes' interest in French painting did not divert him from collecting works by American artists; in fact, over the years he built up an important collection of the works of Glackens, Lawson, Demuth, Maurer, and the Prendergast brothers.

After the war, Dr. Barnes' curiosity was reinvigorated by regular trips to Paris. The artistic landscape of the city had changed considerably. Durand-Ruel (under the direction of the sons of Paul, the senior partner who passed away in 1922), Bernheim-Jeune, and Vollard resumed normal activity. Clovis Sagot, Picasso's first dealer, had died in 1913; Daniel-Henry Kahnweiler, a German citizen whose property had been confiscated during the war, was making a fresh start; Levesque had been killed at the front in 1915, at the age of thirty-nine; Eugène Druet had also died an untimely death in 1916. Henry Barbazanges gained in importance, taking up with Jos Hessel and Georges Bernheim, but he retired in 1923. Paul Rosenberg, in his splendid new gallery in the rue de la Boétie, carved out a dominant position in the Parisian market with

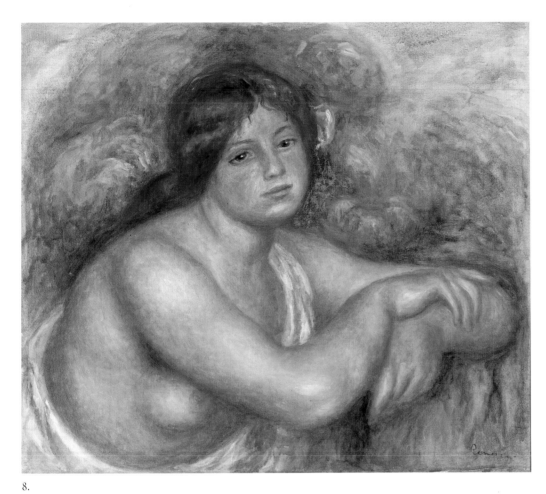

8.

Fig. 8. Renoir, *Bust of Nude*, c. 1910. Oil on canvas, 19 x 22″ (48.3 x 55.9 cm). The Barnes Foundation, inv. no. 157.

Fig. 9. Renoir, *Psyche*, c. 1910. Oil on canvas, 25¼ x 32″ (65.4 x 81.3 cm). The Barnes Foundation, inv. no. 217.

Fig. 10. Renoir, *Nude in Brook*, 1895. Oil on canvas, 32 x 25½″ (81.3 x 64.8 cm). The Barnes Foundation, inv. no. 301.

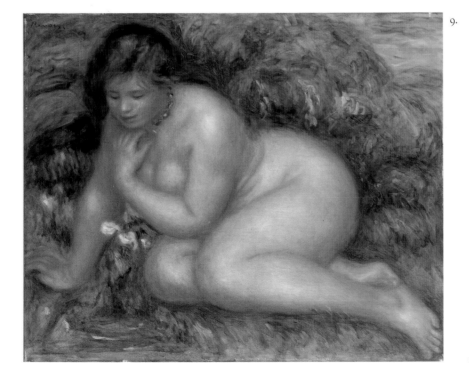

9.

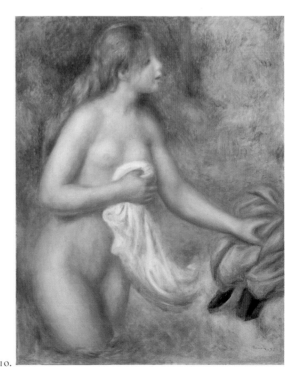

10.

nineteenth-century masters, the impressionists, as well as Picasso, Braque, and Matisse; while Rosenberg's brother, Léonce, opened his own gallery. Newcomers Paul Guillaume and Etienne Bignou were to become the privileged intermediaries of Dr. Barnes.

Paul Guillaume (1891–1934) (fig. 11) in particular merits attention.[30] Of petit bourgeois background, with no links to the art world, he developed an early interest in what was then called "negro art," which brought him into contact with Guillaume Apollinaire, probably after 1910.[31] He was only twenty-three when in June 1914 he opened a small gallery at 6 rue de Miromesnil, with an exhibition devoted to Natalia Goncharova and Mikhail Larionov, Russian artists who had arrived in Paris with the great impresario Sergei Diaghilev. Apollinaire, in his role as mentor, regularly reviewed exhibitions at Guillaume's gallery: Derain, in October 1916; and Matisse and Picasso, in January–February 1918. Excused from military service for reasons of health, Guillaume was able to keep his gallery open during the war. Beginning in March 1918 he published a little magazine modeled after similar publications of Durand-Ruel and Bernheim-Jeune. Entitled *Les Arts à Paris*, it was indicative of Guillaume's areas of activity: African and primitive art, and modern masters, that is, Manet and the impressionists but also Matisse and Rousseau. Guillaume exhibited the works of his "discoveries": Giorgio de Chirico, Derain, Vlaminck, Van Dongen, Marie Laurencin, De La Fresnaye, Utrillo, and Modigliani.[32] He treated his colleagues with respect and appears to have maintained a good relationship with Jos Hessel, Barbazanges, and especially Vollard. His openings became society events, where Picasso stood side by side with Pierre de Polignac and Princesse Murat, André Gide and Jean Cocteau, and were regularly attended by the well-known collectors Jacques Doucet, Alphonse Kann, and Paul Poiret, to cite only a few of the names that Guillaume obligingly listed in his magazine. The "Fête nègre" that he gave at the Comédie des Champs-Elysées in 1919 proclaimed his tastes and ranked him with the leading personalities of the Parisian art world.

Dr. Barnes probably did not meet Paul Guillaume until 1921, when he made his first trip to Paris after the war, but their relationship was well established by January 1923 when Guillaume exhibited some fifty paintings and works of sculpture recently acquired by Barnes before they were sent to the United States, where their exhibition in Philadelphia would raise a general outcry.[33] The critic Waldemar George, very close to Guillaume, describes one day with Dr. Barnes in Paris: "In the morning I went to pick up Paul Guillaume at his house, avenue de Messine; we got into his Hispano-Suiza and drove to pick up Barnes at his hotel, Le Mirabeau, rue de la Paix. At the door was a crowd of dealers, agents, and artists carrying their paintings under their arm, waiting for him to come out, but the doctor seemed totally unaware of these solicitors, who, with difficulty, were held back by the hotel personnel. We first went to the Louvre to see the Oriental, Chaldean, and Assyrian antiquities, then to the Musée Guimet, the Musée Cernuschi, the Museum of Ethnography etc. [...] and to the antiques dealers. [...] At

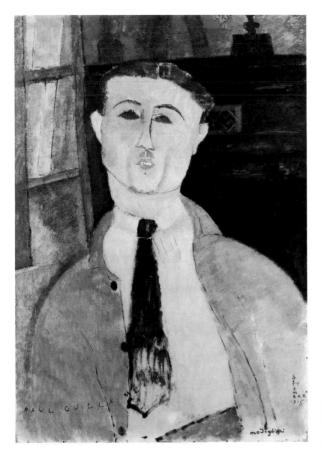

Fig. 11. Modigliani, *Portrait of Paul Guillaume*, 1915. Oil on board, 29½ x 20½" (74.9 x 52.1 cm). The Toledo Museum of Art, gift of Mrs. C. Lockhart McKelvy.

noon we had lunch. Indefatigable, insatiable, Barnes never stopped bombarding us, Paul Guillaume and me, with questions, of the sort: 'Do you prefer Cézanne or Renoir? Who is the greater painter, Rembrandt or Rubens?' We answered as well as we could, but Barnes, wanting to know our reasons, kept on with his questions and wrote down our answers. After lunch we resumed our grand tour and finished the day in a restaurant in the Bois, where we were joined by Paul Guillaume's young wife. We were worn out, but Barnes showed no sign of fatigue, continuing to question us throughout the entire meal. Then, suddenly, around eleven pm, he declared: 'Suppose we go back to the gallery to see the paintings?' Paul Guillaume offered that it was closed but the doctor was already on his feet. We arrived in rue de La Boétie [galerie Paul Guillaume], and the discussion resumed, ceaselessly interrupted by the whys and hows of Barnes. If the questioning came around to Marcoussis, it meant having to trouble the painter to come at once, to answer as best he could the often preposterous interrogations of the doctor. Sometimes it was Lipchitz, Kisling, Gritchenko, or someone else. . . . I never saw Barnes tired; that man had such an appetite for painting and sculpture that he could forget to eat and sleep. And every day for the four or five weeks that he was in Paris it was the same."[34] As for Barnes, he proclaimed Guillaume's gallery "The Temple, Mecca." "I saw there," he wrote, "six African tribal chiefs

next to four chief dancers of the Russian ballet....In one week I met at Paul Guillaume's painters, sculptors, composers, poets, and critics, from England, Japan, Norway, Germany, the United States, and Italy, whom I only knew by name."[35]

It is owing to Paul Guillaume that Barnes became interested in African art and published in English, in 1926, Guillaume's and Munro's *Primitive Negro Sculpture*. Guillaume was also probably the source of Dr. Barnes' interest in Henri Rousseau and "primitive" art. The American collector was interested in all the artists Guillaume represented, enumerated above, and it was also thanks to the young dealer that Barnes discovered Soutine and became one of the few collectors to support him. For several years Guillaume's review, which resumed publication in January 1923 after a two-year hiatus, would celebrate this honeymoon between an enthusiastic, rich, and generous collector, imbued with the advanced ideas on pedagogy fostered in the teachings of William James, George Santayana, John Dewey, and Bertrand Russell (authors probably little-known to the French public then and now), and his "foreign secretary" in Paris. Besides publication of articles by Barnes and his friends, illustrated with reproductions of works acquired by the doctor, *Les Arts à Paris* acquainted the French public with Barnes' grand design — the establishment of the Barnes Foundation in Merion, Pennsylvania, near Philadelphia. From the charter of December 1922, designating the collection as an educational institution, to the official inauguration of the foundation in 1925, Guillaume's little bulletin followed the developments step by step, not without sometimes stooping to base flattery. The articles, especially the one that appeared in French, authored by Dr. Barnes, in October 1923, did emphasize, however, the originality of Barnes' course, his democratic views, his desire to help the disadvantaged, and particularly black American workers, to give them access to contemporary artistic culture that was placed on equal footing with the art of the past. These were unusual ideas for those times. Guillaume, impressed by his visit to Merion in 1926, did not hesitate to call the venture "pharaonic."[36] One may wonder if the very form of Guillaume's account, with the sort of exaggeration likely to engender mistrust, did not convey to a French public that would normally have been receptive to it, an image of the foundation that was too eccentric, in spite of the seventy-five Cézannes and the two hundred Renoirs — astounding figures by themselves — that are noted by the dealer.[37] There was not yet another place in the world with a collection so abundantly illustrative of the most recent developments in French painting. Recall that in the United States, the Phillips Collection in Washington, founded in 1918, opened in 1921, and the Museum of Modern Art in New York in 1929.

Other French publications took interest in the collector from Merion, especially the review of Bernheim-Jeune, edited by Felix Fénéon, who humorously related Barnes' polemic against Doctor Dercum, beginning in 1921. Barnes asked the doctor to prove scientifically that certain of the artists recently exhibited in Philadelphia were crazy, as he said they were. Then

Fénéon started to dream of the day, alas far off, when the Paris Academy of Sciences "would be torn by factions over Bonnard, Maillol, and Picasso."[38] Picabia, who was swept up in dada, represented the circle that persisted in seeing Barnes as an American millionaire who indiscriminately bought everything the dealers (including Paul Guillaume) persuaded him to buy. Although grateful to Barnes for dreaming of a "modern museum," Picabia reproached him for timidity: "Why place those two painters [Renoir and Cézanne] at the beginning of an epoch, when they are only the end, the decay of the preceding age? It is undoubtedly because in recent years Cézanne and Renoir were big business for the Paris dealers and Mr. Barnes believed in speculative theories ... and he paid for it!"[39] In fact, such criticism reflects Picabia's resentment at being passed over by Dr. Barnes and was certainly intended to flatter Jacques Doucet, the newly promoted Maecenas of modern times. Picabia suggested that Barnes should be awarded the "palmes académiques," a minor distinction awarded to teachers and academics, for his enterprise. Although Paul Léon, the highest-ranking official in the Beaux-Arts administration, seemed unimpressed after an interview with Dr. Barnes,[40] the collector from Merion was nonetheless honored by France, made Chevalier of the Legion of Honor on 23 February 1926, and Officer in 1937. Finally, though, Dr. Barnes' undertaking remains little known or appreciated in France. Merion is far from Paris, and enough masterpieces by Renoir and Cézanne were still in French collections in the 1920s. Paul Guillaume, the official chronicler of the Barnes Foundation, grew silent at last: after the October 1927 issue, up to Guillaume's death in 1934, he rarely mentions the Barnes Foundation. The two men apparently quarrelled. Dr. Barnes, who named a room at the foundation in honor of Paul Guillaume in 1927,[41] made one last gesture after Guillaume's death: he made an anonymous gift, via Etienne Bignou, to the innovative Musée de Grenoble of Giorgio de Chirico's *Portrait of Paul Guillaume* (fig. 12).[42]

It was in fact that other Paris dealer from the rue de la Boétie, Etienne Bignou (1891–1950), who henceforth enjoyed the trust of Dr. Barnes, as is witnessed in the Bignou photographic archives preserved at the Musée d'Orsay. After the establishment of the Foundation Barnes purchased numerous masterpieces from Bignou. He encouraged Bignou to open a branch in New York, thereby contributing to the rekindling of Americans' interest in French art in the period between the wars.[43]

The privileged relationships with Guillaume and Bignou notwithstanding, Albert Barnes did not neglect the dealers who had been his first suppliers. He continued going regularly to Vollard,[44] even buying from him one of his most important paintings, Cézanne's *Card Players* (page 123). He likewise continued to deal with Durand-Ruel (see Renoir, *Jeanne Durand-Ruel*, page 49), from whom he would make his last major acquisition, *Mussel Fishers at Berneval* by Renoir (fig. 1), in 1942, a painting the Durand-Ruels had for a long time refused to sell. And when he was in Berlin, he did not fail to visit Paul Cassirer (see Renoir, *Leaving the Conservatoire*,

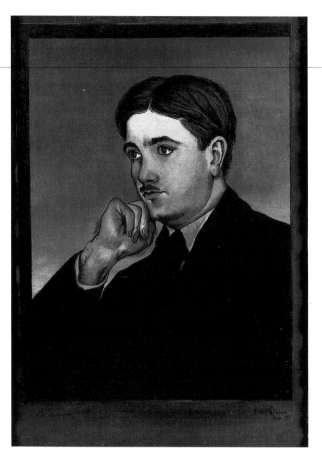

Fig. 12. De Chirico, *Portrait of Paul Guillaume*, 1915. Oil on canvas, 31⅛ x 22½″ (79 x 57 cm). Musée des Beaux-Arts, Grenoble, gift of Dr. A. C. Barnes.

page 51). It was finally in 1926 with Hodebert, partner of Barbazanges (and of Bignou for this deal), that Barnes negotiated the purchase of the last major work of Seurat on the market, *Models* (page 175), while it was on exhibit in London with Lefèvre. Barnes' collection thus included one of Seurat's masterworks, the equal of those possessed by the Art Institute of Chicago, the Louvre, and the Tate Gallery in London.

Like Paul Guillaume, Bignou would be welcomed at Merion, but the most honored guest of the 1930s was undoubtedly Ambroise Vollard, who came to speak to the Foundation's students in 1936, replacing at the last moment Paul Valéry, who had been initially invited out. "A visit to The Barnes Foundation is in itself worth the trip to America," proclaimed Vollard, who cautioned his readers, however, about the difficulties they might encounter in gaining entry.[45]

Although Barnes traded extensively with the dealers, he always proclaimed his independence from them, seeing them essentially as vendors. He wanted to meet the artists in person, and not only to forgo the agent's commission, an extra incentive. Albert Barnes never met Renoir; no doubt he was unable to travel to Cagnes, which Renoir never left at the end of his life because of the war. He did, however, become friends with the painter's son Jean Renoir, the future filmmaker, who was then a potter, commissioning from him a series of ornamental

ceramic pieces.[46] Learning that the French government was at first hesitant about accepting the offer made by Renoir's sons of the *Bathers*, today in the Musée d'Orsay, Barnes, always looking for the opportune moment, offered to buy the painting,[47] probably also hoping to acquire several pieces from the painter's considerable estate.

The most distinguished visitor to the Foundation, however, was Henri Matisse. When he went to Merion in 1930, he rediscovered an unrivaled collection of his works: *Bonheur de vivre* (page 227), which came from the Steins' collection, was only one of a series of works bought *en bloc* from the Danish collector Tetzen-Lund. The installation of the collection, criticized today, must have seemed familiar to Matisse. It was very similar, in fact, to those in the houses of collectors of his work before the war:[48] paintings in gold frames, old and modern together and responding to one another, the largest works hung high. The austere interior spaces of the Foundation building were not unlike those of the Italianate villas that had harbored for a time the works of Cézanne and Renoir. Matisse, himself a collector of long standing of the works of Renoir, Cézanne, and Seurat, was apparently seduced, even using a Barnesian turn of phrase or two to express his approval: "The Barnes Foundation will undoubtedly do away with the artificial, corrupt presentation of the collections over there [that is, the United States], where paintings are barely visible, hypocritically displayed in a mysterious temple- or cathedral-like light."[49] Matisse agreed to carry out in the main hall an immense decorative scheme covering more than 164 square feet on the theme of dance, which "continues the idea" of the decorative panels made for Shchukin in 1909, already expressed in part, according to Matisse, in the rings of dancers in *Bonheur de vivre*.[50] "Paint as you wish, absolutely as if you were painting for yourself," Barnes had said to the painter. Both Matisse and Barnes were satisfied with the result. Rarely had a dialogue between artist and collector been established with such intimacy, through works that belonged in a certain way to both of them.

The French newspapers briefly reported American news accounts of Dr. Barnes' death on 24 July 1951, at the age of seventy-nine, in an automobile accident. Their commentary dealt with the sensational factor — the market value of the collection that was known only through black-and-white reproductions in the Foundation's own publications. The image of the Barnes Foundation as an unaccessible fortress guarding unseen treasures began to build up. Fortunately, over the years the pilgrimage to Merion has become easier. The Barnes Foundation remains one of the special places in the world where one always senses the presence of the old master of the premises, whose single vision is behind each of the extraordinary works that greet the visitor.

Anne Distel
Chief Curator, Musée d'Orsay

THE PAINTINGS

Tarring the Boat (Le bateau goudronné)

July–August 1873
Oil on canvas
23¼ x 23⅝″ (59 x 60 cm)
Signed lower right: *Manet*
Inv. no. 166

During the summer of 1873, Manet worked at Berck-sur-Mer in the north of France, not far from Boulogne, where he had spent several summers before the war of 1870 and conceived a number of masterworks, including *The Luncheon in the Studio*[1] and *The Balcony*.[2]

Tarring the Boat[3] belongs to a group of works from the early 1870s that includes *On the Beach*, one of the best-known, which portrays Manet's wife and brother at the seaside in Berck.[4] These paintings clearly illustrate a period of transition from the dark, smooth treatment of the 1860s to the *plein air* works of the 1870s, with their broken, sketchlike manner that more closely approaches impressionism.

In this maritime scene, we observe the sort of contrast that had been favored by the painter since *Olympia* and *The Dead Toreador*,[5] an opposition between those masses of "blunt luminous black" that Henri Matisse so admired in Manet's work,[6] and touches of vivid or delicate color. Here, the bright, orange-tinted pink of the fire against the hull of the careening boat recalls the pink *muleta* that lies beside the dark body of the dead toreador, or the play of contrasts between the two women in *Olympia* — the black woman dressed in pink opposed to the pink nude with a black ribbon.

Nonetheless, this is not simply a case of previously devised pictorial effects newly applied to landscape. Though he was essentially a Parisian *boulevardier*, Manet was also quite well-acquainted with the real life of the sea. During a period when he intended to pursue a career with the merchant marine, he had spent six months on a training ship sailing between France and South America.[7]

Manet had already painted several seascapes during the summer of 1864 and 1865, including the famous *Battle of the Kearsarge and the Alabama*.[8] But these depict warships or fishing boats seen from afar on a vivid blue-green sea, with the high horizon of Japanese prints. During the summer of 1873, Manet apparently studied the daily activity of seamen and fishing boats close-up, painting scenes from life, such as *Fishermen at Sea*,[9] as well as this powerful image of a tilted hull, in the process of being made watertight with the application of tar. While the image is a factual record of fishermen at their labors, nothing could be further from an anecdote or genre scene than this poetic evocation of three natural elements, almost violently contrasted at the heart of the painting: fire, wood, and water (see detail, preceding page).

F C

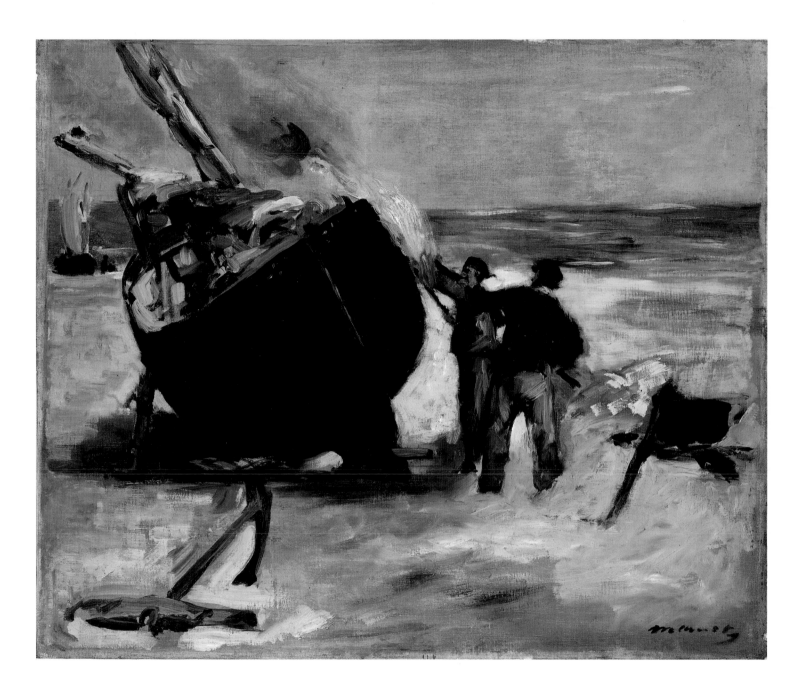

Torso, also called *Before the Bath* or *The Toilette* (*Buste de femme*)

c. 1873–1875
Oil on canvas
32⅛ x 24¾" (81.5 x 63 cm)
Signed lower right: *Renoir*
Inv. no. 9

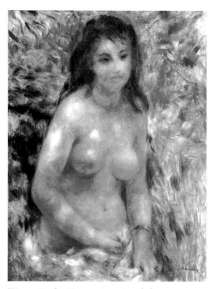

Fig. 1. *Study. Torso, effect of sunlight*, c. 1876. Oil on canvas, 31⅞" x 25⅝" (81 x 65 cm). Musée d'Orsay, Paris; Bequest of Gustave Caillebotte, 1894.

The full range of Renoir's career could be illustrated solely through his depiction of the female nude, and the group of Renoir nudes in the Barnes Foundation alone includes a complete series. Renoir worked with this subject throughout his life, producing a representative version at each stage of his artistic development, and assessing or fine-tuning his changing interpretation. This *Torso*[1] can be dated according to its provenance: it was included among the works that Claude Monet, Berthe Morisot, Renoir, and Alfred Sisley offered at a public sale in Paris on 24 March 1875, one year after their first group exhibition transformed them into "impressionists." On this occasion, the painting sold for the paltry sum of 140 francs; it was bought by the *amateur* Henri Hecht[2] — one of the first to discover Manet, Degas, and the impressionists — who quickly resold it to another collector, the well-known critic Théodore Duret. At the Duret sale,[3] it was purchased by the dealer Durand-Ruel, who resold it in 1912[4] to Dr. Barnes.

Around 1873–1875, Renoir renounced the references to mythology and orientalism that had been recurrent in his nudes of the preceding ten years. Having thoroughly assimilated the influence of Courbet and Delacroix, revered masters whose example permeates his bathers, Renoir's realism corresponded with themes from contemporary "avant garde" and naturalist literature: in this painting, the young woman disrobes — rather than poses — before an ordinary striped mattress, without any of the posturing of a professional model. Moreover, the painter emphasizes the most prosaic elements of the surrounding decor, such as common wallpaper and disheveled linen, which serve as identifying attributes. The original title given in 1875 to the painting, *Before the Bath*, underlines the realism of the subject. Despite an individualized face, with youthful if somewhat tired features, the young woman with long, black eyelashes remains unknown; nonetheless, it is quite clear that Renoir sought to preserve the individuality of his model, transposing the modeling of flesh and physiognomic detail with a firm yet fluid handling of paint. In this regard, the Barnes *Torso* differs radically from a well-lit nude study in the Musée d'Orsay (fig. 1), which was shown at the second impressionist exhibition of 1876, and is quite close in date. In the study, the body is treated as a sunlit object, and the humanity of the figure remains secondary, though the painting is marked by a direct sensuality. The difference in spirit between the two works demonstrates the diverse directions and rapid changes that characterized these decisive years in Renoir's career.

A D

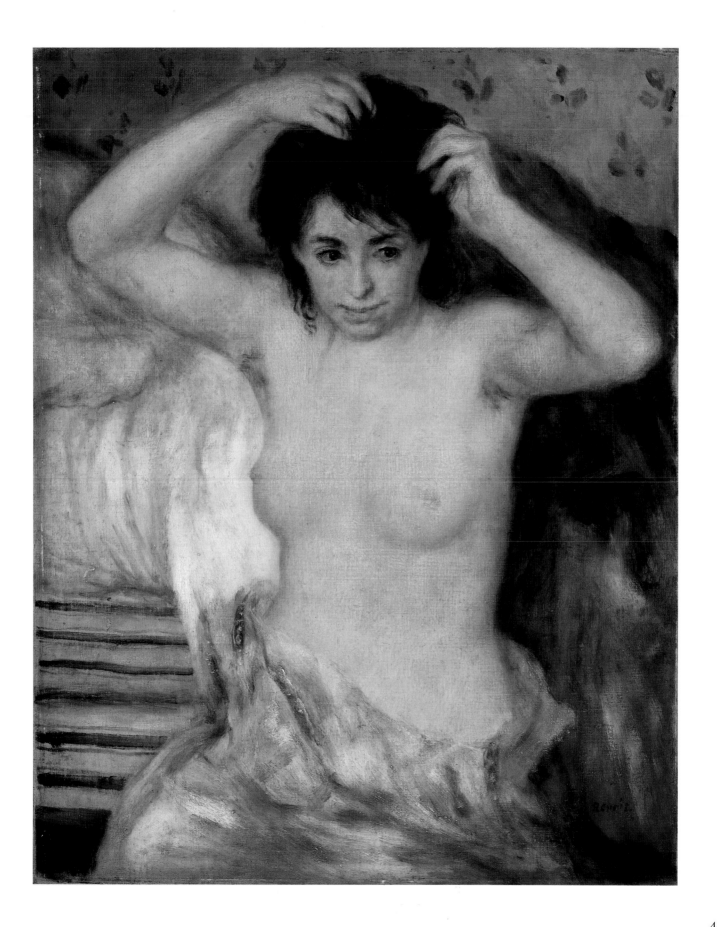

Jeanne Durand-Ruel

1876
Oil on canvas
44½ x 29⅛" (113 x 74 cm)
Signed and dated lower left: *Renoir. 76*
Inv. no. 950

The earliest works by Renoir to have survived are portraits; his first known Salon submission, in 1865, was also a portrait, that of the father of his friend Alfred Sisley (Musée d'Orsay, Paris). Renoir knew how to capture a likeness, as is revealed by his numerous portraits of relatives and friends. And quite naturally, Renoir as a young artist chose to paint portraits as a livelihood. Renoir was perfectly aware of the constraints imposed on him by the necessity to please his patrons, but he rarely made major concessions. Most of his portraits were Renoirs before being mere representations of their subject, and often surprised his sitters.

Jeanne Durand-Ruel,[1] later Mme. Albert Edouard Dureau (1870–1914), was the daughter of Paul Durand-Ruel, Renoir's dealer. The name of Durand-Ruel is also associated with the success of Manet and the other impressionist painters, for it was he who had discovered them and, since the 1870s, provided continual support. Renoir, who owed his first commercial success to Durand-Ruel, remained loyal to him his entire life.[2]

A few details suffice to distinguish the full-length portrait of Jeanne Durand-Ruel from the standard portrait production of the period. The contemporary fashion is carefully delineated: no vaguely historical drapery here, but the sensible fabric of a little girl's dress, tied with a colorful sash and complemented by a charming pair of boots. The setting is also precisely described: a bourgeois apartment, though not garishly opulent, with ordinary wainscoting and papered walls. A vivid blue baseboard suggests the articulation of planes in a very simple space. In a direct manner that does not strain for effect, the artist evokes a comfortable, well-appointed domain that forbears conspicuous luxury. Renoir's brother tells us[3] that the painter always left the choice of costume and pose to his models. This self-conscious deference allows the spontaneous expression of the model's personality — in this case, the demeanor of the little girl, at once shy and flirtatious. The palette of blue, gray, and green is quite cool, heightening the delicacy of the flesh tones; the detailing of the hair is remarkable for its simple juxtaposition of blue, mauve, and yellow hues. Though there is an overall coherence of the brushwork throughout the picture, some rapidly painted surfaces contrast with areas that are more deliberately worked.

The portrait of Jeanne Durand-Ruel, an indisputable success, heralds that of *Madame Charpentier and Her Children* of 1878 (The Metropolitan Museum of Art, New York), which was exhibited at the Salon of 1879, and was one of the first paintings by Renoir to achieve public acclaim. A D

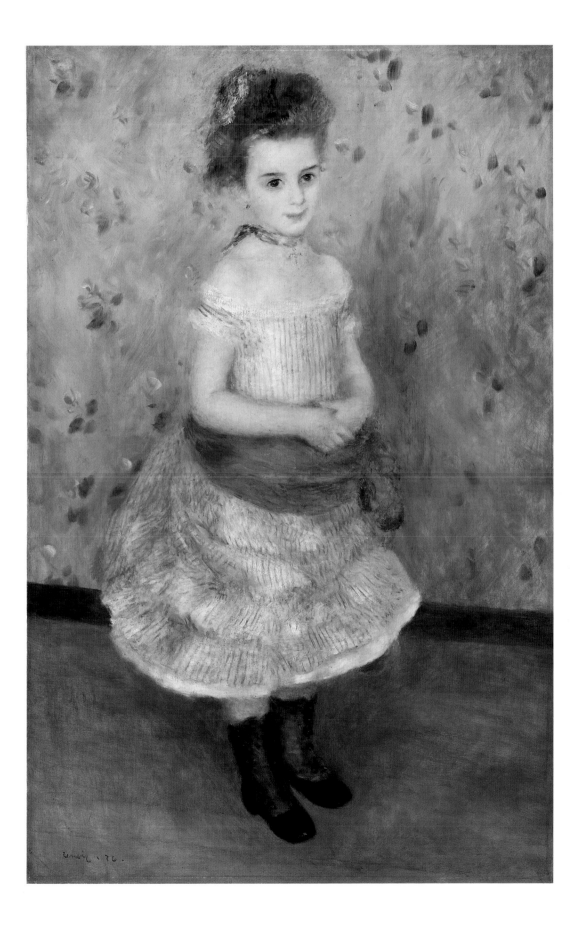

Leaving the Conservatoire (*La sortie du Conservatoire*)

1877
Oil on canvas
73¾ x 46¼" (187.3 x 117.5 cm)
Signed lower right: *Renoir*
Inv. no. 862

Fig. 1. *Ball at the Moulin de la Galette*, 1876. Oil on canvas, 51⅝ x 68⅞" (131 x 175 cm). Musée d'Orsay, Paris; Bequest of Gustave Caillebotte, 1894.

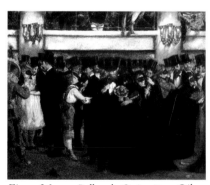

Fig. 2. Manet, *Ball at the Opéra*, 1873. Oil on canvas, 23¼ x 28½" (59 x 72.5 cm). National Gallery of Art, Washington; Gift of Mrs. Horace Havemeyer in memory of her mother-in-law, Louisine W. Havemeyer.

According to Renoir's biographer and friend Rivière,[1] the large *Leaving the Conservatoire*[2] — Rivière's title, in reference to the school of performing arts in Paris — was begun in October 1876, outside the front door of Renoir's studio on the rue Cortot in Montmartre. There is no reason to doubt the accuracy of his statement. Rather than use professional models for these figures, who are close to life-size, Renoir preferred the young working-class people of the district, just as he had for his *Ball at the Moulin de la Galette* (fig. 1). Rivière recounted at great length how much patience it must have taken for Renoir to convince these girls and their mother to pose for him. He even identified the foreground figure for us as Nini Lopez; the roll of paper she holds in her hands — a musical score or dramatic script — identifies the girl from Montmartre as an aspiring actress or singer, thereby justifying the title of the work.[3] Although he did not recall this in his book, Rivière himself posed for the figure of the young man who stands in the right foreground.[4]

Properly speaking, this is not, then, the direct transcription of a familiar scene of Parisian life, but a studied arrangement of figures *en plein air*, with an obvious narrative context. The moment of amiable civility that Renoir portrays here, scarcely more than a pleasant conversation, is clearly expressed in a genial mood. By evoking the Conservatoire, a cradle for the future luminaries of Parisian theater, Renoir seems to trespass on Degas' experimental turf, though in a very different spirit from that sarcastic observer of the socio-professional domain. Renoir's subject can also be compared to another famous image of modern Parisian life, Manet's *Ball at the Opéra* (fig. 2). But Renoir's tone, like the world he depicts — petit-bourgeois, if not lower-class — differs significantly from the piquant, slightly scandalous chic of Manet's painting. In contrast to Manet, Renoir does not clearly describe the setting: like a schematic theater set, the street is only vaguely suggested by a few bare walls. In his express desire to generalize, Renoir suppresses the incidental. This also distinguishes him from contemporary artists of the official mainstream, who remain prisoners of the anecdote.

Leaving the Conservatoire must be compared to Renoir's most famous painting of this period, the *Ball at the Moulin de la Galette*, which was shown at the third impressionist exhibition in 1877, and is probably the most ambitious work of the decade. Once again, Rivière — who published several articles in conjunction with this exhibition that obviously reflect conversations with the painter — emphasized the artist's intention to make this composition "a page of history, a precious, extremely precise commemoration of Parisian life." This reinforces what Renoir had always maintained, that the artist associated himself with the tradition of the large narrative painting. But Rivière hastened to add: "...to address a subject for the sake of its tonality, rather than for the subject itself — this

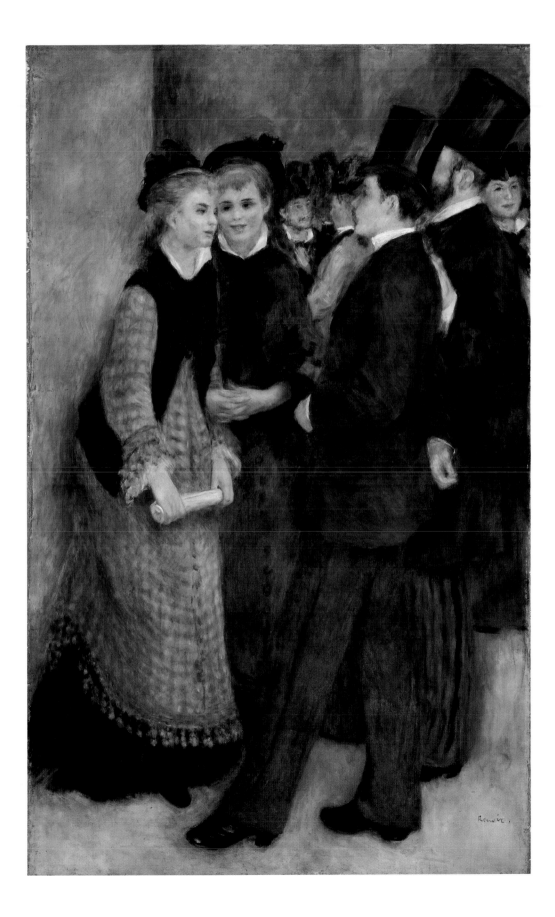

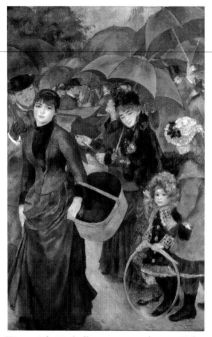

Fig. 3. *The Umbrellas*, c. 1881 and 1885. Oil on canvas, 70⅞" x 45¼" (180 x 115 cm). The Trustees of the National Gallery, London.

differentiates the impressionists from other painters.... M. Renoir has sought and found a contemporary tone."[5] These same remarks can be applied to *Leaving the Conservatoire*, though it is otherwise unrelated to the spontaneous, whirling, particolored atmosphere that distinguishes the subject of the *Ball*. These two paintings are separated by only a few months, and the disparity between them reveals to what degree Renoir — during the same period of time — is able to vary his effects. Nonetheless, in its palette of cool gray, beige, and blue, *Leaving the Conservatoire* does anticipate another scene of Parisian life that was portrayed by the artist, *The Umbrellas* (fig. 3), a work that he labored over during the early 1880s, and one that demonstrates his stylistic change during the period. This analogy between the two works is highlighted by their comparable size.

Some areas of *Leaving the Conservatoire* remain relatively unfinished, and the handling suggests rapid work, with no noticeable corrections. The simplicity of the color scheme, which is deliberately restrained, imbues Renoir's figures with monumentality and strength, while enhancing the freshness of the flesh tones. *Leaving the Conservatoire* does not appear to have been exhibited during Renoir's lifetime. At an unknown date, it entered the collection of the composer Emmanuel Chabrier (1841–1894). The musician was an old friend of Manet, whose celebrated *Bar at the Folies-Bergère* (The Courtauld Institute Galleries, London) also belonged to him, and of Monet and Renoir, whose work he was one of the first to support. There is nothing to suggest that this picture was commissioned by the composer, though this is the kind of subject to which Chabrier would have been attracted. The painting brought a very low price at the Chabrier sale,[6] and was then acquired by the dealer Durand-Ruel. He sold the work to another dealer, A. A. Hébrard, on 27 December 1905, for 24,000 francs,[7] vivid testimony to the rising price for Renoir's work after 1900. Hébrard was acting for Prince Alexandre de Wagram, a collector who had become celebrated for the dauntless enthusiasm with which, in a very brief period of time, he had acquired a magnificent group of impressionist works. Imprudent financial dealings compelled him to dispose of much of his collection, well before his untimely death during the war, in 1918. The spoils of his estate were cause for joy among collectors of the epoch, notably Dr. Barnes (see *The Luncheon*, page 55). Still, the painting did not enter Barnes' collection until 1929, at which time he acquired it for $57,500.[8]

A D

The Luncheon (Le déjeuner)

c. 1879
Oil on canvas
31¼ x 35⅝" (80.5 x 90.5 cm)
Signed lower right: *Renoir*
Inv. no. 45

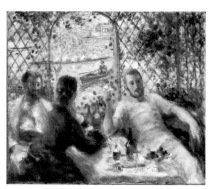

Fig. 1. *The Rowers' Lunch*, c. 1880. Oil on canvas, 21¼ x 26" (55.1 x 65.9 cm). The Art Institute of Chicago, Mr. and Mrs. Potter Palmer Collection.

One may consider *The Luncheon*,[1] an intimate interior scene, as the ideal pendant of another well-known painting by Renoir, *The Rowers' Lunch* (fig. 1), a comparison reinforced by the fact that the same male figure, identified as a certain M. de Lauradour, an oarsman, appears in both works. Manet, Monet, and Caillebotte, as well as academic painters and magazine illustrators, all depicted oarsmen on the Seine. That this preeminent subject of modern life often inspired naturalist novelists of the day, from the Goncourt brothers to Guy de Maupassant, clearly encourages the spectator — in our own time as well as Renoir's — to interpret this type of painting as an episode in a novel. But Renoir's rendition of the theme is free of bitterness, anxiety, or cynicism, unlike much literature of the period. Above all, Renoir, a fervent *habitué* of the Louvre, probably had seventeenth-century Dutch or eighteenth-century French prototypes in mind, and wanted to create his own, modern version of an established traditional type.

The Barnes painting is executed in a brisk manner, allusive yet closely observed, with a clear concern for precise details, such as the wainscoting, the wallpaper design, the shapes of the glasses and plates on the table, the couple's casual attire, even the ring that decorates the man's little finger; indeed, all of these details help particularize the scene.

The plain composition suggests a simplified space. The palette, in a color scale dominated by vivid blue and red, is especially audacious: the woman's hair is composed of touches of ocher, violet, yellow, and gray-blue; the bread, in yellow and dull pink, is accentuated by touches of red. Such brilliance is found in pictures painted by Renoir at the end of the 1870s, which anticipate the major work of the early 1880s, the *Luncheon of the Boating Party* (The Phillips Collection, Washington).

The first known owner of the Barnes picture was the dealer and collector Eugène Blot (1857–1938). In his memoirs, he recalls having acquired it for 400 francs from Alphonse Portier, a small dealer of impressionist paintings.[2] When he had to dispose of it at auction, 9 and 10 May 1900, the painting brought 4,000 francs from a Paris dealer (Bernheim-Jeune or Barbazanges), who immediately resold it to a celebrated collector, the Prince de Wagram. Beginning in 1909, the prince consigned the work to various dealers in Paris — Barbazanges, Druet, Georges Petit — but it was from Levesque, finally, that Dr. Barnes bought the work in June 1913 for 30,000 francs;[3] this escalation in price is indicative of Renoir's commercial success after 1900.

A D

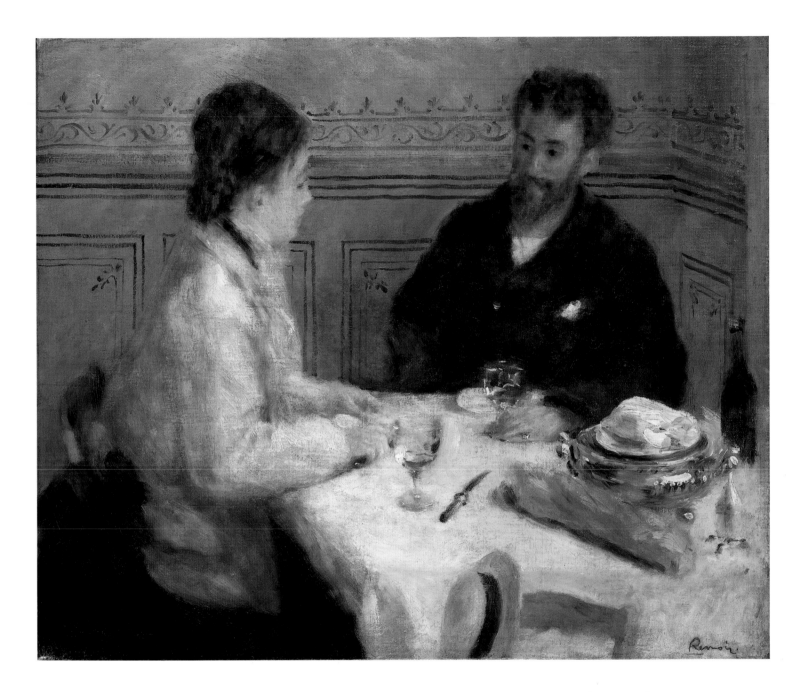

55

Mother and Child (Mère et enfant)

1881
Oil on canvas
47⅝ x 33⅝" (121 x 85.4 cm)
Signed and dated at lower left: *Renoir, 81.*
Inv. no. 15

Fig. 1. *Head of a Neapolitan Girl*, 1881. Oil on canvas, 14 x 12⅛" (35.6 x 30.8 cm). The Montreal Museum of Fine Arts, Adaline Van Horne Bequest.

In the autumn of 1881 Renoir traveled to Italy for the first time, visiting Venice, Florence, and Rome and, late in November, moving on to Naples. He was surprised and impressed by the brilliant Italian light, which throws forms into sharp relief against the sky; by the grandeur of Raphael's art; and by Renaissance and ancient Roman fresco painting. His experiences presented him with intimations that Italian art had a monumentality and timelessness to which he feared impressionist painting could not aspire because it explored fleeting pleasures and the ephemeral play of light. The Italian journey provoked important changes in Renoir's art as he initiated a long and often frustrating artistic search. He sought to ally the modernist painting that he and other young artists had developed over the past twenty years in the gray northern metropolis, Paris, with the imposing and noble classical art that for centuries had flourished on the shores of the Mediterranean and which Italy had blazingly revealed to him.

Renoir painted *Mother and Child* in Naples late in the year 1881.[1] It may well be the work he discussed in a letter of 23 November to the art dealer Durand-Ruel, whose purchase of several paintings earlier in the year had made the Italian trip financially feasible: "I'm very pleased and I think I'm going to bring you back some pretty things. . . . I've started the figure of a girl with a child, if I don't scrape it off."[2] The girl may have been a daughter of his Neapolitan landlord. He told Paul Bérard on 26 November that the daughters were posing for him, adding " . . . they're very pretty, the oldest looks like Leonardo da Vinci's Catherine."[3] The same beautiful peasant girl, wearing the same colorful scarf, posed for a *Head of a Neapolitan Girl* (fig. 1).[4] The girl and baby look more like siblings than mother and child, with perhaps a twelve-year difference in their ages. Indeed, neither in the letter to Durand-Ruel, quoted above, nor years later when he discussed the work with Vollard, did Renoir identify the girl as the baby's mother.[5] Nonetheless, that he intended the two to be seen as mother and child is evident from the wedding band that he painted on the girl's finger. Although he would not marry his own mistress, Aline Charigot, until their first child was five years old, here Renoir scrupulously observed the domestic proprieties. As has been argued, a bourgeois sense of decorum — in art if not in life — would have proven useful, while he attempted to find a middle-class Parisian clientele for his art.[6]

This image of maternal affection has a compelling quality of realism, as if the artist had stumbled upon the peasant girl and her joyous, squirming baby and as quickly captured them on canvas. In fact, the painting is a precise and knowing artistic construction. First, in choosing to paint the subject Renoir invoked a commonplace of nineteenth-century French art and thought whereby the Italian peasant served as the exemplar of innocence, ageless customs and purity of emotion. A contemporary French viewer likely would have recog-

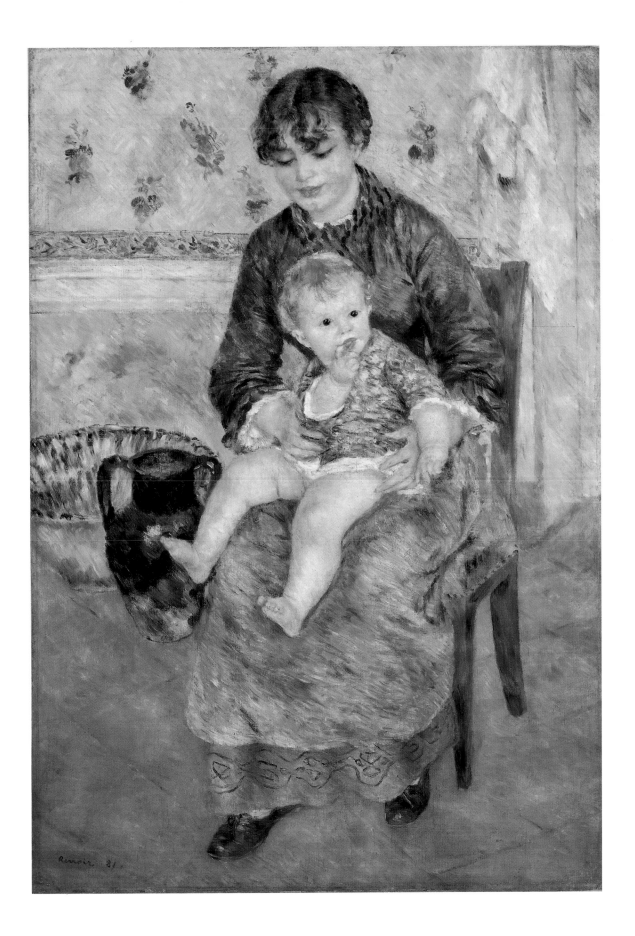

nized in the peasant mother and child that supposedly simple, happy Italian way of life, where blameless love flourished unsullied by the perverseness of the modern world, and where guileless virtue such as the Ancients had known was still to be found. Second, though the scene is set in an interior, Renoir carefully linked the mother and child with the primal forces of nature. The two seated figures form a single, vertical form; the baby's body is circumscribed by the outline of the mother's body, a metaphor of familial safety. Only a tiny, kicking leg breaks the outline, but the foot too is meticulously contained within the form of a large earthenware water pitcher, itself a traditional symbol of female fecundity. Both a large pottery bowl and the red-tile floor suggest the rich, moist clay of the land worked by hand since time immemorial into simple, useful objects. The wallpaper is dotted with sprigs of flowers, evocations of freshness, the bloom of youth, and the simple beauty the natural world sends forth.

Third, the painting evinces the impact of Raphael's art on Renoir. "Every woman nursing a child is a Virgin by Raphael," Renoir once stated.[7] Here the echo of the Renaissance master is found in the monumental grouping of the figures at the center of the canvas, and in the strict geometry by which the horizontal of the wainscoting at left and the vertical door jamb at right lock the figures into the composition. The use of architectural elements to establish a chaste formal rigor in a painting, which Renoir would have observed in the Vatican Stanze of Raphael, was rare in the art of his impressionist years. Even the studied casualness of the pose evokes Raphael. As he visited the museums and galleries where Raphael's paintings hung, surely Renoir could not have escaped that pervasive "figment of the Romantic imagination," as E. H. Gombrich has termed it, with which Italian guides, then and now, regale unsuspecting tourists, the myth that Raphael himself found the models for his Madonnas among Italian peasant girls, that such masterpieces as *The Small Cowper Madonna* (fig. 2) are essentially realistic portraits, begun as simple sketches made by the master as he wandered among the people.[8] Indeed, Renoir later recalled to Vollard his own delight at seeing the *Madonna della Sedia* in Florence, "The most free, the most solid, the most marvellously simple and alive painting that one could imagine."[9]

Mother and Child is Renoir's own 'Madonna of the Chair,' an early experiment in the reconciliation of modern realism and the monumental dignity of the old masters. In Italy, Renoir found one of the paradigmatic themes of Renaissance art, the Madonna and Child, which would play a central role in the art of his own later years, as the domestic idyll of a mother and child.[10]

<div style="text-align:right">C R</div>

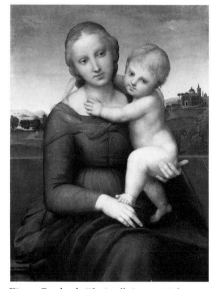

Fig. 2. Raphael, *The Small Cowper Madonna*, c. 1505. Wood, 23⅜ x 17⅜" (59.5 x 44 cm). National Gallery of Art, Washington; Widener Collection.

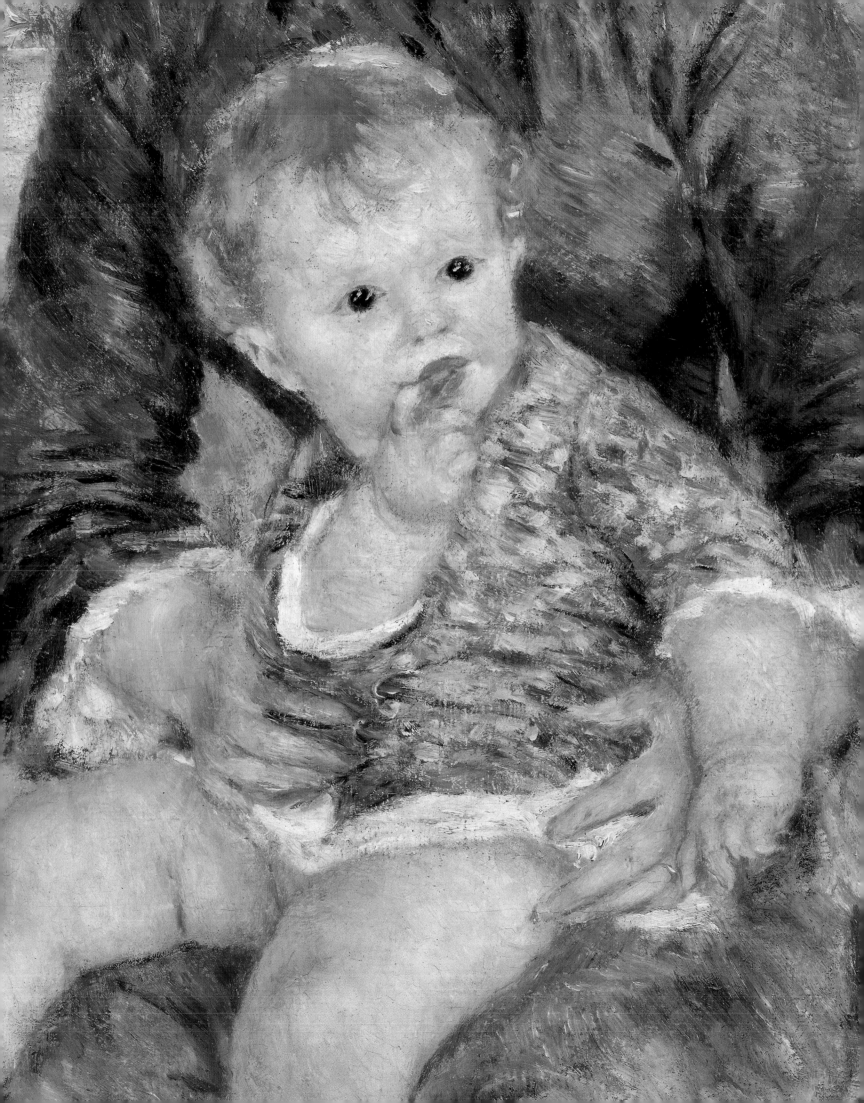

Sailor Boy (Portrait of Robert Nunès)
(Jeune garçon sur la plage d'Yport)

1883
Oil on canvas
51¼ x 31½" (130.2 x 80 cm)
Signed and dated, lower right: *Renoir, 83*.
Inv. no. 325

In August 1883 Renoir traveled to the resort town of Yport, just below Fécamp on the Norman coast, to paint commissioned portraits of Aline and Robert, the two children of the town mayor, Alfred Nunès. Nunès was a cousin of Camille Pissarro, and in 1884 his brother Lionel would be enlisted to help Renoir prepare his never-completed *Abrégé de la grammaire des arts*. On 21 August, the artist wrote to his friend Paul Bérard from Yport that he was "busy...with two brats who make me furious....I hope it will work out."[1] Though Renoir himself was known to linger long over sociable meals,[2] he complained of his gregarious hosts that "There are a few too many parties, that's the weak point....For at their place you spend the whole day at the table."[3] Nonetheless, by early September Renoir had completed the full-length portraits and moved on to the isle of Jersey.

Born on 27 August 1873, Robert Nunès was approaching his tenth birthday when he posed for Renoir. Standing confidently in a brilliant blue sailor suit with white piping, hand on hip like a proud young prince, the boy glances at the viewer with an assurance surprising

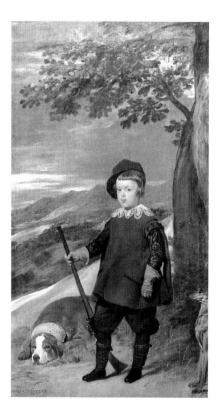

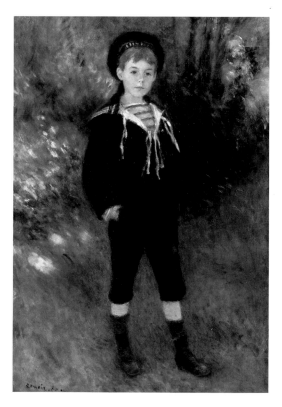

Fig. 1. Velázquez, *Prince Baltasar Carlos as a Hunter*, c. 1635–36. Oil on canvas, 75¼ x 40½" (191.1 x 102.9 cm). Museo del Prado, Madrid.

Fig. 2. *Portrait of Maurice Grimprel*, 1880. Oil on canvas, 21⅝ x 15" (54.9 x 38.1 cm). Private collection, New York.

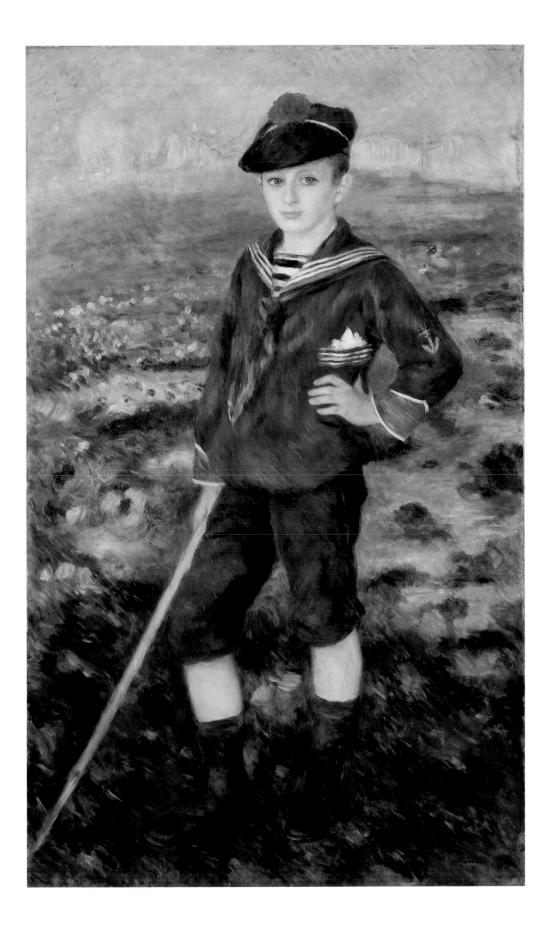

for his years. Renoir here exploited a longstanding tradition of aristocratic portraiture where male children were represented in costumes and with attributes that evoked the brash and manly roles they might assume in adult life. Velázquez's six-year-old *Prince Baltasar Carlos as a Hunter* of c. 1635–1636 (fig. 1) is a precedent. In 1880 Renoir had painted the eight-year-old son of a Parisian banker, Maurice Grimprel, in a similar sailor suit (fig. 2), while in an 1881 portrait, nineteen-year-old Alfred Bérard is a hunter nonchalantly resting against a tree (Philadelphia Museum of Art). Late in life Renoir painted his own son Jean as a bold young hunter grasping an enormous rifle firmly in hand (Los Angeles County Museum of Art).

As was traditional too, Renoir established close formal connections between Robert's portrait and its pendant, *Girl with a Parasol (Portrait of Aline Nunès)* (fig. 3). Eight-year-old Aline's pose is virtually the mirror image of her brother's; the outward direction of her dark-eyed gaze is similar; and even the bright red pompom on her hat matches his. Renoir, however, strongly contrasted the spaces the children inhabit. Robert stands before the open sea, its high horizon flecked with white sails. Coastal rocks glisten in the brilliant sunlight. Aline poses in a garden, a view into the distance all but blocked by a large tree at right and by her own open umbrella that keeps the sun away. Where Robert is promised a sailor's adventurous life in the great world that beckons beyond Yport, his sister contentedly

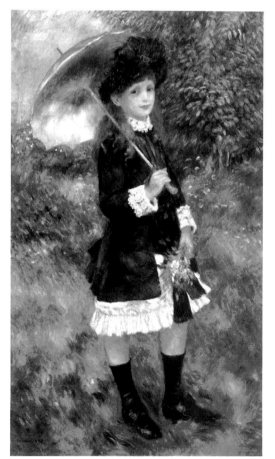

Fig. 3. *Girl with a Parasol (Portrait of Aline Nunès)*, 1883. Oil on canvas, 51¼ x 31½" (130.2 x 80 cm). Private collection.

inhabits the enclosed garden, and there she gathers flowers; she will find her future in the domestic realm. As Renoir well knew from earlier commissions, his society patrons expected their portraits to be flattering, sophisticated, and, in the attitudes they expressed, conventional celebrations of family life. Indeed, as the artist wrote to Bérard of the Nunès portraits, "I can't yet speak to you of success since I'm not the one who has to be satisfied."[4]

The portrait of young Nunès is painted with virtuoso skill. Robert is carefully detached from, almost outlined against, the background of sea and marshy shore. The boy's face is rendered in a detailed and descriptive manner traditional in Renoir's portraits, for as he had written of an earlier portrait commission: "It's necessary for a mother to recognize her daughter."[5] In contrast to this careful delineation of features is the painterly vivacity with which the artist treats Robert's sailor suit. Quick touches of red and mauve animate the dominating pattern of diagonal blue brushstrokes. The landscape background is even more freely painted in a vivid manner typical of Renoir's impressionist landscape style of the 1870s. His interests lay less here in description than in the lively evocation of sunlight playing on water, marsh, and distant, luminous rocks. Renoir used subtle touches of color to reconcile the different painting styles of figure and ground. Thus the boy's red pompom is echoed in touches of red worked into the earth at Robert's feet, and a patch of white paint between Robert's legs answers to the white piping and handkerchief of his suit. Similarly, bright yellow touches in water, rocks, and shore balance the anchor precisely embroidered on Robert's sleeve.

In the early 1880s, following his first journey to Italy and its revelation of Renaissance painting, Raphael, and Antiquity, Renoir was experimenting with ways to give the principal human figures a monumental presence in his paintings, to detach them from and display them against their environments. In distinction to the unification of the pictorial space typical of his impressionist paintings, Renoir now sought to endow his subjects with an almost sculptural presence, not only by painting them more smoothly but also by accentuating the inconsistency between fore- and background painting styles. In the great *Seated Bather* (fig. 4), likely begun soon after the Nunès portraits were completed, the pensive and alluring nude woman who dominates the composition is thrown into relief by the water rushing turbulently over rocks around her, a mosaic of flashing colors in which form all but dissolves. In such works, including *Sailor Boy*, the pictorial tension that Renoir generates as he attempts to balance competing forces captures our attention.[6]

C R

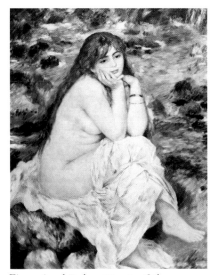

Fig. 4. *Seated Bather*, 1883–84. Oil on canvas, 47½ x 36″ (120.6 x 91.4 cm). Fogg Art Museum, Harvard University, Cambridge; Bequest of Maurice Wertheim, Class of 1906.

Beach Scene, Guernsey (Enfants au bord de la mer à Guernesey)

1883
Oil on canvas
21¼ x 25½" (54 x 65 cm)
Signed with studio stamp at lower right
Inv. no. 10

Fig. 1. *Wave*, 1882. Oil on canvas, 21 x 25"
(53.3 x 63.5 cm). Private collection.

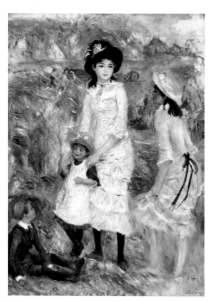

Fig. 2. *Children on the Seashore*, 1883. Oil
on canvas, 36 x 26⅛" (91.5 x 66.5 cm).
Museum of Fine Arts, Boston; Bequest of
John T. Spaulding.

After finishing his portraits of the Nunès children in Yport, early in September 1883, Renoir, Aline Charigot, and his friend Paul Lhote traveled to Jersey and then on to the isle of Guernsey, "the rock on which the great poet groaned for eighteen years," as Renoir called it, referring to the site of Victor Hugo's exile.[1] It was not scenes of banishment and alienation that intrigued him on the island, but Guernsey's rugged beauty and the pleasantly informal seaside sociability that flourished there. "One would think oneself in a Watteau landscape rather than in reality," he told Durand-Ruel.[2] The visitors remained until 8 October, Renoir working steadily on oil sketches — he referred to them as documents — that he would later use to work up finished pictures back in his Paris studio. Many were executed at the rocky seashore where the bathers provided the artist with "a source of real, pleasing motifs.... Nothing is more amusing, while one is strolling through these rocks, than surprising young girls getting ready to bathe; even though they are English, they are not particularly shocked."[3] Among the major paintings to derive from this journey are *By the Seashore* (The Metropolitan Museum of Art, New York) and the *Seated Bather* (Fogg Art Museum, Harvard University, see page 63), for both of which Aline posed. The Barnes *Beach Scene* may have been painted largely in front of the motif on Guernsey. The background and large areas of the left side of the canvas are executed with rapid, swirling brushstrokes of fluid oil paint, including rich strokes of emerald green, applied wet into wet. They suggest waves cascading over the rocks on the shore. Such areas of the painting recall a 'pure' seascape, a dazzlingly fresh and colorful *Wave* (fig. 1).

Vacationers gather at right in the Barnes painting, including a group of the shockproof English girls whom Renoir so admired. Three young girls in straw hats and short skirts happily converse while, at left, two boys play in the sand. This same group of girls, minus the older background figures at far right but including a young boy like the seated figure at left, reappear in a larger painting, *Children on the Seashore*, (fig. 2). Surely painted back in the Paris studio, and in distinction to the more uniform Barnes painting, here Renoir established a sharp division between the smoothly painted foreground figures and the rapidly brushed background, including indistinct rocks, water, and distant bathers. In front of the motif Renoir observed and quickly recorded figures caught up in the animated play of light. Such works remain essentially impressionist. Back in the studio, the artist tried to make a formal, symmetrically disposed figure composition based on the rapidly executed studies of spontaneous and amusing vacationers on the Guernsey beach.

Barnes purchased the painting from Barbazanges Hodebert & Cie., Paris, in 1922 for 180,000 francs.[4]

C R

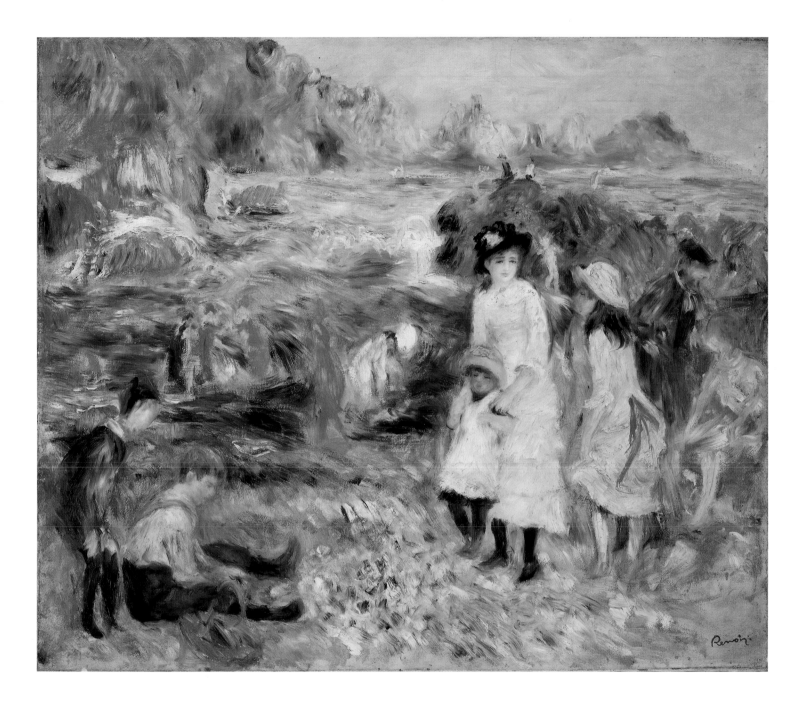

Garden Scene in Brittany (Scène de jardin en Bretagne)

c. 1886
Oil on canvas
21¼ x 22⅛" (54 x 56.2 cm)
Signed at lower right
Inv. no. 161

During the months of August and September 1886, Renoir rented a house, La Maison Perrette, at La-Chapelle-Saint-Briac in Brittany. This summer vacation with Aline Charigot and their eighteen-month-old son Pierre was for Renoir a respite from the daunting task that he had left behind in his studio and that would occupy him again upon his return to Paris in the autumn. For some two years the artist had been at work on a large-scale, multi-figure painting whose progress alternately elated him and drove him near to despair, but which was finally scheduled for exhibition in spring 1887. *The Great Bathers* (Philadelphia Museum of Art, see page 162) was an experiment in a new, more monumental painting style that was meant to carry the artist beyond the insubstantiality of impressionism and to secure for him a place in the grand French tradition of monumental decorative painting. *Garden Scene in Brittany* was executed at La Maison Perrette in the late summer of 1886.[1] On a smaller, more intimate scale it addressed the formal and technical problems with which Renoir also grappled as he painted *The Great Bathers*.[2]

Here Aline sits on a wooden bench, sewing in the sunny garden of the Brittany house. Pierre stands beside her, hand resting on her knee for support, while an unidentified woman exchanges pleasantries as she passes by. The painting celebrates the fecundity of nature: the garden is filled with flowers in bloom and trees whose arching limbs and heavy foliage create a shady bower for mother and child. A pear tree at left groans under the sagging weight of its fruit. Remarkably, every leaf of the trees is individually drawn, the outlines sometimes indenting the painting's heavy white ground. Individual leaves are filled in with jewellike washes of color. These details are not unlike the tesserae of a mosaic, and the resulting stylization of the pictorial surface recalled for Barnes and de Mazia "the decorative patterns in early French miniatures and tapestries."[3] The painting *Return from the Fields* (fig. 1), also dating from the Brittany sojourn, shows a similar drawing of the details before paint is applied, and this work too is painted on a dry, frescolike white ground. From the same moment as well come minutely detailed and elegantly linear india ink drawings of foliage, including one drawing on primed canvas of a leafy tree (New Orleans Museum of Art).

Years later Renoir recalled to Vollard "certain canvases in which I had drawn all the smallest details with a pen before painting."[4] Since the early 1880s the artist had attempted to resolve the problem of formlessness with which impressionist painting was charged, and here he approached a solution. The evident drawing in works like *Garden Scene in Brittany* was not simple preparation for painting but the means by which Renoir defined the compositional structure that controls and orders color. The strong vertical of the tree trunk at right and the horizontal roofline neatly divide the picture plane, while the crisply drawn banks of flowers at lower left and behind the bench carve out the space the figures inhabit.

Fig. 1. *Return from the Fields*, 1886. Oil on canvas, 21¼ x 25½" (54 x 64.8 cm). Fitzwilliam Museum, Cambridge University.

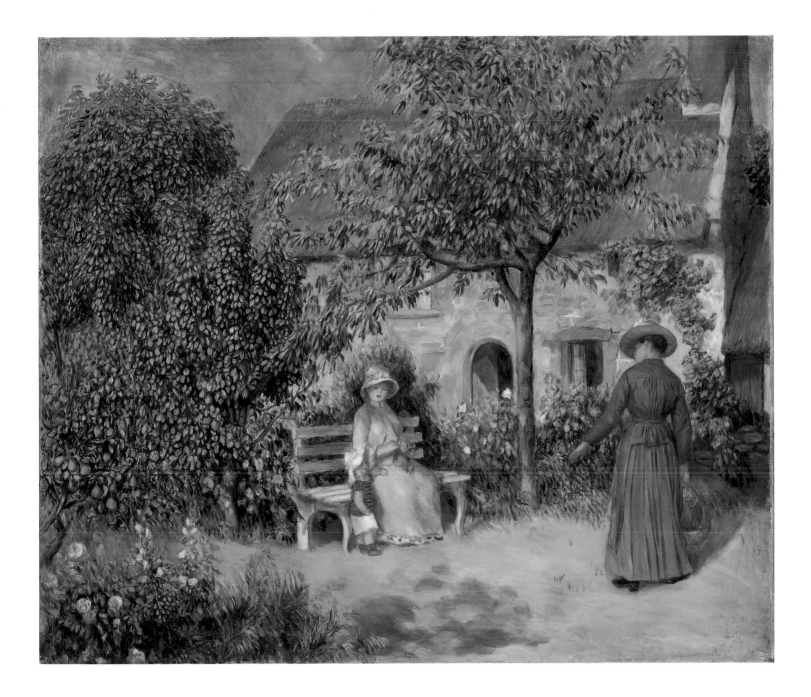

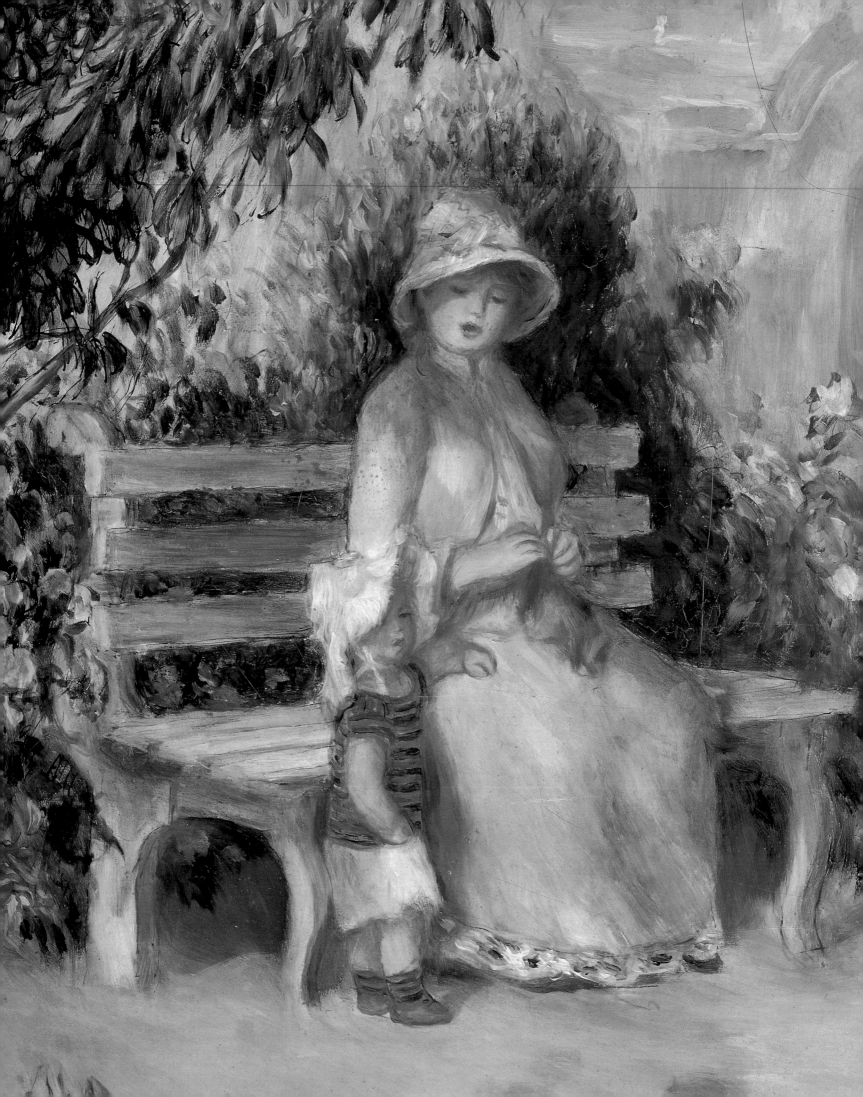

Such technical experiments reached their conclusion in *The Great Bathers*, itself like a fresco in oil paint and filled with carefully drawn linear details, including the massive tree trunk immediately behind the bathers.

This painting as well as the Brittany scenes of late summer 1886 reflects Renoir's study of ancient Roman and Renaissance frescoes in Italy, and his interest in Cennino Cennini's handbook on fresco painting. He now hoped to achieve the monumental solidity and decorative elegance associated with painting on walls. Indeed, *The Great Bathers* was first exhibited with the title "An Experiment in Decorative Painting." Heavily worked canvases like *Garden Scene in Brittany* participated in that slow process of experimentation that reached resolution in *The Great Bathers* and that Renoir then almost immediately abandoned, returning in the later 1880s to a freer and looser style of painting. A prolific painter, Renoir must finally have been frustrated by the constraints of the painstaking work involved in executing paintings such as *Garden Scene in Brittany*.

Dr. Barnes seems to have acquired the painting in about 1916, not directly from Ambroise Vollard as Daulte indicates but through Durand-Ruel.[5] In 1912 an angry Barnes had broken abruptly with Vollard when the dealer, who had never dealt with the doctor previously, requested payment in advance before shipping a painting to Merion.[6] Nonetheless, Vollard had many paintings that Barnes desired and Durand-Ruel often acted as intermediary, sometimes not indicating to Vollard for whom he was acquiring paintings.[7]

C R

Noirmoutiers

1892
Oil on canvas
25¼ x 31⅞″ (65.4 x 81 cm)
Signed at lower right: *Renoir 92.*
Inv. no. 163

By 1892 Renoir was enjoying the fruits of his growing success. In April the state purchased *Young Girls at the Piano* (Musée d'Orsay, Paris) and the following month the Durand-Ruel gallery mounted a retrospective exhibition of 110 works. On his return from a trip to Spain in the late spring, Renoir traveled to Brittany for the summer, spending much of August and September in the resort town of Pornic. Rather than relaxing, however, he grew bored with the seaside and worried about his work, writing to Berthe Morisot: "...I should be painting landscapes. The country here is quite pretty and that is why I am so cross. To paint landscapes is becoming for me an ever greater torture, all the more so because it is a duty: obviously this is the only way to learn one's craft a little, but to station oneself out of doors like a mountebank, this is something I can no longer do."[1]

At least one landscape, now in a private collection, was painted at Pornic, but Renoir soon traveled further afield in search of motifs. "...I went to Noirmoutiers; it is superb and quite like the south, far superior to Jersey and Guernsey; but too far away, much too far. If I were bolder, there would be lovely things to do there, as everywhere else for that matter....I shall write to you when I have painted an interesting landscape."[2]

A tiny island curling out into the Atlantic, Noirmoutiers has long been known for its gentle climate. Renoir may have visited more than once in the summer of 1892, for when Morisot spoke to the artist in Paris in mid-September, he reported that he would be heading back to the island.[3] The Barnes landscape derives from one of those expeditions. It likely depicts the Bois de la Chaise, a woods on the edge of the ocean that guidebooks compare to the Côte d'Azur. The painting was completed back in the studio, however, as was more and more Renoir's custom; as he had told Morisot, he found painting in the open air increasingly difficult.

In its freedom of execution and delicacy of color, *Noirmoutiers* recalls Renoir's impressionist landscapes of the 1870s. Long, looping braids of color establish the trunk and branches of the large tree at left, while quick touches of green and yellow indicate the foliage, a lacy filigree against the sky. Purple and blue brushstrokes, the shadow cast by the tree, meander across the foreground. At mid-ground a few deft highlights, including the red of a seated woman's costume and the brilliant white daub of a sailboat, focus the eye. "I like a painting that makes me want to go for a stroll in it, if it is a landscape," Renoir once said.[4] Here the great sweep of branches erupting from the left reaches across the canvas, intersecting other, more distant trees and defining an invitingly sheltered space for a promenade. Renoir uses these sinuous forms to weave together the composition while a range of thin washes suggests the moist and breezy coastal atmosphere as shadows scud across the ground.[5]

C R

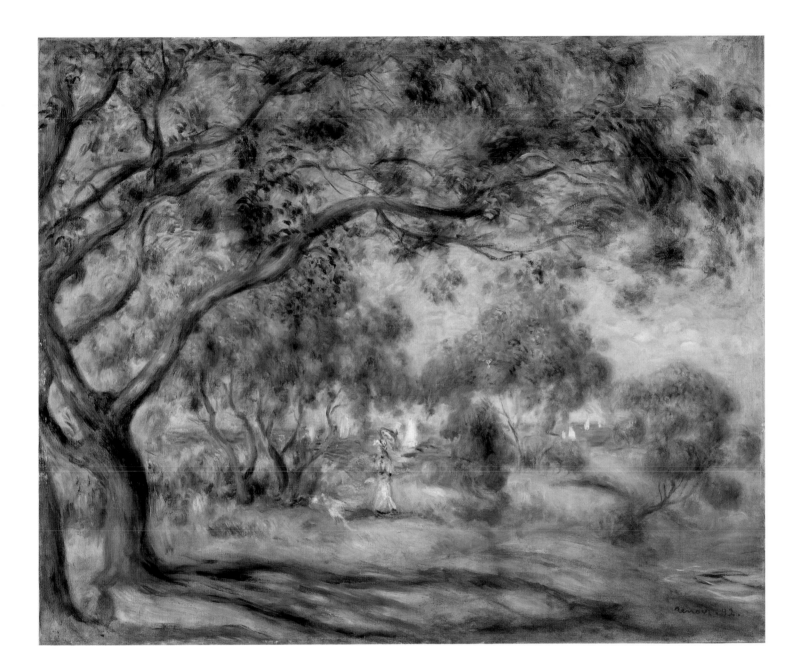

Reclining Nude (La source)

c. 1895–1897
Oil on canvas
25¼ x 61¼" (65.4 x 115.6 cm)
Signed, lower right: P.A. RENOIR
Inv. no. 903

Long before he took up sculpture in 1907, Renoir repeatedly consulted the history of French sculpture in search of direction for his painting. In the mid-1880s François Girardon's lead bas-relief of *Nymphs Bathing* (c. 1670) from the gardens of Versailles provided an elegant example for the complicated grouping of nudes that Renoir was exploring in multi-figure paintings such as *The Great Bathers* (see page 162). Similarly, his undulating and exquisite *Caryatid* pendants of c. 1910 (see page 89) owe a debt to the eighteenth-century sculptor Clodion's groups of intertwined maidens holding aloft flower baskets (see page 90). Increasingly skeptical after 1880 about an impressionist art that evoked nothing more substantial than transitory effects of sunlight, Renoir found in sculpture models for a painting of weight and density.

One French sculptor in particular attracted Renoir's lifelong admiration. From his youth he expressed esteem for Jean Goujon (c. 1510–c. 1565), and often stopped to study the relief carvings of gracefully attenuated women representing water with which Goujon adorned his most important monument, the Fontaine des Innocents (c. 1547–1549) in the heart of Paris. "He has purity, naïveté, elegance; and at the same time the form itself is amazingly solid," Renoir said of the sculptor.[1] Late in life Renoir "felt unconsciously that he was spiritually related" to the sixteenth-century master, his son Jean reported.[2] At times, he consciously emulated the sculptor. In a letter of 1893, Renoir described the paintings he was working on as "some terrific Jean Goujons,"[3] and the influence is conspicuous in *Reclining Nude (La source)*, likely painted a few years later. The impossibly long, sinuously curving body of Renoir's nude recalls Goujon's mannerist figure canon, as seen in such works as the stylobate bas-relief of a reclining nymph from the Fontaine des Innocents (fig. 1). Renoir enclosed his figure in a strong and simple painted stone surround to which

Fig. 1. Goujon, *Reclining Nymph* from the *Fontaine des Innocents*, c. 1547–49. Stone bas-relief, 28¾ x 5" (73 x 12.7 cm). Now in the Musée du Louvre, Paris.

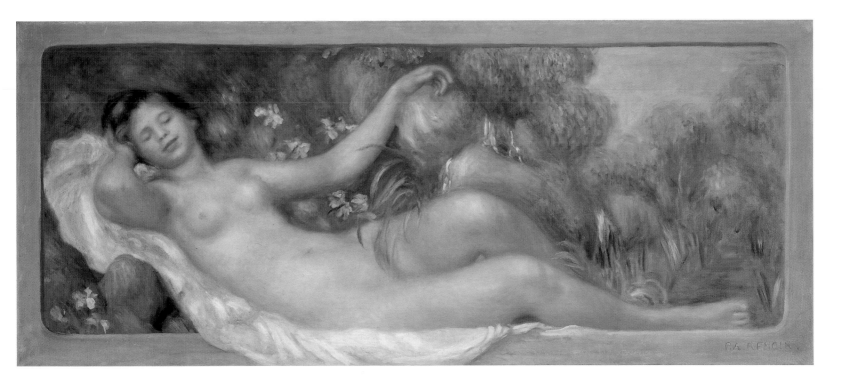

he drew attention by the white sheet that spills over its edge, and by his own signature, which he carved like a classical inscription into the stone. Like Goujon's reclining figure, Renoir's nude is subsumed into architecture, her soft form controlled by but also animating the rock. Nature and art, he implies, conspire to create grace.

Renoir's emulation of Goujon's sculpture underlines the artist's primary painterly concerns at the end of the century. As he attempted to secure his place in the French classical tradition that Goujon had helped initiate, Renoir's studies of old master painting and sculpture continued, and the allusions in his work to the art of the past multiplied. At the same time, Goujon's subject *par excellence*, the female nude, idealized and abstracted into a timeless, pastoral realm, or transformed into allegory, came to play an increasing role in Renoir's art. Renoir also was concerned with decorative painting schemes. *Reclining Nude*, which has the horizontal proportions common to painted overdoors inserted into wall panelling, was executed for the French publisher Paul Gallimard, an important patron of Renoir in the 1890s who influenced the artist's emerging classicism. During these same years the artist was planning to decorate a dining room in Gallimard's house on the — for Renoir — wildly improbable classical theme of "Oedipus Rex." Goujon's sculpture, particularly the reliefs from the Fontaine des Innocents, proposed an ideal of female beauty deeply embedded in the French tradition, and at the same time provided a compelling model for the integration of the female form into architecture.

Like some slumbering Antiope deep in the woods, the nymph in *Reclining Nude* is full of provocative but guileless sensuality. Head tilted back, eyes closed, she displays herself with an instinctive grace, indifferent to the viewer's gaze. Her left hand rests on a rock from which refreshing, cool water springs to nourish the flowers that bloom around her body. Here, the artist conjured the ancient commonplace that equates the female with the elemental forces of nature, specifically water. She personifies *"la source,"* a word in French meaning both spring or fountain and origin. Like water, Renoir's nude is the origin of nature's fertility. Introduced into the French art tradition by the painters and sculptors of the sixteenth-century School of Fontainebleau, including Goujon, the metaphorical representation of woman as water continued to attract classicizing artists of the nineteenth century. Among them were Ingres and Puvis de Chavannes, both of whom depicted "La Source." The motif would remain vital for Maillol, Picasso, and other artists well into the twentieth century.

The evident allusion to Jean Goujon in this painting suggests a further association, more troubling to viewers today. In his late works Renoir almost always presented female nudes as anonymous, unthinking creatures. According to Jean Renoir, "He wanted the subject to lapse into a state of mindlessness, to sink into the void."[4] For the artist, his female models were like amusing house pets whose sensual appetite he admired but to whom powers of intellection need not be ascribed. Indeed, he preferred painting women and children because "Men are too tense: they think too much."[5] It was in Goujon's art that Renoir purported to recognize a precedent for such attitudes: "Those women Jean Goujon carved have something of the cat about them. Cats are the only women who count, the most amusing to paint."[6] In works such as *Reclining Nude*, Renoir evoked the art of

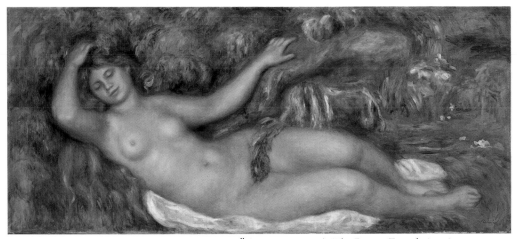

Fig. 2. *Reclining Nude,* 1910. Oil on canvas, 26½ x 61″ (67.3 x 154.9 cm). The Barnes Foundation, inv. no. 97.

Goujon and the classical topos of "the source," but such allusions also served as vehicles for expressing the profound misogyny to which, throughout his life, Renoir remained so blithely blind.

Several years later Renoir returned to the theme of the nude by a stream when he executed a virtual pendant to *Reclining Nude (La source)*, now also at the Barnes Foundation (fig. 2). Dating from around 1910, this painting exudes the same languid sensuality and Venetian coloring of the earlier work. The same association of the feminine and fertile nature is evoked. The pose is similar, though more fully frontal. Now, however, Renoir's brushstrokes are looser, and the subtly colored, long, looping strokes describe both figure and foliage; indeed, the two meld into one another and, as is typical of Renoir's finest late, large-scale nudes, the picture almost seems about to dissolve into a perfumed haze. Renoir no longer is interested here in using rectilinear forms to balance and control the sinuous curves and swellings of nature and the body. Rather, he abandons the stone surround that had served so effectively as a foil to the undulations of the nude figure in the earlier work, and evokes an Arcadia where the hand of man has made no mark.

Dr. Barnes acquired *Reclining Nude* from the Galeries Georges Petit, Paris, for $14,411 in January 1932.[7] Today, it and the later nude hang high on a wall in the principal gallery of the Barnes Foundation, directly opposite *The Dance*, Henri Matisse's monumental experiment in the integration of nude female figures into a commanding architectural environment (see page 276–278). (see page 276–278). C R

The Artist's Family (Portraits)
(La famille d'artiste)

1896
Oil on canvas
68 x 54" (173 x 140 cm)
Inv. no. 819

In September 1890, Renoir and his family moved to the Château des Brouillards at 13 rue Girardon in Montmartre. They inhabited one of several buildings that stood within the picturesque confines of a tumbledown, eighteenth-century estate and there the artist's second son, Jean, was born on 15 September 1894. Not far from such popular Montmartre cafés and dance halls as the Moulin de la Galette, but boasting a garden overgrown with flowers and distant views into the countryside, the Château was a "little paradise of lilacs and roses,"[1] Jean recalled. The other residents of the enclave, including the writer Paul Alexis, a disciple of Zola, were bohemian in temperament and happily tolerant of unconventionality. Sociability was casual and amusing, and Renoir recalled that he painted prolifically while living there. As Jean explained, "the place inspired him."[2]

In the spring of 1896 Renoir posed his family, a servant, and a neighbor in the garden of the Château for a large-scale, formal group portrait. It would be the centerpiece of an exhibition of his paintings to open at the Durand-Ruel gallery in late May. At left is the eldest child of Renoir and Aline, eleven-year-old Pierre, who leans on the arm of his plump, pretty mother. At the center is Jean, not yet two years old, tenderly supported by Gabrielle Renard, the family maid. Raven-haired Gabrielle was a distant relative of Aline's from her native town of Essoyes and had joined the family only a short time before Jean's birth. At right is a pretty young neighbor girl, usually identified as the daughter of Paul Alexis.[3] Knowing that she has caught the eye of Pierre, she plays flirtatiously with her hair.

The large and smoothly painted forms of the five figures, lavishly dressed and pleased to be the objects of Renoir's attention, assume an almost sculptural presence against the pastel landscape of the garden. Puffy masses of foliage, lightly brushed-in, echo the grandly rounded curves of the figures. Contrasting with them are the extravagant and angular silhouettes of the remarkable bonnets that both Aline and Jean wear. Passages such as Aline's blouse are complex networks of multicolored brushstrokes. Elsewhere, however, Renoir engages in a virtuoso display of his skills in monochromatic painting as he invests large areas of black, white, red, and blue clothing with subtle yet vivacious nuances of color, full of painterly energy and intelligence.

The Artist's Family immediately reveals its debt to the great tradition of large-scale, multi-figure portrait painting with which the royal and aristocratic families of Europe celebrated their lineage and authority. Artists from Titian and Veronese, Velázquez and Goya, and Rubens and Van Dyck provided generations of great families with monumental, idealized displays of empowerment. Indeed, fancily dressed Jean is presented to the viewer for special admiration in a way that recalls the little Infanta who receives the gaze of her proud royal parents in Velázquez's *Las Meninas* (fig. 1). Striding forward confidently, Aline

Fig. 1. Velázquez, *Las Meninas*, 1656. 122 x 108⅝" (310 x 276 cm). Museo del Prado, Madrid.

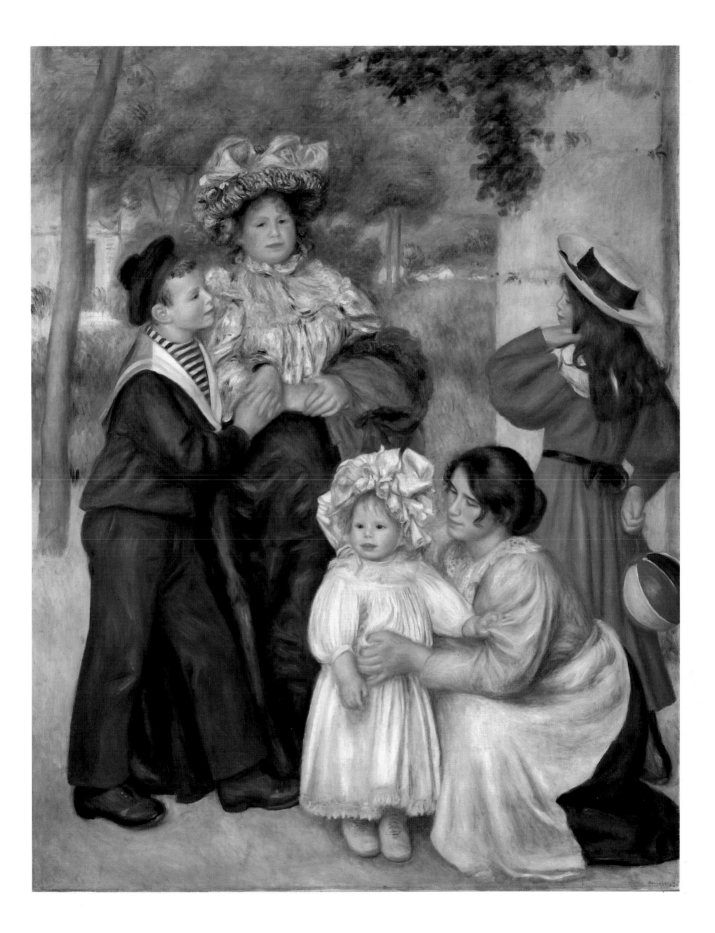

and Pierre themselves recall Van Dyck's portraits of the haughty Genoese nobility stepping out to take the air. This tradition of baroque display in family portraits enjoyed a revival in the late nineteenth century in the works of fashionable painters like Sargent and Boldini, while in his devastating *Bellelli Family* of 1867 (Musée d'Orsay, Paris) Degas subverted the tradition to reveal a family in disintegration.

The Artist's Family, it has been argued, shows Aline Renoir as "a stylish woman" and her family as "full-fledged members of the bourgeoisie."4 By this point in his career, to be sure, Renoir enjoyed financial success and growing fame. He could afford to maintain household servants, and Aline could wear expensive clothes. As Jean recalled, however, Renoir gaily proclaimed his own exuberant "bad taste" when confronted by genteel discernment, preferring the vibrant colors only the peasants wore to the sober tonalities that the middle classes preferred.5 Surely, Aline is overdressed for a stroll in the garden, in kaleidoscopic clothing and a hat like some exotic bloom. Little about her outfit is conventionally tasteful. Rather, it resembles the extravagant costumes, including the hats with whimsical, striking profiles, that were worn by the habituées of the Montmartre cafés and depicted by Toulouse-Lautrec in such works as *The Dance at the Moulin Rouge* (fig. 2). In the 1890s, outfits such as Aline's had come to serve as a badge of membership in bohemian Montmartre, "that hybrid of leisure-industry and counter-culture,"6 which in the fin-de-siècle offered refuge from middle-class conformity.

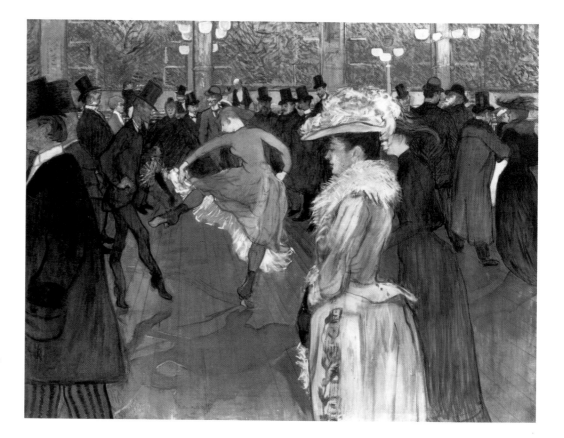

Fig. 2. Toulouse-Lautrec, *The Dance at the Moulin Rouge*, 1890. Oil on canvas, 45½ x 59" (115.6 x 149.9 cm). Philadelphia Museum of Art, The Henry P. McIlhenny Collection in Memory of Frances P. McIlhenny.

Nor is this painting, as its customary title would imply, a convincing image of the traditional bourgeois family, private and self-contained. Gabrielle appears to be far more than a maid, the tender care she lavishes on Jean bespeaking love. It is as if these children have two mothers, each one a font of warmth, security, and reassurance. As Jean himself recalled years later of the family's many maids: "It would have astonished me if anyone had said that these lovely girls were not part of our family. I did not try to define a kinship about which there was certainly no doubt in my mind."[7] Intimate feeling among the Renoir ménage was not confined to the family, but sprang up where people were tender and kind. Most intriguing in this regard is the little neighbor girl who wanders into the portrait. Family she is not, but a member of that larger unit, the raucous and sociable bohemian community of the Château des Brouillards. There, Renoir seems to say, friendship and fellow feeling among a disparate and otherwise unrelated group of like-minded people help to make life good. When first exhibited, the painting was not specifically associated with Renoir's family at all. It was called, simply, *Portraits*.

Drawing wittily on traditions of aristocratic portraiture, the picture represents the artist, his family, and friends not as members of the middle class, which of course they were, but as members of that new aristocracy of the spirit and imagination in which artists and intellectuals located themselves on the margins of, and in tacit opposition to, genteel society. This enchanting and cheerful painting celebrates Renoir's hard-won freedom, however illusory, from the weight of bourgeois convention.

Dr. Barnes first attempted to buy *The Artist's Family* in 1915. On 25 January 1915, he wrote to Durand-Ruel in Paris inquiring about a self-portrait that he understood Renoir had deposited with the dealer for safekeeping. Would the artist be willing to sell the work? "You might explain to Renoir that I now have fifty of his paintings, and that I think that he is the greatest of modern painters, and that my collection is to be given to the city of Philadelphia along with the Widener and Johnson collections....I think that it is safe to say that I have spent in purchasing paintings by Renoir the sum of a million and a half francs, and it is my hope to make this collection one of the best in the world."[8]

On 24 February, Joseph Durand-Ruel replied that the painting on deposit "is not a portrait of Renoir, but of his family," adding that the artist "has always refused to part with it. I believe he wants to give it to the Louvre after his death."[9] The picture descended to Renoir's youngest son, Claude, however, and Barnes acquired it for $50,000 through the Paris dealer L. C. Hodebert on 18 February 1927.[10]

C R

Bather and Maid (La toilette)

Oil on canvas
c. 1900
57⅛ x 37⅜" (145.1 x 94.9 cm)
Signed lower right
Inv. no. 899

In their study of Renoir, first published in 1935, Barnes and de Mazia were disparaging of *Bather and Maid*, then in the Bernheim-Jeune collection: "With all its exquisite passages of painting, its skillful placing of volumes in space, and its very effective pictorial organization, the painting is banal and academic; it lacks the spark of life and seems as if Renoir had painted a parody of…what the official Salon would pronounce excellence in art."[1] Soon after, however, in November and December 1935, Barnes had the opportunity to study the painting again in two consecutive exhibitions, at the Étienne Bignou Gallery in New York,[2] and on 10 December he bought the work from Bignou.[3] Yet Barnes never revised his original assessment for later printings of *The Art of Renoir*.

That Barnes should acquire a painting about which he harbored reservations helps illuminate the principles behind his formation of the world's largest collection of Renoir paintings. Along with Cézanne, Renoir was for Barnes a cornerstone of modernism. From the early years of art buying, he expressed his intention to build a significant, representative collection of Renoir's works. This, Barnes later explained, would include paintings to "illustrate his defects as well as his virtues."[4] Barnes championed Renoir's late works, which other connoisseurs often scorned. He particularly praised the artist's vibrant colors. In this regard, Barnes maintained, Renoir held his own against the most advanced painters of a new generation, and his finest works made "the best of Matisse look sick in effective, daring, dramatic color-contrasts."[5] Indeed, Barnes exchanged Matisse's vivid 1907 *Boy with a Butterfly Net* (Minneapolis Institute of Arts) in partial payment for *Bather and Maid*.[6] In spite of his doubts about the painting, Barnes seems to have understood that *Bather and Maid* is one of Renoir's most ambitious paintings of the late 1890s; in both subject and style it anticipates and introduces Renoir's achievement in the twentieth century, and thus plays a pivotal role in a collection where the artist's late works figure so prominently.

The two principal figures in *Bather and Maid* are simple, monumental forms that dominate the composition, the sinuous, complementary curves of their bodies creating a graceful outline against a wall of foliage that, curtainlike, fills the entire canvas and hides the horizon. In a strikingly similar lady and maid in a painting of the previous decade, *La Coiffure*, 1888 (Private collection, New York), Renoir paid close attention to the contemporary specificity of dress and furniture. Here, though, he located his duo in a pastoral setting far beyond the quotidian realm of leisured sociability. Now, only a jumble of clothing, including a flower-bedecked straw hat, acknowledges contemporaneity. Anticipated in earlier 'Bather' paintings, the timeless Arcadia in which Renoir situated *Bather and Maid* came to predominate in the nude paintings of the final years.

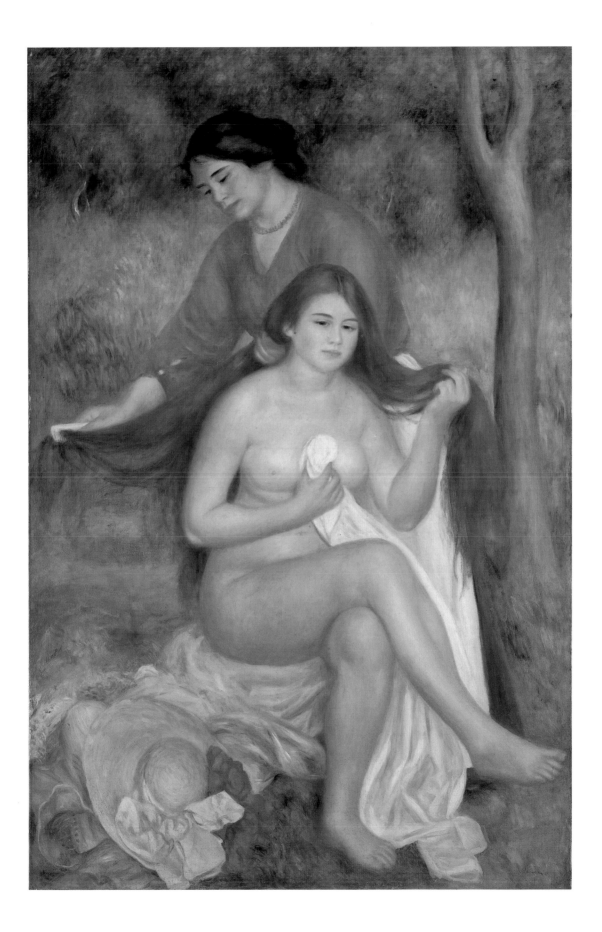

As Renoir understood, images of nude bathers in the woods enjoy a long and privileged tradition in European painting. The Venetian Renaissance and Rubens were vital presences for Renoir in these years. Indeed, the mild gesture of modesty as his voluptuous bather hides her nakedness with a cloth reaches back even further to echo the 'Venus Pudica' figures of ancient Roman sculpture. Renoir evoked such traditions while at the same time removing any implication of narrative. As much as his bathers may recall the bathing Dianas and Bathshebas of older art, or indeed, the ponderous and sanitized nudes of contemporary academic art, they are here archetypal evocations of the 'eternal feminine.' While the viewer may seem to have stumbled upon them in the woods, the bather is not alarmed by our intervention but, calm and quiet, returns the viewer's gaze evenly.[7] The bather's magnificent, long tresses are like a cascade of water, a motif that reinforces the ancient trope associating the nude female with the forces of nature. Further, Renoir plays off the fair skin and reddish hair of the bather against the ruddier complexion and jet-black hair of her maid.

In this painting, as well, Renoir begins to explore the large, boneless female figure canon that predominates in his later years. His female nudes are not so much Rubensesque in their pneumatic proportions as they are, increasingly, pictorial abstractions, composed on the canvas so as to create beautiful rhythms on the picture plane. Existing out of time, and in no identifiable place, their broad, simplified roundness evokes a longed-for but irrevocably absent Eve, with associations of beauty, simplicity, and innocence. Renoir dedicated his final years to invoking this ideal.

Such monumental, robust paintings as *Bather and Maid* would appeal powerfully to early twentieth-century artists who, like Renoir, increasingly turned to the ancient, classical Mediterranean tradition in their art. Thus, Renoir's painting anticipates the idealized and self-absorbed nude female sculptures of Aristide Maillol. Similarly, Matisse's *La Coiffure* of 1907 (Staatsgalerie, Stuttgart) recapitulates Renoir's painting in a more advanced mode. For such artists, as for Dr. Barnes, no distinction need be made between old Renoir and his younger, vanguard contemporaries; all fought the modernist battle, itself steeped in tradition.

C R

The Promenade (La promenade)

c. 1906
Oil on canvas
64¼ x 50¾" (165 x 129 cm)
Signed at lower right
Inv. no. 571

Fig. 1. *Claude and Renée*, 1902–03. Oil on canvas, 31 x 25" (78.7 x 63.5 cm). National Gallery of Canada, Ottawa.

Fig. 2. *Promenade*, 1870. Oil on canvas, 32 x 25½" (81.3 x 65 cm). The J. Paul Getty Museum, Malibu.

Children play a prominent role in Renoir's art. They are the subjects of many of his most important portrait commissions in the 1870s and early 1880s, from such patrons as the Bérard and Durand-Ruel families. His depictions of the sons and daughters of these patrons reveal his solicitous and sympathetic understanding of children's tentative, trusting personalities. By 1901, with the birth of Claude (Coco), Renoir was the father of three sons, and they were among his favorite models. He frequently portrayed them alone or in the loving care of the family maids. Such images of children and their relations with adults figure largely in the art of Renoir's old age, and in that of early twentieth-century contemporaries both in France and abroad.

The Promenade, likely painted at Essoyes in the summer of 1906, is one of Renoir's most compelling images of a child and adult. According to the Barnes Foundation archives, the little girl is Julienne Dubanc, from Essoyes, and the woman is the maid and model Adrienne, remembered by Jean Renoir as "a blonde Venus who walked like a goddess."[1] Here, the two stroll in the woods, and the woman turns her head familiarly as if to greet a neighbor she has chanced upon. The child firmly grips the woman's hand and follows confidently behind, ignoring passers-by in her intent search for more pink flowers to pluck. Though neither figure was a family member, the painting communicates the instinctual trust between a vulnerable child and a grownup that Renoir also explored in contemporary depictions of his own sons and their nurses such as *Claude and Renée* (fig. 1). Here as there, Renoir rejoiced in discerning and depicting kindness and innocence.

He had treated the theme of a couple in the woods earlier in his career, in the *Promenade* of 1870 (fig. 2). In that work, the implication is of seduction as, hand in hand, the sun-dappled young couple moves deeper into the sheltering woods, away from our gaze. The impressionist painting technique and off-center placement of the figures impart the sense of a fleeting moment, observed by chance. In the painting of 1906, on the other hand, Renoir belied the seeming casualness of the scene by placing the strolling woman at the center of the canvas, firmly locked into place by the strong, repeated verticals of tree trunks. Freely and thinly painted, the woods is less environment here than a vibrant backdrop against which the monumental figures arrange themselves. As with many of his late large-scale portraits, including *The Artist's Family*, Renoir found his prototype in the baroque court portrait tradition. Like Peter Paul Rubens' great *Artist's Family* (The Metropolitan Museum of Art, New York), however, *The Promenade* replaces solemn, self-important display with a beguiling sense of happily unself-conscious intimacy and trust.

C R

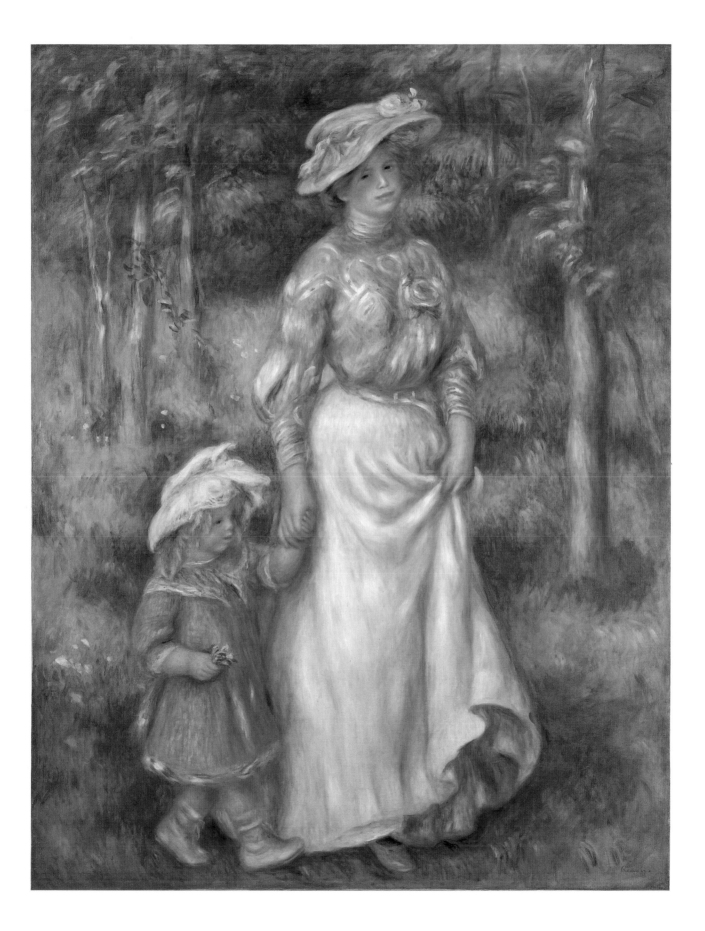

After the Bath (Après le bain)

1910
Oil on canvas
37½ x 29¾" (95 x 76 cm)
Signed and dated lower left: *Renoir. 1910.*
Inv. no. 142

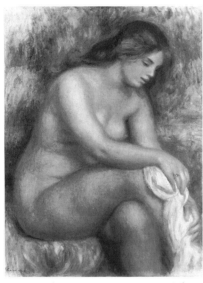

Fig. 1. *Bather Drying Her Leg*, c. 1910. Oil on canvas, 33 x 25⅝" (84 x 65 cm). Collection Museu de Arte de São Paulo.

As has been noted, Renoir's two masters in the art of painting the female nude were Titian and Rubens, both of whom he admired for their skill in allowing thin, luminous coats of paint to suggest quivering flesh. In the final decade of his life, Renoir returned to the theme with renewed intensity, painting numerous single and multi-figure bather compositions. *After the Bath* is one of several canvases devoted to single bathers. Like contemporary works such as *Bather Drying Her Leg* (fig. 1), the buxom figure dominates the composition, filling the canvas almost to its edges. Set into leafy but largely undifferentiated landscape backgrounds, clutching towels amidst discarded piles of clothing, these voluptuous, enormous women are fully absorbed in their sensuality and unaware of the viewer's presence. In this they differ from Renoir's more provocative late nudes who confront the viewer with even, unashamed gazes, including a 'Venetian' reclining figure of 1903 (fig. 2). Here, the features of the bather are even more highly generalized. One would be hard-pressed to identify a sitter or to ascribe a personality to the woman. Rather, such images constitute Renoir's paean to the 'eternal feminine,' conceived by him as tranquil, luscious, and compliant.

In the present picture, paint is applied freely and thinly, with gray tones enhancing the vividly ruddy pink of the flesh. The weave of the canvas is evident through the figure, whose swirling colors and undulating forms suggest Renoir's intimate and tactile manipulation of paint, like a lover's manipulation of flesh. The active brushstrokes belie Renoir's increasingly feeble condition and failing grasp of his brushes. This wallowing in painterly sensuality and youth was perhaps a way for the artist to elude inevitable decline, which was by now well advanced.

After the Bath is one of four paintings by Renoir that Barnes acquired from Durand-Ruel on 18 December 1915.

C R

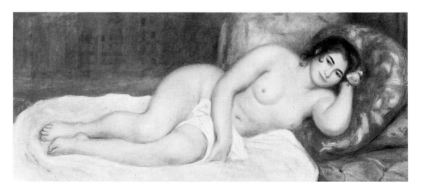

Fig. 2. *Reclining Nude*, 1903. Oil on canvas, 36 x 72 (91.4 x 182.9 cm). Private collection.

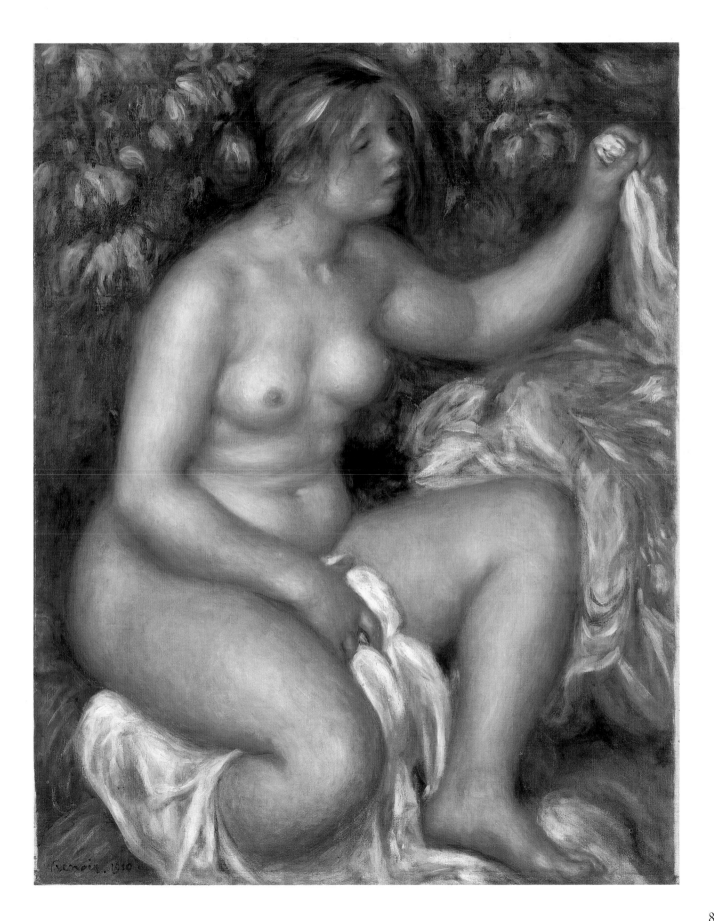

Caryatids (*Panneaux décoratifs*)

c. 1910
Oil on canvas
Each 51¼ x 17¾″ (130 x 45 cm)
Each signed lower right
Inv. nos. 918, 919

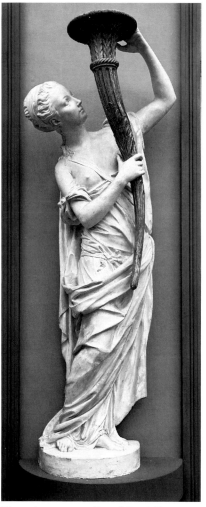

Fig. 1. Anonymous, *Draped Female Figure*, 1775–1800. Plaster, partially gilded. Philadelphia Museum of Art.

In his youth, Renoir served an apprenticeship with a painter of porcelain plates, excelling at profiles of Marie-Antoinette. For a time, he painted fans with copies of Watteau, Lancret, and Boucher. He decorated window shades with edifying religious scenes destined for the missions of East Asia, and he painted murals, many on mythological themes, for some twenty Parisian cafés, none of which has survived. This broad, early training in the *métier* of decorative painting left Renoir with a lifelong interest in the French decorative tradition, and an enthusiasm for the elegant decors of the *ancien régime*. Like a *peintre-ornémaniste* of the eighteenth century, he went on to create decorative schemes for the homes of favored patrons such as the Bérard and Durand-Ruel families. In the 1890s he began work on dining room decorations for Paul Gallimard in a neo-Pompeian mode, and in 1909 he painted pendant dancing-girl decorations for the dining room of Maurice Gangnat.

The pendant canvases of coupled nudes in niches, painted about 1910 and found in Renoir's studio at his death, their intended destination unknown, reveal the artist's continued allegiance to the decorative tradition. Supporting leafy garlands that loop around their bodies, the figures are enframed by the simple architecture of stone niches. Renoir exploits the tension generated by the play of the nudes' pliant, curving forms against the curving but rigid architectonic shapes. As with his *Reclining Nude* (see page 73), Renoir seems to have found inspiration in French sculpture. One critic pointed specifically to Jean Goujon's standing female figures in bas-relief on the Fontaine des Innocents as a model.[1] The same sculptor had created, for the Tribune of the Louvre, the most acclaimed caryatid figures in French sculpture. Even though Renoir's nudes are not true caryatids as they do not bear loads, they participate in that long tradition of anthropomorphizing architectural decoration that had been introduced into the French tradition by the sixteenth-century decorators of the School of Fontainebleau. This use of nude or semi-nude female figures in paint, plaster, or stone to animate both exterior and interior spaces remained a constant of the French decorative tradition throughout Renoir's lifetime. Indeed, as the new century dawned the tradition enjoyed renewed vigor in the decoration of such monumental buildings as the Grand Palais and the Hôtel du Gare d'Orsay in Paris, built for the Universal Exposition of 1900.

"I was brought up on the eighteenth-century French masters," the artist told Vollard,[2] and these figures suggest Renoir's special debt to eighteenth-century precedents. The gracefully spiraling poses of the nudes recall the draped female *torchère* figures bearing cornucopiae, of the kind that decorated the dining room of the luxurious pavilion at Louveciennes built by the architect Claude-Nicolas Ledoux for Madame du Barry in 1770–1771 (fig. 1). In their robust animation, they also recall works by the sculptor Claude Michel, called Clodion,

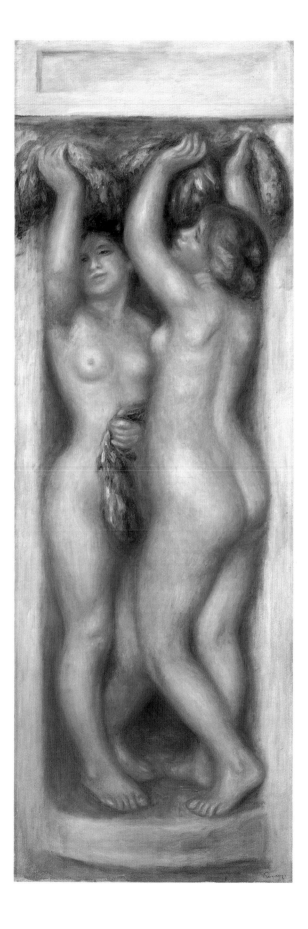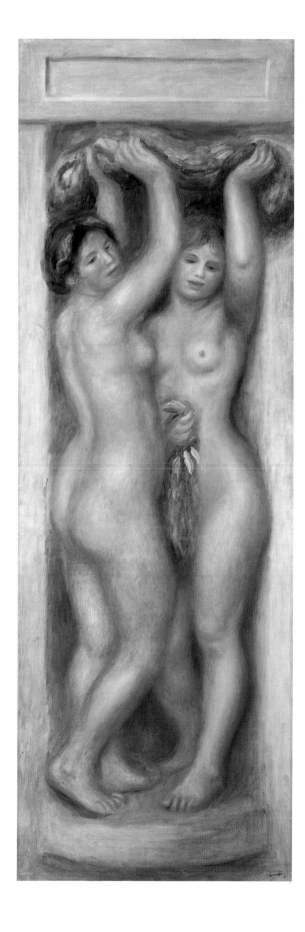

Fig. 2. Michel, known as Clodion, *Bacchantes with Fruit and Flowers*, late eighteenth century. Plaster, height of each 89½" (227.3 cm). Philadelphia Museum of Art, Given by Eva Roberts Stotesbury in memory of Edward T. Stotesbury.

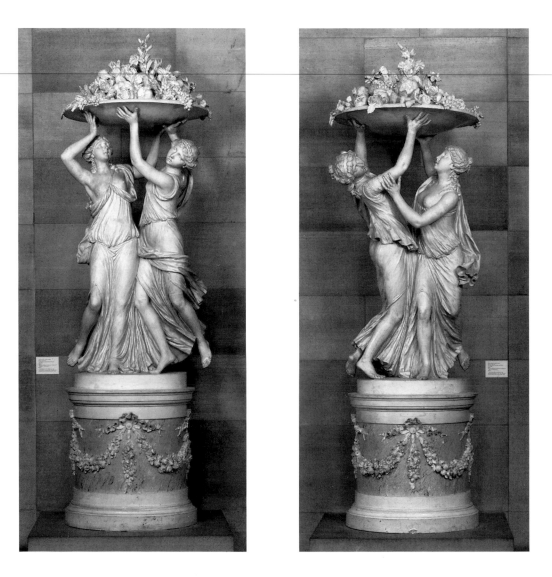

such as the groups of nymphs holding aloft platters of fruit, created at the end of the eighteenth century for the Hôtel de Botterel-Quintin in Paris (fig. 2).[3] From sculpture groups such as Clodion's, Renoir would have learned how to relate the sinuous, twisting figures one with another, and how to balance their movements, gestures, and gazes to establish complementary rhythms within and between the canvases. Full of undulating movements and counter-movements, Renoir's pairs of nudes are symmetrically disposed, with the figure seen from the rear to the left in one and to the right in the other, but also animated by subtle contrasts; in one, both women gaze down on the viewer, while in the other they glance upward.

Late in life Renoir remarked, "How I would like to do decoration again, like Boucher, and transform entire walls into Olympus."[4] For Renoir, Boucher stood at the pinnacle of the decorative tradition because of his skill in painting the principal motif of that

tradition, the nude female body. In these pendants, Renoir emulates the free, almost caressing brushstroke with which the eighteenth-century master represented the female body. The panels are thinly and rapidly painted, and warm pink flesh tones are touched with gray accents that echo the feigned stone surrounds. The bright green of the garlands provides the strongest color note of the pendants.

It is not surprising that in the final years of his life Renoir should evoke eighteenth-century decorative forms. Beginning with the Goncourt brothers in the 1860s, French critics had undertaken a highly favorable re-evaluation of eighteenth-century decoration. Once dismissed as frivolous and insubstantial, it now was praised as a distinctive achievement, exemplary in its elegance, grace, and craftsmanship. More than that, it was recognized as a distinctively French achievement, particularly expressive of the genius of the nation. Indeed, under the impact of the contemporary *art nouveau* decorative style, the whole notion of decoration itself found renewed appreciation,[5] and the echo of this revaluation is heard in Renoir's dismissal of those who disparaged Boucher as a 'mere' decorator. "As if being a decorator made any difference!"[6] Contemporary with the vanguard cubism of Braque and Picasso, works such as *Caryatids* declare Renoir's long allegiance to the great French tradition of decorative nudity, and at the same time carry the aged artist back to the themes and motifs of his apprenticeship a half-century before.

<div align="right">C R</div>

Bathers (Les baigneuses)

c. 1918
Oil on canvas
26½ x 32″ (80 x 65 cm)
Inv. no. 709

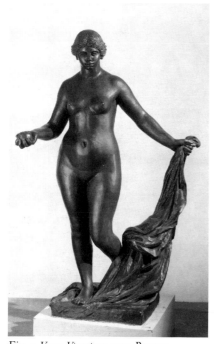

Fig. 1. *Venus Victorious*, 1914. Bronze,
71½ x 44 x 30½″ (181.6 x 111.8 x 77.5 cm).
Tate Gallery, London.

As early as 1867, with *Diana the Huntress* (National Gallery of Art, Washington), Renoir proclaimed the female nude as a dominant theme in his art. Henceforth, it would be the subject of many of his most ambitious public paintings. Even at the height of his impressionist phase during the 1870s, he returned repeatedly to the motif, as in *Study, Torso, effect of sunlight*, c. 1876 (see page 46). In the mid-1880s, seeking to find a way beyond impressionism and to ally his art with the French classical tradition of Poussin, Girardon, Boucher, and Ingres, he undertook *The Great Bathers* (Philadelphia Museum of Art; see page 162), a large-scale, multi-figure decorative composition of female nudes.

"New things weary me," the artist told Vollard.[1] Much of his late painting constitutes a re-evaluation of the central themes and motifs around which he had built his art. Living increasingly in the south of France from 1908 on, he sought to evoke the timeless realm of the ancient Mediterranean world. It was here that he painted such overtly classicizing subjects as the *Judgment of Paris* canvases. Near the end of his life, crippled, confined to a wheelchair, and with paint brushes strapped to arthritic hands, the artist turned to the motif once again. He created a group of nude bather compositions, including the Barnes painting, that constitute an evocative, if troubling, coda to his lifelong investigation of the theme.

Five female figures, clothed and naked, inhabit a verdant landscape. They do not communicate with one another; each is absorbed in the pleasure of her body and its intimate proximity to cool, refreshing nature. The pose of the prominent figure who stands at left with a white cloth clutched in her hand had been anticipated in the *Judgment of Paris* of c. 1913–1914 (Hiroshima Museum of Art) and given monumental sculptural form in the bronze *Venus Victorious* (fig. 1) that Renoir and Richard Guino had created in 1914. Similarly, the seated, clothed woman at right recalls the figure of Paris in a 1908 *Judgment of Paris* (Private collection, Japan) for which Gabrielle Renard had posed. The figure at upper right, whose raised right arm precisely aligns with the edge of the canvas, recalls the nude figures seen from the rear that Renoir had sketched and painted since the 1880s. Grasping foliage in both hands, she is a kind of Daphne, leafy metamorphosis underway. Without depicting a specific classical subject, Renoir evoked the imagery of the classical world.

This painting, like many late bather compositions, is a remarkable improvisation. In countless paintings and drawings over the years, the artist had generated an extensive repertory of nude female figures and poses. As early as 1897, in his *Bathers in the Forest* (fig. 2), the artist painstakingly assembled into a new configuration several individual bather figures developed over the previous decade, many in preparation for painting the Philadelphia *Great Bathers*.[2] In the final decade of his life, however, the sense of artistic struggle so tangible in both Philadelphia and Merion paintings disappeared from Renoir's bathers.

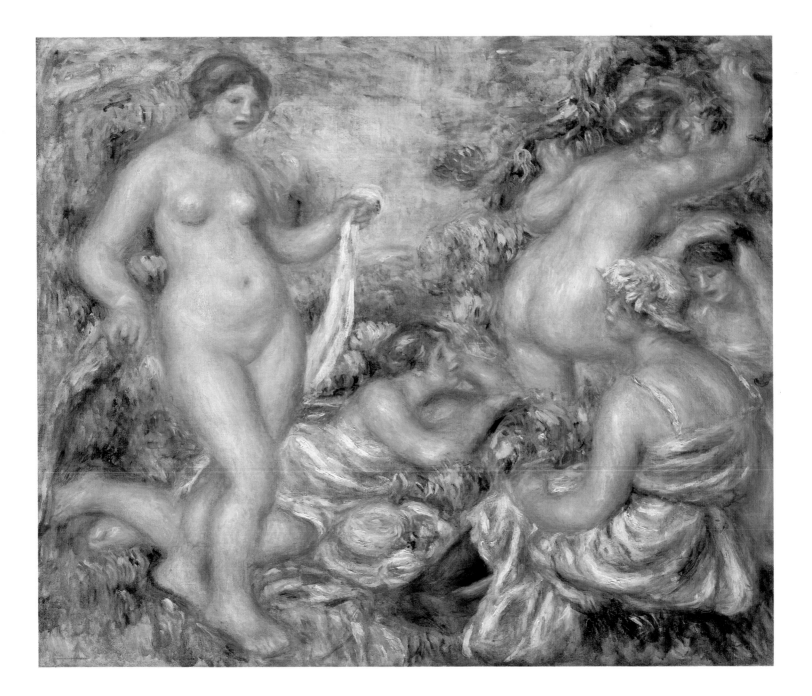

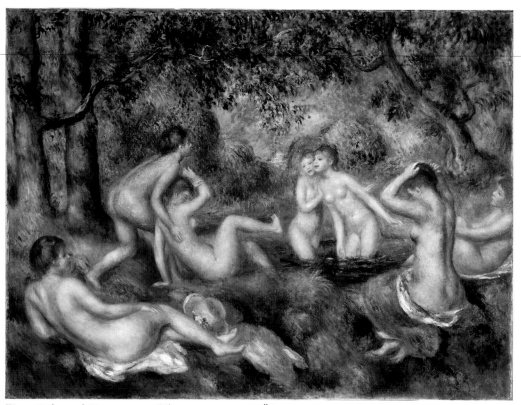

Fig. 2. *Bathers in the Forest*, c. 1897. Oil on canvas, 29 x 39¼" (73.7 x 99.7 cm). The Barnes Foundation, inv. no. 901.

Now, it seems, he was able to summon that repertory of figures and poses to mind at will. In a manner reminiscent of Antoine Watteau's processes of pictorial composition, he grouped bather figures in pleasing and seemingly spontaneous new combinations. Informed by his vast experience of hand and eye, Renoir painted fluidly, quickly, and without hesitation.

The picture is far more than a random accumulation of unrelated figures. Renoir explored several aspects of the voluptuous female body, from front and back and side, in repose and at moments of bodily tension. He found elegant and telling formal rhymes among the bodies and body parts, and established undulating, interwoven rhythms across the canvas. Thin washes of tone and brilliant highlights give the painting a vibrant animation. The enormous figures, ruddy personifications of bodily vitality, are defined by eddying swirls of paint that knit them into an equally animated landscape. These women are fused with an opulent and robust nature.

In such lyrical late works the artist achieved a pantheistic intensity of vision that was new in his art. And yet it is this very equation of the feminine with the inchoate forces of nature, the insistent celebration of female passivity and unself-consciousness, that renders the works problematical. As has been demonstrated, Renoir participated here in a deeply defensive construction of femininity, likening women to nature in order to deprive them of individual awareness, at the moment when political feminism was emerging as a factor in

French public life.[3] To be sure, he had painted bathers throughout his career, and now such themes offered the artist escape from the brutal war that threatened his family. In the earlier works, however, Renoir's refusal to recognize the consciousness of his female subjects was willful and articulate. In these late bathers, painted so impetuously, his denial of individual consciousness to his subjects had become for the old man an instinctual refusal. Long slighted by connoisseurs who regarded them as 'retardataire' — though admired by and influential on such artists as Picasso and Matisse — the late bathers paintings are perhaps among the most challenging achievements of twentieth-century classicism.

Knowing the central role that bather imagery played in Renoir's art, Barnes was always anxious to acquire important bather paintings. During much of 1923 he unsuccessfully negotiated for the acquisition of *The Great Bathers*, then in the collection of Jacques-Emile Blanche.[4] It would ultimately be acquired by Barnes' rival collector, the Philadelphia painter Carroll S. Tyson, Jr. When in the same year it seemed that the French government might refuse the Renoir family's gift of the monumental, late *Bathers* (Musée d'Orsay, Paris), Barnes was quick to indicate that, if the occasion arose, he himself would happily buy the painting.[5] Barnes acquired the present *Bathers* in January 1932, for $15,000 plus $750 commission, from Maurice Renou, Paris, via La Peinture Contemporaine, Lucerne.[6]

C R

Madame Monet Embroidering (Camille au métier)

1875
Oil on canvas
25⅝ x 21⅝″ (65 x 55 cm)
Inv. no. 197

Fig. 1. Fantin-Latour, *Sisters Embroidering*, 1855. Charcoal on paper, 9¼ x 8½″ (23.4 x 21.6 cm). Musée du Louvre, Paris.

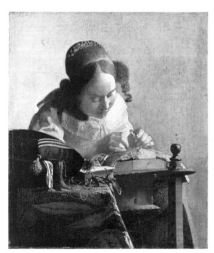

Fig. 2. Vermeer, *The Lacemaker*, 1669–70. Oil on canvas, 9½ x 8¼″ (24 x 21 cm). Musée du Louvre, Paris.

On 24 March 1875 this painting was included in an auction of work by Sisley, Renoir, Morisot, and Monet. The sale was organized by the artists themselves to stimulate interest in their work at a time when the art market was moribund. *Madame Monet Embroidering* sold for a mere 290 francs, hardly enough to cover the cost of materials and the frame.[1]

The flickering brushwork and richly varied palette of the painting appeal to the modern sensibility, but in 1875 such works were considered contemptible by many critics. When Edouard Manet asked Albert Wolff, the influential critic at *Le Figaro*, to give a favorable mention to the forthcoming auction, Wolff noted the sale in his column but also commented acerbically, "The impression which the impressionists achieve is that of a cat walking on the keyboard of a piano or of a monkey who might have got hold of a box of paints."[2]

Although no specific source or compositional precedent has been found for *Madame Monet Embroidering*, paintings of embroiderers and sewers were popular during the nineteenth century and treated by a variety of artists including Fantin-Latour, whose charcoal studies, paintings, and lithographs Monet may have known (fig. 1). He may also have been aware of Vermeer's *The Lacemaker*, acquired by the Musée du Louvre in 1870 (fig. 2). In addition, the subject very likely appealed to Monet because of its analogy to painting. Although the painting at first appears sketchy and rapidly executed, careful inspection of *Madame Monet Embroidering* reveals a composition that emphasizes pattern (for example, foliage, rug, Madame Monet's dress, and latticework) and a surface consisting of scores of carefully placed and layered brushstrokes of differing size and color.[3] Like Madame Monet's handiwork, the paint surface is complex and carefully woven, creating a particularly rich and pleasing visual experience. No doubt such paintings inspired the following passage in the brief introduction to the 1875 auction catalogue written by the critic Philippe Burty: "[These pictures] are like little fragments of the mirror of universal life, and the swift and colorful, subtle and charming things reflected in them will deserve our attention and admiration."[4]

The dress worn by Madame Monet in the Barnes picture also appears in three paintings of her by Renoir assigned variously to 1872 and c. 1874.[5] One scholar has asked whether "Camille, whom we are led to believe was extremely fashion-conscious, [would] have worn the same dress in 1875 that she was wearing in 1872." He proposes that Monet may have signed and dated the Barnes painting "after the event," and suggests, therefore, that *Madame Monet Embroidering* was done before 1875.[6] Otherwise scholars agree about the date of the Monet, which is stylistically consistent with other works of late 1874 and 1875.

C S M

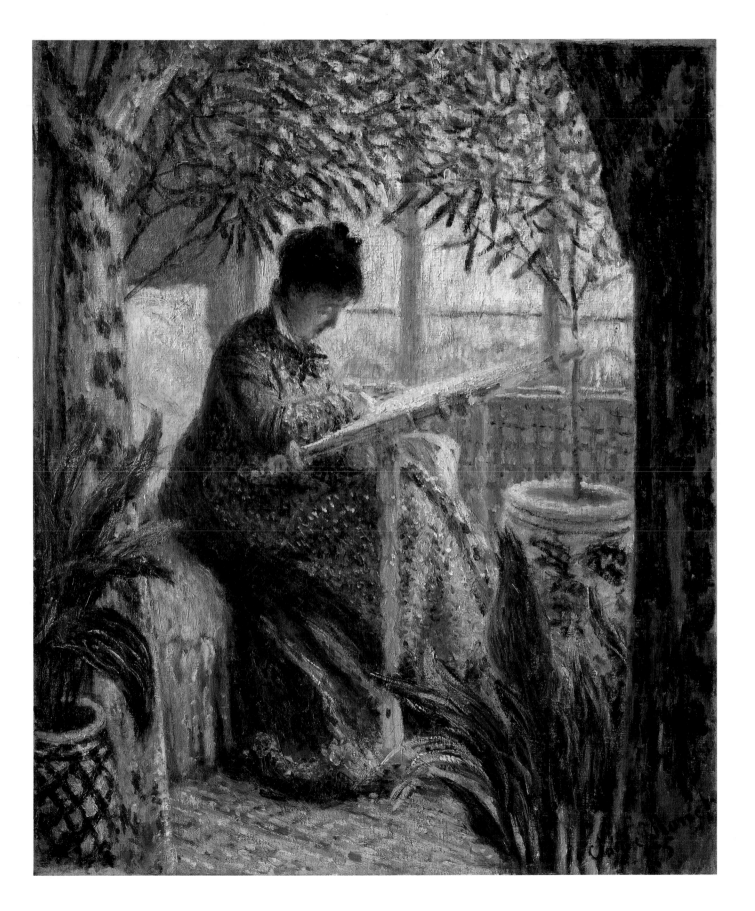

The Boat Studio (Le bateau-atelier)

1876
Oil on canvas
28⅜ x 23½″ (72 x 59.8 cm)
Inv. no. 730

Fig. 1. Daubigny, *The Floating Studio*, 1861. Etching (first state), plate size 5⅛ x 7″ (13.1 x 17.8 cm). The George A. Lucas Collection of The Maryland Institute, College of Art, on indefinite loan to The Baltimore Museum of Art.

Between 1871 and 1878, Claude Monet lived in Argenteuil, a town on the Seine about fifteen minutes by train from Paris.[1] In 1873 the artist had a small boat studio made, so that he might paint from the water. It was probably inspired by a similar floating atelier that Charles François Daubigny, whom Monet knew, had launched in 1857 in order to paint riverscapes along the Oise and the Seine (fig. 1). In an article published in January 1927, the critic François Thiebault-Sisson recounted Monet's memories of his early days in Argenteuil and the purchase of the studio boat: "'It [was] in [the] studio [at the house in Argenteuil], from which I could see everything that passed along the Seine at a distance of 40 or 50 paces, that I produced my first nautical scenes of Argenteuil, until the day when a lucrative sale filled my pocket with enough money to buy myself a barge and have it outfitted with a cabin made of boards. There was just enough room to set up my easel. What delightful hours I spent with Manet on that little boat! He painted my portrait there. I painted one of his wife and one of him there. Those lovely moments, with all their illusions, their enthusiasm and their fervor, should never have ended.'"[2]

Manet painted Monet and Camille aboard the floating studio in 1874 (fig. 2). Monet himself depicted the floating studio in 1874 (fig. 3) and again in the Barnes picture in 1876. It also appears incidentally in other riverscapes by Monet, but in the works in Otterlo and

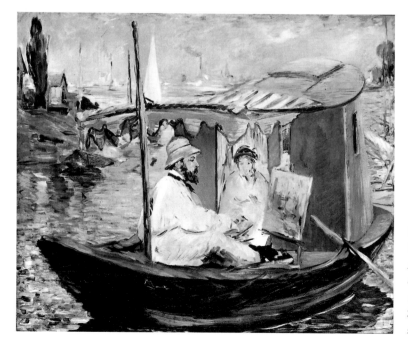

Fig. 2. Manet, *Monet Working on His Boat in Argenteuil*, 1874. Oil on canvas, 32½ x 39½″ (82.5 x 100.5 cm). Bayerische Staatsgemälde-sammlungen, Munich.

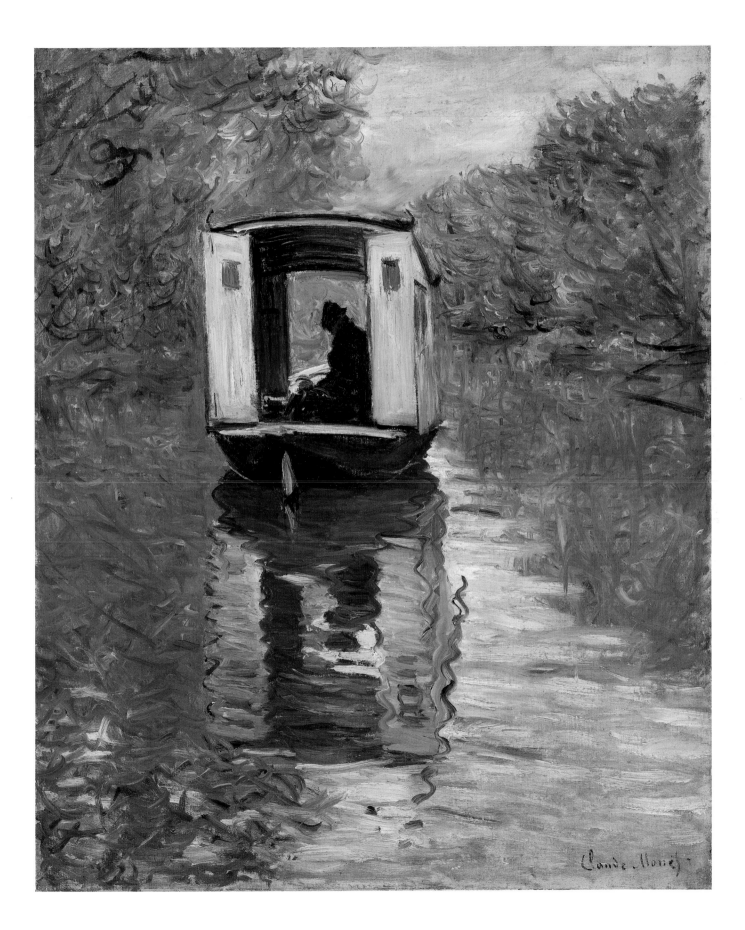

Merion the bateau-atelier itself is the focus of the artist's attention. Moreover, each work is further distinguished by the presence of the artist, who has depicted himself at work inside the makeshift cabin.

The canvas in Otterlo includes a view of the banks of the Seine at Argenteuil, but Monet painted the Barnes picture farther downstream along a narrow branch of the river between the island of Marante and the town of Colombes.³ The paint handling of the first work is loose but stylistically more characteristic of the so-called high or classic phase of impressionism in the mid–1870s. The brushstrokes are shorter and tighter, and Monet seems to have been more concerned with rendering an accurate record of the effects of color and light. In contrast, the brushstrokes of the painting in the Barnes Foundation are bolder, more deliberate, and more patently abstract; the palette is limited to a narrower range of broken blues, greens, reds, and lavenders. The resulting effect is distinctly tonal: quasi-Whistlerian, richer, and more evocative.

Even the self-portrait of the artist at work inside the cabin is more pronounced. In the earlier picture the image of the artist is ambiguous and barely perceptible, but in the Barnes picture Monet's silhouette is clearly defined against the backlight. Although the self-portrait in the Barnes composition is more prominent, both are very important and are by no means negligible details.⁴ Monet's presence in these pictures contradicts, or at least

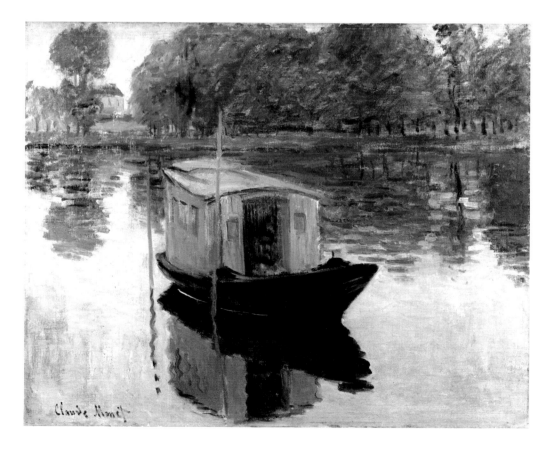

Fig. 3. *The Floating Studio*, 1874. Oil on canvas, 19¹¹/₁₆ x 25³/₁₆″ (50 x 64 cm). Collection: Rijksmuseum Kröller-Müller, Otterlo, The Netherlands.

Fig. 4. *Morning on the Seine, near Giverny,* 1897. Oil on canvas, 32 x 36½" (81.3 x 92.7 cm). Museum of Fine Arts, Boston; Gift of Mrs. W. Scott Fitz.

mitigates, the artist's reputation as a painter who worked in the open air (*en plein air*) directly from the subject (*sur le motif*). Obviously he could not have observed himself at work on the boat; his self-portrait refers directly to the imaginative and creative role of the artist. To a degree, then, as a result of both the bolder style of the Barnes painting and the more aggressively presented self-portrait, Monet asserts the fictive aspects of the painting. In doing so, he draws attention to the inadequacies of impressionism, especially its well-known emphasis on empirical effects of light and color. It appears that as early as 1876 Monet had begun to move deliberately beyond the boundaries of the movement whose name had been inspired by the title of one of his paintings only two years earlier.

Finally, the composition and stylistic interests of *The Boat Studio* in the Barnes Foundation seem to be at least indirectly related to those of one of Monet's most successful series of the 1890s, the *Mornings on the Seine* (fig. 4), also painted along a narrow passage of the Seine from a bateau-atelier, but twenty years later.

C S M

Bathers at Rest (Les baigneurs au repos)

1875–1876
Oil on canvas
32¼ x 39⅞" (82 x 101.2 cm)
Inv. no. 63
Signed, lower right, in red: *P. Cézanne*

Fig. 1. *Bathers at Rest.* Oil on canvas, 13¼ x 18⅛" (35 x 46 cm). Fondation Jean-Louis Prevost, Musées d'art et d'histoire, Geneva.

In the radical and short-lived review *L'Impressioniste*, which accompanied the four-week run of the third impressionist exhibition in 1877, the progressive critic Cordey noted of *Bathers at Rest*:

"I do not know what qualities one could add to this picture to make it more moving, more passionate, and I look in vain for the faults of which it is accused. The painter of the *Bathers at Rest* belongs to the race of giants. Since he does not lend himself to comparisons with ordinary painters, it has been found convenient to deny him altogether; nevertheless he has respected his forerunners in art, and if his contemporaries do not do him justice, future ages will rank him among his peers, beside the demigods of art."[1]

Cézanne showed sixteen works and was given his own wall in a place of honor. Clearly the committee in charge of hanging the show — Renoir, Monet, Pissarro, and Caillebotte — wished to demonstrate their profound respect and, perhaps, indicate their satisfaction that Cézanne had rejoined the movement after having dropped out of the previous year's exhibition. However, no works were sold and the show was as great a financial disaster for its participants as the previous attempts to find some means of escaping the established criteria of the official Salon. Caillebotte, the most prosperous of the group, did eventually have the foresight to purchase *Bathers at Rest* (his address, 9 rue Scribe, is inscribed on the back of the elegant Louis XV frame). Whether it was among those works — some of the monuments of impressionist painting — offered to the state by the terms of his will at Caillebotte's death in 1894 is far from clear.[2]

That the work should have caused critical distress in 1877 (or 1894 for that matter) is perhaps not so difficult to understand. Even in the context of Monet and Renoir at their most vigorous, it is an object without recognizable precedent in the history of painting. The surface retains much of the rough handling of paint which Cézanne used in the swiftly laid-on palette-knife pictures of the 1860s, but now the working of the surface has taken on a new refined intensity — layer upon layer of lean pigment is smoothed out within the outline of the figures and certain panels of color in the landscape, and built up in sculptural ridges around these flattened areas. The effect is analogous to opulently tooled Spanish leather. The use of color is no less a departure from convention, even in the highly unconventional context of the rue Peletier 1877 exhibition. The sky enveloping Mont Sainte-Victoire ranges from a muted denim to a sharp royal blue; threads of bright orange and red are set into the central figure's chest and torso; most radical (and jarring still on every encounter) is the brilliant chartreuse "shadow" that falls behind the figure in profile with his erect elbow on the far left. All the vigor, intensity, and coloristic departure from

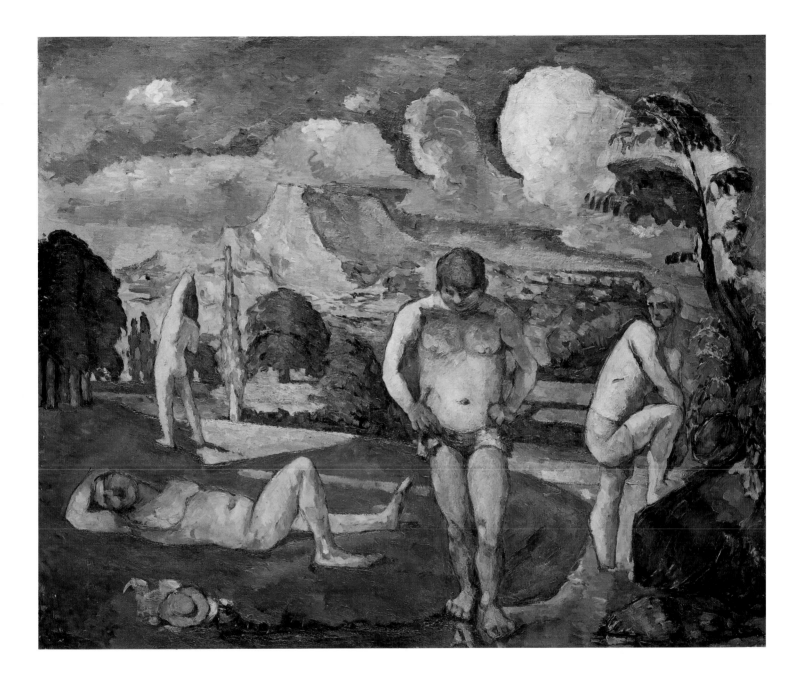

conventional observation that mark the paintings of the last decade of Cézanne's life are here and resolved, belying the note in the modest exhibition checklist that declares this as a "projected study for a picture" (*étude; projet de tableau*).³ As Cordey (but few others) realized, it was a grandly ambitious declaration and established a new plateau in Cézanne's development from which he would build for the next thirty years.

The subject — men lounging and posturing around a pond in the landscape near Aix-en-Provence — was not new in his work. It is a theme that originates in early drawings rooted in boyhood memories of long summer outings with his friends Zola and Baille up to the reservoir created by Zola's engineer father, north of the mountain. A sketchbook watercolor establishes the composition (dated by Rewald 1875–1877: Watercolors, no. 61), though with only a vague suggestion of the background figure to the right; it is developed further in a small and somewhat disturbingly hirsute oil sketch (fig. 1). Several related drawings survive that suggest that the poses of the figures derive from a combination of observed models, antique statues in the Louvre and, for the reclining figure, a painting entitled *Interior Grec* by the academician Gérôme (ironically one of the most vocal opponents to the acceptance of the Caillebotte collection). More general comparisons for the composition have been drawn to Michelangelo's *Battle of Cascina* or, still more vaguely, antique sarcophagi. It does seem likely that Cézanne would have known the large painting by his fellow impressionist Bazille, *Summer Scene: Bathers*, done in 1869 and shown in the Salon the following year (fig 2). In certain, albeit superficial ways, Cézanne's formal arrangement derives directly from this large work.

To know so much about the formal evolution of the work does little to clarify its meaning. The lyrical harkening back to boyhood serves as a point of interpretive departure, but there is little here to suggest nostalgia or distance in time. Many other ideas have been advanced, ranging from an absorption with the eternal values of antique relief sculpture to

Fig. 2. Bazille, *Summer Scene: Bathers*, 1869.
Oil on canvas, 61¼ x 62½″ (158.2 x 158.8 cm).
Fogg Art Museum, Harvard University,
Cambridge; Gift of Mr. and Mrs. F.
Meynier de Salinelle.

Fig. 3. *The Bather*, c. 1885. Oil on canvas,
50 x 38⅛″ (127 x 96.8 cm). Collection, The
Museum of Modern Art, New York.
Lillie P. Bliss Collection.

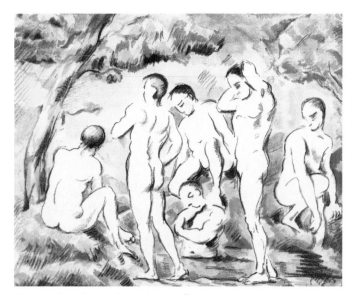

Fig. 4. *Male Bathers*. Oil on canvas, 11½ x 15½″ (29.2 x 39.4 cm). The Barnes Foundation, inv. no. 101.

Fig. 5. *Male Bathers*. Lithograph, 9 x 11″ (22.9 x 27.9 cm). The Barnes Foundation, inv. no. 699.

an unselfconscious revelation of latent homoeroticism. None has proven particularly revealing in face of the picture's great magnitude. It is an aggressively rendered object of profound gravity. Cézanne would return to the central figure ten years later (fig. 3). By then calmness and a deliberateness of execution that can truly be called classical have taken over. In turn, Cézanne would in the 1880s and early 1890s return to multi-figure male bathers as a theme; one of the most pastoral is also in the Barnes collection (fig. 4). However, he would never again take up the theme with this same aggressive and prolonged determination.

The importance of this image for Cézanne is underscored by the color lithograph (fig. 5) that he made in 1896 (perhaps in some yet-undiscovered connection with the Caillebotte bequest scandal) on the encouragement of the art dealer Ambroise Vollard, who had just given him, in 1895, the only other major Paris showing he would have in his lifetime after the third impressionist exhibition in 1877. By now, at least within the complex and limiting methods of lithography, the heat of the painting is diffused, colors have blended and simplified, the chartreuse triangle is gone entirely. Happily, a version of the print seems to have been the first work by Cézanne purchased by Albert Barnes, bought for him from Vollard in 1912 by the painter Glackens.

J J R

Leda and the Swan (*Léda au cygne*)

c. 1880–1882
Oil on canvas
23½ x 29½″ (59.8 x 75 cm)
Inv. no. 68

Fig. 1. *Olympia*, c.1877. Graphite on watercolor paper, 9¼ x 11¼″ (24.7 x 28.6 cm). Philadelphia Museum of Art, Mr. and Mrs. Carroll S. Tyson, Jr., Collection.

Fig. 2. G. Marconi, *Leda and the Swan*, c. 1875. Albumen silverpoint from glass negative, 10⅛ x 6⅛″ (26.4 x 15.6 cm). Philadelphia Museum of Art, Anonymous gift.

Luxe, calme et volupté: Baudelaire's summation of a state of erotic languor rests at the core of much French painting from Delacroix to Matisse. The young Manet, in his *Olympia* of 1863, brought the notion to a new level of public intensity. That idea held Cézanne's attention throughout the 1870s and early 1880s in various watercolors and small paintings. Yet in these he employed a quality of irony, a wry if sympathetic humor, which sets his images well apart from the grand tradition of Titian, Goya, and Manet and the reclining nude (fig. 1), placing them in a sub-genre of erotic narratives.

The Barnes *Leda and the Swan* is Cézanne's largest and most ambitious picture on the theme. More than any other, it conveys a sense of detachment: a voluptuous nude, propped up on a plush chaise-longue, receives with thinly disguised indifference the attentions of her suitor, in this case Zeus in the form of a swan. Cézanne knew his classics well; a worn copy of Ovid's *Metamorphoses*, from which this subject derives, was in his library. He was certainly aware, particularly given his love of Boucher, of the theme's history in French painting; he also must have known that the theme often served as a happy vehicle for popular erotica (fig. 2).

Yet if it is an image of considerable levity and boudoir ease, it is one to which he gave his full attention. The paint is quickly and decisively laid on in directional strokes that resemble the "constructivist" canvases of the 1880s; a separation of colors gives the surface a very consistent animation. Two drawings relate to the image; in one the woman lifts a champagne flute (fig. 3), while in the other the swan is introduced in the same area. The figure seems first to appear in a small, early painting[1] in which the woman gazes at herself in a mirror; in a much closer work, the swan is obliterated by a still life of pears and a napkin on a table that is read upside-down from the nude, obviously put on at some point when Cézanne abandoned the first image.[2]

Ambroise Vollard claims that Cézanne was inspired, in this theme, by Courbet's *Woman with a Parrot* (now in the Metropolitan Museum of Art, Havemeyer Collection) but *Olympia* would seem the better candidate as a general basis of departure, if only from the actual arrangement of the figure. Vollard also notes, and in this he has been followed by others, that Cézanne was working from some graphic source, perhaps a popular print or photograph yet undiscovered. The Barnes painting has been dated as early as 1868 and as late as 1886–1890. The former seems impossible just because of the brightness of the palette here and the complete absence of charged sexuality that marks the early nudes; the later date doesn't align with the brisk, unblended application of paint and the essential bluntness of the image. Perhaps it was executed early in the 1880s, the closest comparison being the Getty Museum's *Eternal Feminine*.

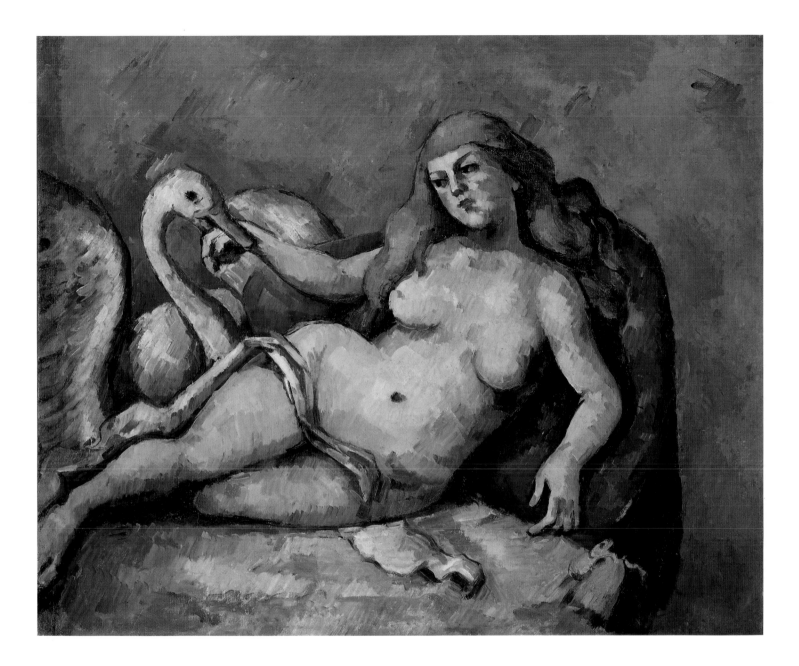

Fig. 3. *Reclining Female Nude* from *Sketchbook I*, page 6 recto, 1882–1890. Graphite, pencil, traces of oil paint, numbered: 6 erased. Philadelphia Museum of Art, Gift of Mr. and Mrs. Walter H. Annenberg.

Attempts to find a reference to Zola's Nana also fall short. This enchanting cocotte first appears in the end of the novel *L'Assommoir* in 1876 and is developed fully in her own novel published in 1879, just when Cézanne was visiting his old friend in Medan. Nana was, as here, blond, voluptuous, and knowing, but the type was already firmly established in literature, art, and popular handouts. It seems more likely that *Leda*, while of the same sisterhood, is drawn on a more general type whose interest for Cézanne was somewhere between true attraction and humorous distance.

JJR

Gardanne

1885–1886
Oil on canvas
25⅝ x 39⅜″ (65 x 100 cm)
Inv. no. 92

Fig. 1. *The Village of Gardanne*, 1885–86. Oil on canvas, 36¼ x 29⅜″ (92.1 x 74.6 cm). The Brooklyn Museum, Ella C. Woodward and A.T. White Memorial Funds.

Fig. 2. *View of Gardanne*, 1885–86. Pencil on paper, 8½ x 12¼, irregular (21.6 x 31.1 cm). Collection, The Museum of Modern Art, New York. Lillie P. Bliss Collection.

The hill town of Gardanne, located seventeen kilometers southwest of Aix-en-Provence, is now an important industrial center for bauxite and cement production; in antiquity its elevation on the plain of the long south slope of Mont Sainte-Victoire made it a critical guard point on the road to Marseilles. Cézanne lived there with Hortense Fiquet and their son from the summer of 1885 until some point after his marriage to Hortense in April 1886. The red-tiled houses compressed against the hill topped by the distinctive bell tower appealed to him in a variety of ways. Two vertical oil paintings emphasize (and to some degree exaggerate) the steep rise of overlapping architecture ascending the height.[1] For the Barnes canvas Cézanne placed his easel outside the perimeter of the village, some forty-five degrees to the right of the vantage point of a picture now in Brooklyn (fig. 1). This position allowed him a panoramic view of the town and the buildings lining the street at the foot of the slope. He created a picture of measured and deliberate evenness that both recalls the broad views of Pontoise, done under the stabilizing influence of Pissarro earlier in the decade, and relates immediately to the grand horizontal vistas of the bay of Marseilles seen from L'Estaque and the view of Mont Sainte-Victoire from the Arc valley, executed in the second half of the 1880s. There is a similar quality of containment here that is profoundly satisfying and resolved.

The five trees just to the left of center withdraw with a geometric precision within the stepped recession of the houses behind, but, of course, they don't completely, since the clump of trees on the right (evenly balanced in intensity to the green of the isolated trees) keeps them in mutual reference to the picture plane. Above the isolated trees the step-back of rooftops is suggested by the most discreet modulations of color (no lines separating one from another). The bold declaration of the three-dimensionality of the two angled houses on the far right makes comprehensible the more complex dimensions of the structures grouped below the tower. Cézanne's formal language is so deliberately active here that the viewer is in danger of losing sight of how completely the artist conveys the absolute sense of his own position in the landscape and the place itself, witnessed in full sunlight with all its color brought to full value. The roughly sketched-in, dull sky allows no release into atmospheric space; only the two circular watch towers just over the crest of the hill on the far right permit some reference to things beyond.

A drawing now in New York (fig. 2) gives a rare insight into the evolution of Cézanne's painting. As Adrien Chappuis soberly observed, it is a "preliminary sketch in which the artist studied and resolved the construction and general rhythm of his oil painting."[2] Within the relatively restricted means of a soft pencil Cézanne established all the essential compositional and spatial dynamics that he would take on in the painting.

JJR

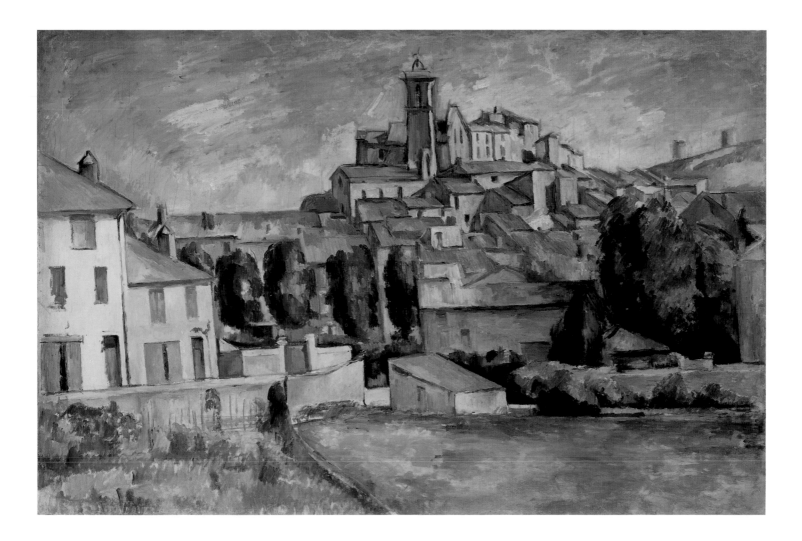

Madame Cézanne

1885–1887
Oil on canvas
36½" x 28¾" (92.6 x 72.9 cm)
Inv. no. 118

Fig. 1. *Portrait of Mme. Cézanne.* Oil on canvas, 31⅞" x 24" (81 x 61 cm). Musée de l'Orangerie, Paris; Guillaume-Walter Collection.

Little is known of the life of Hortense Fiquet, though her oval face became one of the most repeated images in Cézanne's works, appearing in some forty-four paintings and numerous drawings (see *Woman in a Green Hat*, page 141). A tall, handsome brunette with large, black eyes and a sallow complexion, she first met Cézanne in 1869 in Paris when she was nineteen and an artist's model. Cézanne must have felt deeply drawn to her even though he was desperately shy of women. It was perhaps her seemingly docile and calm temperament that encouraged him, for she became his mistress that same year. Their only child, Paul, was born in 1872; thereafter their liaison disintegrated, even though Cézanne adored his son, who would later become his primary confidant and advisor. The couple would live apart for periods both before and after their marriage in 1886, though at least two journeys they took together are recorded. Their relationship, despite attempts to make it seem particularly unsettled, was not so very different from the nineteenth-century norm. Hortense posed for Cézanne with great patience and loyalty; portraits of her have speculatively been dated in clusters from 1872–1877, 1885–1887, and 1890–1894.

Here Madame Cézanne is shown in three-quarter length, seated in an unseen chair in a simple room. The only architectural ornament is the painted wainscoting that declines gradually to the right. She wears a high-collared blouse over which she has gathered a blue shawl, roughly sketched by Cézanne in black and purple to give a particularly rich effect. She is turned nearly full-face, her long, elegant hands crossed with great composure on her lap. Her gaze is directed just to the right of the painter's easel; her mouth is slightly drawn-in (the drawing blurs at this point) at its right corner, suggesting a mood of vague melancholy. The squareness of her pose and upright posture give her an air of great dignity and presence. This is heightened by the loose workings of lavenders and blues of the wall behind her head, creating a luminous aura around her figure.

This work compares most closely with another portrait of Madame Cézanne in a similar pose, though with a chairback and arm in evidence without any markings on the wall, which was part of Paul Guillaume's collection (fig. 1). This canvas is executed in the same relatively free manner, with passages of the white ground left exposed, giving a quality of transparency similar to the Barnes picture. In the Paris painting, partly because her head is turned to expose her left ear in profile, she seems more immediately alert and assertive, her pursed mouth and the set of her jaw illustrating the quality of independence and passive willfulness said to have marred her relationship with Cézanne. By contrast, the Barnes picture, while equally knowing of its subject, seems to be both more elevated as a characterization and more revealing of a formal respect drawn from profound knowledge.

JJR

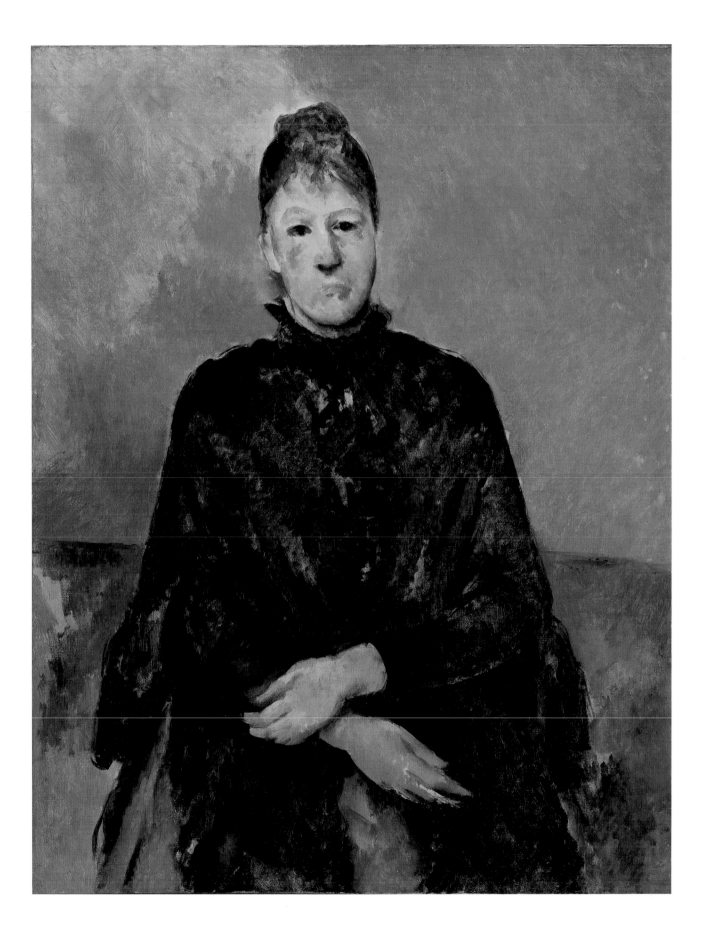

Boy in a Red Vest (*Garçon au gilet rouge*)

1888–1890
Oil on canvas
25⅞ x 21½" (65.7 x 54.7 cm)
Inv. no. 119

Between 1888 and 1890 Cézanne lived in an apartment in Paris on the Ile Saint-Louis: 15 quai d'Anjou. As John Rewald has observed, several pictures and watercolors can be dated to that time by the recurrence of a distinctive red band that appears in the background of his figure studies above the white wainscoting.[1] Three of these images depict an Italian youth with long chestnut hair traditionally identified as a professional model: Michelangelo di Rosa.[2] The same boy appears in another oil and two watercolors (figs. 1, 2, 3). It was only with the death of Cézanne's father in 1886, when the artist came into his inheritance, that he could comfortably afford to pay models for any period of time. This opportunity allowed him to concentrate on one figure in different poses and slightly different settings in a way that had earlier been possible only in paintings of long-suffering members of his family and friends who acted as his sitters.

Perhaps because of this (although Madame Cézanne and his son, Paul, continued to model for him), his figure paintings after 1886 took on a degree of concentration and complexity, a formal and psychological depth of penetration, resulting in some of the greatest achievements of his career. The critic Gustave Geffroy noted, when he saw the version of the *Red Vest* now in Washington at Vollard's exhibition in 1895, that it could "stand in comparison with the most beautiful figures in painting."[3]

In all four paintings di Rosa is dressed in identical costume: white shirt with a soft winged collar open at the throat, a loosely tied blue cravat, brown trousers and, most notably, a rather theatrical, broad-lapeled, red waistcoat. In all, the boy is introspective, with a downward turn to his mouth that has suggested to many a certain melancholic reverie. However, in the other three he is cast into poses with some distant historical reference: the contrived elegance of Bronzino and Tuscan mannerism in Washington; the pensive aloofness of a Michelangelo sibyl in Zurich; the strict handsomeness of a fifteenth-century Renaissance profile portrait in New York. These references, which lend him a certain elevation and stature — Geffroy's "beauty" in comparative terms — are absent from the Barnes picture.

Not unlike some of the portraits of Madame Cézanne from about this time, there is in the Barnes version of the *Red Vest* a slight downward point of view and a weighted neutrality that belie any broader reference and place this figure in a quite different expressive realm from the others. The boy's slight frame, sloping shoulders, leftward-cast eye, and lank hair pulled behind his large, adolescent ears are witnessed with attention and refinement. This could suggest, on the part of Cézanne, affection and tenderness. Yet the Barnes painting is neither a portrait nor an object in a still life, as has sometimes blithely been observed of Cézanne's most concentrated figure studies. Fleeting emotions, should he be

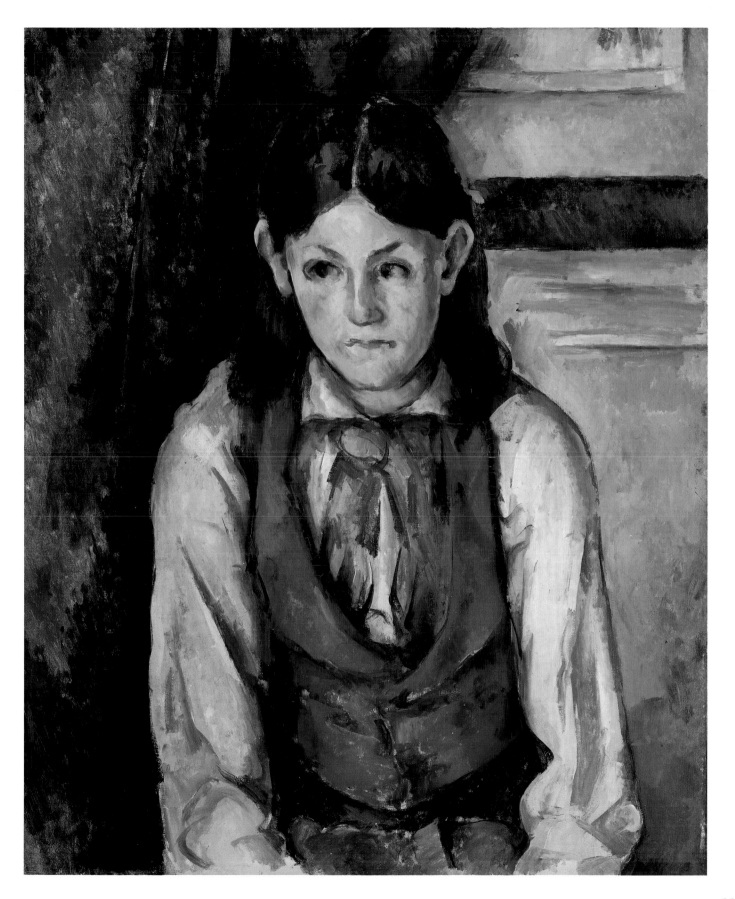

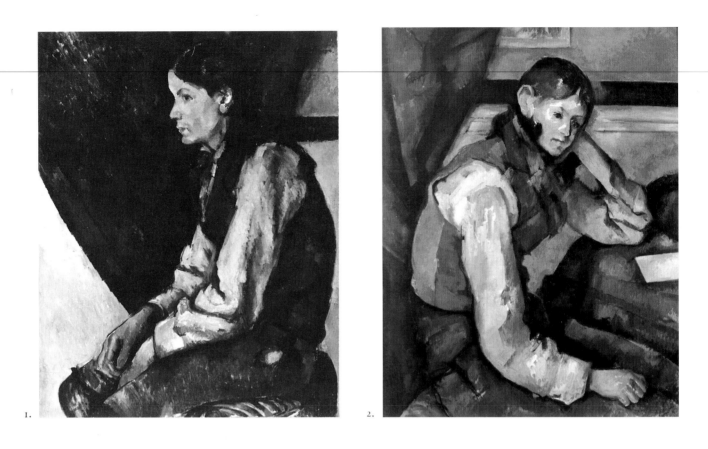

1.

2.

Fig. 1. *Boy in a Red Vest*, 1888–90. Oil on
canvas, 32 x 25⅝″ (81.3 x 65.1 cm). Private
collection.

Fig. 2. *Boy in a Red Vest*, 1888–90. Water-
color, 31½ x 25⅝″ (80 x 64.5 cm). Foundation
E. G. Bührle Collection, Zurich.

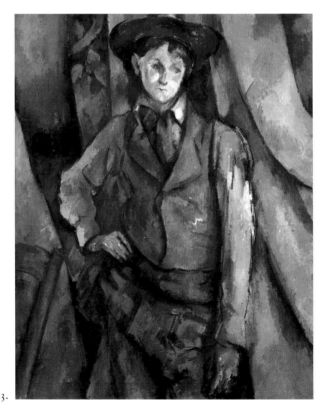

Fig. 3. *Boy in a Red Waistcoat*, 1888–90.
Watercolor, 35¼ x 28½″ (88.1 x 72.3 cm).
National Gallery of Art, Washington;
Promised Gift of Mr. and Mrs. Paul
Mellon.

3.

capable of them, or psychological animation are submerged in a bluntly plain and hauntingly irrefutable image.

The repetition of the red waistcoat and the pleasure Cézanne took in it, playing it against the green shadows in the white shirt, the blue, lavender, and green of the wall beyond and the deep scarlet and purples of the drape — keying his picture to one colorist prop — are not unusual for Cézanne at this date. Four paintings of his son Paul dressed in a brilliant red harlequin costume date from the same period. Yet in the four paintings of di Rosa, in which Cézanne manipulates his motif within a series of different poses and settings, he establishes a range and dimension unprecedented for him.

<div align="right">J J R</div>

Potted Plants (*Pots en terre cuite, et fleurs*)

1888–1890
Oil on canvas
36¼ x 28¾″ (92 x 73 cm)
Inv. no. 116

Fig. 1. *Still Life with Petunias*, c.1885. Oil on canvas, 18⅛ x 21⅞″ (46 x 55.6 cm). Private collection, Switzerland.

In contrast to the justly celebrated still lifes of fruit and household objects that stand among Cézanne's most complex and heroic achievements (see *Compotier, Pitcher, and Fruit*, page 135), flower paintings play a distinct and quite different role in his work. While no less carefully staged, the flower paintings often retain, well into the 1890s, an ease and spontaneity that link them to this popular sub-genre done by his impressionist colleagues in the 1870s. As will sometimes happen in portraits of his wife and son, or in certain forest landscapes where the trees themselves become the dominant element, it is as if Cézanne to a degree has let down his guard. Lyrical movement is placed in balance with monumental stability; the grace of living things comes into complete harmony with their absolute nature. It is a quality more often found in his watercolors. The Barnes *Potted Plants* is perhaps his single most lyrical painting in this mode.

Four terra-cotta pots of markedly different sizes are crammed onto a narrow shelf. As John Rewald has noted, the site is probably the greenhouse situated near the pool behind Cézanne's father's house, the Jas de Bouffan, on the outskirts of Aix-en-Provence.[1] It is, in all likelihood, the place where he painted his wife a year or two later (now in The Metropolitan Museum of Art, New York). A similar close-in view of potted plants (in this case petunias [fig. 1]) was probably done in the same space.

A more panoramic alignment of pots appears in a watercolor in Paris (*Les pots de fleur*, c. 1885, Cabinet des Dessins, Musée du Louvre). In the earlier still life it seems as if Cézanne has done little to adjust the objects in making the picture. However, in the Barnes work a straw-bound rum bottle has been pushed into the middle ground next to a small white pitcher. An empty blue vessel sits on a rounded marble (?) slab that projects over the shelf on the far left. Most telling for Cézanne's strategic arrangement of his motif, a red patterned cloth has been placed between two pots and under the pitcher, falling to the edge of the canvas. From this dense arrangement of objects in the lower third of the picture emerge the tangled stems of the geraniums; the flower of one just touches the top of the canvas. The three-dimensional effect of the shadow under the shelf is minimized by its loosely painted transparency. None of the pots is drawn in a fully volumetric way; the back lip of the one set further back dissolves altogether. Only the sharply declining line of the projecting slab introduces spatial perspective and this is counteracted by the cutting in half of the pot on the left by the edge of the canvas. The drawn extension of the plants through the upper two-thirds of the canvas places the picture plane in shallow relief. It is a remarkably lean and elegant composition.

The colors are subdued and applied in thin, subtly modulated washes. Bare canvas is often left exposed, allowing the white ground beneath to serve as highlights. Nearly all the

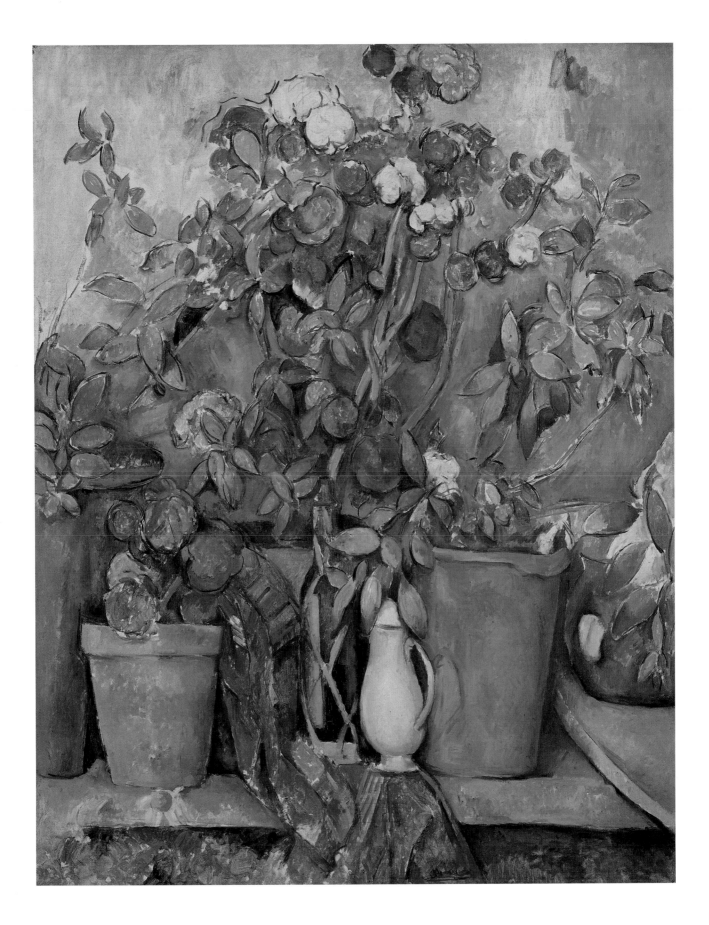

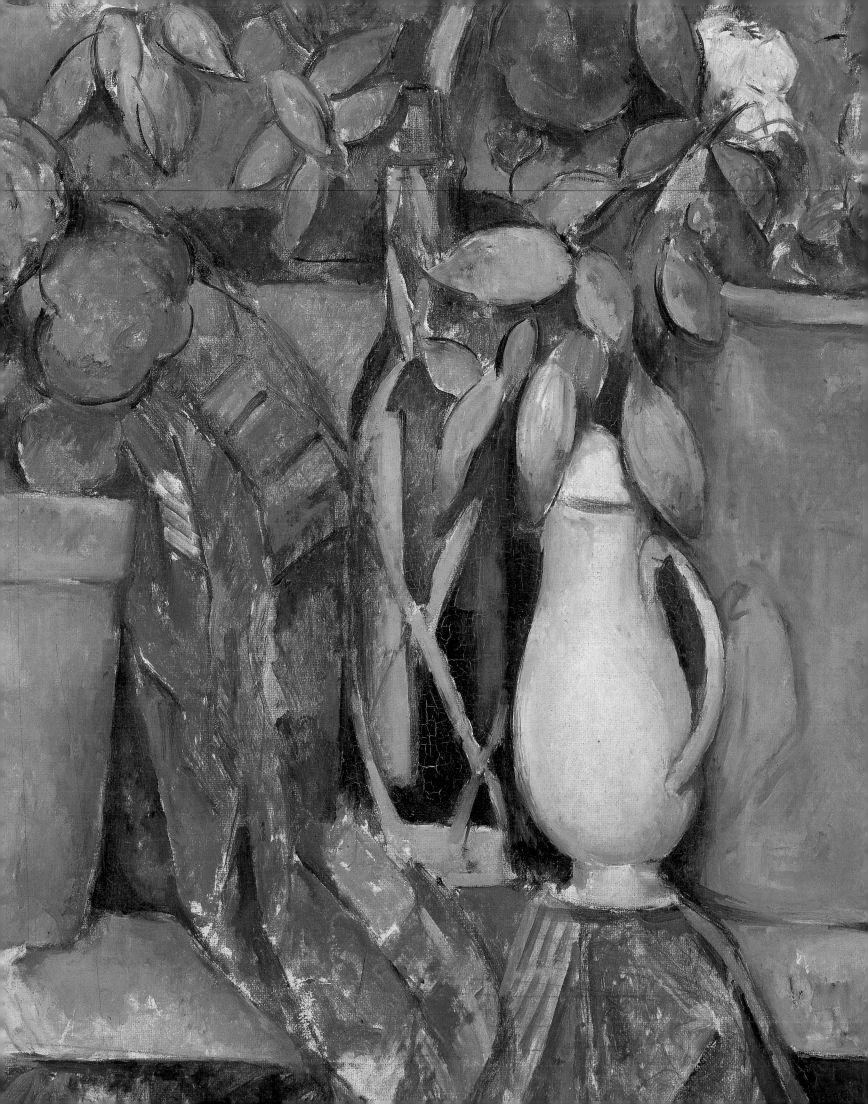

shapes are established by thin blue/black lines drawn with the brush, either to set up the forms initially, before the addition of color, or applied on top, to sharpen certain outlines or to turn and link shapes within the low relief of the space. The overall quality is one of silvery paleness; objects are seen in a limpid, watery light. This, plus the leggy, undernourished look of the plants, suggests that it is a winter's day.

There is in each work by Cézanne an inexplicable equilibrium between the things presented and their effect. As his first biographer, Joachim Gasquet, made emphatically clear, he was already true to his motif, looking hard and inventing nothing. The mystery is always how the two activities, seeing and painting, can become so inextricably one.

J J R

The Card Players (*Les joueurs de cartes*)

1890–1892
Oil on canvas
52¾ x 71½" (134 x 181.5 cm)
Inv. no. 141

In March 1891, Paul Alexis wrote from his native Aix-en-Provence to Emile Zola that Cézanne was "painting at the Jas de Bouffan, where a worker serves him as a model."[1] This is the one piece of contemporary documentation that establishes Cézanne's use, as subjects, of farm hands from his father's place on the outskirts of Aix. The reference could apply to several of Cézanne's paintings of individual men in rustic dress and demeanor who stolidly posed for him. The simple interiors have been taken to be either the kitchen of the Jas de Bouffan or some space within the surrounding farm buildings (figs. 1 and 2). Cézanne had known these men all his life and had for them a clear sympathy, admiring their "simplicity and natural dignity."[2] At least since Georges Rivière in 1923 it has been understood that the same men appear here, playing at a game of cards, and in four other closely related paintings from the first half of the 1890s, which Lionello Venturi has justly declared to be a series of masterpieces.[3]

The Barnes picture is the largest of the series and by far the most heroic. It is, in terms of scale, among the most ambitious undertakings of his entire career, second only to the three versions of female bathers that he would do near the end of his life (see *Nudes in Landscape*, page 161). Its evolution in comparison to the other paintings and several related

Fig. 1. *The Drinker*. Oil on canvas, 18 x 14¾" (45.7 x 37.5 cm). The Barnes Foundation, inv. no. 189.

Fig. 2. *Man in a Room*. Oil on canvas, 31½ x 22½" (80 x 57.2 cm). The Barnes Foundation, inv. no. 209.

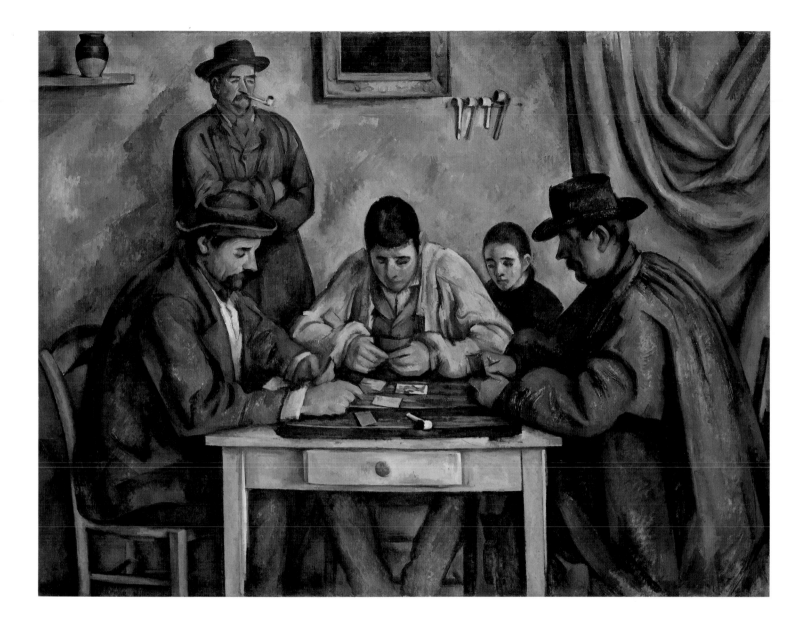

watercolors and drawings can to some degree be established,[4] but as is so often the case with Cézanne, the exact relationship of study to finished work, individual figures to multiple composition, does not follow any conventional pattern. It has long been assumed that the two most complex paintings, the Barnes' and another, half the size, of four figures (fig. 3), precede the three two-player pictures (fig. 4), and that the chronological development is one of concentrated simplification and distillation. It also seems certain that at no point did Cézanne pose all of his figures in one setting, but worked instead from individual studies that were then incorporated into the more complicated composition. Through Cézanne's son, the names of some of the models have been suggested: Père Alexandre (perhaps the standing figure smoking a pipe here); a gardener, Paulin Paulet, as one of the players with his daughter, Leontine, posing for the child.[5] However, even with these identifications, there is little quality of portraiture here, as loaded with character as the figures may appear and as tempting as it is to attribute to them specific personalities.[6] Cézanne has clearly chosen these figures to serve him to some greater formal and expressive end.

The five figures pose in a shallow stage of space, its perimeters precisely established by the chair on the left (which just connects with the picture edge); the green-glazed olive jar (a sliver of wall showing just above it); the truncated, framed picture in the center (the theatrical drape resolving its gathered folds and dropping straight in parallel to the right edge of the canvas); and, most emphatically, the unadjusted perspective of the kitchen table (the vertical line of its top exactly paralleling the canvas edges, the knob of its drawer falling precisely in the right/left center of the picture). The three players are painted with great amplitude, the stern folds of their bulky clothes amplified by their broadly sloping shoulders and ham-fisted hands. The standing smoker is less fully realized in space, his blue

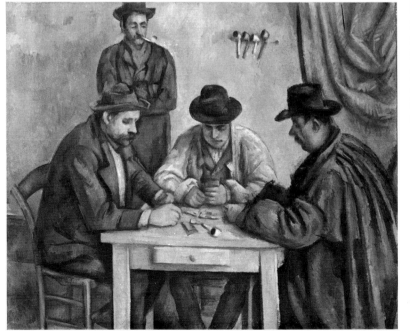

Fig. 3. *The Card Players*, 1892. Oil on canvas, 25½ x 32″ (64.8 x 81.3 cm). The Metropolitan Museum of Art, New York; Bequest of Steven C. Clark, 1960.

peasant's smock engaging more with the colors of the wall than anything else in the space except the similar garment worn by the player on the right; this blue, however, is boldly set off against the golden drape. The volumetric weight and psychological degree of participation of the passively watching figure are in pointed contrast to the simple and beautiful geometry of the child's oval face as she sits, peering over her father's (?) shoulder watching the progress of the game. The central player's "V'ed" legs, seen under the table, converge just at the bottom of the painting, anchoring him and the whole group with a particular solidity. For all its gravity, the paint is applied with a deliberate evenness, in open strokes that give the whole a textural unity rare in Cézanne's work.

A solidity and absence of exploration in this work suggest, particularly given the unprecedented number of "studies" and related works, that Cézanne came to it with an advanced sense of pre-formulation and resolve placing it last in the sequence. Such easy speculation is put to doubt, though, if the Barnes picture is compared to the smaller *Card Players* (fig. 3). The artist repeats himself nearly to the point of creating a replica, which is highly unusual for him and suggests the importance the subject held for him. The four male figures are, with minor turns of the head and adjustments of hands, nearly identical in pose and color. Even the four pipes in the rack similarly alternate white to brown. The turn of the chair, the angle of the white table, the position of the players' legs...all are markedly similar.

Yet, without proposing a chronological relationship, one can see that Cézanne has used elements in the Merion picture that set it quite apart from that in New York. The introduction of the child into this very masculine company immediately adds a new dimension, her alert innocence lifting the dour tone of this soundless adult world and suggesting

Fig. 4. *The Card Players*, c. 1890–95. Oil on canvas, 18¾ x 22½" (47.5 x 57 cm). Musée d'Orsay, Paris; Bequest of Count Isaac de Camondo, 1911.

Fig. 5. Le Nain brothers, *The Card Players*, 1635–40. Oil on canvas, 25 x 30″ (63.3 x 76 cm). Musée Granet, Aix-en-Provence; Bequest of Marquis de Perier, 1855.

a human dynamic outside the hermetically closed space in which the game takes place. Other elements — the shelf, the framed picture (unidentifiable to date) — allow Cézanne a greater manipulation across the back wall, and the space between it and the players has been opened up by the elimination of the dark hat worn by the central player in the New York version. In reverse contrast within this wonderful game of additions and subtractions, the brocaded pattern of the drape that occurs in the New York picture has been repressed here, allowing it to fold and drop with still greater weight. Most telling are the elements of the game itself, played in the Barnes canvas on some type of gaming board (backgammon?), which adds a knot of decorative and colorful concentration in the center of the composition, perhaps introduced to accommodate and stabilize the much larger scale of the picture.

The works of Cézanne have been placed into broad categories, those drawn directly from nature and others that were "souvenirs of the museums," the greatest — as here — inevitably partaking of both sources.7 Considerable effort has been spent, in discussion of the card player series, to draw attention to the art of the past as its essential point of departure. Artists as far-ranging as Giotto, El Greco, Tintoretto, Titian, Veronese, Le Nain, Chardin, Daumier, Gavarni, and Caillebotte have been cited, all with a certain validity.

The most concrete comparison can be made with a Le Nain painting of card players (or rather card sharks, since its subject is the popular seventeenth-century one of the fleecing of an innocent by cheats), which Cézanne is said to have admired in the local museum in Aix (fig. 5). Cézanne's biographer recorded that the artist stopped short at this picture, noting, "That's how I'd like to paint."[8] According to Gasquet, alas a master of embellishment though he knew Cézanne well, the artist would often choose older works by Poussin, Ingres, or Le Nain as challenges to his own ability. His love of Le Nain can be well documented and, certainly, there are many elements of Le Nain's *Card Players* that bear comparison to the Barnes picture and others in the series. Three figures are gathered around a table, cards in hand. Some of the deck has been played out; one card faces up on the table (in Cézanne's case a colorful royal card, perhaps the king of hearts). The Le Nain figures are caught at a theatrical moment, all looking up, the youthful victim only distantly aware of the dupe. (Could he be some kin in his role in this drama to the child in the Barnes picture?) In complete contrast, Cézanne's trio studiously concentrates on the game.

From this point, any pattern of derivation subsides, despite the exhaustive search for other possible visual sources. Perhaps the most important element of such comparisons is the suggestion that Cézanne's art may have had a new kinship to genre painting. By the middle of the nineteenth century the genre tradition had been essentially exhausted except by the most minor of illustrative artists, replaced by Courbet and Millet with a more vehement naturalism that dispelled any literary associations. But for Cézanne's figurative paintings, particularly those of the 1890s, no other generic term can serve (see *Woman in a Green Hat*, page 141). Though his models have been described as "Balzacian peasants" in this context, his purpose seems not to be assertively naturalistic (or social) nor, to test the historical alternative, is there any quality of allegorical moralizing. The link, historically, is most closely made to Chardin, whose still and beautiful figures are posed in interior light free of any immediate interpretive clues. Cézanne essentially reinvented genre painting, passing it on to Picasso.

J J R

Well: Millstone and Cistern under Trees
(Meule et citerne sous bois)

1892
Oil on canvas
25⅝ x 31⅞" (65 x 81 cm)
Inv. no. 174

Fig. 1. The well, photographed by John Rewald. Cézanne recorded the site in two watercolors.[2]

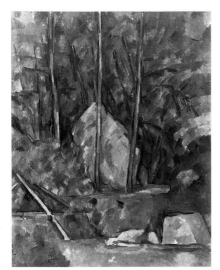

Fig. 2. *The Cistern at the Château Noir,* c. 1900. Oil on canvas, 29¼ x 24" (74.3 x 61 cm). The Art Museum, Princeton University. Lent by the Henry and Rose Pearlman Foundation.

On 27 November 1889, Cézanne wrote to Octave Maus: "I must explain that having achieved only negative results from the numerous studies to which I have devoted myself, and dreading the criticisms that are only too well justified, I have resolved to work in silence until such time as I should feel myself capable of defending theoretically the result of my experiments."[1]

Maus was the secretary of the group called Les XX, who had invited Cézanne to exhibit with them in Brussels. Despite his distant tone, Cézanne readily agreed to participate and sent three pictures the following January. However, the letter serves to demonstrate what we know, from several other sources, of Cézanne's increasing sense of isolation, reinforced by his deep, natural shyness and waves of self-doubt. Even in Paris he would avoid acquaintances on the street and attempt to regain, if only to a small degree, some of the communal spirit that had characterized the old impressionist circle. He visited Monet at Giverny that September. After a few days of seeming pleasure in the company of his friends, he left abruptly, taking slight at a presumed liberty.

Because of this desire for privacy, especially while working, Cézanne sought landscape themes that were particularly secluded. The vast, empty terrain east of Aix, going up the western slope of Mont Sainte-Victoire, which he knew intimately from childhood rambles, offered numerous places where he could work undisturbed (see *Bibémus Quarry,* page 157). He especially favored a steep ridge of rocky hills, strewn with boulders, just north of the road that runs from Aix to Le Tholonet. A crude path, cutting up from the main route, leads through the forest to the unfinished and abandoned villa, the Château Noir, which he attempted to buy in 1899 along with its surrounding land. Down from the villa, at a point where the path forks to form a small opening, an ancient cistern is crowned by a simple well head. Cézanne's loyalty to his motif is documented by a photograph taken by John Rewald some forty-five years after the painting (fig. 1). A later painting from an angle more to the right shows the three poles that leaned over the cistern to form a brace from which a bucket could be lowered to the cool water (fig. 2). The round object to the left of the well is a millstone, part (with the long quarried stones beyond) of an abandoned attempt to build an oil press near the spring (fig. 3).

It is a mysterious and magical spot, washed by radiant sunlight cutting in from the right. To judge from this painting, the site allowed the artist a mood of great ease and contemplative serenity. Consistently light brushstrokes cover the surface, moving in and through the gently drawn tree trunks and branches that form a theatrical screen, slowing any swift movement to the well, stones, and cliff beyond. Yet the bare saplings are not on one

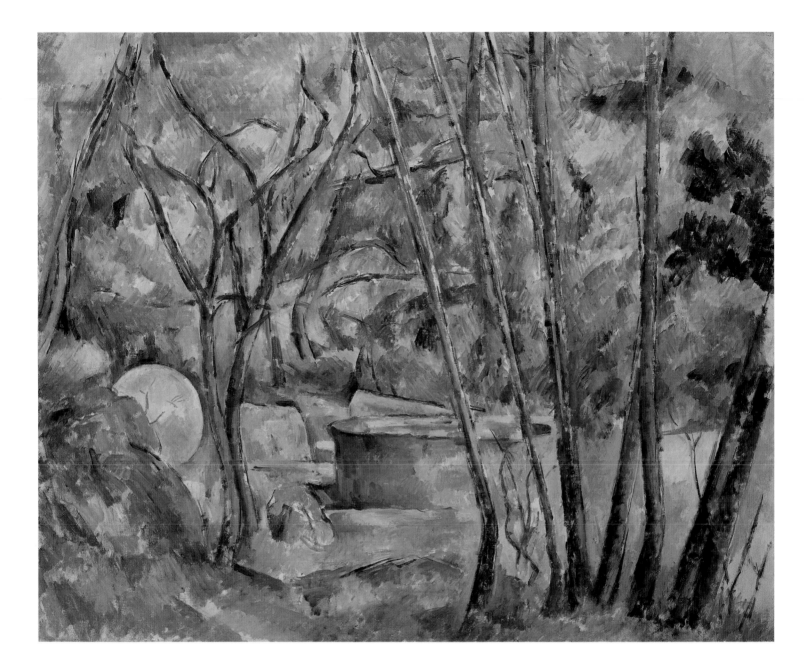

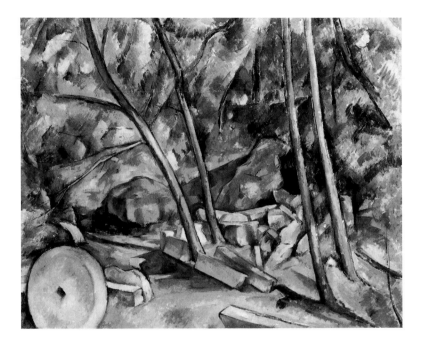

Fig. 3. *Millstones in the Park at the Château Noir*, 1892–94. Oil on canvas, 29 x 36⅜″ (73.7 x 92.4 cm). Philadelphia Museum of Art, Mr. and Mrs. Carroll S. Tyson, Jr., Collection.

plane and their linear complexity merges with and detaches from the landscape — black drawn lines covered over with touches of color reemerge only to regain their linear definition from slivers of bare canvas. What may be a break from the enclosed space beyond the mound of rocks in the middle distance is woven over with washes of pale green and orange, gentler variants of the underbrush and rock colors. Only a few pale blue strokes just along the top of the canvas hint of an escape to the sky.

As with other works by Cézanne in which drawing plays such a large role, a discreet thinness of color begins to blur the distinction between oil painting and watercolor. In such cases he achieves a level of delicate refinement that is truly enchanting.

J J R

House and Trees (Maison et arbres)

1890–1894
Oil on canvas
25⅝ x 31⅞" (65.2 x 81 cm)
Inv. no. 147

Fig. 1. *House Behind a Tree*, 1882–84. Pencil and watercolor on white paper. Collection Walter Feilchenfeldt, Zürich.

Isolated farmhouses in the region around Aix, surrounded by trees in sheltered sites away from the punishing winds of the mistral, were a favored subject for Cézanne. These structures were often abandoned due to the rules of inheritance in Provence, which distributed property among sons evenly, thereby sometimes separating the house from the spring, which was so critical in this arid landscape. It is difficult to imagine active life within the houses depicted by Cézanne. They stand as precise geometric objects within nature, which is not to deny their humanity. To a striking degree, Cézanne included man-made elements in nearly all his landscapes and never followed Monet's exploration of "pure" nature. Even his depictions of the most grandly realized works of nature on an immense scale, such as the late Mont Sainte-Victoires, are pervaded with the profound Mediterranean tradition of human presence.

The simplest things appealed to Cézanne greatly. The house is the most rudimentary of structures. Yet as generic as it may be to the region, it is unlike any other that appears in his oil paintings. All of its eccentricities are gently recorded: the diagonal water pipe (perhaps leading to a cistern) across its short end; the long, narrow window coursing between what we take to be two floors at the left of the long façade; the fissured settling crack that scars the façade just to the right of the low door. The wall surrounding it does not follow the rectangle of the house; it is set nearly parallel to the road (and the picture plane), dissolving into bushes on the right while the left end cuts sharply back against the building. A field appears at the far right, though there is little sense of contained versus open space. Everything is presented in an even, pale, unifying light. It may be the same building that appears in a watercolor dated 1882–1884, but turned more to the left behind a large tree absent here (fig. 1).[1]

At the Barnes Foundation this picture is hung on the same wall as the *Potted Plants* (see page 119). The tonality and mode of the two pictures are disconcertingly similar. Restrained and of a particular refinement, they both employ linear forms (in this case the more severe black trunks of the trees) that move elegantly through a field of white, gray/blue, and pale pink, merging nearly completely with the field at times but never to the point of dislodging Cézanne's subtly achieved sense of distance. The landscape, by definition, deals with deeper space and dimensional conditions less easily controlled than in a still life, but the pleasure Cézanne takes in understatement and in simplicity is shared by both works.

J J R

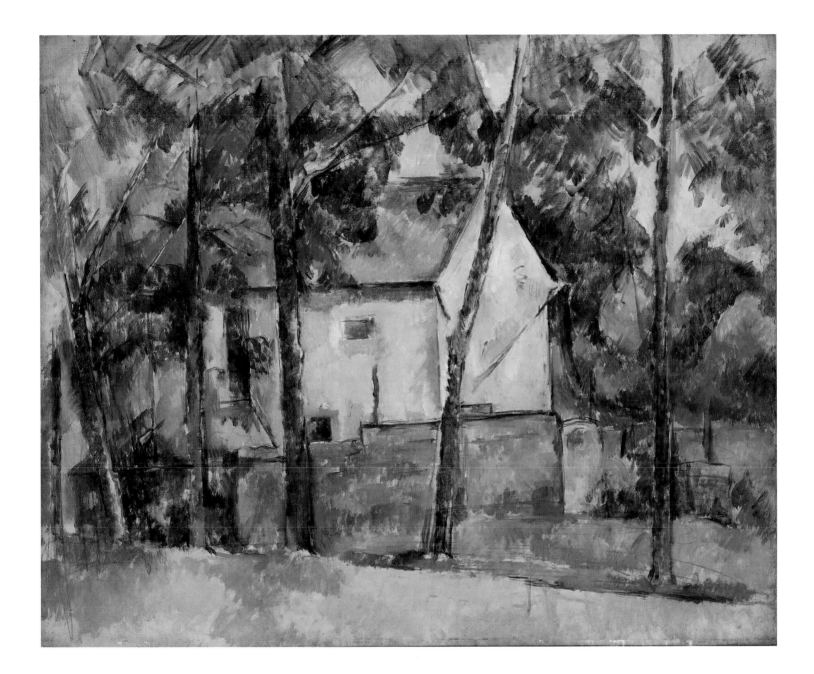

Compotier, Pitcher, and Fruit (Nature morte)

1892–1894
Oil on canvas
28¾ x 36¼″ (72.5 x 91.8 cm)
Inv. no. 128

Fig. 1. *Two Pitchers and Fruit*. Oil on canvas,
25 x 31¼″ (63.5 x 79.4 cm). The Barnes
Foundation, inv. no. 148.

Lionello Venturi, who usually restricted himself to observed facts when describing Cézanne's works in his critical catalogue, concludes his notice on this picture with the observation: "*Réalization parfaite.*" It is a picture remarkable in its absolute resolution and grandeur, one of Cézanne's largest and most fully orchestrated works in this genre. It stands among the most joyous and sumptuous creations of his career.

A rustic, drop-leaf table inscribed with a lozenge pattern is placed at an angle in a room with blue walls scored by a red band at the chair-rail level. An opening into another space with rust-brown walls is dramatically draped with a heavy beige curtain. Two fabrics are arranged on the table: a white napkin, pulled up to a peak near the center of the composition, and a blue and brown curtain with a green floral pattern familiar from other still lifes in the 1890s. On the apron of his broad stage Cézanne has arranged apples and oranges at stately intervals, grouping and separating them in a brilliant play of red, orange, yellow, and green. A white compote near the back edge holds three oranges and two apples. The faience milk pitcher serves, in terms of its bright floral design and its rippled lip, as the compositional and coloristic pivot of the picture, its exuberant shape and design acting as a decorative and three-dimensional source of energy from which the rest of the picture seems to take its lead.

This pitcher, a household object from the kitchen of the Jas de Bouffan, appears in five other late paintings by Cézanne and one watercolor (fig. 1). As much as they differ from one another, these works are all conceived in a particularly grand and ambitious mode by Cézanne, in which one mundane object serves as a kind of catalyst that brings the artist into full voice. There is an artificiality to these pictures, far from the earlier "natural" still lifes. The palpable sensuality of the fruit and objects is no less felt, but now they take on a still larger role in a more ambitious and formally staged manner. It is as if we had come to the last act of the drama with all the players brought back on stage in a final fugue of color and compositional complexity in which all questions of composition strategy and coloristic balance are resolved in a classical and heroic unity. In their assured resolution and grandness of conception these still lifes, all involving the decorated milk pitcher, can be directly compared, as a group, to the theme that would hold Cézanne most closely at the end of his life: the landscapes of Mont Sainte-Victoire.

J J R

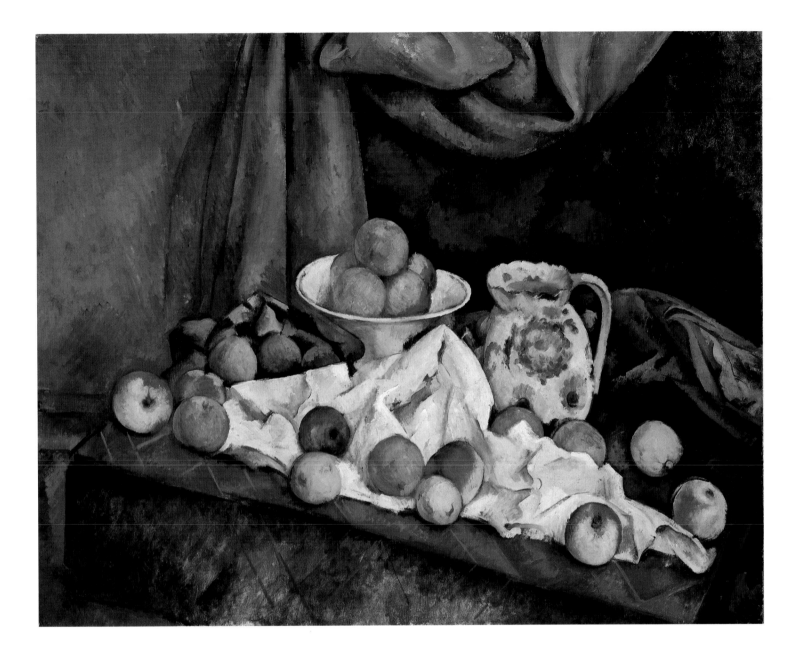

Mont Sainte-Victoire (La Montagne Sainte-Victoire)

1885–1895
Oil on canvas
28⅝ x 38⅛″ (72.8 x 91.7 cm)
Inv. no. 13

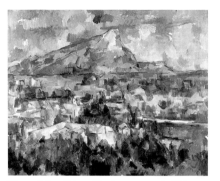

Fig. 1. *Mont Sainte-Victoire*, 1902–06. Oil on canvas, 27½ x 34¼″ (69.9 x 87 cm). Philadelphia Museum of Art, The George W. Elkins Collection.

The mountain called Sainte-Victoire is inextricably bound to the legends and sense of place of Aix-en-Provence. Its dramatic profile dominates the plain east of the city. The name is said to date from Marius' victory over the barbarians in the first century B.C., in a colossal battle during which the river Arc, which skirts the mountain's flanks to the southwest, ran red with the blood of the slain.[1] For many, its irrefutable presence is profoundly linked to the art and person of Cézanne. It appears throughout his work (see *Bathers at Rest*, page 103; *Gardanne*, page 111); as a theme it reaches a dramatic climax in a series of works he painted during the last four years of his life (fig. 1).

The mountain appears here as a gentle thing, gradually encountered over the broad plain of the Arc valley. The ascent to the summit is achieved slowly through the undulating foothills. The point of view is from the southwest, from which the climactic peak, familiar from the late works, is reconciled into a more integrated element of the landscape. Its slopes decline in two steady folds to the long ridge on the right, called Le Cengle. The arched aqueduct to the right establishes a long line running through the center of the picture, and parallels the vast expanse of the mountain, set against an unmodulated pale sky. The geometry of the farm buildings, the angled perspective of the cultivated fields, and the carefully gathered clumps of trees create a deliberate and stately rhythm, which is then carried through in the arching lines that define the ascent of the mountain. A roughed-in barrier of ocher undergrowth, just at the footlights of Cézanne's stage, prevents any swift movement into the greener landscape beyond, which then moves subtly back into ocher and blue up the slopes of the mountain.

The titanic force that the mountain will assume, for Cézanne, when seen directly from the west, is implicit: it is a vast and stately panorama. But his theme here is essentially pastoral and, somehow, very Mediterranean within the most profound classical traditions. As John Rewald has noted, this landscape of Sainte-Victoire "in its limpidity, rigor, sharpness of focus and almost liquid clarity of color does not have many equals among Cézanne's views of Provence."[2]

J J R

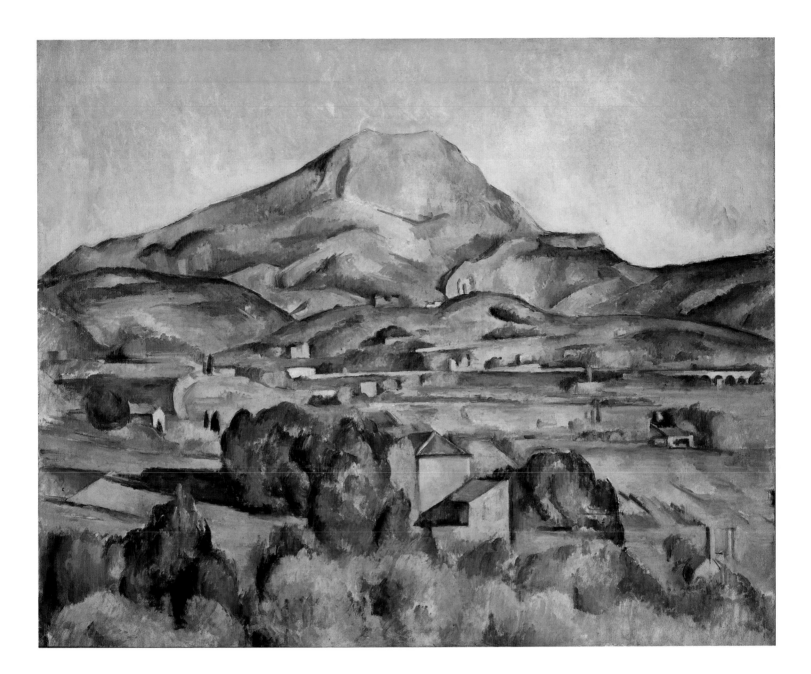

Woman in a Red-Striped Dress (Portrait de femme)

1892–1896
36¾ x 28¾" (93.2 x 73 cm)
Inv. no. 151

Fig. 1. *Old Woman with a Rosary*, 1895–96.
Oil on canvas, 33½ x 25⅝" (85 x 65 cm).
Trustees of the National Gallery, London.

This is among the earliest works by Cézanne acquired by Dr. Barnes, and while he would grow to doubt somewhat its virtue, it certainly ranks among his boldest purchases.[1] Even among Cézanne's numerous figure studies from the 1890s, the force of presence here is almost unique, shared only, perhaps, by the haunting *Old Woman with a Rosary* (fig. 1). A woman, assumed to be a servant at the Jas de Bouffan, sits within a complexly defined interior with the solidity of granite. The weight of her heavy features, the tautness of her hair severely pulled back into a bun, her stern gaze, and her firm grip on the book she holds suggest a force of will quite apart from that of the passive and sometimes oxlike men who patiently posed for Cézanne at about this time. There is no sense here of the ease Madame Cézanne achieved while posing for her husband (see *Woman in a Green Hat*, page 141). This woman has the quality of a massive form placed under tension, which no amount of ornamental design — the complexly rendered pattern of her red-striped dress — can dispel. The space itself seems to share her unease. The two levels of wall behind are painted in rugged, contrasting light and dark blues and grays, with occasional touches of brilliant green keying up the background to the brightest reds in her dress. A table (or commode) holding a half-seen vessel rudely projects on the left. An iron poker and fire-pinchers lean against the wall to the left. An inexplicable object (a basket with a handle, or more likely, given its coppery tone, a coal bucket) takes up nearly all the space behind her chair. The picture has the density and compression of those dour portraits Cézanne would do of his gardener, Vallier, in the early twentieth century, but here the measured application of paint does not progress into the almost painful quality of urgency that marks the very late portraits. It is a picture rendered in his "dark manner," which does not — quite to the contrary — project any negative sinister sense of the sitter. She simply serves as the point of origin for one of his most masterful pictures.[2]

J J R

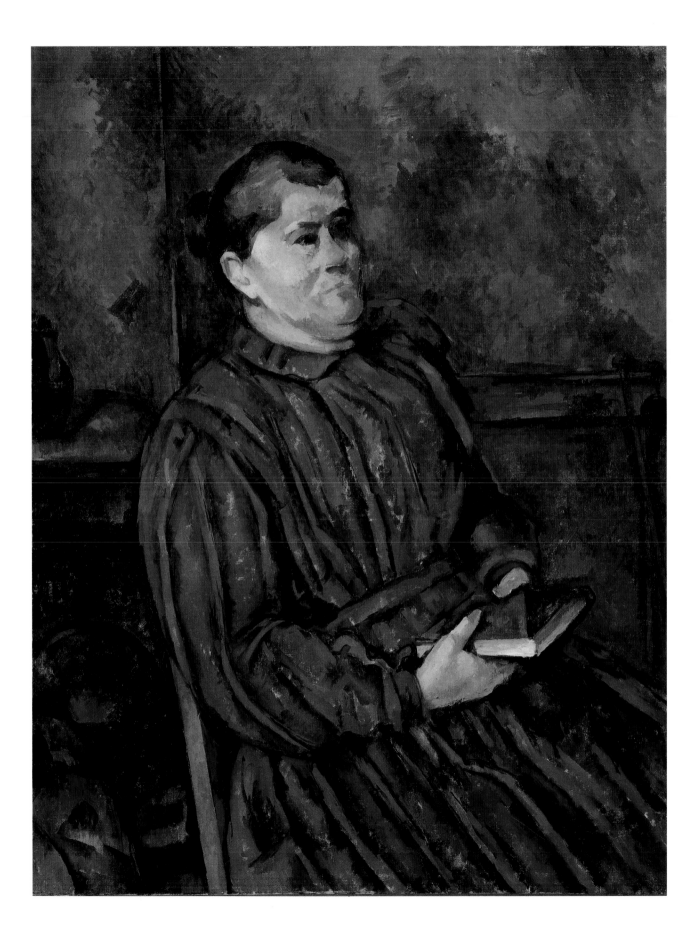

Woman in a Green Hat (Madame Cézanne)

1894–1895
Oil on canvas
39½ x 32″ (100.2 x 81.2 cm)
Inv. no. 103

In January 1915, Barnes wrote to the art dealer Durand-Ruel in Paris: "For several years Vollard has had for sale a large Cézanne, portrait of Madame Cézanne, which you will find illustrated in Meier-Graefe's monograph on Cézanne. The woman is seated on a chair, the arms of which are visible, and the sitter's hands are also visible. She wears a very peculiar hat, tilted somewhat over her face. The whole general scheme of the portrait is blue and gray.... You cannot mistake the picture, because it is the only one of its kind that Vollard has, or that I have ever seen anywhere else."[1] Three months would pass before negotiations were finally concluded. The case was made more complicated by Barnes' desire to work through a second party, having been offended by Vollard's refusal to accept his credit in an earlier encounter.[2]

Barnes, working from memory and a bad photograph, was correct on nearly all counts in his description of the painting. Madame Cézanne sits in a green upholstered chair with heavy volutes on its arms that date it to a bourgeois style popular under Louis-Philippe in the 1840s. She is dressed in a neatly tailored blue suit, its weave recorded with loosely worked strokes that deepen to a rich purple in the shadow, while areas of white show through to give a particularly animated sense of its folds and panels. The hat is, as Barnes notes, indeed eccentric: a broad, green and blue brim is topped by a sugarloaf crown to which is attached a dark green foliage, looking for all the world like a fig leaf! Despite Madame Cézanne's acknowledged taste for expensive clothes, it can't be compared to any illustration in the popular millinery catalogues of the day. Cézanne would sometimes take pleasure in a certain spirit of "dress up," in the numerous paintings he would do of his son as Harlequin, for example. The hat has given the title to the picture at least since 1895, when Ambroise Vollard listed *Madame Cézanne au Chapeau Vert* among the few works that he chose to identify in his exhibition of some one hundred and fifty paintings in Paris that year.[3]

Mme. Cézanne is seated well back in the chair, which is angled at forty-five degrees in the space. Her right arm rests lightly on the arm of the chair so that her waist turns in such a way as to bring her torso and shoulders completely into the plane of the canvas. The gentle turn of her head slightly more to the left completes the set of spiral shifts that resolve in the conical hat. This discreet spatial movement is played off the walls behind, which appear to meet as a broad recessive angle, though the corner (if there is one) is either hidden behind the figure or made ambiguous by the vertical gray painted band that ascends from the dado. The room recedes in elegant deference to the figure before it.

The oval features of Hortense Fiquet are easily recognized (see *Portrait of Madame Cézanne*, page 113). Her face is painted with great refinement, in contrast to the more

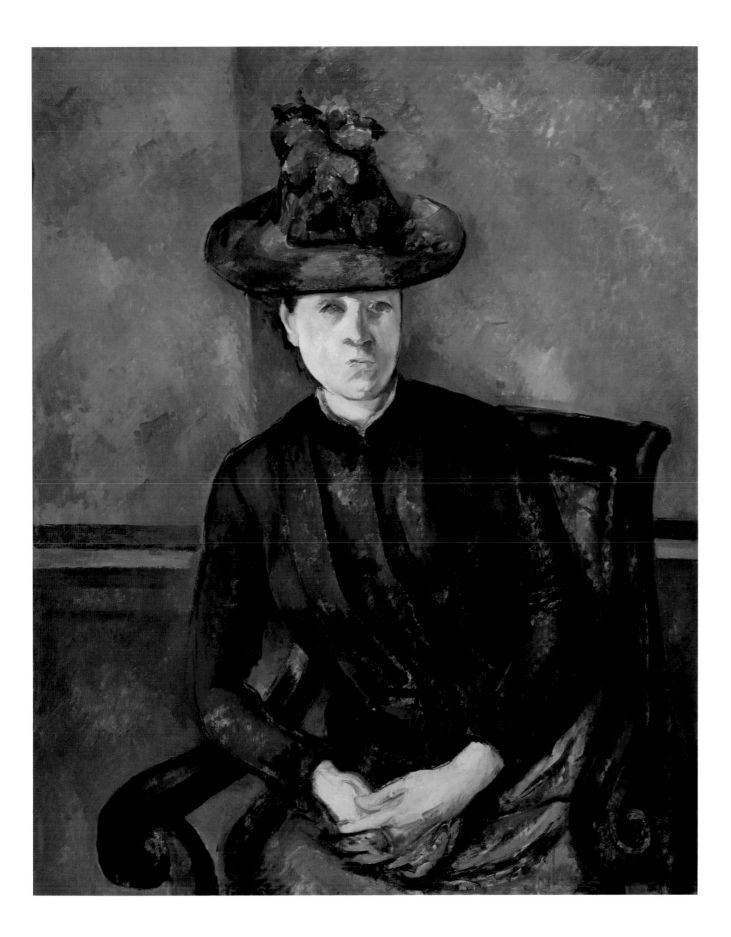

Fig. 1. *Woman Seated in Blue*, 1902–06. Oil on canvas, 34⅝ x 28" (88 x 71 cm). Pushkin State Museum of Fine Arts, Moscow.

loosely sketched hands. Cézanne has left his first start for the left hand, repressed with only a few strokes of rust brown. It is, as Barnes noted, unlike any other depiction of her. Despite her air of somber ease, the picture has a quality of distant formality, as if Cézanne were remembering some yet undiscovered image within the history of three-quarter-length portraiture. As portraits by Pontormo and Raphael enter one's mind in relation to the *Boy in a Red Vest*, the prop-like hat here hints at some Renaissance or baroque prototype.

Cézanne returned to this kind of subject later in two paintings of an anonymous sitter, fashionably dressed in a suit and hat, though in one the hat is more conventional by the fashion standards of the 1890s (fig. 1). The most telling aspect of this comparison is the manner in which both women, his wife and a studio model, are brought into a broader realm of formal images that sets them apart from conventional portraiture or genre. Particularly in the case of Madame Cézanne, this does not detract from our sense of her as a

specific person. As Cézanne will often do with a still life object or a landscape element, he transforms his subject into something beyond everyday reference, while maintaining all of its essential truth. Gustave Geffroy, one of Cézanne's most perceptive early critics, wrote in his 16 November 1895 review of Vollard's show: "At the Vollard Gallery, in the rue Laffitte, all passers-by may enter and find themselves confronted by some fifty (*sic*) canvases: figures, landscapes, fruit, flowers, upon which at last may be based an estimate of one of the finest, greatest personalities of our time. When this test has been made, and it is high time that it should be made, all that is obscure and legendary in Cézanne's career will be cleared up, and there will remain his work, severe but charming, and furthermore erudite, powerful, yet simple.... He is supremely sincere, intense and artless, rugged and subtle. His work will be hung in the Louvre, and the collection contains more than one canvas which will enter the museums of the future."[4] JJR

Ginger Jar and Fruit (Le vase paillé)

c. 1895
Oil on canvas
28¾ x 23⅝" (73 x 60 cm)
Inv. no. 181

Cézanne is an artist for whom it is futile to attempt to establish rules and exceptions. When broad categories of his work are surveyed, certain favored compositions and color arrangements do emerge, linked to one another in a way that suggests subtle interconnections and a pattern of exploration over time. But within this general pattern each picture has the quality, nowhere more evident than in this still life, of being invented anew as if the artist wished to establish different formal and expressive problems to be solved. The referential element, the blue, straw-bound ginger jar, appears over a decade in no less than ten paintings and two watercolors, placed as here on a plain wooden table in various relationships with fruit and background elements. There is an audacity in his assertive and virile manipulation of light, space, and color that sets this still life quite aside from any other work to which it can be compared in terms of shared elements.

A table stands in the middle of a brilliantly lit space against a mottled dark background. On the table, carefully arranged, is a red and white striped napkin (see *Still Life with Skull*, page 149), over which are strewn apples and pears, several of extraordinary size. The familiar ginger pot (which still exists in Cézanne's studio at Les Lauves in Aix) rests firmly at the back of the table, though its exact relationship to the table top is unclear. The side edges of the table align in a radically steep, one-point perspective, emphasizing the table's isolation from the sides of the canvas. The boldness of this effect is paralleled by the intensity of light coming from the upper left, resulting in the deep shadows in the folds of the napkin and two precise shadows thrown by the fruit on the far right. No shadow falls within the legs of the table or against the wall beyond.

The patterns on the wall are roughly sketched in, with bold workings of purple/blue, green, and red creating a highly animated field that interacts with the intense force of the still life proper. The white of the ground shows through with just enough luminosity to balance the light that brings the foreground to such a high pitch of intensity. The essential tone of the background is established by the blue and purple of the ginger jar, while touches of red and green thread through the flat field, picking up other colors from the concrete objects before it. Mysterious forms — a spadelike shape (a bread board hung by a string), a projecting "elbow" of lighter pigment — invite speculation that Cézanne has placed the still life against some other painted surface of his own creation, such as the screen in the background of *Table, Napkin, and Fruit* (see page 147), or the partially seen canvas in the background of numerous other still lifes. However, no image in his recorded works provides an explanation. The illusion of immense scale confounds the problem, since the ginger jar is, in actuality, quite small; the patterns of the background might be, therefore, finer and more delicate, such as the wallpapers that appear in earlier still lifes.

J J R

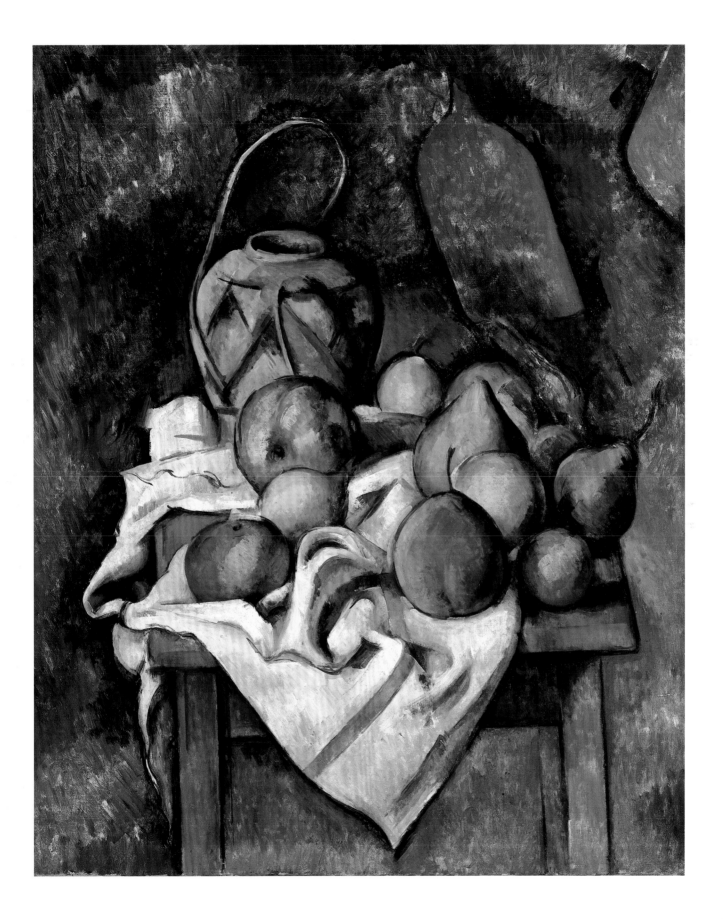

Table, Napkin, and Fruit (*Un coin de table*)

1895–1900
Oil on canvas
18¼ x 22″ (47 x 56 cm)
Inv. no. 172

According to Meyer Schapiro, "One should not underestimate, however, Cézanne's feeling for the beauty and poetic connotations of things he represented. Contrary to the view of his art as indifferent to the sensuousness of fruit, Cézanne's apples (and also his less frequent pears and peaches) are often the objects of a caressing vision, especially in his late works".[1] While this statement was made as a general reference, Schapiro could well have been describing his experience of this work, had it been available to him.

Seven pieces of fruit — three fully ripe peaches, three apples, and a green pear — are carefully stacked against a blue-rimmed, white dish that is presented at a nearly ninety-degree angle. The effect is that of a grandly generous offering set in a nimbus from which a stately cadence moves throughout the surface. The central fruit, accented by two finely drawn peach leaves laid on its surface, acts as a bull's eye from which the other objects demur in subtle degrees of unfocus and thinner execution. The white napkin that literally "peaks" above the plate on the right supports and amplifies the gently subsiding undulation, right to left, which resolves in the green fruits on the far left that are loosely outlined in black and only partially colored-in. Just above these, an inexplicable brown arch contains the still life proper of the table top; a similar straight line just beyond on the back wall compresses background and foreground. The dynamics of the composition are completely three-dimensional across the table, right to left, forward to back. The consistent high color of the fruits (whatever their degree of finish) and the brilliant white of the cloth completely unify the table top.

Two panels of a folded screen appear in the background, set into what appears to be an opening with a white vertical band, the blue plane of which aligns with the front edge of the table. It has been suggested that it is the object which appears in the Barnes *Still Life with Skull* (page 149), a whimsical thing, created by Cézanne in his youth.[2] If so, it has been supplemented with horizontal bands that serve as a kind of wainscoting detached from the wall. In this zigzag of linear perspective introduced by the screen the dimensional complexity of the foreground is reenacted, but in a more low-keyed, loosely brushed manner. To return to Meyer Schapiro: "[Cézanne's] still-life is a model world that he has carefully set up on the isolating supporting table, like the table of the strategist who mediates imaginary battles between the toy forces he has arranged on his variable terrain."[3] All of the grandeur of the heroic still lifes that will follow in the 1890s are implicitly present here.

J J R

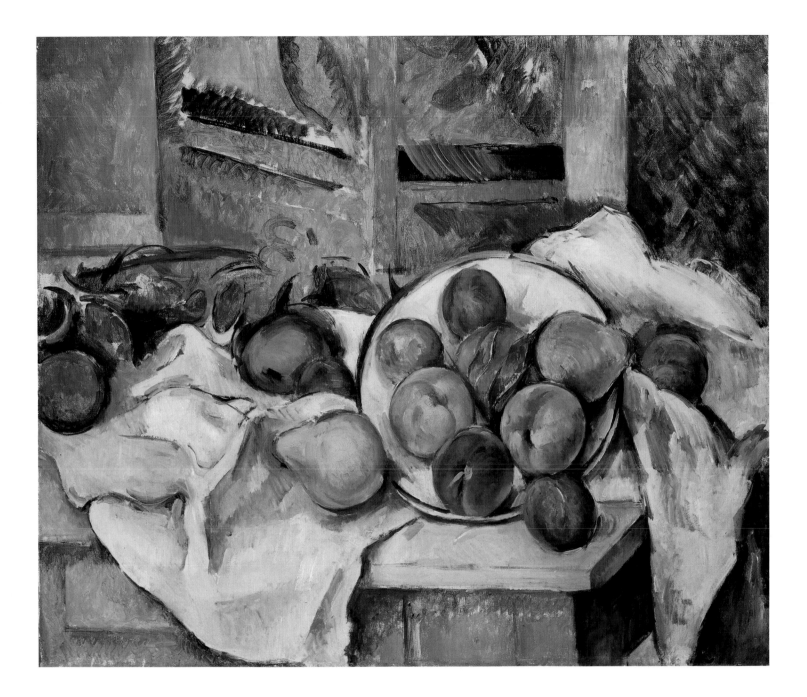

Still Life with Skull (*Nature morte au crâne*)

1895–1900
Oil on canvas
21⅜ x 25⅝″ (54.3 x 65 cm)
Inv. no. 187

Fig. 1. *Foliage and Rustic Scenery*, detail. Painted folding screen, 158¼ x 98⅜″ (402 x 250 cm). Musée Granet, Aix-en-Provence.

Fig. 2. van Roestraten, *Vanitas*. 24¾ x 19¼″ (63 x 49 cm). Collection Dr. Philip Lindstedt, Goteborg.

Cézanne painted still lifes with skulls at the beginning and the end of his career.[1] As his dealer Vollard would report, he found them beautiful things to paint (see *Boy with Skull*, page 151). Lawrence Gowing, commenting on these still lifes, observed a profound playfulness in his depiction of such morbid objects: death, banalized in the company of everyday objects, winks like the grim reaper. As has been noted, Cézanne was quite aware of the ironic tradition of sixteenth- and seventeenth-century *vanitas* still life.

A simple wooden table with one drawer, probably the same that appears in *Table, Napkin, and Fruit* (see page 147), holds seven pieces of fruit, six of them pears (two still green; four ripened to a lustrous orange). The largest pear (or is it an apple, always one of the nagging questions, whose importance seems to linger over all still lifes of this nature) sits on a small, radically tilted plate. A brilliant lemon, the aggressive player, coloristically, in this crescent of larger fruit, sits on a corner of the red-striped napkin that envelops one of the pears and cushions the skull. Just behind, in a way that is difficult to decipher, is the fifth panel of a six-fold screen that Cézanne painted in his youth in the company of Zola, a lark in the general manner of a Lancret *fête champêtre*. The screen stayed in the Jas de Bouffan (Cézanne's father's house at Aix) and served as a backdrop, in equally fragmented appearances, in other Cézanne still lifes (fig. 1 and see *Table, Napkin, and Fruit*). If there is some private reference in this quotation from his youth it is far from clear. Certainly Cézanne took pleasure in playing the triangle of yellow (actually the skirt of a shepherdess) against the tallowed tone of the skull. In his endless play and retreat from associative meanings, the forced introduction of the shaft of leaves just left of the skull must drolly tease at the long tradition of crowns of laurel, fame, and immortality (fig. 2).

The work, for all of its rich solidity and dense build-up of color, is relatively uncomplicated in comparison with other still lifes dated to this period. Its essential quality is one of forthright, unproblematic robustness underscored by a weighty humor. It also bears one of the more fortuitous studio accidents to occur in a work of Cézanne. The streak of bright orange over the skull's right eye socket (a serendipitous occasion of Gowing's "wink") and the angled smear of the same pigment just to the right of it are remnants from another, still-wet canvas, stacked face-to-face against this painting at some early point in its life. Cézanne was famously casual with his works after their completion. Since he had little immediate urge to exhibit after the 1870s, he simply stored his works in piles around the studio and house. It is much to the credit of the early owners of this work (and Dr. Barnes himself) that a restorer was not requested to "correct" this happy accident.

J J R

Boy with Skull (*Jeune homme à la tête de mort*)

1896–1898
Oil on canvas
51¼ x 38¼" (130.2 x 97.3 cm)
Inv. no. 142

Fig. 1. Attributed to Campagnola, *Youth Seated Contemplating a Skull*. Engraving.

Few works by Cézanne have prompted as much subjective speculation or have so openly invited biographical and associative readings.

A handsome young man leans on his elbow, staring into space past a skull resting on a pile of books. Behind him, as a theatrical backdrop, hangs the heavy, floral-patterned curtain that will occur as a frequent studio prop in other pictures painted in Aix during the last decade of Cézanne's life. The palette is dominated by a subtle range of purples, cobalt blue, and moss green, through which shines the luminous white of the papers on the table and the skull. The mood is inescapably one of melancholy. "The indifferent gesture contrasts with the colors suggesting death and despair."[1]

It was sometimes thought that the sitter was Cézanne's son, who would have been in his mid-twenties at the time this picture was painted. However, Paul *fils* was rarely in the south at this point, and Venturi's observation that the figure is actually a local worker, who appears in another painting of about this date entitled *The Reader*, seems more likely. John Rewald confirms that the sitter is the son of the peasant woman at the Jas de Bouffan whom Cézanne portrayed as a cook.[2] There is little quality of portraiture here; the man, for all the individuality of Cézanne's figures, seems cast in some predisposed role.

Skulls recur as still life elements for Cézanne in several pictures (see *Still Life with Skull*, page 149). His niece reported that near the end of his life he had a stack of them in his bedroom. Their presence is not to be taken as morbid. Vollard reports him to have said: "A skull is a beautiful thing to paint." Yet beyond their attraction as objects, Cézanne certainly was not unaware of the long tradition of *vanitas* still lifes, with death introduced among material or living things as a *memento mori*. The tradition of man confronting mortality is also a long one in Western art. Venturi was the first to draw attention to the fifteenth-century print by Giulio Campagnola in which a youth, eyes downcast and arm raised to his head, shares the foreground with a human skull (fig. 1). In a more direct analogy Theodore Reff illustrates a painting by François-Marius Granet, then, as now, in the local museum in Aix, showing an old man, again asleep with his head propped in his hand, at a table with an open book, a skull in his lap, a continuation of the theme of a philosopher/scholar confronting the brevity of life.[3]

Clearly Cézanne intended to do a picture, as he would have said, "for the museums" . . . one which would be recognized as standing in a long and serious continuum of common themes in Western art, as far from it as he appeared to be, to many of his contemporaries, from that tradition. But in so doing, he has removed any literary or didactic references intrinsic to earlier uses of the subject — there is little sense of admonition or active moral principle here — whence the struggle to explain fully his intent. For

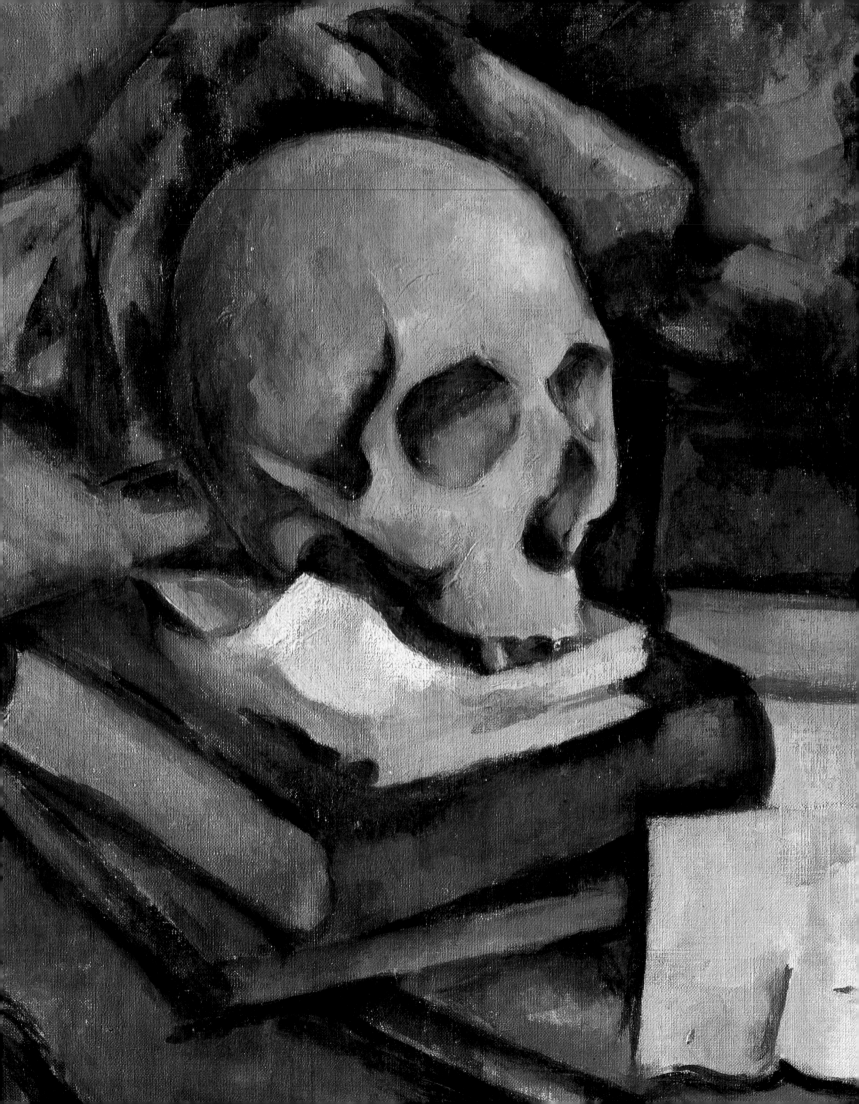

Meyer Schapiro and Reff, the picture is essentially the work of an old man rethinking his youth by placing a son-like figure in direct contrast to mortality. Whatever Cézanne's meaning here, the grace and dignity of this image place it a far distance from the expressions of his youthful morbidity. There is a heroic nature to this graceful youth — not yet brought down by the weight of life despite (or, because of) his pensive state. To follow Cézanne's first biographer, Joachim Gasquet, the aging artist fell into moments of grave doubt and despair but, finally, always rallied in the fundamental knowledge of his own genius and a new perspective on art. In this spirit, the youth here becomes Cézanne's young Werther, a Hamlet of sorts (fig. 2).

J J R

Fig. 2. *Hamlet and Horatio (after Delacroix)*, c. 1870–74. Oil on paper mounted on canvas, 8⅝ x 7⅝" (21.9 x 19.4 cm). Private collection, Philadelphia.

Chrysanthemums (Vase fleuri)

1896–1898 (Rewald); c. 1900
Oil on canvas
27½ x 22¾" (70 x 57.8 cm)
Inv. no. 162

Fig. 1. *Flowers*, copy after Delacroix's *Roses and Hortensias*. Oil on canvas. Pushkin State Museum of Fine Arts, Moscow.

Joachim Gasquet, in describing the monkish quarters on the rue Boulegon in Aix where Cézanne moved after the Jas de Bouffan was sold in 1896, notes that over the bed hung "the famous Delacroix watercolor of flowers he had acquired from M. Vollard after the Choquet sale, which he was literally mad about."[1] Cézanne made a large copy of this work in oil (fig. 1), which Venturi groups with the Barnes *Chrysanthemums*. While it seems likely that these two lushly exuberant works are more separated in time than Venturi had speculated, the comparison is compelling, as they share a swiftness of execution and exploration of broadly diverse floral colors.[2] Whereas the Barnes picture was clearly painted directly from an arrangement Cézanne made in his studio, it may well reflect his memory of other Delacroix watercolors he would have known from the collection of his good friend and early supporter, Victor Choquet.[3]

The heavy green, red, and rust carpet that was in Cézanne's studio at Les Lauves until World War II is hung from the wall, falling in two abundant folds onto a small table. The floral-patterned curtain that appears in so many late still lifes hangs on the right and drops behind the table while a quite different color field is introduced by the solid blue fabric softly gathered on the surface before it. In the center appears the white milk pitcher with a blurred flower decoration, also a favorite studio prop for Cézanne in his late still lifes (see *Compotier, Pitcher, and Fruit*, page 135). Large stalks of orange, yellow, white, and pink chrysanthemums are roughly placed in the pitcher.

Following the actual structure of the petals, the flowers are depicted with short, directional strokes that establish a nearly electric wave of staccato animation, carried out, albeit in broader and wetter applications, in the equally brilliant colors of the carpet. The softer tones of the curtain and the rosette wall beyond are applied more evenly, with more drawn-out strokes. In the lower left, the white ground of the canvas (in contrast to the white pigment of the pitcher) is left exposed, creating a quality of transparent luminosity that pervades the entire picture. Only the passive blue of the cloth on the left allows a respite from the pulsing energy that vitalizes the surface.

J J R

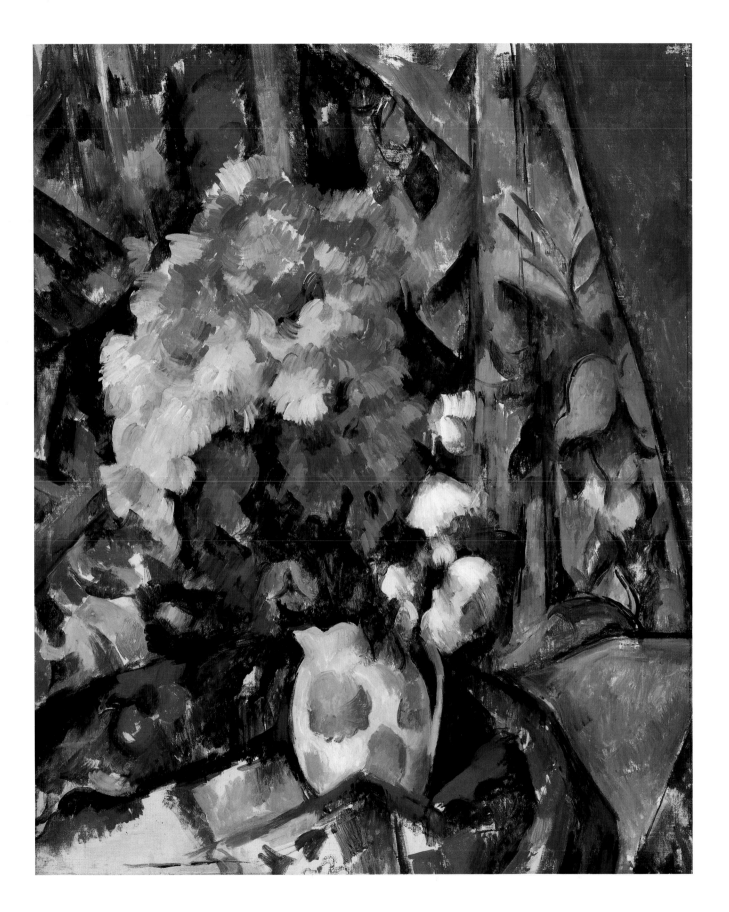

155

Bibémus Quarry (Carrière de Bibémus)

1898
Oil on canvas
36¼ x 28⅝" (92 x 72.8 cm)
Inv. no. 155

The landscape of Provence is scattered with stone quarries, some of them dating back to Roman times. As John Rewald has pointed out, an alert visitor to that region can identify buildings by the specific quality of their stone, among the most distinctive being the soft ocher-colored blocks "as though the rays of the sun had been captured in [them]," which come from a huge, randomly worked quarry just east of Aix at Bibémus.[1] This quarry is the subject of numerous paintings and watercolors by Cézanne during the last decade of his life (fig. 1). They date from 1895, when he rented a *cabanon* (a small shack) just on the edge of the quarry, in which he stored his painting gear until a year or two before his death in 1906.

With its predominant orange stone and green pines, Bibémus shares many physical aspects with the area downhill to the south around the Château Noir, where Cézanne often

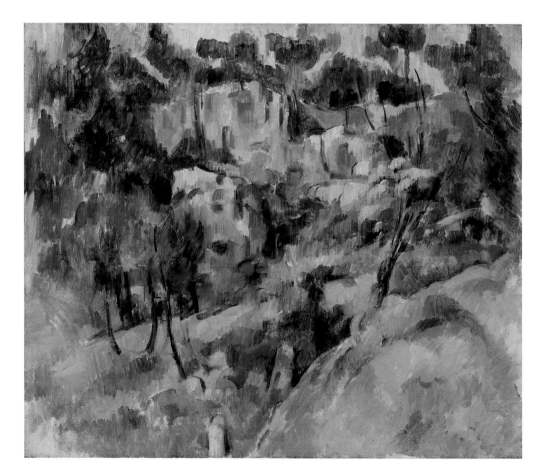

Fig. 1. *Corner of Quarry*, 1900–02. Oil on canvas, 17¼ x 20⅞" (44 x 53 cm). The Barnes Foundation, inv. no. 218.

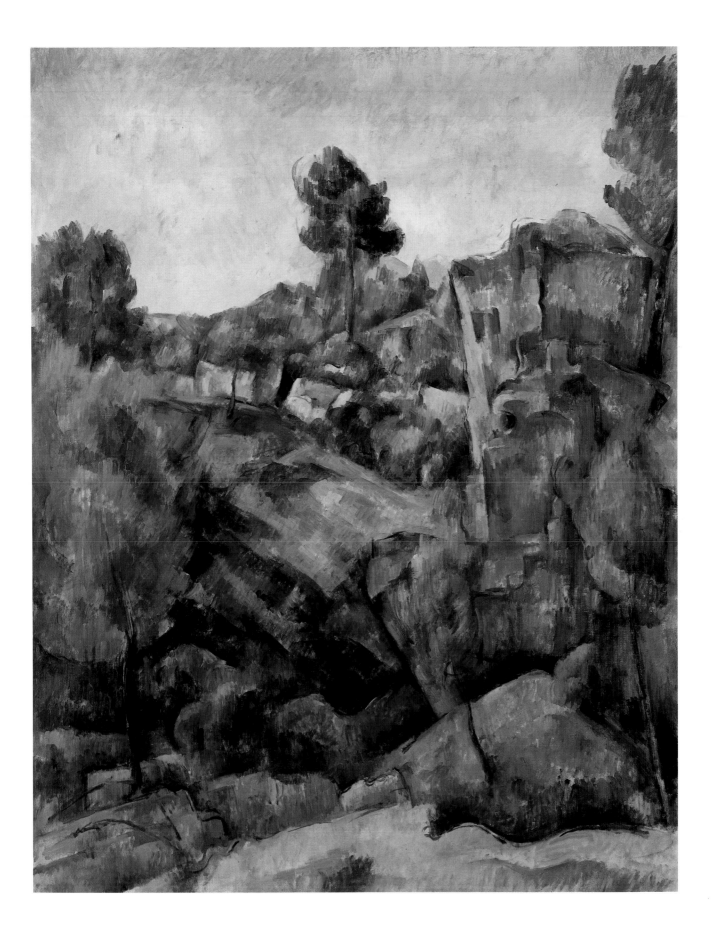

Fig. 2. *Mont Ste.–Victoire Seen from Bibémus,* c. 1897. Oil on canvas, 25⅝ x 31½" (65.1 x 80 cm). Baltimore Museum of Art. Cone Collection, formed by Dr. Claribel Cone and Miss Etta Cone of Baltimore, Maryland.

Fig. 3. *Bibémus Quarry.* Oil on canvas, 25⅝ x 21¼" (65 x 54 cm). Collection Stephen Hahn.

worked at this time. However, as opposed to the steep ridges (overhanging and forming caves at the top of the rise) that ascend from the Tholonet road, the labyrinthine quarries at Bibémus form sharp, irregular cuts into the wind-swept plateau with Mont Sainte-Victoire beyond (fig. 2). Despite subsequent overgrowth and reforestation, these depictions always impart a sense of the workings of man. Just to the north are the reservoir and dam engineered by Zola's father, where Cézanne played and swam with Emile in their youth, which perhaps lent it a particular potency for the artist some forty years later. Even today, the particular isolation and private magic of this place are evident.

The vertical composition is one Cézanne favored in many of his paintings of this site; it can be described in terms of the complex means of escape that are allowed from the floor of the quarry into the limpid sky above. The gently undulating floor, its irregularity accented by penlike drawings in black paint, drops quickly away into a gully of undergrowth, from which ascends a sheer tower of orange and blue rock that leans into the picture on the right. On the left, the ascent is more gradual, arching over one rounded mound of rocks topped by a thick-trunked pine. The ascent then continues to another, sheerer shelf on which stands, halfway up, a taller tree, its branches extending above the landscape proper to create a centralizing silhouette against the sky. The distant, lavender mountains are only glimpsed beyond the lip of the quarry, optically pulled close-in by the intense noonday light.

The contrast of cut stone and natural formation contains nothing probative, nor is there any sense of opposition within these shapes. It is as if Cézanne, by his selection of this particular view, simply wished to put such elements into an ordered and timeless relationship. The picture is made with great deliberateness; the mood is one of a patient, unhurried pleasure taken from so grand, yet private a site.

A comparison to a strictly similar picture, in which the position of the artist is moved slightly to the right so that the towerlike aspect of the manmade cliff is still more evident, shows to what differing degrees one site could affect Cézanne (fig. 3). This picture is executed in consistently broad strokes that take on a directional play throughout the canvas. Individual forms are flattened into semi-independent planes so that the movement, bottom to top, takes on a quickened, exalting manner. While the palette of the Barnes pictures is nearly identical, it is staged in a very different mode: dense applications (particularly in greens) in contrast to thinner washes of color, the sharpness of edges picked up in drawn lines, which merge gently with the massive forms they define. As Cézanne would note near the end of his life, the essential goal of his career was to come to some resolution between himself and his subjects. The variety of artistic resources he commanded in resolving "problems" is what always re-engages us within each work.

J J R

Nudes in Landscape (Les grandes baigneuses)

1900–1905
Oil on canvas
32⅛ x 39⅞" (82 x 101.2 cm)
Inv. no. 191

Fig. 1. *The Bathers*. Oil on canvas,
51¼ x 76¾" (130.2 x 194.9 cm). Trustees of
the National Gallery, London.

Fig. 2. *The Large Bathers*, 1906. Oil on
canvas, 82 x 99" (208.3 x 251.5 cm).
Philadelphia Museum of Art, Purchased
for the W. P. Wilstach Collection.

No single theme in Cézanne's immensely varied oeuvre held his attention so intensely as that of nude bathers in a landscape. Some two hundred works are devoted to this subject; of the fifty-one paintings by Cézanne at the Barnes Foundation, eight are on this theme.[1] During the last decade of his life he undertook three large canvases depicting female bathers, one now in the National Gallery, London (fig. 1), another still larger at the Philadelphia Museum of Art (fig. 2), and the picture here. For many, these three monumental canvases are the culmination of Cézanne's career. As much as they have been analyzed and discussed, their relationship to Cézanne's work as a whole and their specific meanings remain elusive.

The shared features of the three works are simply stated. Ample female nudes are grouped in various poses of animation and leisure in a sheltered glade. They are placed well forward in the space, which is flanked by arching trees, and the scene opens to sky and more distant landscape in the center. On the far left, a common figure strides into the gathering, while near the center, two or three others have turned and seem to be about to depart. In the nearest foreground a black dog reclines near a picniclike still life (this passage is left vacant in the Philadelphia picture), a genre element that adds a charmingly mundane turn to what, otherwise, is a timeless theme. Clearly, Cézanne is responding to a long tradition of pastoral images that passed from Raphael, Giorgione, Poussin, and Boucher to Delacroix, Courbet, Manet, and Renoir (fig. 3). However, the means by which he explores this theme in these three works — the manner of execution and expressive impact — could not be more different.

The Philadelphia picture is most often selected as the third and most resolved of the group. Its grand scale, consistently thin execution, and unfinished state place it in a category defined as architectural and solemn — its essential quality being that of transcendent grandeur and calm. The London picture, very near in scale to the Barnes bathers, is more richly painted and intensely colored. Its surface is worked in a rough blocked-in manner, with the figures sharply outlined in black, all of which gives it a particularly compressed, nearly sculptural force. The Barnes picture is still more densely executed, sections of its surface built up through multiple layers of paint to the point of luminous incrustation. In contrast to the London and Philadelphia pictures, the figures are complexly modeled in a broad variety of flesh tones, shot through with brilliant reds, jade greens, and dark blues. They are matched in coloristic intensity by the deep green foliage, cobalt sky, and the brilliant white of the smokelike clouds ascending through the opening. This picture has a labored and charged energy that sets it quite apart from the other two. In execution and color it falls precisely between the complex application of the 1877 *Bathers at Rest* (see page 103) and the

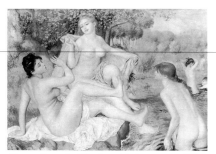

Fig. 3. Renoir, *The Great Bathers*, 1887. Oil on canvas, 45½ x 67" (115.6 x 170.2 cm). Philadelphia Museum of Art, Mr. and Mrs. Carroll S. Tyson, Jr., Collection.

Fig. 4. Emile Bernard, *Cézanne Seated Before the Bathers*, March 1904. Photograph, 10¾ x 14¾" (27.3 x 37.5 cm).

exuberant views of Mont Sainte-Victoire from after 1900. Lionello Venturi described it as having a particularly "expressive drama, the branches of the trees shooting out like broken arrows, the lights and shadows set into combat."[2]

Considerable thought has been given to the evolution of this picture, particularly in relationship to the two others.[3] On the evidence of its more worked-over surface, it is generally agreed that it precedes the others, even though all three seem to have actively engaged Cézanne's interest until 1906. Ambroise Vollard, who sat for his portrait in 1899, mentions that Cézanne "was also occupied by a bathers subject, begun about 1895, on which he labored almost to the end of his life." Two visitors to Aix in 1905 noted a bathers subject, begun a decade earlier, which showed eight nearly life-size figures. The Barnes painting depicts in fact nine nudes; the back of a departing figure only partially seen between the frontally seated redhead and the tree trunk on the right could have been easily overlooked. Most important, the painter Emile Bernard photographed the artist, seated before the Barnes canvas in his studio at Les Lauves, when he visited Cézanne in the spring of 1904 (fig. 4). He mentioned, in a letter to his mother from a return visit the following year, that the work had progressed considerably. His photograph has allowed a unique insight into the evolution of this work, documenting its slow and final progress. The most obvious change is the adjustment made to the far left nude who appears, in the 1904 photograph, advanced before the other figures so that she is standing nearly on the picture's edge, thereby dominating the entire group. In the final version she has been reduced to a scale more relevant to the other nudes; her right foot is now placed behind the shelf of grass on which many of the nudes sit, while her head has been abbreviated into a summary form reminiscent of Brancusi. The development of the first form can still be discerned, particularly the changes around the head, where a dense build-up of paint in green and black outline the present profile.[4] All the other essential features of the picture are in place by 1904, though, even to judge from so unclear an image, the entire surface — particularly in the definition of features and anatomy — underwent a considerable program of labor.

This clarification of its long evolution further detaches the Barnes picture from the other two canvases, confirming its quite different impact. Whereas the women in the Philadelphia and London pictures, both begun just at the turn of the century in all likelihood, share a certain leisured serenity, the nudes in the Barnes picture posture and gesture with a nearly manic theatricality. Even in her diminished state, the striding figure at right has an emphatically operatic presence, dragging her opulently unfolding robe behind her to mark her entrance. The woman kneeling to her right seems to pay her deferential homage, while the central, red-haired figure kneeling in profile seems awe-struck. The standing figure, modeled with a particularly sensuous combination of flesh tones and silvery blues, lifts her arms above her head in a gesture that has been justly noted as blatant provocation, while the grand nude on the far right, her gender emphasized by the black sketched lines on her belly and thighs, stretches against the tree (to which she is tied?) in elongated splendor.

The connection between this work and the highly sexual images, often violent in nature, of the 1860s, has often been noted. It is distanced from those works, which are often presented as the product of youthful heat, by the permeating historical self-consciousness that lifts it to a new level of rhetorical dignity. Many of Cézanne's nude studies, particularly those of females, continuously refer to sculpture and paintings of the past. The central nude here is, in reverse, an antique kneeling Venus he often drew in the Louvre; the striding figure has been compared to a Rubens Venus, while the figure against the tree echoes certain bound Andromaches depicted by Titian. The overall drama might reflect the theme of the chaste goddess of the hunt and the forest, Diana, gathered with her troop, a subject well known to Cézanne through eighteenth-century depictions and his reading of Ovid. The tension of the narrative — Diana in her cold splendor was the cruelest of all goddesses — had, perhaps, particular resonance here. Yet such readings are, at best, speculative. Cézanne's late imaginary inventions — his art of the museum versus those works drawn from direct observation — translate from his vast visual and literary knowledge, used completely to his own ends. As clearly as this work relates to both his earliest creations and most active late interests, he is working toward a sense of the masterpiece: the art of museums. In discussions of the late bather subjects, John Rewald aptly quotes a general observation made by Sir Herbert Read, which has equal bearing here: "Cézanne found that it is the most difficult thing in the world to give direct expression to visionary conceptions. Unchecked by an objective model, the mind merely flounders over an expanse of canvas. It may achieve a certain force, a certain vitality, but it will lack not only verisimilitude, which matters little, but the knitting together of form and color into a coordinated harmony which is the essential of great art. Cézanne came to realize that to achieve such a harmony the artist must rely, not on his vision, but on his sensations. To realize the sensations — that became the watchword for Cézanne. It amounted to a self-imposed conversion: a spiritual renewal. The dynamic vision of the romantic had to be transformed into a static vision of the classical."[5]

J J R

M. Loulou

1890
Oil on canvas
21⅝ x 18⅛" (55 x 46.2 cm)
Signed and dated upper left: *P. Ga. 1890*
Inv. no. 589

Gauguin left Paris in June 1890 for the coastal village of Le Pouldu in Brittany. There he resettled at the Buvette de la Plage, the small inn owned by Marie Henri that he had decorated the previous winter with Meyer de Haan. Around 1919, Marie Henri's firsthand knowledge of Gauguin's life and work at Le Pouldu was passed to Charles Chassé, author of an early study on Gauguin's Breton period, by way of her longtime companion, Henri Mothéré. Concluding his important description of the activities of Gauguin and his circle, Mothéré wrote, "among the number of canvases painted by Gauguin at Le Pouldu, one must mention a beautiful portrait of a child, that of the young Louis Le Ray, whose parents, very close to the author, frequently received him in their home."[1] That portrait, no doubt the one today in the Barnes Foundation, is dated 1890 and inscribed by the artist to his young sitter, "à Mr Loulou — Souvenir."

Gauguin painted few actual portraits of children during his Breton period, although his earlier work includes many sensitive and innovative depictions of his own children.[2] It is not surprising, however, that from frequent visits to the Le Ray household he elected to record the likeness of this seemingly charming boy, who must have reminded him of his own son.[3] Judging from his costume — boys typically wore dresses and long hair until school age — the sitter could not be much past six. The youngest of Gauguin's five children, his son Pola, whom he had not seen for five years, would have been six and a half in the summer of 1890. Moreover, the artist had learned in December that Pola, who lived with his mother in Copenhagen, had miraculously survived a fall from a third-floor window.[4]

Gauguin placed his diminutive subject in a sumptuously colored setting, one in keeping with the decorative, synthetist aims of his art in 1890. A pink-skirted chair, its upholstery a marvel of fanciful floral patterns, surrounds the child's deep blue costume. Each form — the white ruffled collar, the tendrils of brown hair, the violet bow or flower floating inexplicably on the back of the chair — enlivens the composition with crisp, irregular silhouettes. Gauguin placed stylized hydrangeas, which grow plentifully in Brittany throughout the summer, before a brilliant green field that is rendered in long, parallel brushstrokes and juxtaposed with an intense orange background for maximum chromatic impact. Though the green passage may imply a field of grass or a hydrangea bush, its identity and placement in space are ultimately ambiguous, like the abstract, curving backgrounds Gauguin often employed in his portraits.[5] These elements combine to establish a context in the natural world but, as with the artist's portrayals of his own children, they also evoke a child's realm of fantasy and imagination.[6]

M P

Haere pape

1892
Oil on canvas
35⅞ x 26⅛" (91.2 x 66.4 cm)
Signed and dated lower left: *P. Gauguin 92*
Inv. no. 109

Fig. 1. Borobudur relief: *The Tathagat Meets an Ajiwaka Monk on the Benares Road*; bottom: *Maitrakanyaka — Jakata. Arrival at Nadana*, photograph, c. 1880–89. Private collection.

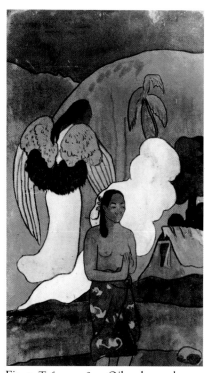

Fig. 2. *Te faruru*, 1892. Oil and gouache on cardboard. Museum of Fine Arts, Springfield, Massachusetts; James Philip Gray Collection.

During 1892 Gauguin created some of his most deeply symbolic paintings and sculpture based on Polynesian religion and folklore. *Haere pape*, however, which probably belongs to the second half of the year, illustrates no overtly narrative content and typifies the kind of genre painting Gauguin made throughout his first Tahitian voyage.[1] The Tahitian title of the work, characteristically inscribed on the painting, cannot literally be translated from Gauguin's idiosyncratic Tahitian, but it implies, "she goes down to the fresh water."[2] *Haere pape* represents a scene the artist would have frequently observed among a people who bathed several times a day — a young woman, drying herself with a towel beside a stream — and partakes of his numerous representations of women near or in the water.

This figure, a blue and yellow pareo wrapped around her waist, first appeared in one of the artist's best-known Tahitian paintings, *Ia orana Maria*, an unorthodox annunciation scene from late 1891 or early 1892.[3] One of the Tahitian women who greets the Virgin assumes this hieratic pose, her hands held directly upright in a gesture of prayer. In 1951, Bernard Dorival traced this pose to one of the figures (at the extreme upper left) in the Buddhist relief carvings of the Javanese temple at Borobudur, of which Gauguin owned two photographs (fig. 1).[4] As was his practice with many of the reproductions he took with him to Tahiti, whether of ethnographic material or of contemporary European painting, Gauguin freely appropriated motifs from these reliefs to generate imagery for his art. He then inventively transposed such stock figures from one composition to another, thereby investing them with new meaning. For example, in a small gouache and oil painting from 1892 (fig. 2), ironically titled *Te faruru* ("to make love"), he incorporated the figure again, this time as the Virgin herself.[5]

In *Haere pape* the woman stands on salmon-colored sand, in a landscape that zigzags back in space toward the horizon. She is silhouetted against a clump of distant trees that rise up behind her much like the white smoke in the gouache (fig. 2). Gauguin added a humorous note in the snakelike branch that threatens to "strike" the little gray and blue dog as it drinks from the stream.[6] The loose, varied paint handling is almost impressionistic in some passages, as is the pastel tonality of the palette, but the distinctive, puzzle-shaped reflections in the stream approach the nearly abstract color patterns Gauguin would invent to symbolize the mysterious, renewing powers of Tahiti's waters.[7] In his transformation of this Tahitian motif, Gauguin chose not to endow *Haere pape* with metaphysical import. What were praying hands now hold a towel. Yet a kind of fiction persists even in the artist's genre paintings, for he maintains the figure in a luminous, pristine landscape devoid of the encroaching presence of European civilization in Polynesia.

M P

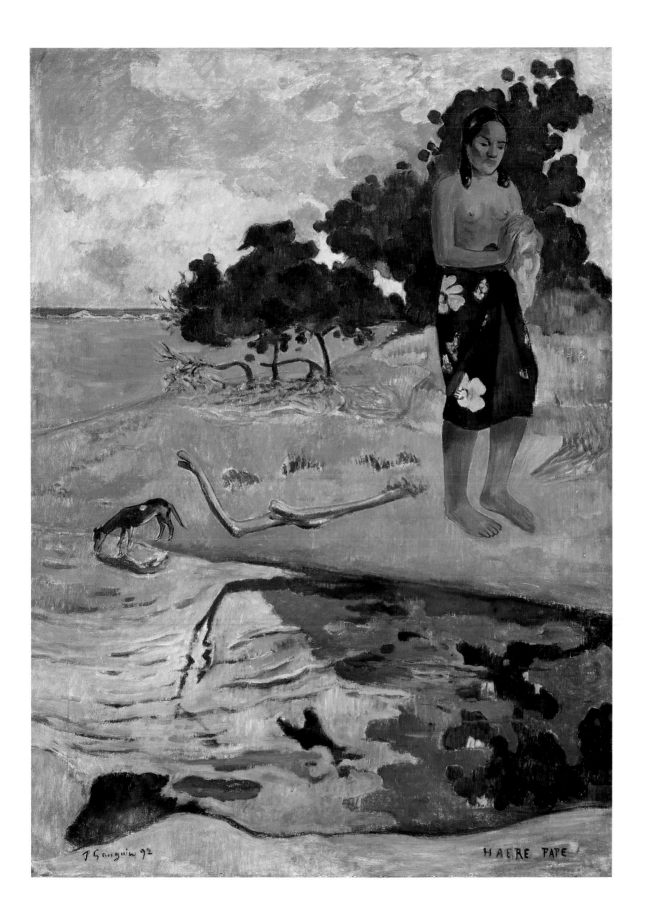

Joseph-Etienne Roulin

1889
Oil on canvas
26 x 21⅝" (66.2 x 55 cm)
Signed upper left: *Vincent*
Inv. no. 37

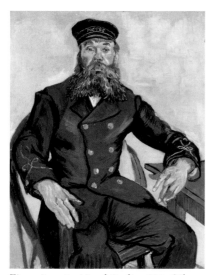

Fig. 1. *Portrait of Joseph Roulin*, 1888. Oil on canvas, 32 x 25¾" (81.2 x 65.3 cm). Museum of Fine Arts, Boston; Gift of Robert Treat Paine II.

Fig. 2. *Portrait of Joseph Roulin*, 1888. Oil on canvas, 25¼ x 18⅞" (64.1 x 47.9 cm). The Detroit Institute of Arts, Anonymous loan.

Between July 1888 and April 1889, Vincent van Gogh painted six portraits of Joseph-Etienne Roulin, the mail handler (*entreposeur des postes*) at the Arles railroad station. The postman, as van Gogh referred to him in his letters, was important to the artist both as a close friend and as the personification of the good-natured, well-intentioned people of Provence.[1] "Roulin," van Gogh wrote to his brother Theo in the spring of 1889, "though he is not quite old enough to be a father to me, nevertheless has a salient gravity and a tenderness for me such as an old soldier might have for a young one.... [He is] a man who is neither embittered, nor sad, nor perfect, nor happy, nor always irreproachably just. But such a good soul and so wise and so full of feeling and so trustful."[2]

Van Gogh and Roulin probably met in the Café de la Gare, where the artist rented a room from May until mid-September 1888, before moving to the so-called Yellow House not far from the house where Roulin lived with his wife and children at 10, rue de la Mont de Cordes. Van Gogh's first reference to Roulin appears in a letter of 28 July to the artist's sister Wilhelmina: "I am now engaged on a portrait of a postman in his dark blue uniform with yellow. A head somewhat like Socrates, hardly any nose at all, a high forehead, bald crown, little gray eyes, bright red chubby cheeks, a big salt-and-pepper beard, large ears. This man is an ardent republican and socialist, reasons quite well and knows a lot of things."[3] In a letter written to Theo the same day, the artist added: "A man more interesting than most."[4]

In late July and early August van Gogh painted the forty-seven-year-old Roulin seated in a chair (fig. 1) and also executed a head-and-shoulders portrait (fig. 2). In late November or early December he painted him again (fig. 3) when he did a series of portraits of Roulin, Madame Roulin, their two sons, and their baby daughter.

Van Gogh painted three additional bust-length portraits of Roulin, probably in early 1889 (including figs. 4, 5). Surprisingly, none is cited in van Gogh's correspondence of the winter of 1888–1889, which includes references to nearly every painting he did between December and April; consequently, we have no information about the exact dates and the sequence of the three portraits. However, since the backgrounds appear to be variations on the wallpaper pattern used in the five versions of the portrait of Roulin's wife known as *La Berceuse* (fig. 6)[5], painted between December 1888 and late March or early April 1889, as well as in the portrait of Dr. Felix Rey of early 1889 (Pushkin State Museum of Fine Arts, Moscow), scholars generally assign the three portraits of Roulin to the same period.[6]

Of the three versions, the example in the Museum of Modern Art is the most

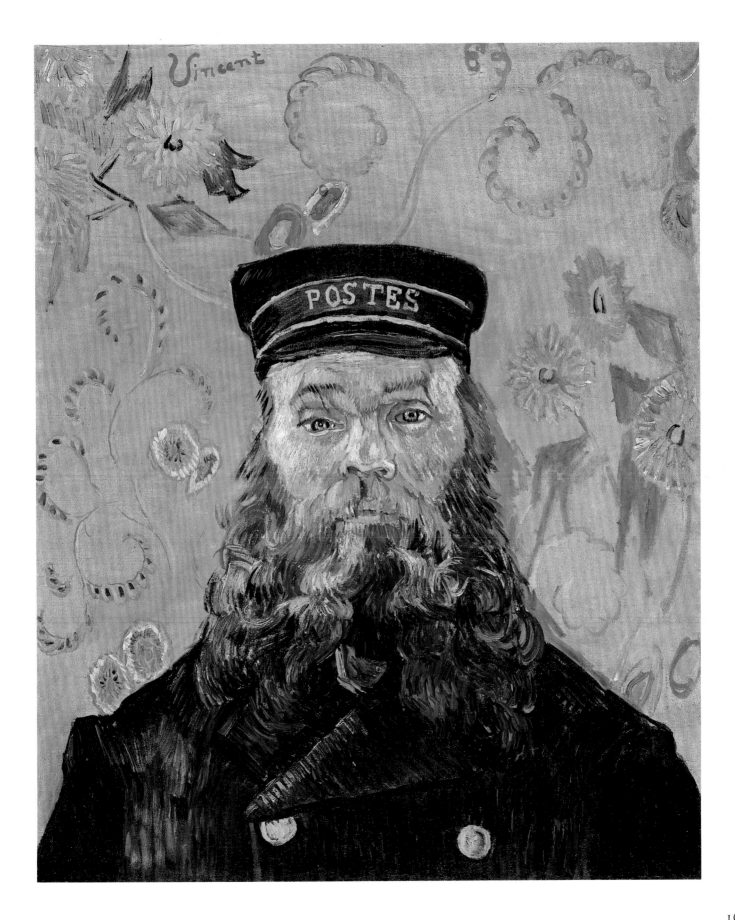

accomplished. Its thoroughly worked surface and more complex background reflect a degree of finish and resolution that sets it apart. The version in Otterlo is comparatively weak; it exhibits neither the confident resolve of the New York example nor the fresh palette and vigorous brushwork of the painting in the Barnes Foundation.7 It is possible that the Otterlo canvas is a variant made after one of the others, a practice that is not uncommon in van Gogh's work of 1888–1890. Indeed, it relates closely to the Barnes painting; in both, the wallpaper pattern used for the background includes the floral motif but not the fishscale pattern visible in the version in New York and the five versions of *La Berceuse*.

The portrait of Roulin in the Barnes Foundation is distinguished by four important characteristics. First, the palette is brighter and fresher than the others; as a result, it makes a stronger visual impression. Second, it is the only version that is signed. Third, although signed, it is perhaps unfinished; the brushstrokes of darker green to the right of Roulin's face and shoulder suggest that van Gogh considered changing the background to a color closer to that of the example in the Museum of Modern Art.

The fourth distinguishing characteristic, the color of the edging of Roulin's uniform, may allow us to identify the Barnes version as the last of the three. In van Gogh's letter of 28 July to his sister, he referred to Roulin's uniform as "dark blue ... with yellow." In another letter written about the same time, he again noted that color of the edging: "a blue uniform, trimmed with gold."8 In the New York and Otterlo versions the uniform has yellow or gold edging, but in the Barnes canvas it has navy blue or black edging. If this is in fact a different uniform, it is probably the one van Gogh referred to in a letter of about 22 January 1889, as having been worn by Roulin to his farewell party before he left for a new

Fig. 3. *Portrait of Joseph Roulin*, 1888. Oil on canvas, 25⅝ x 21¼" (65 x 54 cm). Kunstmuseum, Winterthur; Gift of the Heirs of Georg Reinhart, 1955.

Fig. 4. *Postman Roulin*, 1889. Oil on canvas, 25⅝ x 21¼" (65 x 54 cm). Collection: Rijksmuseum Kröller-Müller, Otterlo, The Netherlands.

Fig. 5. *Portrait of Joseph Roulin*, 1889. Oil on canvas, 25¼ x 21½" (64 x 54.5 cm). Collection, The Museum of Modern Art, New York. Gift of Mr. and Mrs. William A. M. Burden, Mr. and Mrs. Paul Rosenburg, Nelson A. Rockefeller, Mr. and Mrs. Armand Bartos, Sidney and Harriet Janis, Mr. and Mrs. Werner E. Josten, and Loula D. Lasker Bequest (by exchange).

post in Marseilles.[9] Should this be the case, the Barnes portrait was probably painted during one of Roulin's return visits to see his family on 28 January or in early April 1889. If van Gogh realized that the April visit was the last time that he would see his friend, he may have presented him with a signed portrait as a parting gift.[10]

Although we may never know the exact circumstances of the three portraits of Roulin, clearly the postman was of more than passing significance to van Gogh. The exceptional strength of Roulin's friendship and loyalty was never more apparent than in the days following the well-known episode just before Christmas in 1888 when, after a violent argument with Gauguin, van Gogh mutilated his own ear and presented the severed lobe to a prostitute at a bordello. Roulin and his wife visited van Gogh at the hospital during his confinement (Roulin was allowed to take van Gogh for a visit to the Yellow House on 4 January); he kept Theo informed about the artist's recovery; and he accompanied him when he was released from the hospital on 7 January (they had dinner together that evening).

The only individual who appears more often in paintings by van Gogh (except for the artist himself) is Roulin's wife. It is possible that van Gogh hoped to create an image that would convey a religious significance of the kind that he described to Theo in connection with one of the versions of *La Berceuse*. In portrayals of ordinary, common people van Gogh saw the potential for expressing a sense of spirituality or holiness. In short, the pantheistic vision that is more easily recognized in van Gogh's sowers, reapers, blossoming fruit trees, starry sky, and wheatfields may also extend to the people around him: "These people whom history tells us about, doges of Venice, Crusaders, apostles, holy women, were of the same character and lived in a manner analogous to that of their present descendants.

"And I must tell you — and you will see it in 'La Berceuse,' however much of a failure and however feeble that attempt may be — if I had the strength to continue, I should have made portraits of saints and holy women from life who would have seemed to belong to another age, and they would be middle-class women of the present day, and yet they would have had something in common with the very primitive Christians."[11]

<div style="text-align: right">C S M</div>

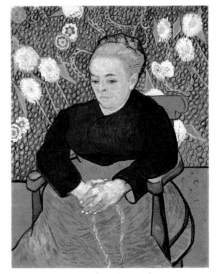

Fig. 6. *La Berceuse*, late December 1888 or early 1889. Oil on canvas, 36½ x 28⅝" (92.7 x 72.8 cm). Museum of Fine Arts, Boston.

Entrance to the Port of Honfleur (Entrée du port, Honfleur)

1886
Oil on canvas
21¼ x 25⅝" (54 x 65 cm)
Signed lower left: *Seurat*
Border painted on the canvas by Seurat.
Inv. no. 942

Fig. 1. *Channel of Gravelines, Petit Fort Philippe*, 1890. Oil on canvas, 29 x 36¼" (73.7 x 92.1 cm). Indianapolis Museum of Art, Gift of Mrs. James W. Fesler in memory of Daniel W. and Elizabeth C. Marmon.

After attracting both acclaim and scandal by exhibiting *Sunday Afternoon on the Island of La Grande Jatte* at the eighth and last impressionist exhibition, in May 1886, Seurat, the young newcomer to the Parisian avant-garde, left to work at a Channel port, as he did every summer during his brief career. That year he chose Honfleur, so often depicted by painters before and after him.[1]

This busy port was also an elegant holiday resort. Seurat consistently chose to paint its somewhat desolate and deserted areas rather than its more picturesque sites. The scene is virtually uninhabited. Sailboats appear immobilized by an eternal calm, and the steamboat *La Maria*, coming from Folkestone at full steam in the center of the painting, seems as if it will never arrive.[2] While the almost powdery technique of minute dots stills all movement, it also admirably transcribes the soft and lustrous northern light.

The seascapes painted by Seurat at Honfleur share a common peculiarity: in the foreground, a contrapuntal motif generally occurs — seemingly arbitrary, even ingenuous, in its compositional placement — at once realistic and foreign to the almost dreamlike setting. Here, a cruciform mooring post seems to threaten the entire scene. Elsewhere,[3] it might be a sailboat's encroaching stem, anchors, or another, even more pivotal mooring post (fig. 1). The powerful, solitary presence of these signs further accentuates an impression of melancholy, transparency, and immateriality, qualities that compose the peculiar spell of seascapes by Seurat.

Writers and poets of the day were particularly responsive to Seurat's maritime landscapes. J.-K. Huysmans, Paul Adam, and Emile Verhaeren all spoke of these works with admiration; Félix Fénéon, a militant supporter of neo-impressionism (and of Seurat in particular), summarized his thoughts in the mannered Mallarméan language of the time: "In their calm and melancholy, the seascapes of M. Seurat reach as far as the distant falling sky, lapping endlessly."[4] In reference to the Honfleur landscapes that Seurat exhibited in 1887, Fénéon spoke of "a style of breadth, of serenity, and of ineffable nuance."[5] He contrasted the seascapes by Seurat and Signac with those of the impressionists, who were interested in the fleeting instant; there, "straining to prove that the moment was unique results in a propensity for making nature grimace.... To synthesize an essential appearance that still preserves the sensation of a landscape, that is what the neo-impressionists endeavor to achieve."[6]

It is worth noting that in the year that these comments were published, Seurat probably gave *Entrance to the Port of Honfleur* to Félix Fénéon.[7]

F C

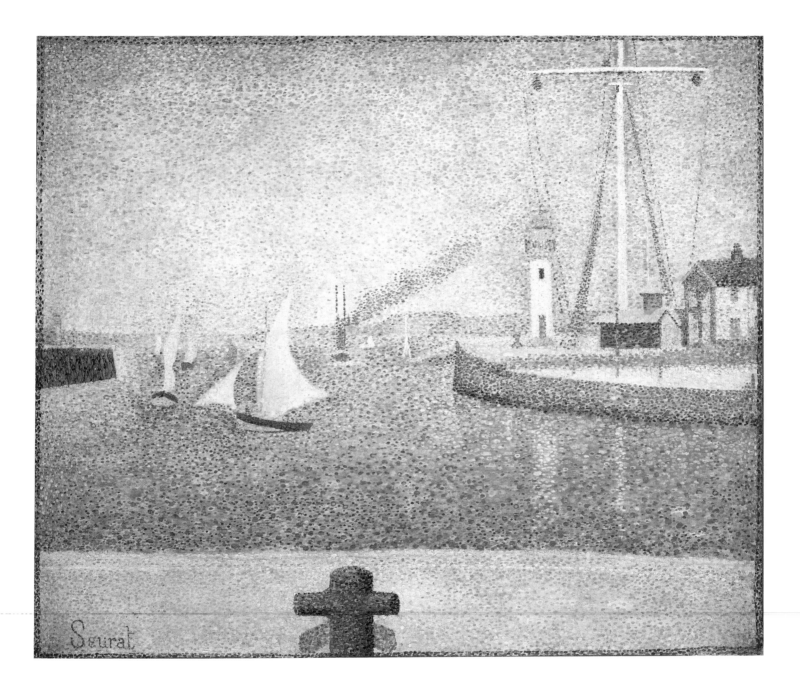

Seurat

173

Models (Poseuses)

1886–1888
Oil on canvas
78¾ x 98⅜″ (200 x 250 cm)
Signed lower right: *Seurat*
Border painted by Seurat
Inv. no. 811

Following *Bathers at Asnières* (1884) and *Sunday Afternoon on the Island of La Grande Jatte* (1884–1886), *Models*[1] is the third large picture that Seurat exhibited in public, and the second executed in his new pointillist — or "neo-impressionist" — manner. It was, until now, less famous and popular than the preceding two, only because it has been less looked at and studied, and was almost never reproduced. Nonetheless one of the artist's most ambitious works, *Models* is also among the most important paintings of his career, and one of the richest in interpretive possibilities, as significant for the history of modern painting as Cézanne's large *Bathers* or Picasso's *Demoiselles d'Avignon*.

This canvas is painted on the same monumental scale as the history paintings at the official Salon. Seurat's contemporary Arsène Alexandre wrote that it represented the young painter's attempt "to prove that his theory, which was so well-suited to subjects *en plein air*, was applicable to large-scale interiors with figures...."[2] In fact, in the context of *La Grande Jatte*, one objection to Seurat's technique had been that the pointillist system of contrasting color was suited, at best, to the representation of immaterial things — light, water or foliage, for example — but not the human figure. In the fall of 1886, then, this more traditional subject matter represented a distinct challenge to Seurat's revolutionary technique. Keeping within the confines of realism, the title clearly implies a depiction of contemporary models at work — or a single model in three separate stages of activity: disrobing, dressing, and posing. The scene can be precisely dated from accessories and hairstyles that were in fashion in 1886–1887, and also from the presence of *La Grande Jatte*, which is shown leaning against the studio wall within this painting, and which had been an object of scandal a few months before, at the last impressionist exhibition of 1886.

Nevertheless, the thematic connotations are abstract or indirect. One of many possible interpretations suggests that the picture represents a naturalist version — not without a certain wit — of the Three Graces: a side-by-side arrangement of three women in which the central figure is seen from the back, and those on either end face forward, or turn slightly in a three-quarter view (fig. 1). This antique sculpture had been widely copied since the Renaissance, and a plaster cast could be then found in any artist's studio. Seurat separated the original group and reversed the scheme, rotating the model in the center toward us. The process resembles Manet's transposition of allegorical figures from an engraving after Raphael into the modern world of *Luncheon on the Grass*. Here, the three slender demigoddesses have descended from the realm of myth into the Batignolles district, where they have become bored models.

Fig. 1. *Three Graces*, second century B. C. Marble Roman copy of an antique prototype. Musée du Louvre, Paris.

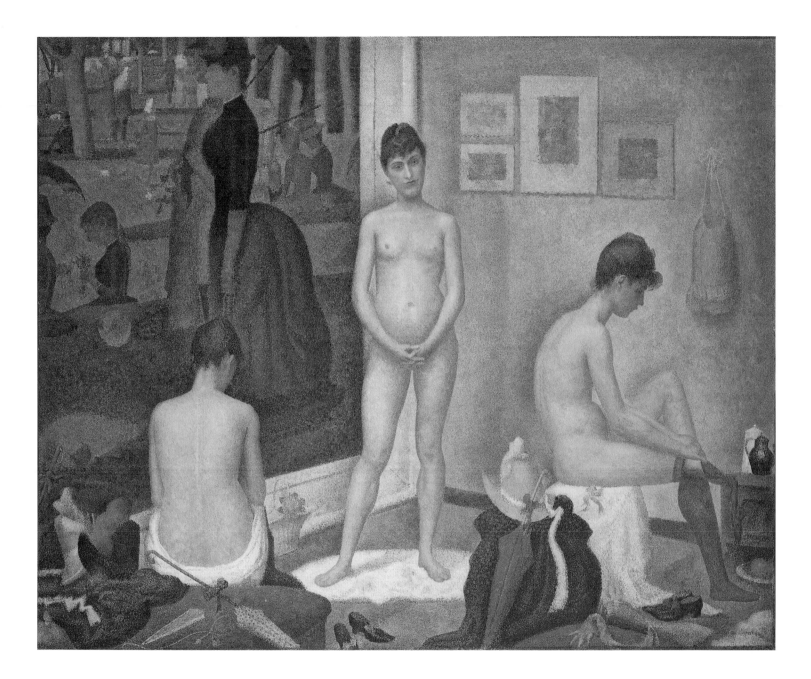

Seurat's context is commonplace: nudes in a studio before a painting that rests on the floor. But the artist exploits every possible connection between the two elements of his composition: the nude women might be models from *La Grande Jatte* — where they appear fully dressed — who have returned to the studio to disrobe. Strewn about the foreground are articles from the "painting-within-a-painting": the hats, shoes, parasols, and small basket of flowers that have been cast off by these women. Such elements tempt us to contemplate oppositions: dressed and undressed, truth and artifice, nature and culture, the captured instant of daily life and the timelessness of art.

Of course, we must also place the work in its aesthetic context: Seurat set out to prove that his "scientific" approach to composition and color was both important and practical. By adapting a theme through which he could revisit and reconceive academic norms, he at once defied official painting and challenged impressionism's emphasis on the ephemeral. This ambition was very difficult to sustain, and Seurat had great difficulty finishing the work: "Canvas with plaster very discouraging," he wrote to Signac. "Can't understand a thing. Everything stains — very heavy going."[3] Aside from the gesso ground (to which, it seems, he was not accustomed), the artist's principal challenge consisted of accommodating the pointillist idiom to large-scale painting in a more systematic fashion than he had managed to achieve thus far. In fact, we do see certain areas in which he applied enlarged touches of paint — red, for example, in the blue fabric at the lower right, or blue on the yellow parasol, lower left.

By implementing a technique that was thoroughly new and "scientific," but with accumulated references to great art of the past — from Greco-Roman to Raphael and Ingres (figs. 2, 3) — Seurat situated his painting within the grand tradition. Fénéon understood this well when he wrote that Seurat's *Models* "diminishes our memory of nudes in art galleries, and those of legend."[4]

This large masterpiece was a difficult work to sell. When an offer was made in Brussels in 1889, Seurat responded with proud reserve: "I find it very difficult to set a price for it. For expenses I count a year at seven francs per day: you can see where that gets me. In short, I'd say that the collector's personality can pay me the difference between his price and mine."[5] Diplomacy and a modest price were not enough to make the sale. After Seurat's death, the painting belonged to his friend, the symbolist poet Gustave Kahn, then to Count Kessler at Weimar, who hoped to give the work to the Berlin Museum.[6] Unfortunately, when the picture reappeared on the market, the original frame, which had been painted by Seurat, had been lost.[7] *Models* continued to pass through dealers in Paris and London, where it captivated artists and critics such as Picasso, Robert Delaunay, Guillaume Apollinaire, and Roger Fry.[8]

Finally, "this vast picture of superior, smiling serenity," already characterized in 1888 as "the most ambitious effort of the new art,"[9] entered the Barnes collection in 1926.

F C

Fig. 2. *Model from the Back*, 1887. Oil on canvas, 9⅝ x 6″ (24.5 x 15 cm). Musée d'Orsay, Paris.

Fig. 3. Ingres, *Bather of Valpinçon*, 1808. Oil on canvas, 57½ x 38⅜″ (146 x 97.5 cm). Musée du Louvre, Paris.

"A Montrouge" — Rosa La Rouge

1886–1887
Oil on canvas
28½ x 19¼" (72.3 x 49 cm)
Signed upper left: *H. T. Lautrec*
Inv. no. 263

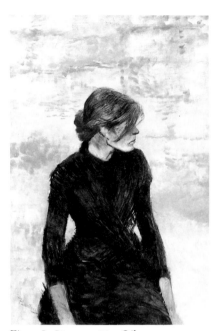

Fig. 1. *La Pierreuse*, 1889. Oil on canvas, 29⅛ x 19¾" (74 x 50 cm). Private collection.

Fig. 2. *La Blanchisseuse*, 1889. Oil on canvas, 37 x 30" (93 x 75 cm). Private collection, Northbrook, Illinois.

Nothing in Lautrec's background — he was from an old, aristocratic family of southwestern France — suggests that he would become a painter of Parisian life, especially that of Montmartre. Both his precocious gift as a draftsman and his being a cripple contributed to his pursuit of a career in art. Between 1882 and 1887, he attended the studio classes of the Salon painters Léon Bonnat and Fernand Cormon. His fellow students under Cormon, who included Anquetin, Emile Bernard, and van Gogh, encouraged him to work in a modern idiom.[1] His interest in the urban working-class was influenced by his friendship with Aristide Bruant,[2] a singer associated with the "Bohème" of Montmartre, a neighborhood popular for its dubious charm. In *"A Montrouge" — Rosa La Rouge*,[3] which was created at a crucial moment in the development of Lautrec's art, the artist's personal style is already clear; from this point on, his art would show an increasing concern with modern subject matter and freer technique.

The identification of the model has often caused confusion; the title contains a wordplay that has led some scholars to conclude that Rosa La Rouge and Carmen Gaudin — who infected Lautrec with syphilis — were one and the same, though the painter and historian François Gauzi, one of Lautrec's fellow students, clearly distinguishes between the two. When Lautrec met Carmen Gaudin on the avenue de Clichy, he was fascinated by her red hair,[4] and wanted "this young woman in simple clothes like a working girl" to become his model. Lautrec was attracted by this type of beauty, her common charm and "tough [hardened] appearance," as can be seen in several pictures[5] (fig. 1). Gauzi wrote that she "was punctual, very discreet, and long remained his favorite model. For him she was a laundress"[6] (fig. 2). Carmen not only embodied the working world, but more important, she was the model for Lautrec's first image of prostitution, a theme also favored by Degas. The naturalist and classical (timeless) images in Lautrec's work coincide with the poems sung by his friend Aristide Bruant. Some of his feminine portraits became veritable social stereotypes, evoking specific neighborhoods of Paris. *A Batignolles, A la Bastille, A Grenelle:*[7] these panels executed by Lautrec, illustrating Bruant's songs, were used to decorate the singer's cabaret, Le Mirliton.[8] In *A Montrouge*, Carmen represents the heroine from Bruant's *Refrains*, published in 1886:[9]

> It's Rosa . . . don't know where she comes from
> She has red hair, a dog's head . . .
> When she passes they say, here comes "Red,"
> At Montrouge.

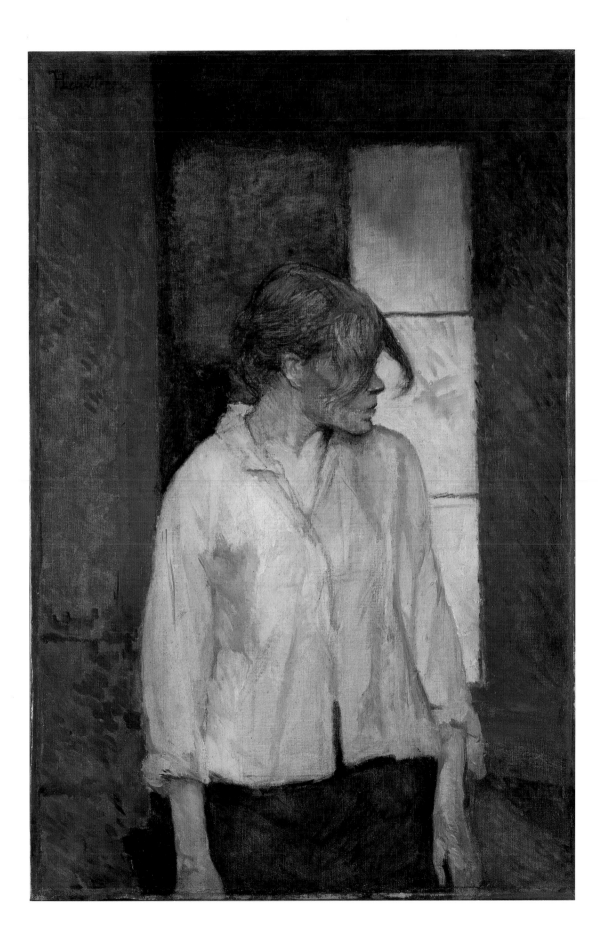

When she gets a "John" in a corner
Me, I'm right there...not far at all...
And the next day the cop finds some "red,"
 At Montrouge.

In a play on the meaning of Montrouge, the color red—which also has political implications—is echoed in the color of Rosa's lips and hair, and constitutes a forceful allusion to the blood that is spilled at the end of this sordid verse. Her torso faces us while her head is sharply turned away, as she looks over her shoulder.

Lautrec has reduced his palette to a Rembrandtesque tonality of tawny, neutral colors. While his early work had been characterized by a conventional sort of somber realism, his use of colored shadows now reflects the recent developments of impressionism.[10] With marvelous expertise, Lautrec concocts a milky tone, enlivened by large strokes of green, pink, and yellow. Deep shadows set off the model's pronounced chin and accent the slumped shoulders. The grid formed by the window panes makes the composition simple and blunt, and emphasizes the model's profile and striking red hair.[11] The seductive fascination of the model is concentrated on the set of the jaw, which is enhanced by the light.

Whenever he applied a new technique, Lautrec found a specific, appropriate style; for reproduction he transformed this particular painting into a simplified drawing. This line drawing appeared in the *Courrier Français* in June 1889 (fig. 3)[12] under the title "Boulevard Extérieur." Nonetheless, we cannot date this group of paintings to this year or 1888, as Joyant suggests,[13] since the Mirliton panels were completed in November 1887,[14] when Lautrec delivered photographs of them to Jules Roques, the editor of the review.

For this work, Lautrec probably used photographs furnished by Gauzi (fig. 4). In the photographs (or their negatives), the tonal values of the silhouette are lost against the background, a sharp contrast that Lautrec inverts in the painting. Photographs with the inscription "Carmen Gaudin 1887," written in Gauzi's hand, confirm this date, which corresponds to Lautrec's stylistic evolution.

A R

Fig. 3. *Boulevard Extérieur*, 1889. Printed in *Le Courrier Français*, June 1889. Private collection.

Fig. 4. Carmen Gaudin, photographed by François Gauzi. Private collection.

Reclining Nude (Nu couché)

1897
Oil on wood
12¹³⁄₁₆ x 16⅛″ (32.5 x 49 cm)
Signed lower left: *H. T. Lautrec*
Inv. no. 573

Fig. 1. *Crouching Woman with Red Hair*, 1897.
Oil on cardboard, 18¼ x 23⅝″ (46.4 x 60 cm).
San Diego Museum of Art.

The two Lautrecs acquired by Dr. Barnes are characteristic works: they evoke the artist's feminine world, and his preference for redheaded models.

With this nude,[1] Lautrec pursued a timeless theme that had occupied Titian (the *Venus of Urbino*) and Manet (*Olympia*), while avoiding the example of Alexandre Cabanel or Adolphe William Bouguereau, whose mythological nudes dominated the official Salons. Instead, he adopted the direct approach of Degas, producing a technical exercise that demonstrates his skills as a naturalist and a colorist. The model's unrestrained pose is accentuated by her relaxed attitude and indirect gaze. Like Degas' nudes, Lautrec's are not in agreement with traditional painting, in which the model "always assumed a studied pose, facing the spectator,"[2] nor do they make any concessions to the ideal. In this respect Lautrec is not unlike J.- K. Huysmans, whose list of locations and situations that justify a nude include: "the bed, the studio, the anatomy amphitheater, and the bath."[3]

Vibrant hatching in this work gives a tactile surface to the bed cover, and, through contrast, emphasizes the sensuality and subtle rendering of the flesh tones. Lautrec stresses the contours of the body with an elegant, expressive arabesque. In a play of complementary colors, the figure's redness enhances the blue of the divan; the rhythm of the cushions creates a three-beat compositional pulse. In its graphic power and coloration, this nude prefigures Matisse.[4]

One iconographic detail makes it possible to date this work: the divan and the hanging mats seem to be identical to the setting of the *Crouching Woman with Red Hair*,[5] dated 1897 (fig. 1). The background in these two studies suggests that these nudes were painted at Lautrec's residence on the avenue Frochot. In fact, a report describing the artist's memorable housewarming invitation of May 1897 to a "cup of milk" reveals that the walls were decorated with "straw mats."[6] According to Richard Thomson,[7] the same redheaded model probably posed for both paintings. Lautrec alludes to her in November 1897 as "a reliable model whom I was finally lucky enough to hire."[8] The painter confided to Yvette Guilbert his misgivings about "lifeless" models; a regular at the public brothels,[9] Lautrec had always preferred to paint prostitutes because "they are so alive."[10]

Among Lautrec's numerous representations of women, nudes are rare. The artist consistently shuns the drapery and modest gestures that tend to characterize the genre. Acquired by Barnes from Etienne Bignou,[11] this is one of the last nudes painted in Lautrec's brief career. After this late date of 1897, Lautrec's work grew darker and more thickly painted. Then, alcoholism was already beginning to take its toll, precipitating his premature death in 1901 at the age of thirty-seven.

A R

Unpleasant Surprise (Mauvaise surprise)

1901
Oil on canvas
76 x 51″ (193.2 x 129.5 cm)
Signed lower right: *Henri Rousseau*
Inv. no. 281

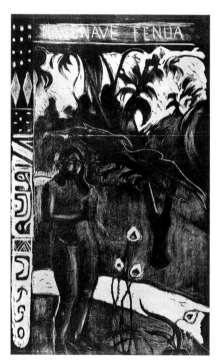

Fig. 1. Gauguin, *Nave Nave Fenua (Delight-ful Land)*, from the "Noa Noa Suite," 1894–95. Woodcut, 13⅞ x 7⅞ (35.2 x 20 cm). National Gallery of Art, Washington; Rosenwald Collection.

Fig. 2. Ingres, *Roger Rescuing Angelica*, 1817. Oil on canvas, 57⅞″ x 74¾″ (147 x 190 cm). Musée du Louvre, Paris.

This large painting is somewhat atypical within Rousseau's *oeuvre*.[1] It depicts a nude woman, facing us and raising her hands in a gesture of supplication. At her feet, a bear with protruding claws and open jaws strikes a menacing pose. The bear is being shot by a rifle-wielding hunter, who hides among the rocks. In the middle ground, beyond the sparse foliage of a tree, is a river or pond, landscape elements rarely seen in Rousseau's art. The drawing is diligent and precise; the shapes of the figures and vegetation seem cut from cardboard or cloth, like stage flats. Although the woman's silhouette recalls woodcuts by Gauguin (fig. 1), the subject remains unclear. Is it the woman who is surprised by the bear, or the other way around? This could be an illustration of the proverb, "It's a case of the biter bit."

In *Unpleasant Surprise*, Rousseau appears to adapt a rescue scene from classical iconography, such as Perseus and Andromeda or Roger and Angelica. Perhaps he was specifically reminded of Ingres' celebrated *Roger Rescuing Angelica*, in the Louvre (fig. 2); the subject was taken from *Orlando Furioso* by Ariosto (1474–1533), which was still familiar and well-read in the nineteenth century. We note, however, that Rousseau seems to reconceive the literary theme as an episode from popular melodrama or pantomime.

This picture was one of seven that Rousseau exhibited at the Salon des Indépendants of 1901,[2] where it was noticed by several critics. While some admired Rousseau's patience and sincerity, others were sarcastic: "I cannot, however, pass over in silence the *Unpleasant Surprise* offered to us by Henri Rousseau. It is a bear, by that fantasy-painter, about to devour a woman who is very poorly finished"[3] (a pun in French: "mal léchée" means poorly "finished" and, more literally, insufficiently "licked," suggesting that the woman in this painting is a victim of both the painter and the bear).

Renoir probably saw this painting in the shop of Ambroise Vollard, who had acquired it in 1909: "It's curious how disconcerted people are when they confront the qualities of a true painter. The Douanier Rousseau must exasperate them above all others! This scene from prehistoric times, and right in the middle, a hunter dressed in an outfit from the Belle Jardinière,[4] carrying a gun.... But isn't it possible to enjoy a painting for the harmony of the colors alone? Is it necessary to understand what it means? And what a lovely tonality, this canvas by Rousseau! Do you recall, face to face with a hunter, a naked woman?.... I'm certain that Ingres himself would not have disliked that."[5] Later, *Unpleasant Surprise* was included in the posthumous Rousseau retrospective exhibition held at the Salon des Indépendants in 1911.[6]

M H

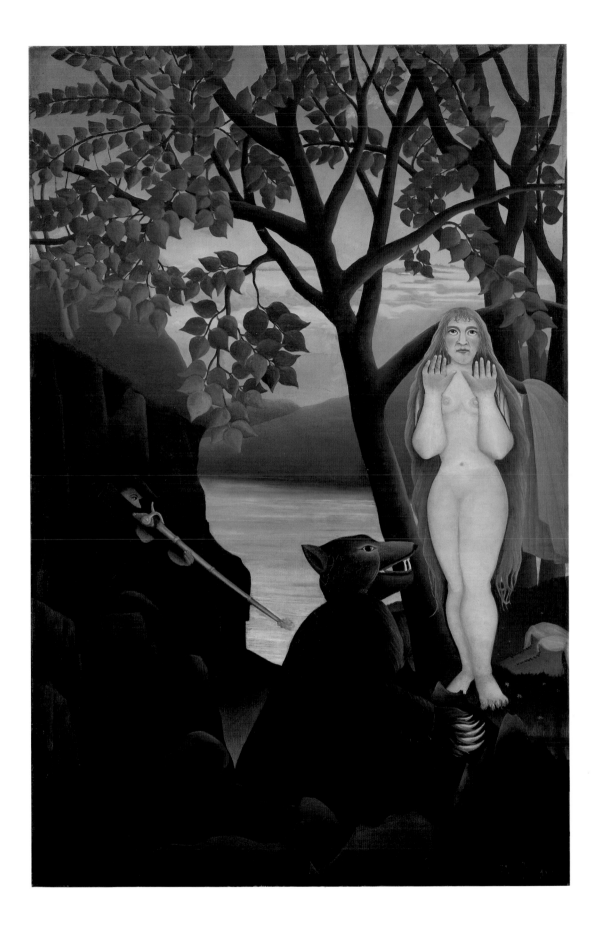

Scout Attacked by a Tiger (*Eclaireur attaqué par un tigre*)

1904
Oil on canvas
47⅜ x 63¾" (120.5 x 162 cm)
Signed lower right: *Henri Rousseau*
Inv. no. 584

Fig. 1. *The Jungle: Tiger Attacking a Buffalo*, 1908. Oil on canvas, 67¼ x 75⅜" (172.1 x 191.5 cm). The Cleveland Museum of Art, Gift of the Hanna Fund.

Though Rousseau's first tropical forest scene was painted in 1891, most of his celebrated jungle pictures were produced after 1904. The artist's predilection for portraying the untamed jungle is demonstrated by the number of works he devoted to this theme (close to twenty-five in all) and their meticulous execution. At the time, according to a legend propagated by Guillaume Apollinaire, it was believed that Rousseau's exoticism was the product of a trip to Mexico; in fact, his knowledge of exotic plants and animals was derived solely from the Jardin des Plantes in Paris, and from illustrations in picture books such as the *Bêtes Sauvages*, published by the Galeries Lafayette around 1900.

In his way, Rousseau expressed a common sentiment of the epoch, the urge to forsake the grim cities and inhuman surroundings of industrial civilization. While his contemporaries Gauguin and Rimbaud had abandoned Europe, Rousseau seems to have retreated into an interior world — alone in his studio or his customs office, he imagined the dramatic and dangerous exploits of adventurers in a strange land, as in *Scout Attacked by a Tiger*. The scout and the animals in this work are loosely inspired by Delacroix. Rousseau's many tigers[1] (fig. 1) are generally represented on a stiff diagonal line — the artist experienced difficulty positioning his figures and animals on the ground. According to an apt description by Roch Grey, the sister of the painter Serge Férat and one of Rousseau's early admirers: "Every image exists in remote relation to its own reality; both the scout's mule and the tiger that attacks it remain almost suspended in midair, just atop towering grasses that do not bend under their weight."[2]

The title that Rousseau himself gave to this work presents a problem. If the scout is leading the way, where is the regiment that should presumably be following him? In this regard, it is tempting to identify *The Tiger Hunt* in the Columbus Museum of Art[3] as a pendant, or the study for a pendant, given the considerable disparity in size. That work depicts a bivouac; one of the men wears the same white cloak, and the African saddle is identical in both pictures.

Scout Attacked by a Tiger was exhibited at the Salon des Indépendants in 1904.[4] In a formal portrait photograph taken around 1907 at his studio on the rue Perrel, Rousseau is shown seated before the work, suggesting a certain pride of place among the jungle pictures. The painting also appeared in a Rousseau exhibition at the Bernheim-Jeune gallery in 1912, where it was seen by Arthur B. Davies and Walt Kuhn, who tried to purchase or borrow it for the New York Armory show of 1913.[5]

M H

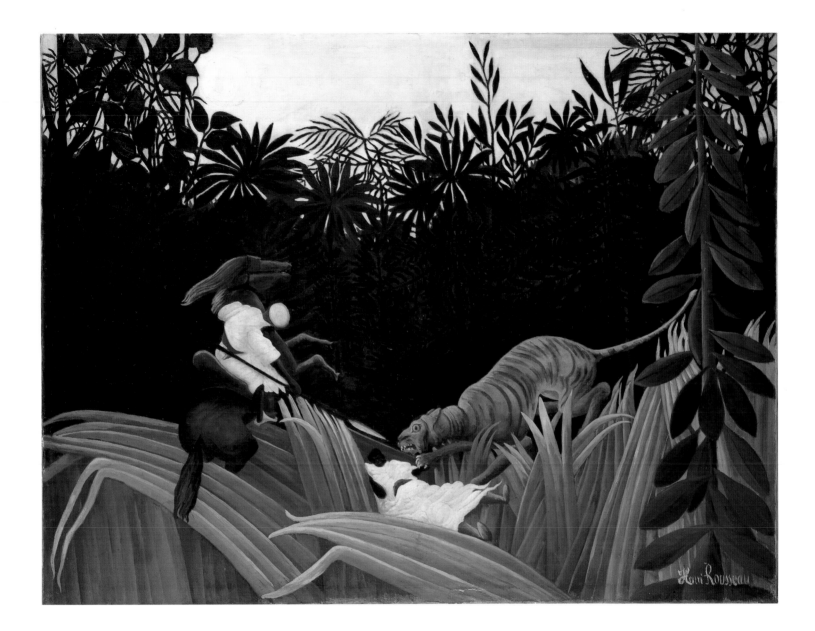

Woman Walking in an Exotic Forest (Femme se promenant dans une forêt exotique)

1905
Oil on canvas
39⅜ x 31¼" (99.9 x 80.7 cm)
Signed lower right: *Henri Rousseau*
Inv. no. 388

Fig. 1. *Exotic Landscape*, 1910. Oil on canvas, 51¼ x 64" (130.2 x 162.6 cm). The Norton Simon Foundation, Pasadena.

Fig. 2. *In the Forest*, c.1886. Oil on canvas, 27½ x 23¼" (70 x 60.5 cm). Kunsthaus Zürich.

Rousseau's subject matter is drawn from a startling variety of milieux, from the mundane to the exotic. At one extreme are cityscapes of modern Paris and townscapes on the Seine, an iconography of urban and rural life filtered through a sensibility of promise and good faith; at the other, equatorial jungles of extravagant foliage, inhabited by savages and savage beasts, both noble and cruel. In this remarkable picture, these two worlds are joined, and a strange poetry emerges from their contrast.

What is this woman doing in a tropical forest, wearing a stylish summer frock and surrounded by Rousseau's extravagant, eerily oversized plants? The odd circumstances resemble a dream. A string of enormous oranges (which were a luxury in Rousseau's time) brighten the dark-green tonality of the painting and create a tonal contrast that is unusual for the artist, though it appears again in *Exotic Landscape* (fig. 1).[1] At the upper right, several pale pink flowers pick up the color of the woman's dress, while a row of blue flowers completes the refined harmony of hues. However, the drawing of the figure is less skillful; Rousseau always had difficulty placing his characters' feet on the ground.

Another painting by Rousseau (*Woman in Red in the Forest*, Private collection, Paris)[2] depicts a woman with a large hat and a parasol, strolling in a forest of gigantic flowers. What were Rousseau's intentions? Why would he want to show a Parisian woman in her Sunday best against a backdrop of artificial decor? It is tempting to see these two paintings as related to *The Dream* (The Museum of Modern Art, New York). In that painting, one of the artist's most important, a woman appears in a tropical forest overgrown with flowers and marvelous fruits, and inhabited by human figures and animals. This woman, situated before an impenetrable screen of vegetation, could almost be an image of Rousseau himself, an isolated individual; in several other dreamlike paintings, Rousseau appears to identify with a solitary figure.

A third picture of a *promeneuse*, probably from a much earlier date (fig. 2), is set in a more temperate forest, while two other similar depictions of women walking (Musée d'Orsay, Paris, and Musée Picasso, Paris) occur in conventional surroundings. The models for these pictures cannot be identified with certainty, and their costumes do not allow us to date the paintings with any degree of precision, for Rousseau's figures were not necessarily dressed in contemporary clothes.

M H

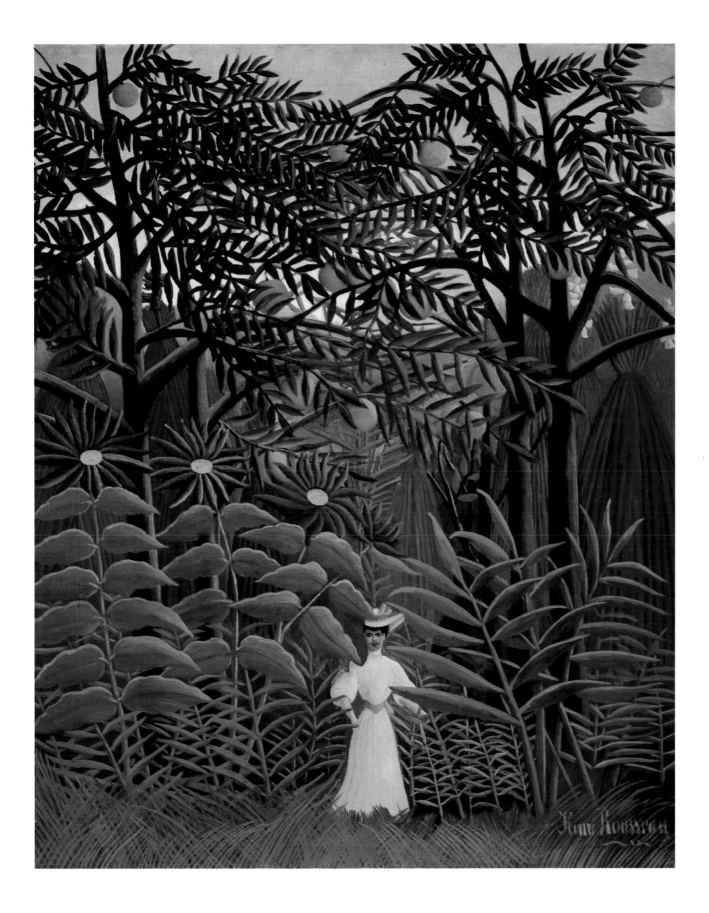

Woman with a Cigarette (La femme à la cigarette)[1]

1901
Oil on canvas
28¾ x 20″ (73.1 x 50.8 cm)
Signed upper left: *Picasso*
Inv. no. 348

Fig. 1. *"La Chata,"* 1899.
Pencil, watercolor, and
gouache on paper,
12½ x 3″ (31.6 x 7.6 cm).
Museu Picasso,
Barcelona.

In spite of her cigarette, this woman is not a disreputable sort, like the terrible procuress "La Chata"[2] (fig. 1) whom Picasso caricatured in Málaga in 1899. She is not, to judge from the modesty of her attire, one of those overdressed *demimondaines* that he so often depicted in Madrid and Paris in 1901;[3] nor is she one of those derelict women seated at a table with a glass of absinthe, prisoners of a solitude that encloses them like the stranglehold of their own arms.[4]

This figure is probably a portrait rather than a character type, for her gaze is direct, and certain facial characteristics are precisely described — the slight fleshiness of the lower part of the face, for example, and the delicate violet circles around the eyes. Surely it is this quality that guided Paul Eluard in 1944, when he selected *Woman with a Cigarette* to illustrate his book *A Pablo Picasso*, where the artist's portraits are described as "mirrors of truth."[5]

In this work, the painter was able to dispense with the usual pictorial motifs — bistro table, siphon bottle, and glass — that would have permitted us to place this woman, specifying what and where she is. In this way, he presents her to us as she presents herself: frank and uninhibited, though her expression is not innocent or completely trusting.

Picasso's debt to Toulouse-Lautrec is well known, and critics did not fail to observe it at the time (see Félicien Fagus, in his review for *La Revue blanche* of Picasso's first exhibition in Paris with Ambroise Vollard, early in the summer of 1901).[6] One can only be delighted, then, to find that Lautrec did depict a *Woman Smoking a Cigarette* (fig. 2), in which an undeniable resemblance — if not an established kinship — can be remarked.

For those who know the phases of his career, this is one of those works that herald a new direction in Picasso's oeuvre. The incandescent exuberance of color that characterized most of the pictures exhibited at Vollard — "Like all uncompromising painters," Fagus said, "[Picasso] adores color for its own sake"[7] — has been replaced by a restricted range that is largely dominated by blue. Moreover, the Barnes painting already reveals early signs of a mannerist style that will develop over the next three or four years; in this regard, the pale, elongated hands assume a singular importance. The blue period is imminent.

H S

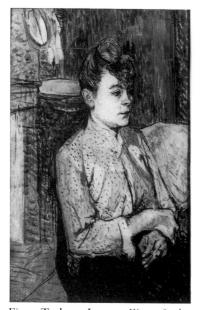

Fig. 2. Toulouse-Lautrec, *Woman Smoking a Cigarette*, 1890. Pierre noire, oil, and gouache on cardboard, 18½ x 11¾ (47 x 30 cm). The Brooklyn Museum.

The Ascetic (L'ascète)¹

1903
Oil on canvas
46⅝ x 31¼″ (118.4 x 80.8 cm)
Signed upper left: *Picasso*
Inv. no. 318

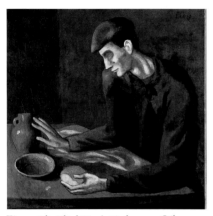

Fig. 1. *The Blind Man's Meal*, 1903. Oil on canvas, 37½ x 37¼″ (95.3 x 94.6 cm). The Metropolitan Museum of Art, New York.

Fig. 2. *The Frugal Repast*, 1904. Etching on a zinc plate, 18¼ x 18¾″ (46.3 x 37.7 cm). Musée Picasso, Paris.

Since his exhibition for Vollard had been a success, it is difficult to say why the twenty-year-old Picasso abandoned the dazzling palette and exuberant subject matter that had already come to characterize his work. According to the artist, the suicide of one of his friends marked the sudden onset of the blue period: "I started painting in blue when I learned of Casagemas's death."[2] As he would later recall, this decision was not favored by success: "It was only later, when I set about to do blue paintings, that things went really badly."[3] In fact, an inner necessity drove him toward this *Nekya*, the hellish descent that, in 1932, C. G. Jung described as a veritable pathology.[4] It seems, in any case, that Picasso derived a kind of moral philosophy from the tragedy: "He believes," Jaime Sabartés would relate, "that Art is the offspring of Sadness and Suffering (and we agree). He believes that sadness lends itself to meditation and that suffering is the basis of life"[5] — a notion that was probably not foreign to the poet Max Jacob, a close friend from the early years in Paris, who would never waver in his conviction that "suffering constitutes the soul's well-being."[6]

Thus, at the same time that he developed this monochromy of sadness, Picasso chose suffering humanity as a theme that was both appropriate and specific: prostrate beggar women, syphilitic prostitutes observed at the Saint-Lazare prison in Paris, mothers and children who are defeated and alone, couples in the throes of joyless and hopeless love.

The blows dealt to the body by disease, solitude, and poverty, as well as the decrepitude of old age, can be seen especially in four canvases of 1903 — that is, at the height of the blue period, which began in fall of 1901 and continued to 1904. These are all closely related in concept and treatment: *The Old Jew*, *The Blind Man's Meal* (fig. 1), *The Old Guitar Player*,[7] and *The Ascetic*. The monochromy of the last of these is severe — "an extreme point in the artist's addiction to blues," writes John Richardson[8] — scarcely illuminated by the livid pallor of cadaverous flesh. The effect is heightened by the encroaching presence of a formless shadow in the background, which doubles the size of the starving old man. Further, anatomical distortions — facial dissymmetry, painfully hollow shoulders and rib cage, and elongated, emaciated fingers — accentuate the pathos and decay of the suffering body.

It is clear that this unfortunate figure is not ascetic by choice, for no mystical flame illuminates his famished gaze; as in *The Frugal Repast* (fig. 2), etched the following year,[9] this poverty is inexorable. Less a gaze, in fact, than a paradoxical, open-eyed blindness, his vacant expression makes him a table companion for *The Blind Man's Meal* — the same crust of bread, the same carafe, the same empty vessel — at which he shares the bread and water of those condemned to misery.

H S

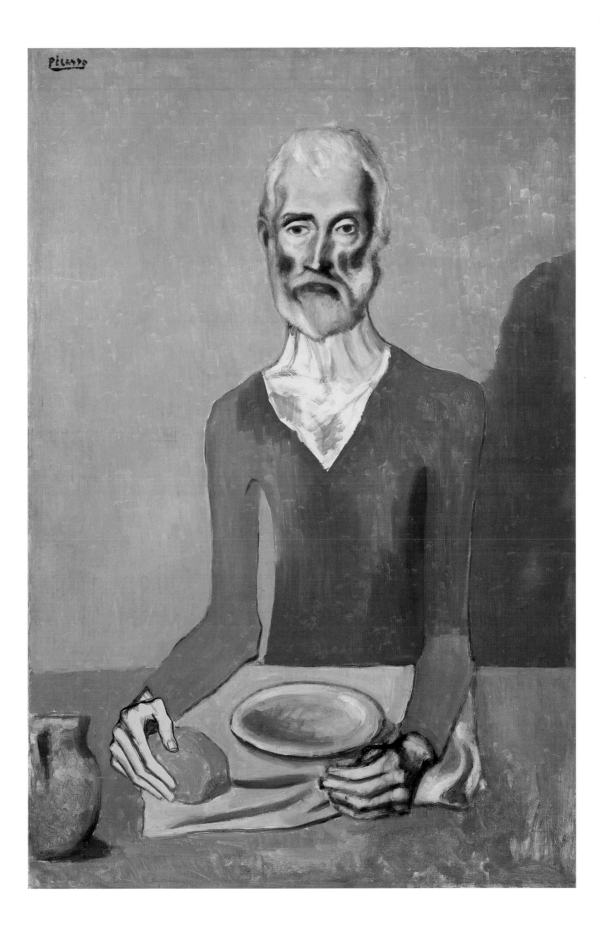

Acrobat and Young Harlequin (Acrobate et jeune Arlequin)

1905
Oil on canvas
74⅞ x 42⅝″ (190.3 x 107.8 cm)
Signed and dated lower right: *Picasso 1905*
Inv. no. 382

The *Acrobat and Young Harlequin* is one of Picasso's largest canvases devoted to the circus and *fête foraine*, a subject from which he drew much of his imagery during the rose period of 1904–1906.[1] Transcribed in part from his firsthand experience of itinerant fairground entertainment in Montmartre, these *saltimbanques* also belong to a broad period iconography of the vagabond performing artist — and the artist in general — as estranged bohemian outcast. As such, they are familiar to us from the verse of Baudelaire, Verlaine, Laforgue, and Apollinaire, where *saltimbanques* and related characters from the *commedia dell'arte* embody creative genius and alienated melancholy.[2] In Picasso, the slender body types, delicate gestures, and refined facial features lend a quasi-aristocratic mien to figures such as the *Acrobat and Young Harlequin*; their emaciation is idealized, a conflation of poverty and grace as physical and spiritual states of being. The work also shares its fin-de-siècle air of ennui with contemporary accounts of fairground culture, in which the *saltimbanque* was sentimentalized as a kind of *vanitas* motif.

> An imaginative clown, a faultless mime, a daring gymnast, a precise juggler: how is he inferior to a poet or musician? They both draw from the same sources and the same laws rule their art.... But, as they say, the work of one remains, while that of the other is fleeting. Ah, what does it matter?! Are not the most fugitive things also the most beautiful?[3]

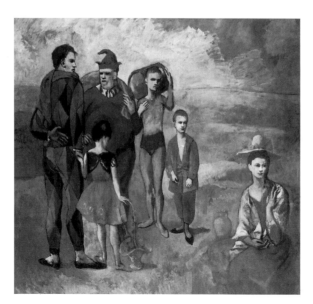

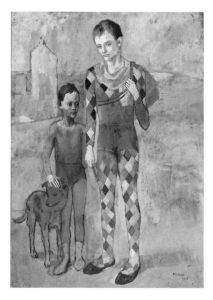

Fig. 1. *Family of Saltimbanques*, 1905. Oil on canvas (83¼ x 90⅜″ (212.8 x 229.6 cm). National Gallery of Art, Washington, Chester Dale Collection.

Fig. 2. *Two Acrobats with a Dog*, Spring 1905. Gouache on cardboard, 41½ x 29½″ (105.4 x 74.9 cm). Collection, The Museum of Modern Art, New York. Gift of Mr. and Mrs. William A. M. Burden.

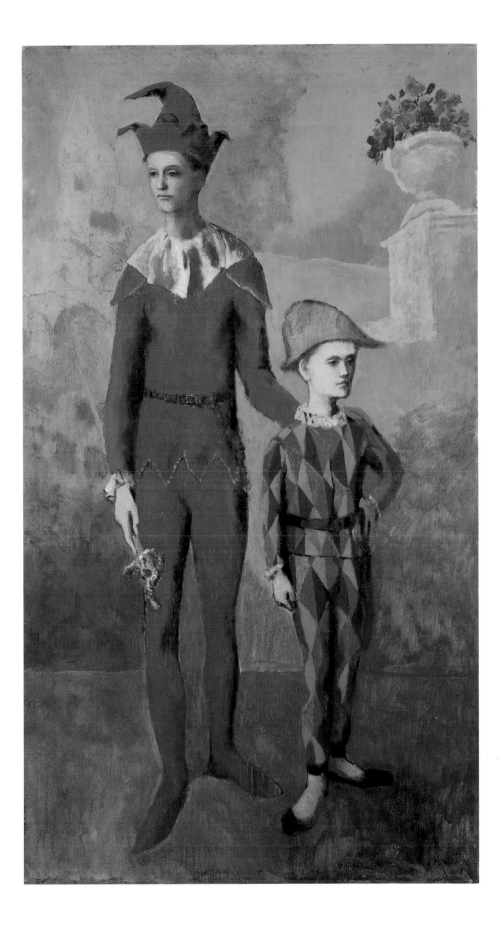

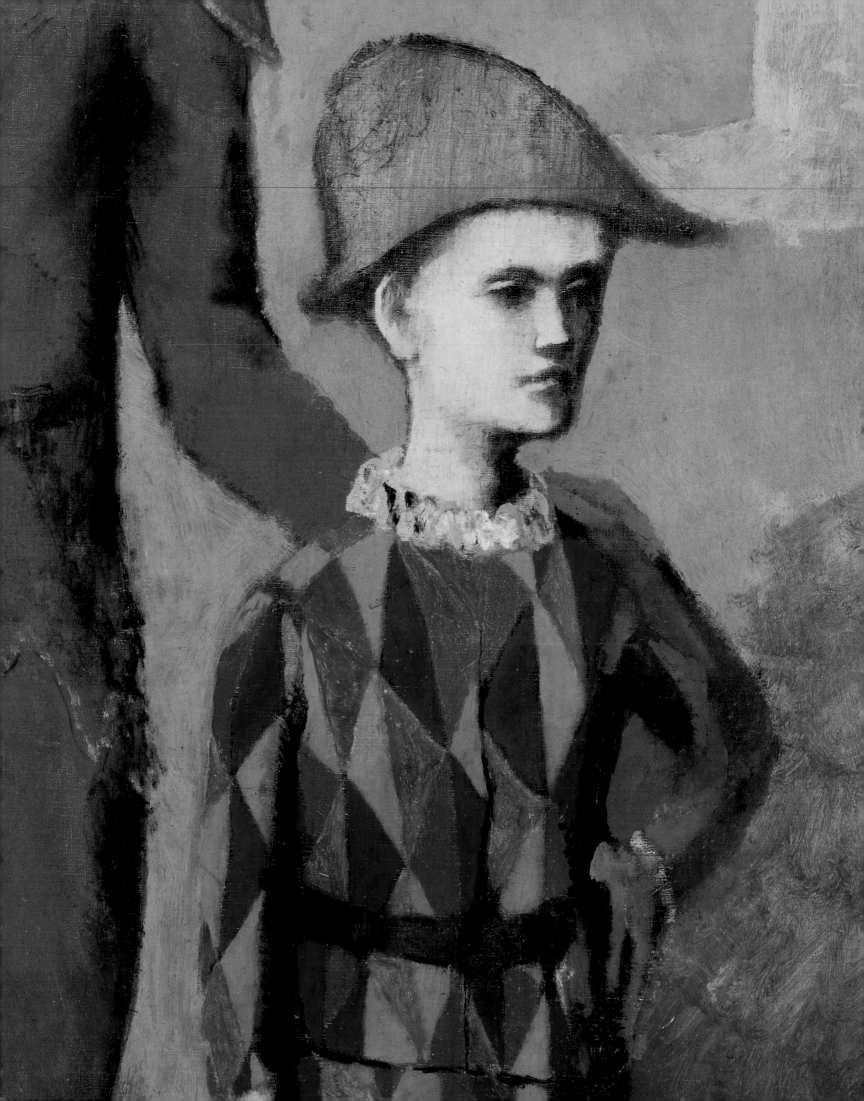

The picture is clearly related in style and iconography to Picasso's grand *Family of Saltimbanques* (fig. 1). As E. A. Carmean has shown, two previous compositions lurk beneath that large work; one of these, a reverse image of Picasso's gouache *Two Acrobats with a Dog* (fig. 2), echoes the two youths in the Barnes painting.[4] Variations on this pair occur throughout 1905 (fig. 3), including the center of the *Family of Saltimbanques* itself, though their costumes change.[5] Indeed, the scale of *Acrobat and Young Harlequin* suggests that, rather than abandon his project for a monumental two-figure composition, Picasso transferred it to a more accommodating vertical format. In the process, the performers have been relocated to a shallow stage, their stark setting converted into a painted backdrop and enlivened by an urn with flowers. This *mise-en-scène* probably represents the kind of small, traveling outdoor theater at which drama, vaudeville, and farce were played on the public square.[6] While neither the Harlequin nor jester costume appears to have been common to fairground or circus productions of the epoch, Harlequin appears throughout contemporary popular illustration and literature. One additional source for Picasso may have been the Harlequins painted by Cézanne c. 1890, isolated, full-length representations that the artist probably saw at Vollard's gallery in 1905.[7]

Acrobat and Young Harlequin may be the painting that Picasso shipped to Venice in March 1905 for the Biennale (from which it was rejected).[8] This suggests that the work should be dated to early that year.

JSW

Fig. 3. *Comedian and Child*, 1905. Gouache and pastel on board, 27½ x 20″ (69.7 x 51 cm). The National Museum of Art, Osaka.

The Girl with a Goat (La jeune fille à la chèvre)[1]

1906
Oil on canvas
53¼ x 40⅛" (139 x 102 cm)
Signed lower left: *Picasso*
Inv. no. 250

Fig. 1. *Woman at Her Toilette*, 1906. Pen, ink, and watercolor on the back of an advertising label for Crème Simon, 2¾ x 2" (7 x 5 cm). Musée Picasso, Paris.

Fig. 2. *Study for "The Girl with a Goat,"* 1906. Graphite on a sketchbook page, 5⅛ x 7¼" (13 x 18.5 cm). Musée Picasso, Paris.

According to an account by Picasso's companion Fernande Olivier, their visit to Gósol during the summer of 1906 was a delight. The artist's financial difficulties had been temporarily allayed by Ambroise Vollard, who had recently purchased some twenty paintings, and thus Picasso, who had not visited his native land for two years, was enabled to travel to this village deep in the Pyrenees near Val d'Andorre. The return to nature, where Picasso regained his health and spirits, bore fruit. Over the course of several weeks,[2] his output was considerable; the monumental nudes of adolescents[3] and women, including Fernande herself,[4] justify the epithet ("flesh period") that is sometimes used in reference to the work from Gósol.[5]

The Girl with a Goat is echoed in several contemporaneous pictures, including *The Harem*,[6] where — like obsessive variations on a theme — multiple versions of the girl appear in the form of other posing nudes; and *The Toilette*,[7] where a second model holds a mirror before which, with both arms raised, she fixes her hair. Apparently, this figure satisfied Picasso, and it pleased him to reproduce it.

Several sketches and watercolor studies can be linked to the development of this painting. Some are on separate sheets, such as the small *Woman at Her Toilette*, inscribed in a cameolike oval[8] (fig. 1); others occur in the pages of Picasso's sketchbooks from Gósol. The so-called *Carnet Catalan*,[9] for example, contains separate studies of the girl, the child, and the goat, as well as a lively group sketch, invigorated by a nervous drawing style, in which the girl looks in a mirror to confirm the pleasing effect of her pose (fig. 2).[10]

In the large composition, the representation is more formal and hieratic. These qualities are further reinforced by the verticality of the background curtain and the striking elongation of the girl's body. We cannot fail to detect two models here: that of Ingres, a rich source for Picasso, who had discovered the *Turkish Bath* at the Salon d'Automne of 1905;[11] and that of the antique, reflected in the Cupid who playfully imitates the engaging gesture of a *canephorus*. It is amusing, in this case, to find a winged Cupid from an advertisement for beauty cream on the back of the small *Woman at Her Toilette*. Further, a more explicit affinity has been observed between the graceful, elongated body type of the girl and certain *Flying Eros* statuary figures from Myrina, now in the Louvre.[12]

What accounts for the mysterious, vaguely equivocal appeal of this picture? One factor is the strange gathering itself: an animal appraising the prepubescent girl, whose body expresses modesty and reserve, in contrast to the indifference of the little boy.[13] Still more compelling is the sensation of latent sexuality;[14] as yet concealed within these immature bodies, it will reveal itself shamelessly once the threshold of initiation — represented here by the parted drapes — has been crossed into *Les demoiselles d'Avignon*. H S

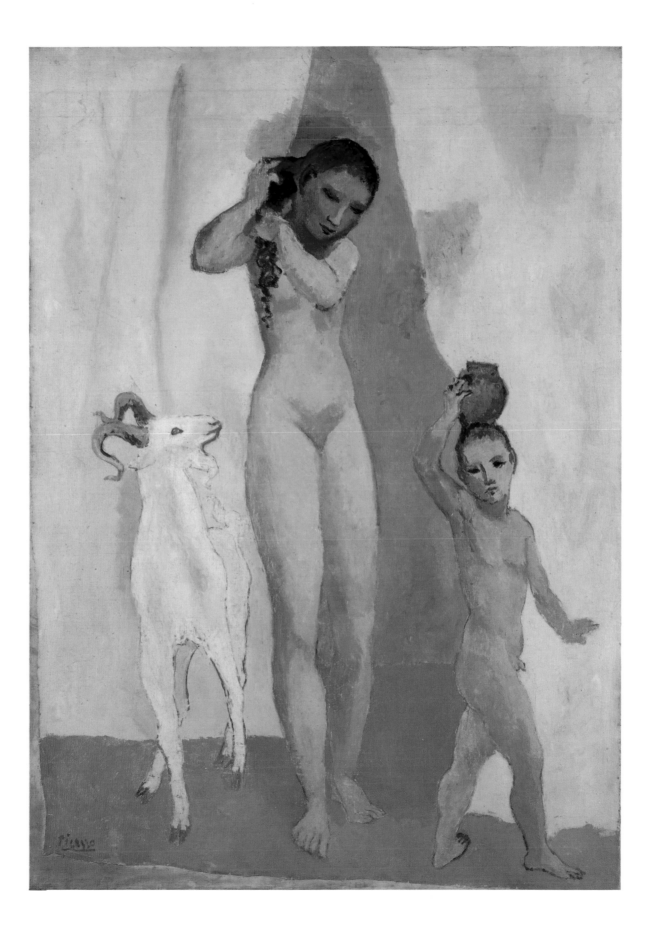

Composition: The Peasants (Composition: les paysans)

1906
Oil on canvas
86⅝ x 51⅝″ (220 x 131 cm)
Inv. no. 140

Fig. 1. Letter from Picasso to Leo and Gertrude Stein, 17 August 1906, with sketch for *Composition: The Peasants*. Pen and ink on paper, dimensions of sketch 7⅛ x 4¾″ (18 x 12 cm). Beinecke Rare Book Library, Yale University, New Haven.

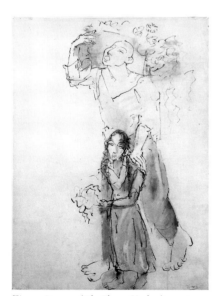

Fig. 2. *Paysans (The Flower Vendors)*, 1906. Ink and watercolor on paper, 24½ x 18⅜″ (62.2 x 46.7 cm). Art Gallery of Ontario, Toronto, Gift of Sam and Ayala Zacks, 1970.

The monumental *Composition: The Peasants* was executed by Picasso in 1906 upon his return to Paris from Gósol, a small village in the Spanish Pyrenees where, with Fernande Olivier, he had passed the summer months.[1] A letter from Picasso and Fernande to Leo and Gertrude Stein written in Paris on 17 August includes a sketch of the picture (fig. 1), which Picasso says he is "in the process of making." The figures are described in the letter simply as a man and a little girl who carry flowers, though the painting is sometimes referred to as *The Flower Sellers* or *The Blind Flower Merchant*. When it was exhibited in Roger Fry's second post-impressionist exhibition of 1912 at the Grafton Galleries in London, the work was labeled *Composition*, a title that Picasso appears to have confirmed years later.[2] We should note, of course, that Picasso was notoriously unforthcoming on matters of iconography in his work; the generic title *Composition* may well have been a device with which the artist intended to frustrate harassing inquiries over "proper" interpretation. Nonetheless, preliminary sketches for the picture were probably created in Spain, and seem to represent an indigenous peasant subject of some kind.[3]

Though the image of an oxherd appears at least once in Picasso's prior work at Gósol, most drawings for *Composition: The Peasants* feature the two figures alone (fig. 2), suggesting that the oxen were a late addition. To confuse matters, one color sketch sets the figures in Montmartre, overlooking Paris with a distant view of the Eiffel Tower (fig. 3). There, the presence of a female Harlequin implies a spirited, parodic dress-up version of the work that resembles the posters of Jules Chéret (fig. 4), ubiquitous period images of costume balls, music halls, and other forms of Parisian popular entertainment. Ultimately, the significance of the final painting remains obscure, though the specific incongruity of elements such as the oxen and flowers connotes a particular custom or folkloric source.[4]

Stylistically, *Composition: The Peasants* represents a critical anomaly in Picasso's oeuvre. During the summer of 1906, Picasso embraced a formal and iconographic language of pagan classicism. In conspicuous contrast to the vulnerability of the *saltimbanques* from the preceding rose period, the nude youths of Gósol achieve new weight and serene poise, with rounded silhouettes and contained gestures that are firmly bound by a fluid contour line. The rustic mountain village milieu is evoked as an arid Arcadia, warmly lit by an earthy palette of ocher and gold. After Picasso's return from Spain, and through the winter of 1906–1907, the new figural canon would grow increasingly stolid and robust, and physiognomy would be further schematized according to the reductivist model of antique Iberian sculpture. Coming as it does during this episode of stylistic archaism, *Composition: The Peasants* marks a striking interval. Only the oxen, which recall the shallow Assyrian relief sculpture that Picasso might have seen in the Louvre, retain the linear profile. The extreme

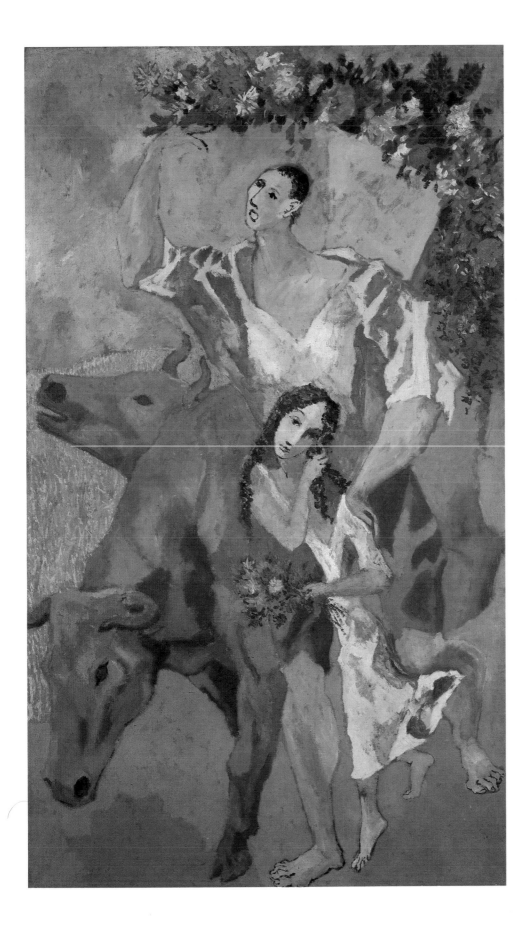

Fig. 3. *Figure Study*, 1906. Watercolor and red chalk on paper, 11¾ x 9¼" (30 x 23.5 cm). Collection Marina Picasso.

Fig. 4. Chéret, *Folies-Bergère "Le Miroir,"* 1892. Lithographic poster, 46½ x 32¼" (118 x 82 cm).

attenuation of the two peasants — the girl's meager midsection, the man's small head and tapering arms — severely contradicts the proportions established at Gósol, while their dynamism deviates from the composure that governs most other works of the period. The composition is drastically compressed, with peasants and oxen virtually competing to occupy the same shallow space, and the abstract effect of flattened volume is augmented by the faceted flicker of lights and darks across their crumpled surfaces.

These qualities of figural and spatial distortion have led scholars to observe that *Composition: The Peasants* heralds the radical all-over patterning of Picasso's *Demoiselles d'Avignon* (and by extension, certain characteristics of cubism). Moreover, since Alfred Barr's account in 1946, the stylistic peculiarities of the Barnes picture have been attributed to a second model from Picasso's native Spain, the works of El Greco.[5] He first borrowed El Greco's attenuated figural type during the late 1890s, returning to it for the manneristic blue period of 1901–1904. As John Richardson has shown, Picasso's acquaintance with the sixteenth-century master was cultivated among his Spanish friends, including Ignacio Zuloaga, who collected El Greco, and Miguel Utrillo, who wrote about him.[6] In fact, Picasso's return to El Greco in 1906 was probably motivated by Utrillo's monograph on the painter, which was published in Barcelona that year. More specifically, it is assumed that *Composition: The Peasants* is loosely based on El Greco's *Saint Joseph and the Christ Child*, which was reproduced in Utrillo's book, though Picasso's giant is, in gesture, torsion, and gait, virtually the mirror image of a parcel-carrying female figure at the far right of another illustration, the *Expulsion from the Temple*. Ultimately, the canon of figural proportions and the abstracted folds of drapery are salient features of El Greco's vision, which Picasso could have derived from any number of examples.

The literature on El Greco around 1906 reveals an appreciation that may have advanced Picasso's devotion to the artist as a spiritual ancestor. In the magazine *Les Arts*, Paul Lafond describes El Greco as a visionary thinker whose painting is almost primordial in its raw emotional depth, yet wholly original in its exalted stylization of the natural world. Significantly, the pictures are said to lack completion (*achèvement*) in the technical sense, redefining finish as a function of overall effect or meaning. An enemy of convention, El Greco is portrayed as an outsider, having attained summits by pursuing an untraveled path.[7] In this modernist characterization, El Greco bears a startling resemblance to Picasso's other favored master during the period, Cézanne, whose impact on his work was mounting at that time. Both revered for their unyielding devotion to a highly personal aesthetic vision, the two painters were potent figures of self-identification for Picasso during a critical moment of transition in his career.

J S W

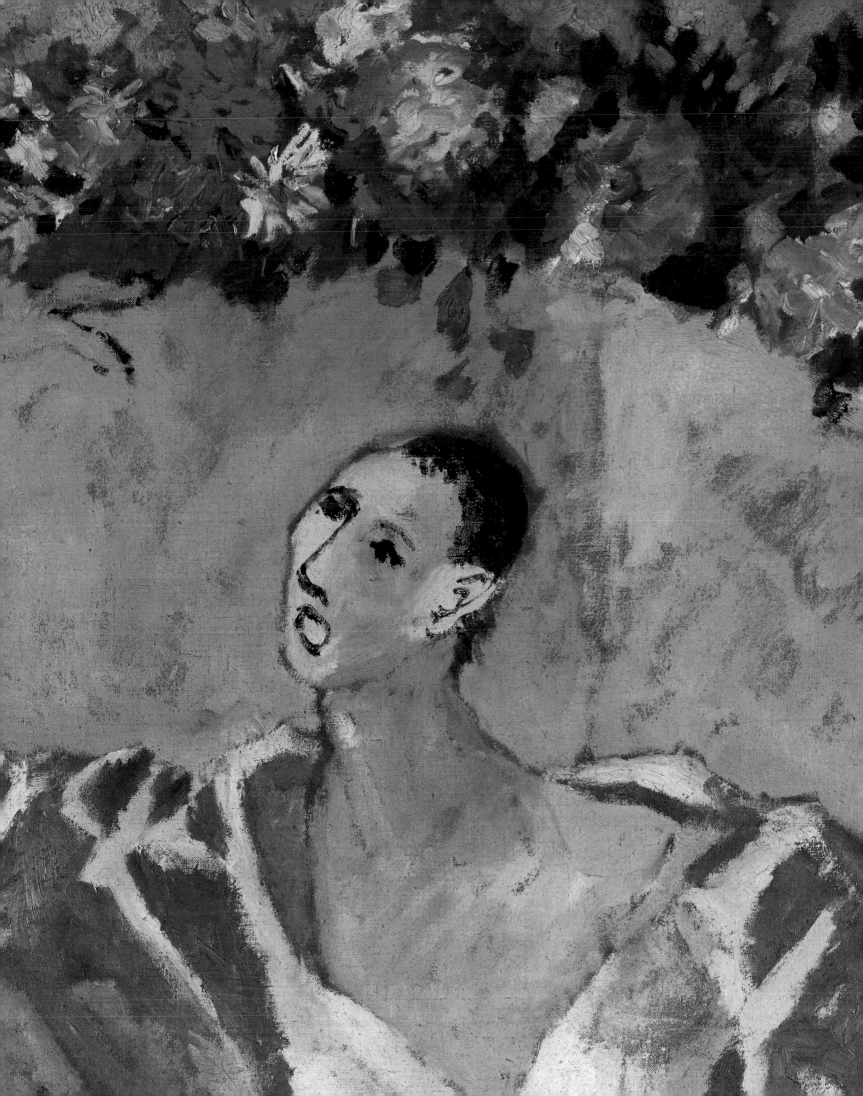

Head of a Woman (*Tête de femme*)

1907
Oil on canvas
18⅛ x 13″ (46 x 33 cm)
Signed and dated upper left: *Picasso 1907*
Inv. no. 429

Head of a Man (*Tête d'homme*)

1907
Oil on canvas
13 x 9½″ (33.1 x 24 cm)
Signed and dated lower right: *Picasso 1907*
Inv. no. 419

These two pictures were painted while Picasso was at work on his great canvas of 1907, *Les demoiselles d'Avignon* (see page 235).[1] Celebrated now in part for its radical styliza- tion of human physiognomy, the *Demoiselles* was conceived and executed during a dense period of restless pictorial research in which Picasso continually reconceived both the composition as a whole and the character of each figure. This process left a long run of sketches, studies, and smaller ancillary paintings to which the Barnes heads clearly belong.

Recent, painstaking study by William Rubin and Pierre Daix concerning the concep- tion and development of the *Demoiselles* allows us to date the two heads with relative specificity. Picasso's work for the large canvas was informed by his close acquaintance with examples of so-called "archaic" and "primitive" art, and the *Demoiselles* appears to have been executed in two stylistic phases that reflect the formal and expressionistic impact of both Iberian and African tribal sculpture.[2] According to this scheme, the Barnes pictures have been ascribed by Daix to the first phase of work, executed in 1907 between March and early June.[3] By that time, Picasso's Iberianism had developed since summer 1906 from a simplified, distinctly sculptural treatment of the figure and face to a flattened, more angular and schematic geometry. The shape of the head, a pointed oval, is typically echoed within by oversized blank or staring almond eyes, while the nose is described as a large, pointed wedge — what the poet Paul Eluard later dubbed "en quart de Brie" (as a wedge of cheese). The *Head of a Woman* also shows the scroll-like ear that Picasso borrowed from two small Iberian stone heads of Cerro de los Santos (works that entered his own collection in March 1907).[4] The striations and scoring on the nose and cheeks of both heads derive from the conventional chiaroscuro technique of cross-hatching, though they may also represent an extrapolation of scarification patterns that ornament African Kota and Hongwe reliquary figures.[5] While the *Head of a Woman* quite clearly compares to another canvas that has been dated to early June (fig. 1), we should note that Picasso coarsened and colored the hatching motif during the second phase of work on the *Demoiselles* (late June–early July), and the resemblance of *Head of a Man* to another head executed in the new, more brutal manner (fig. 2) argues for the later date.

In relation to the final composition of the *Demoiselles*, the *Head of a Woman* roughly corresponds to the two central standing nudes. The *Head of a Man*, with its moustache and downward tilt, is probably a late study for the sailor, a pivotal figure — ultimately abandoned — in Picasso's initial conception of the picture as a brothel scene.[6] Nonetheless, the androgyny of both heads reflects a morphological and iconographical ambiguity inherent in the new schematizing language of form that Picasso would come to exploit more fully with cubism. J S W

Fig. 1. *Study for the Sailor: Bust of a Man*, June 1907. Oil on board, 21 x 14¼″ (53.5 x 36.2 cm), Musée Picasso, Paris.

Fig. 2. *Bust of a Nude Woman*, June–July 1907. Oil on canvas, 31⅞ x 23⅝″ (81 x 60 cm). Private collection, Switzerland.

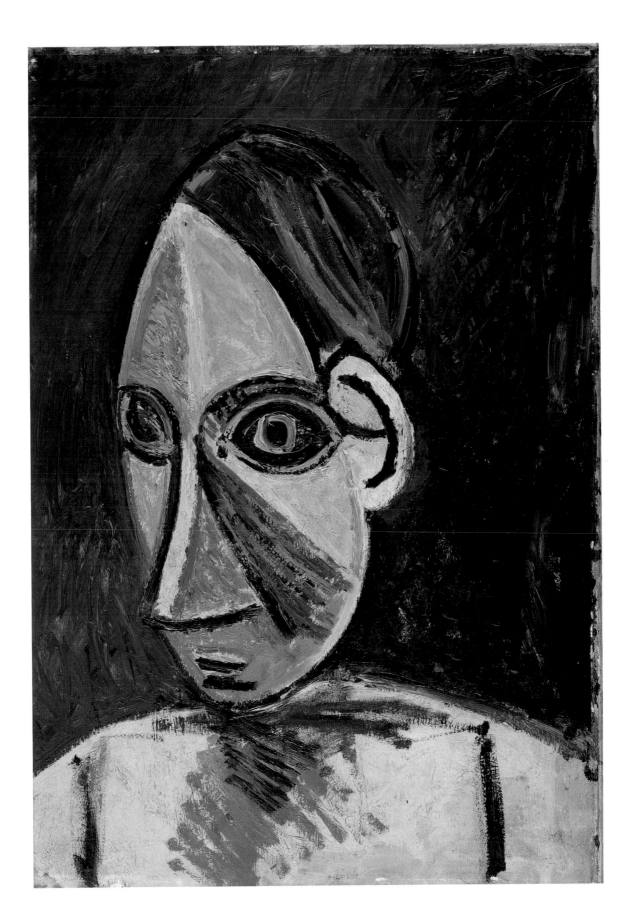

Napkin, Knife, and Pears (Serviette, couteau, et poires)

1908
Oil on canvas
8⅝ x 10½" (22 x 26.7 cm)
Inv. no. 437

Fig. 1. *Plate and Fruit Dish*, Autumn 1908.
Oil on canvas, 18 x 21¼" (46 x 54 cm).
Private collection, New York.

Napkin, Knife, and Pears is most striking for its tight focus, a cropped, close-up view that is unusual, if not quite anomalous, in the history of pre-war cubism. The effect is heightened by a comparison with Braque's *Plate and Fruit Dish* (fig. 1), a more conventionally framed still life from which the *Napkin, Knife, and Pears* appears virtually to have been lifted intact as a compositional detail (omitting only the pedestal of the *compotier*). In fact, the Barnes picture would fit almost exactly over the corresponding portion of *Plate and Fruit Dish*, which is roughly four times its size. Both paintings date from autumn 1908,[1] when Braque's work was deeply impressed with the formal lessons of Cézanne, whose still-life iconography is directly — almost symbolically — quoted by Braque here.

The exact relationship between the two works is difficult to define. *Napkin, Knife, and Pears* may have been produced first, as a study, though the very concept of studies and completed pictures is itself problematic in the context of cubism. The mature cubism of Picasso and Braque is an art of continual stylistic research; while numerous sketches and drawings were produced (especially by Picasso) in relation to paintings, formal painted preparatory work is somewhat alien to the cubist oeuvre, in which conventions of finish are largely subverted in even the most elaborate pictures. Nonetheless, the period of nascent cubism to which these two still lifes belong reveals at least one possible precedent of this kind. The small *House at L'Estaque* (Musée d'Art Moderne, Villeneuve-d'Ascq) from late summer 1908 is presumed to be an oil sketch for *Houses at L'Estaque* (Kunstmuseum, Bern), a larger work of the same date.[2] As with the Barnes still life, the smaller landscape represents only a portion of the more complex companion picture. Whether or not the *Napkin, Knife, and Pears* is a preparatory work, the severe cropping of the composition is rare, though something like it occurs in contemporaneous pictures by Picasso, such as the small, close *Still Life with Fruit and Glass* (The Museum of Modern Art, New York). It may, then, merely represent a compositional device that the two artists investigated independently of one another, and soon abandoned.

Napkin, Knife, and Pears is one of fifteen pictures that are recorded in the Kahnweiler gallery archives for the year 1908. It is therefore possible that the still life was included that November in Kahnweiler's one-man exhibition of Braque's recent work.[3] The show, with its catalogue preface by the poet-critic Guillaume Apollinaire, marked the introduction of early cubism to public and critical scrutiny (and the first time that a critic, Louis Vauxcelles, would characterize the new language as a reductive pictorial geometry of "cubes").

JSW

The Pitcher (Le broc)

1909
Oil on canvas
16½ x 13¼″ (42 x 33.8 cm)
Inv. no. 430

Fig. 1. *Guitar and Fruit Dish*, Winter–spring 1909. Oil on canvas, (28¾ x 23¾″ (73 x 60 cm). Kunstmuseum Bern, Hermann and Margrit Rupf Collection.

The Pitcher was probably painted in Paris during the winter or early spring of 1909,[1] at which time Braque's oeuvre was taken up almost exclusively with landscape and still-life themes. The objects represented here — a pitcher, a cup, a slice of melon, and a large napkin or tablecloth — conform to the limited range of studio and kitchen articles that figured in his work of the moment. Though this repertory would soon expand to include the paraphernalia of the café table, the careful selectivity that Braque demonstrates c. 1909–1911 seems to designate the cubist pictorial universe as a hermetic realm conceived solely for the contemplation of form.

Of course, the impression of a closed world is established above all by the rarefied ambiguities of the cubist formal language. Stylistically comparable to Braque's much larger *Guitar and Fruit Dish* (fig. 1), *The Pitcher* represents a number of characteristics that define the nature of early analytic cubism as it was developed simultaneously by Braque and Picasso. A severely reduced palette of ochers, grays, and greens heightens the impression of shallow or bas-relief space. Arbitrary lights and darks and faceted form conspire to disrupt any clear distinction between concave and convex volumes and planes. Patches of discrete, parallel, diagonal brushstrokes (generally more painterly in Braque than Picasso) remind us of cubism's debt to Cézanne, while interrupted contour lines permit the Cézannesque *passage*, or elision of near and far, which Braque had first fully explored the previous summer in his views of L'Estaque. A serrated, fanlike profile can be traced clockwise along the right-hand perimeter of the group of objects, establishing the kind of overall organizing principle that is more common in Braque's landscapes of 1908–1909 (at La Roche-Guyon, for example) than in his still lifes.

For all of its formal complexity, however, *The Pitcher* also reveals the sly wit by which Braque and Picasso rescue a cubist picture from dry cerebrality. The melon slice, cup, and handle of the pitcher comprise a triple-*entendre* on the pictorial resemblance between three very different kinds of volume. The iconography of this image may also harbor the kind of visual/verbal pun that we more often associate with the collages and *papiers-collés* of 1912–1914. As Alvin Martin has noted in the context of another painting from the period, one word for "pitcher" in French is *le broc*, a homonym for the artist's name that also appears to have been the original title of this work.[2] We play this wordgame inadvertently whenever we refer to the picture as "a Braque."

J S W

Married Life (La Vie conjugale)

1913
Oil on canvas
47 x 59½″ (119.2 x 151 cm)
Signed and dated lower right: *R. de La Fresnaye 1913*
Inv. no. 971

Fig. 1. *Married Life*, 1912. Oil on canvas, 38⁵⁄₁₆ x 46¾″ (97 x 117 cm). The Minneapolis Institute of Arts.

Fig. 2. Forain, *The Model's Repose*, 1909. Etching, 9⅜ x 11¾″ (24 x 29.8 cm).

La Fresnaye painted two versions of *Married Life*. The Barnes picture is much larger than its counterpart in the Minneapolis Institute of Arts (fig. 1), and probably represents a later, more finished presentation piece: planes and surfaces are broader, geometric shapes are firmer, and traces of cubistic transparency (reminiscent of Léger's work from 1911–1912) have been greatly reduced.[1] Certain details in the original — a plate, an ashtray, cigarette smoke — have been eliminated, making the second version somewhat less anecdotal. Above all, the Barnes painting is distinguished by flat areas of saturated primary and secondary colors, a form of decorative planarity for which La Fresnaye's work was well-received by critics otherwise hostile to cubism.[2]

The iconography of *Married Life* is curious. La Fresnaye was one of several pre-war painters in the circle at Puteaux and Passy who applied cubist style to domestic genre themes. In this regard, *Married Life* compares very closely to André Lhote's *Convalescence* (Private collection) from 1913, a similar interior with two figures in repose before a still life. However, one preliminary drawing shows that the woman in *Married Life* was originally clothed, and La Fresnaye's subsequent decision to portray her in the nude raises unusual questions of meaning and intent that cannot be resolved simply by citing distinguished antecedent images of the dressed and undressed, such as Manet's *Luncheon on the Grass*.

In its binary opposition of the sexes, *Married Life* suggests a conventionally gendered allegory of nature and culture, but the domestic scenario it portrays is more problematic.[3] The authenticity of the title appears to be established by the catalogue for La Fresnaye's one-man show at the Galerie Levesque in spring 1914, where the Barnes picture is listed as *La Vie conjugale*.[4] Given the context of "married life," obvious connotations of authority and subservience between the two figures add a peculiar charge to the easy intimacy of their rapport. In fact, the dynamics of marriage, "free union" and *concubinage* were a topic of broad moral and legal debate in France during the pre-war period, and it is to this discourse that La Fresnaye's image clearly belongs.[5] The Minneapolis picture was also reproduced in a salon review of 1913 as "Le Peintre et son Modèle,"[6] possibly an editor's offhand attempt to identify a narrative scheme. Attributes or activities of studio life are conspicuously absent from both versions, but implications of casual eroticism had long been a popular cliché of the artist's studio (fig. 2), and the newspaper caption may betray a natural period assumption about the relationship between La Fresnaye's two figures.

J S W

The Skinned Rabbit (Le lapin écorché)

n.d.
Oil on canvas
28¼ x 23⅝″ (73 x 60 cm)
Inv. no. 333

This dead rabbit has been reduced to a mere carcass, eviscerated and bloody, his eye a dwelling place for the last, meager trace of life. The paint handling is sumptuous — a full range of reds and crimsons spread out in long streaks that follow the contours of the limbs. The rabbit is displayed on a stained white cloth atop a table.[1]

Dead animals are, with few exceptions, the principal theme of Soutine's many still lifes. In these works, he expresses his obsession with death and bloodshed. This picture is among the most startling examples. It is devoid of anecdotal detail, unlike two other versions in which the simple addition of forks is enough to tame and transform the tragic scene into an evocation of familiar kitchen routine.

Soutine's still lifes generally combine direct observation with a model taken, consciously or not, from the history of painting. His dead rabbits, suspended by their feet, bring to mind Chardin; turkeys with spread wings have their precedent in the numerous hunting trophies of seventeenth- and eighteenth-century painting; Rembrandt is the acknowledged prototype for various versions of *The Slaughtered Ox*.

By depriving this sacrificed animal of all aesthetic and cultural embellishments, Soutine universalizes the motif. But the picture is not a straightforward study, like Géricault's paintings of cadaverous body parts; this is demonstrated by the care with which Soutine composed the work, framing the beast on three sides by the cloth, the table edge, and faint lines in the background. Soutine takes care to feature the rabbit carcass by representing it in perspective, while the table top is viewed instead from above. Such a sober presentation of a bloody carcass, this wretched body stripped of its own skin, reveals the moderation and restraint of Soutine's expressionism. Dr. Barnes places Soutine after Daumier, from whom "he took the method of so simplifying and distorting objects as to make them appear monstrous or grotesque, but without loss of essential reality."[2]

M H

214

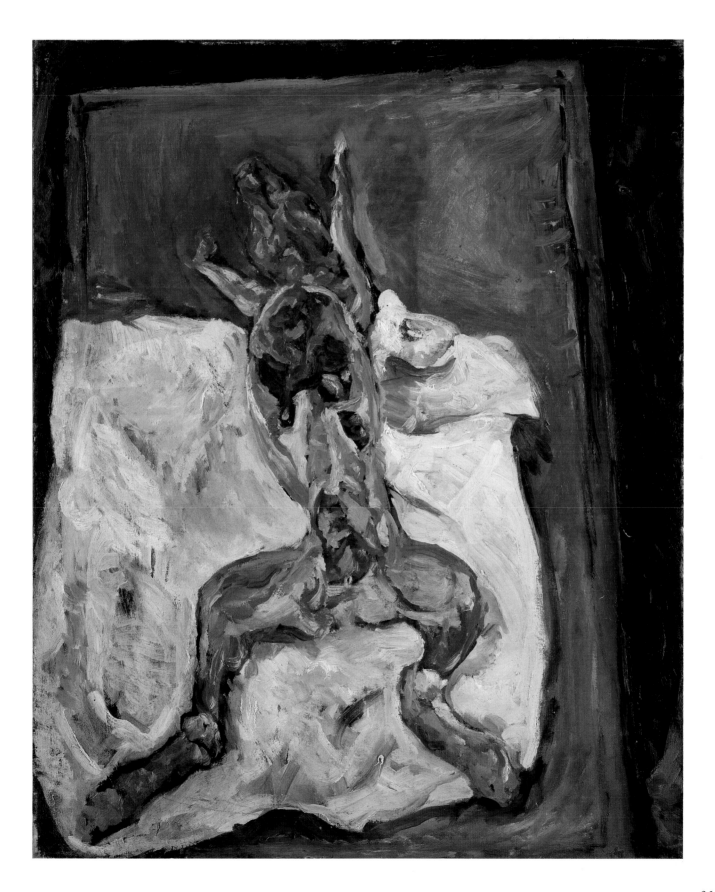

215

The Little Pastry Cook (Le petit pâtissier)

n.d.
Oil on canvas
26⅛ x 19¾" in (66.3 x 50.3 cm)
Inv. no. 442

The most striking thing about this portrait[1] is the extravagant use of color, which has been pushed to the same violent extreme as the caricatural quality of the drawing. Neither van Gogh nor Vlaminck ever heightened the exaggeration of form and color to this degree. Nonetheless, dramatic aspects of the picture — the violent asymmetry of the face, with its monstrous ear; the rumpled coat, which is animated by a play of blue and yellow; and the bright red handkerchief that this figure holds in his clenched fist — do not incite a dramatic mood. Perhaps this is due to the calculated composition and formal pose: settled in an armchair, the sitter faces front with a distracted and distant gaze, while the pose of his body, which is cropped below the knee, just approximates a three-quarters view. Indeed, this is the stock formula of the bourgeois portrait, one that reflects well on sitter and painter alike. Sunk into an adult's armchair, this adolescent acquires, even surpasses, the formal dignity of van Gogh's *Joseph-Etienne Roulin* (see page 169), a quality that can be traced back to the parliamentary and ecclesiastical portrait tradition of Rigaud and Largilière.

The Barnes picture is among the first in a series of portraits of pastry cooks by Soutine. It can be most closely compared to a version in the Musée de l'Orangerie, though there the figure is more tightly framed, with a downward gaze.

Soutine is represented in the Barnes collection by many works. *The Little Pastry Cook* played a decisive role in Dr. Barnes' discovery of the artist, and in his relations with the art dealer Paul Guillaume, who sold many paintings to Dr. Barnes. In his review *Arts à Paris*, Guillaume recalled: "One day I had gone to a painter's studio to see a Modigliani, and I noticed in the corner a work that interested me right away. It was a Soutine, a picture of a pastry cook — an extraordinary, fascinating, real, and truculent pastry cook, afflicted with an immense and magnificent ear, surprising and just right: a masterpiece. I bought it. Dr. Barnes saw it at my place. 'It's a peach!' he cried. The spontaneous pleasure he derived from this canvas changed Soutine's fortune all at once, transforming him overnight into a recognized painter, sought after by patrons, no longer the object of condescension — a hero in Montparnasse."[2]

In *The Art in Painting*, Dr. Barnes analyzes Soutine's technique at length. He finds that the artist's use of color is constructive, not arbitrarily expressionist, and essential to the formal definition of pictorial space. Thus, in *The Little Pastry Cook*, the back of the armchair is viewed frontally while the armrests are seen from above, a strategy of perspectival disruption originated by Cézanne and standardized in Matisse and cubism.

M H

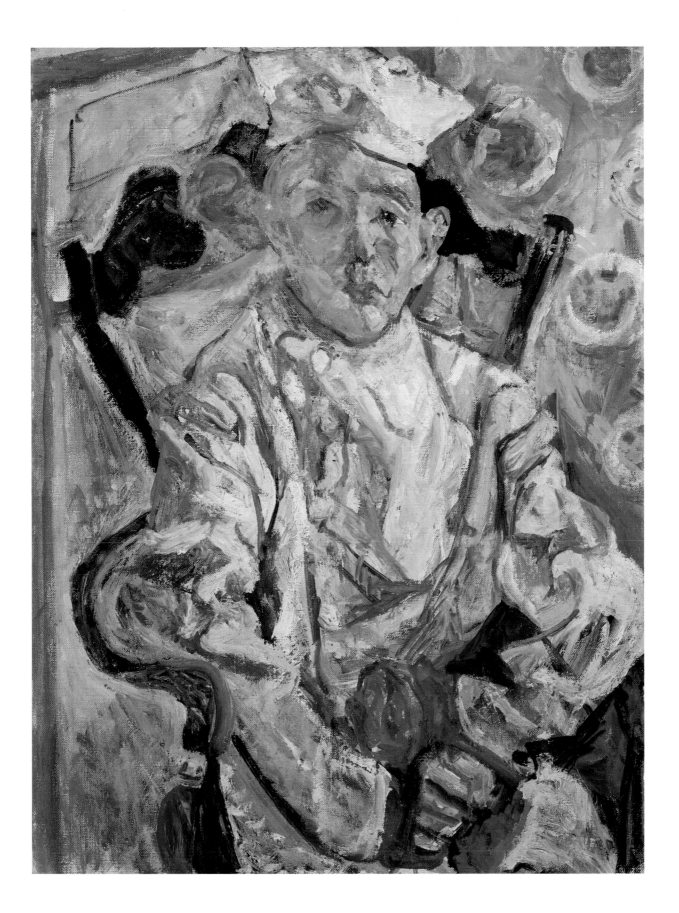

Reclining Nude from the Back (Nu couché de dos)

1917
Oil on canvas
25⅛ x 39⅛" (64.5 x 99.5 cm)
Inv. no. 576

Modigliani painted some two dozen sitting and reclining female nudes during 1916–1919. Roughly half, including the Barnes *Reclining Nude from the Back*, appear to date from 1917 alone.[1] Unlike the artist's vast repertory of portraits of friends and lovers, the nudes generally depict unidentifiable models. Many of the pictures share a dark, warmly sensuous palette of russet browns and crimson, against which flesh tones appear to emit a heated glow. In the reclining nudes, the model's attenuated silhouette reaches slowly to either side of the canvas, typically just touching the left-hand edge and extending beyond the right — the compositional equivalent of a languorous bodily stretch. Frequently, the figure's gaze is cast directly at us, though the effect was probably intended to be less confrontational (in the manner of Manet's *Olympia*, for example) than inviting; in the Barnes picture, this exchange is blunted by the masklike stylization of blank eyes.

In the blatant voluptuousness of his nudes, Modigliani frames the model as an object of desire and possession, her availability heightened by broad, unadorned settings that present or feature the body for delectation. The bed or divan across which they recline is often just minimally recognizable as such, and these works stand out for having renounced the mediating conventions of history and fantasy — tropical vegetation, exotic props, or domestic interiors[2] — associated with modern depictions of the *odalisque*. This is especially significant during World War I, when representations of the body in French painting were largely dominated by cool, chaste, drapery-clad creatures of the neo-classical tradition. The frank carnality of Modigliani's works was, predictably, a factor in their reception at the time. In December 1917, Modigliani's patron Léopold Zborowski organized the artist's first one-man show at the Galerie Berthe Weill in Paris, from which five nudes — branded indecent — were confiscated by the police.[3]

Despite appearances of a single-minded eroticism, the nudes also reveal an oblique, self-conscious encounter with pictorial tradition. A good number of the works paraphrase poses from the art history of the female nude, and the prototypes are readily identifiable: Ingres' *Grande Odalisque*, Goya's *Maja desnuda*, and Manet's *Olympia* are each represented in virtually identical formats and settings, as if the artist and his model were producing a *tableau-vivant* parade of established types.[4] The Barnes nude clearly impersonates Boucher's *Dark-Haired Odalisque* (fig. 1), which was bequeathed to the French state in 1914. While each instance of paraphrase may represent an attempt to redress affectation with plain sexuality, we note that the strategy of appropriation equally serves to aestheticize Modigliani's desiring gaze.

J S W

1. Boucher, *The Dark-Haired Odalisque*, 1745? Oil on canvas, 21 x 25½" (53.5 x 64.5 cm). Musée du Louvre, Paris.

Portrait of Jeanne Hébuterne Seated in Profile

1918
Oil on canvas
39⅜ x 25½″ (100 x 64.8 cm)
Inv. no. 422

Fig. 1. *Portrait of Jeanne Hébuterne (Profile)*, 1918. Oil on canvas, 39⅜ x 25⅝″ (100 x 65 cm), Private collection, Paris.

Fig. 2. *Relief of Osorkon I*, Egyptian antiquity of the XXIInd Dynasty. Pink granite, height 55⅛″ (140 cm). Musée du Louvre, Paris.

Modigliani met Jeanne Hébuterne in early 1917, when she was an art student at the Académie Colarossi, and the two set up house together on the rue de la Grande Chaumière in July. Hébuterne occupied Modigliani's work during the last three years of a life by then racked with poverty and ill-health. The couple had one daughter together in 1918; carrying their second child, Hébuterne committed suicide one day after Modigliani's death from tuberculosis, on 25 January 1920.

This portrait is one of two paintings by Modigliani that depict Hébuterne seated in profile; the pictures are nearly identical in composition, though she wears clothing of rich red and purple in the alternate version (fig. 1).[1] The cool blue-gray of the Barnes picture more closely conforms to the lightened palette that graced Modigliani's work during the year the couple spent on the Côte d'Azur near Nice and Cagnes, beginning in spring 1918.[2] There too, Modigliani's attenuated canon of figural proportion achieved an elegant, manneristic extreme to which the S-curve of the coiffure, neck, and shoulder in this work also clearly belongs. The portrait may portray Hébuterne during her first pregnancy, though a definitive distinction between this and other body types in Modigliani's oeuvre is difficult to sustain.

It is possible that the profile silhouette, which is rare in Modigliani, was further suggested to the artist by Hébuterne's conic coiffure, an exaggeration of the hairstyle that she is remembered to have worn in the south.[3] The flourish this adds to the gradual tapering of her form from bottom to top has a decorative quality that suits the growing emphasis on abstract design in Modigliani's later work. As a mannered, ornamental attenuation of the head, the coiffure closely recalls a type of ancient Egyptian crown that first appears in depictions of deities and kings during the Old Kingdom, and recurs throughout the subsequent history of Egyptian art (fig. 2). We know that Modigliani was a passionate admirer of Egyptian antiquities in the Louvre. As Edith Balas has shown, with the stone heads and Caryatids of the pre-war period, Egyptizing formal principles in the artist's work are comprised of blocky mass, schematic physiognomy, and a functional or conceptual relationship to architecture.[4] But Egyptian form is no less relevant to the mannerism of 1919, for which a sinuous, linear stylization of the figure could have been drawn from other varieties of incised bas-relief sculpture in the Louvre. Like an exotic headdress, the coiffure-crown lends a physical impression of hieratic poise to the profile portrait of Hébuterne; a pun on composure and balance, it also typifies the fashionable, streamlined archaism that would soon come to occupy between-the-wars art and design.

J S W

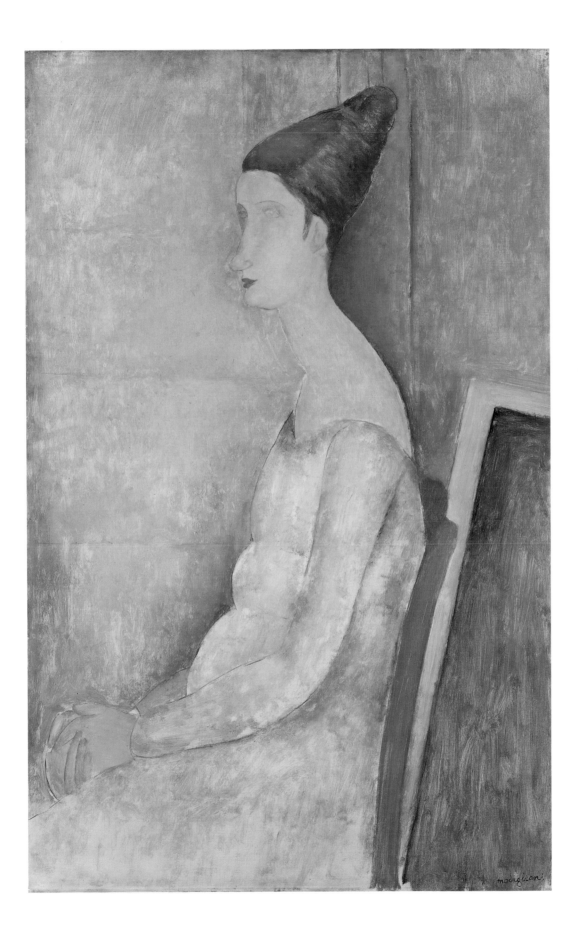

Portrait of Jeanne Hébuterne, Left Arm behind Head

1919
Oil on canvas
39⅜ x 25¾" (100 x 65.3 cm)
Inv. no. 285

Fig. 1. Ingres, *Vénus anadyomène*, c. 1858.
Oil on paper, 12⅜ x 7⅞" (31.5 x 20 cm).
Musée du Louvre, Paris.

Fig. 2. *Caryatid*, 1913, Mixed media on
cardboard, 23⅝ x 21¼" (60 x 54 cm). Centre
National d'Art et de Culture Georges
Pompidou, Paris.

Modigliani's portrait oeuvre is distinguished by its remarkable consistency of format: frontal busts and seated half-lengths predominate by far, and the sitters' gestures are generally unself-conscious and at ease. With its boneless left arm sprung straight up and bowed behind the head like a framing arch, the *Portrait of Jeanne Hébuterne* is a striking anomaly of design.[1] The posture, a pantomime of voluptuous display, has a broad ancestry in depictions of the female figure, both clothed and nude, including a modern pictorial lineage with which Modigliani would have been closely acquainted. Above all, the motif was virtually a regular feature of Picasso's most important work of 1907–1908, including the *Demoiselles d'Avignon* (see page 235), the *Nude with Drapery* (State Hermitage Museum, St. Petersburg), and the *Three Women* (State Hermitage Museum, St. Petersburg), with an afterlife that lasted well into cubism; Picasso, in turn, seems to have lifted it from Ingres (fig. 1), whose work was shown in a retrospective at the Salon d'Automne of 1905. The progress of the upthrust elbow can be charted elsewhere, in the work of Cézanne, Matisse, and de Chirico, for example, though it is Picasso's disjointed articulation of the body that most fully informed the strain of the locked shoulder in Modigliani's portrait.[2] The first public exhibition of the *Demoiselles d'Avignon* in July 1916[3] brought new urgency to the expressive potential of this pose, which subsequently appears in the sculpture of Modigliani's friend Ossip Zadkine. His *Demeter* of 1918 (Stedelijk Van Abbe Museum, Eindhoven) is probably not without its own bearing on the Barnes portrait.

Most conspicuously of all, the contortions of Jeanne Hébuterne also conform to a prior series of works by Modigliani himself, the Caryatids of 1911–1914 (fig. 2).[4] In these pictures, largely executed in charcoal, watercolor, or gouache, the artist conceived the female body as a kind of weight-bearing architectural support, and experimented obsessively with the stylistic effects of compression and rotation on various configurations of the nude. In context, and in conjunction with Modigliani's contemporaneous work in stone, a sculptural conceit justifies the distortions of proportion and pose; conversely, with the *Portrait of Jeanne Hébuterne*, the manner of the caryatid has been emancipated from any reference to its original function, and derives a certain pathos from this state of displaced purpose. Now more columnar than squat, the result is also vaguely phallic, recalling a similar transformation of the female sitter in the work of Modigliani's former mentor, the sculptor Constantin Brancusi, whose *Princess X* (Philadelphia Museum of Art) of 1916 is a more striking example of this sort of fetishistic projection.[5]

J S W

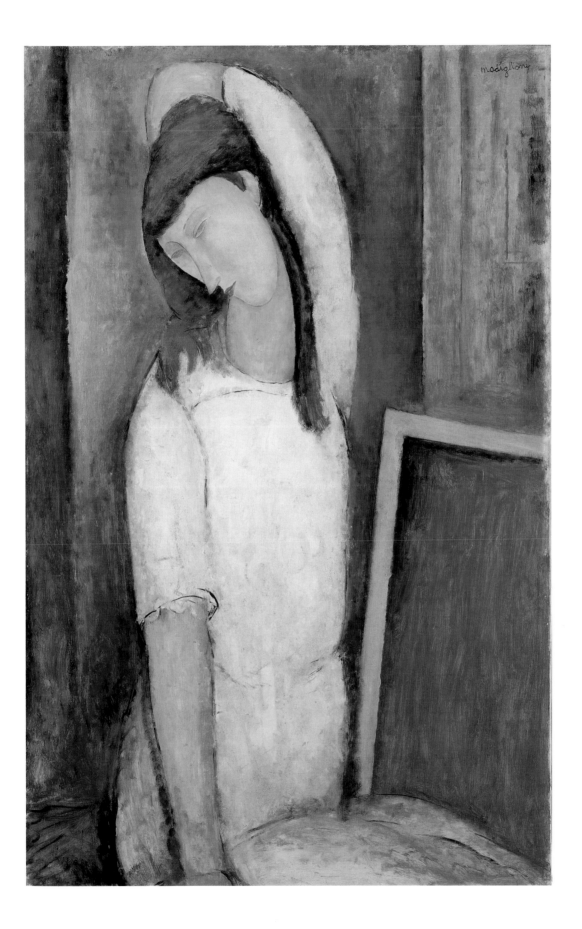

Girl with a Polka-Dot Blouse (*Jeune fille au corsage à pois*)

1919

Oil on canvas

41⅜ x 28⅝″ (105.2 x 72.7 cm)

Inv. no. 180

Fig. 1. *Head*, 1911–12. Limestone, height 25⅝″ (65 cm). The Barnes Foundation, inv. no. A249.

Fig. 2. Cézanne, *Madame Cézanne in Red*. Oil on canvas, 35 x 27½″ (89 x 70 cm). Museu de Arte, São Paulo.

Girl with a Polka-Dot Blouse demonstrates how closely Modigliani's painted portraits rely on the stone heads that he produced in 1911–1912.[1] The cut of the girl's blouse, high at the throat, emphasizes the resemblance of her head to the format of the sculptures, most of which stand on flat-bottomed, cylindrical necks (fig. 1). Elongated proportions and schematic physiognomy are drawn directly from the earlier heads, though we note how their depersonalized facial features are subjected in the painted portraits to subtle, almost caricatural adjustments for physical and psychological idiosyncrasy. The rigorous frontality of the work is also a governing principle of the stone heads, which were generally conceived according to the structural precepts of a weight-bearing architectural caryatid. While this portrait shows less plasticity than some of Modigliani's painted heads (in keeping with the lighter, more lyrical character of his work in 1918–1920), the firm delineation of the hair, eyes, nose, and mouth is a direct graphic equivalent of the inscribed and projecting features in stone. Blank, clear blue eyes also duplicate the haunting sculptural effect of a blind or visionary gaze. Many of these qualities in the sculpture were probably adapted by Modigliani from a variety of African masks, most notably Fang, Yaure, Baule, and Marka examples,[2] though by the time of the Barnes portrait, these original sources were fully assimilated and difficult to discern. An element of androgyny in the painting can more clearly be traced back to models from both tribal and ancient Egyptian carving.

If the head of *Girl with a Polka-Dot Blouse* is a direct offspring of Modigliani's sculpture, the entire figure is a more distant heir to Cézanne's portraits of Madame Cézanne (fig. 2 and see page 113). The columnar verticality of a sitting/standing pose, at once ambiguous and hieratic, and the remote impassivity of mien virtually constitute an homage to the master, and are well-suited to the artist's bias toward archaic sculpture. The repose of hands is also a recurring gesture in Cézanne. Even the slight tilt of the sitter (her form is nudged several degrees off a vertical axis by the leaning edge of a tall blue-green band at the left) emulates the instability that Cézanne lent to portraits of his wife, whose pitch is a laconic formal index of psychology or inner life. Modigliani's figure is less intensely painted than Madame Cézanne; face, clothing, and background are all less worked, and flat, mottled surfaces are more decorative than built-up. Ultimately, both his appropriation of Cézanne and his decorative modifications — including the cool palette — correspond to the state of figural painting in France toward the end of World War I, which was marked by a new classicizing emphasis on grace, balance, and restraint.

J S W

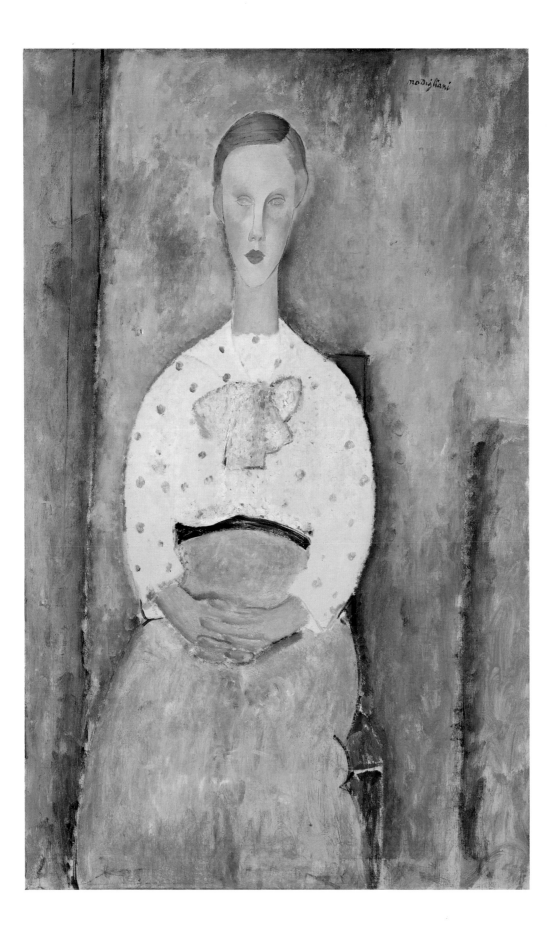

Le bonheur de vivre (The Joy of Life)

1905–1906
Oil on canvas
69⅛ x 94⅞" (175 x 241 cm)
Inv. no. 719

The *Bonheur de vivre* has assumed almost legendary status as a key work within the history of twentieth-century painting, but because of its relative inaccessibility its actual place within that history has been difficult to assess. Given the fact that reproductions of paintings are the primary medium through which they participate in the ongoing history of art, the *Bonheur de vivre* will quite possibly "re-enter" history in a fresh way as a result of its being reproduced in color.

For when one sees the picture in color — not as an elegant *grisaille* combination of Ingres and art nouveau, but ablaze with bright reds, yellows, and violets, and intensely "mixed" in style — one is forced to deal with just how contradictory and problematical it is. One also better understands its relationship to Picasso's *Demoiselles d'Avignon* (fig. 8), which was painted in part as a response to it — and which is another major early example of what might be called the aesthetics of "stylistic discordancy" in twentieth-century painting. For like the *Demoiselles* — though to very different ends — the *Bonheur de vivre* employs stylistic contradictions and inconsistencies in a complex and expressive way.

Throughout the picture, there are surprising differences in paint application and abrupt changes in manner of rendering, even in adjoining passages. The upper half, for example, is as freely brushed and as abstractly rendered as any European painting done before Kandinsky's 1912 "Improvisations," and displays an exuberance in paint handling and a subtlety of surface effects that Matisse himself would never quite equal. The lower half of the painting, by contrast, is quite varied in brushstroke and rendering, but contains a number of figures that are strongly outlined and self-contained, and which seem quite separated from their surroundings.

A strong tension also exists between the idyllic subject matter, which sets before us a variety of earthly delights — love, dance, music, absorption with nature — and the violent, primitivistic effect of the ensemble. While all of the figures except the ring of dancers express languor or repose, the painting as a whole throbs with nervous energy, clashing colors, and pulsing arabesques.

Moreover, while the painting seems at first to represent some sort of earthly paradise or mythic Golden Age, a time of unforced "mutual love,"[1] the various figures are curiously disconnected; and many seem quite unaware of each other's existence. This is even true of the two reclining nudes in the middleground, one turned toward us, the other turned away, who seem blissfully unaware of each other's presence; in fact the complementary color contrast between their orange and blue hair is emblematic of the underlying tensions and contrasts that seem to be at the core of the painting's structure.

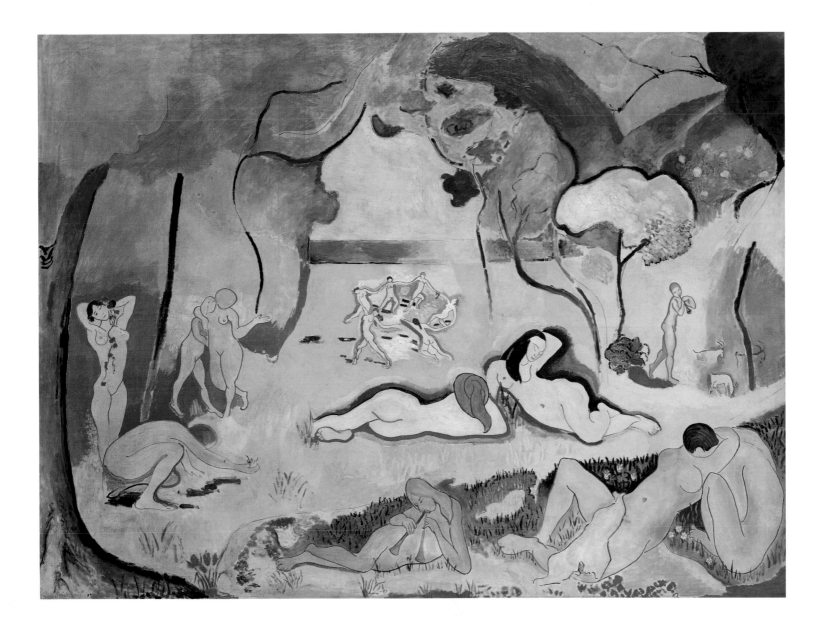

These tensions extend to the traditional literary genres alluded to in the painting, which combines quite divergent traditions of idyllic imagery — Golden Age, pastoral, and bacchanalian themes — in a contradictory way that parallels the mixture of formal styles.[2] The mixed subject of the *Bonheur* brings together different aspects of the European "grand tradition" of depicting figures in a landscape by alluding both to the older Renaissance pastoral tradition and to what Lawrence Gowing has called the modern "pastoral of the primitive."[3]

The stylistic openness and ambivalent subject matter of this painting have provoked a wide range of differing interpretations. The inconsistencies in the relative scale of the figures, for example, have been understood as reinforcing the symbolic and literary overtones of the scene, which appears to hover somewhere between dream and reality. General parallels have been noted with a number of ancient texts, particularly Longus' *Daphnis and Chloe* and Virgil's fourth Eclogue.[4]

Ablaze with large areas of complementary colors, and populated by figures that are as remarkable for their self-absorbed narcissism as for their exhibitionistic sensuality, the painting also evokes a variety of psychological associations, and has been discussed in terms of a broad range of underlying themes — running a gamut from such lofty, impersonal subjects as the incarnation of the Sacred to the painter's own infantile sexual fantasies.[5]

Also remarkable is the relative scarcity of men in the picture; only the shepherd is unequivocally male, and even the genders of the pairs of lovers are not entirely clear.

In its charged atmosphere of femaleness, the *Bonheur de vivre* seems to evoke quite specifically the dreamlike atmosphere of a more recent literary work, Stéphane Mallarmé's "L'Après-midi d'un faune," an erotic reverie that it parallels quite closely in imagery, color, and overall structure. As in the Mallarmé poem, which evokes a vision of languorous nymphs bathed in tawny light, the individual figures in the *Bonheur de vivre* are vivid and sensual, yet the relationships between them are ambiguous. And as in the Mallarmé poem, one intuits an overall sense of coherence within the work, even though its fractured syntax makes its narrative core tremulous and elusive.[6] At once bucolic and yet also worldly, clearly symbolic but essentially ambiguous, the *Bonheur de vivre* (like "L'Après-midi d'un faune") projects a powerful but curiously abstract eroticism.[7]

This painting marked an extreme departure in Matisse's work, not only in terms of subject and style, but also in the way he went about creating it. Throughout most of his career, he had painted from direct visual experience rather than from imagination. Among his previous pictures, only *Luxe, calme et volupté* (fig. 1) had a literary theme (its title comes from the refrain of Baudelaire's "Invitation au Voyage") and had been done largely from imagination. Being able to compare these two works in color allows us to see how clearly related they are in terms of general chromatic range, but how different they are in ambition and effect. If *Luxe, calme et volupté* is Apollonian and rather chaste in feeling, the mood of the supple and sensual *Bonheur de vivre* is Dionysian. And while the colors in the earlier painting describe an atmospheric and essentially naturalistic kind of light, in the *Bonheur de vivre* color

Fig. 2. *Landscape at Collioure*, 1905. Oil on canvas, 18⅛ x 21⅝″ (46 x 55 cm). Statens Museum for Kunst, Copenhagen.

is employed as an equivalent for the sensation of brilliant luminosity rather than as a description of it. The *Bonheur* embodies the full force of Matisse's reaction against neo-impressionism and also the beginning of a new primitivism in his work — both of which are related to his experiences during the summer of 1905 in the relatively remote and "primitive" village of Collioure.

It was in this fishing port near the Spanish border that Matisse and André Derain began to work in the loosely brushed and colorful style that would come to be called *fauve*. At the beginning of the summer of 1905, Matisse had continued to work in the neo-impressionist manner typified by *Luxe, calme et volupté*, and according to Derain he was initially cautious about abandoning neo-impressionist color and brushstroke.[8] But as the summer progressed, Matisse was able to free himself from the regularly inflected brushstroke and color typified by *Luxe, calme et volupté*, and began working with the bright, non-atmospheric colors and extremely varied touch that are so well exemplified in *Landscape at Collioure* (fig. 2).[9]

Matisse began the *Bonheur de vivre* in October 1905,[10] shortly after he returned to Paris, and during the next few months he did a number of studies for the individual figures (fig. 3) and for the overall composition.[11] As he had done with *Luxe, calme et volupté*, he used the image of an actual landscape to provide the setting and structural format for his large composition — the recently painted *Landscape at Collioure*, which is arguably the most original landscape he painted that summer.[12] In it, the interaction between the processes of

Fig. 3. *Reclining Nude Playing Pipes*, 1905. Pen and black ink on white paper, 18 x 23¼" (45.8 x 60.4 cm). Private collection.

Fig. 4. *Study for Le bonheur de vivre*, 1905. Watercolor on paper mounted on board, 10 x 12⅝" (25.4 x 32 cm). Collection of Mr. and Mrs. Henry Hope Reed.

painting and drawing are very finely balanced, and it employs an exceptionally rich counter-point between sinuous arabesques and irregularly shaped patches of color. The composition of this landscape provided Matisse with a highly abstracted version of a real place in which he could set the image of his reverie.

The manner in which he began to accommodate the landscape to his new theme can be seen in a watercolor of the same scene (fig. 4), in which small touches of rosy skin tones are indicated at the places where several of the figures would appear in the final painting. Following this, the composition was worked out in greater detail in a small pen and ink drawing (fig. 5), in which the general placement of almost all the figures, except for the ring of dancers, is already indicated. Probably soon afterward, Matisse did the small oil sketch now at the Barnes Foundation (fig. 6), in order to work out the main structural elements of the composition and to set down some of the chromatic ideas suggested by the drawing. The colors in the small Barnes panel are softer than those in the final painting, and not all the figures are yet indicated, but the basic chromatic structure is remarkably well thought-out. Although the figures are quite summarily rendered, the contrasting hair colors of the reclining nudes are already indicated, and so is the pair of lovers at the lower right. Significantly, the center of the composition, an oblique bar of green and violet in the original landscape, is left open in both the drawing and the Barnes oil sketch, as if waiting for another force to fill it.

It is here that Matisse would set the ring of dancers — his first depiction of this celebrated motif, and his first attempt at rendering figures in motion — in the oil sketch now in San Francisco (fig. 7). Evidently inspired by his experience of watching the Catalan fishermen of Collioure dancing on the beach that summer,[13] the ring of dancers introduces a dynamic element into the image. The energy of their dancing seems to animate the rest of the scene and also completes a broad circular movement that revolves around the two reclining women, emphasizing the circular and fluid nature of the composition, which is echoed in the undulating curves of the trees. In the San Francisco oil sketch, the positions of the figures are clearly indicated. The intertwined pair of lovers in the right foreground is now clearly drawn, and the right-hand figure in the middleground is transformed into a reclining nude with one arm raised behind her head — a voluptuous pose that Matisse would use in a number of later works.[14]

For the final painting, Matisse almost certainly made a full-scale cartoon.[15] Years later, he remembered the process of composition as having been especially fragmentary: "This picture was made by the juxtapositions of things conceived independently from each other, but arranged together. Whereas afterwards I sought more unity in my compositions, such as the *Dance* in Moscow, which came out of the *Joie de vivre*."[16] The disjunctive method of working from numerous small studies is reflected in the overall effect of the canvas, especially in the perspective. The various figures are seen as if from different vantage points, and their relative sizes are determined by the structural and expressive roles they play rather than by their physical distance from the picture plane.

The *Bonheur de vivre* is also one of Matisse's most overtly eclectic pictures. Its subject and composition place it squarely within a tradition of pastoral painting that goes back to

Fig. 5. *Study for Le bonheur de vivre*, 1905. Pen and ink and pencil on paper, 6¾ x 8¾" (17.5 x 22.5 cm). Private collection.

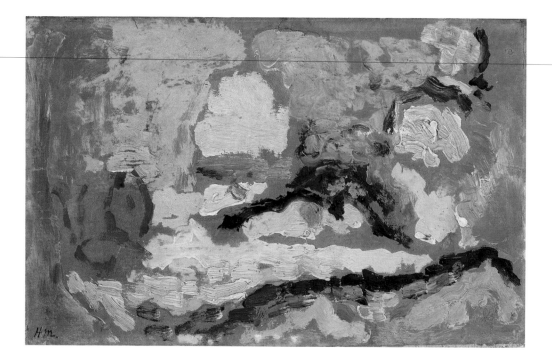

Fig. 6. *Study for Le bonheur de vivre*, 1905.
Oil on canvas, 4¾ x 7½″ (12.1 x 19.1 cm).
The Barnes Foundation, inv. no. 35.

the Renaissance and that was still quite vital at the beginning of the century. But as we have
seen, it mixes different aspects of that tradition in rather unusual ways. In fact, it seems to
aim at nothing less than a summation and synthesis of the whole of Western painting.
Various writers have commented on the complexity of the painting's sources, which range
from prehistoric cave painting to the compositional structure of Cézanne's bather paintings
and the sinuous arabesques of contemporaneous art nouveau decoration. The art historical
inspiration for the ring of dancers alone has been ascribed to artists as diverse as Mantegna,
Ingres, Goya, and Agostino Carracci; other sources, such as Greek vase painting, medieval
tapestries, works by Antonio Polliauolo, and early Renaissance book illumination can be
added to the list.[17]

And yet for all of its allusiveness, for all of the glimpsed reminders of earlier art, this
highly original painting takes an extremely aggressive stance toward the "grand tradition"
of pastoral painting. For it not only mixes this tradition with non-Western and primitive
sources — as in the spatial construction, which recalls Persian miniatures, and in the stylis-
tic references to cave painting — but also subverts that tradition by the violence and dis-
sonance of the way it is painted. The painting's allusions to Titian, Carracci, Poussin,
Ingres, Puvis de Chavannes, and even to such recent works as Signac's *Time of Harmony*
(1893–1895) and Derain's *The Golden Age* (1905) are what might be called "antithetical"
allusions — for the historical associations of the subject are in large measure deconstructed
by its style and rendering.

This is clearly evident when one compares the final painting with the San Francisco
oil sketch. The relatively consistent style, naturalistic scale of the figures, and evenly inflected

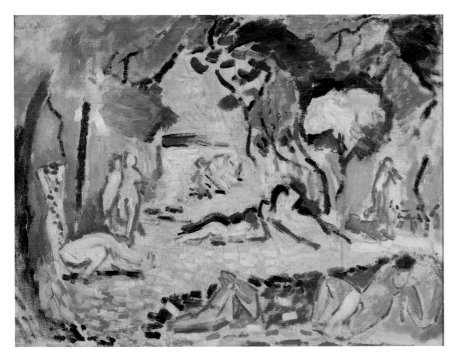

Fig. 7. *Sketch for Le bonheur de vivre*, 1905.
Oil on canvas, 18 x 23½" (45.7 x 59.7 cm).
San Francisco Museum of Modern Art.
Bequest of Elise S. Haas.

surface of the San Francisco painting keep it clearly within the bounds of traditional pastoral painting. The oil sketch, like neo-impressionist idylls, is a direct translation of that tradition into a "modern" idiom. But the *Bonheur de vivre*, garish in color and nearly absurdist in its hodge-podge of styles and poses, represents an open declaration of rupture with that tradition. It is this rupture which makes it so important within the history of modern painting and within Matisse's own career.[18]

Matisse was acutely aware of the importance of this painting. It was the only work that he sent to the 1906 Salon des Indépendants and he seems to have set great store by its success — no doubt hoping that a large and innovative painting with a pastoral subject would serve as an implicit declaration of his status as a modern master.[19]

That the painting was meant as a kind of manifesto was not lost on the critics of the time. Charles Morice, who had strong reservations about the work, nonetheless referred to it as the "question" of the Salon. The crowds found the painting hilarious and strange, Morice reported, but he himself found it to be too synthetic, schematized, and theoretical. Matisse, he felt, seemed to have "thought less about the objects in his composition than about the means of execution. . . . Le Bonheur de Vivre, this? But life is absent from it!"[20]

Although Louis Vauxcelles saw "great qualities" in the painting, he also found it to be overly schematized.[21] One of the sternest critics was Paul Signac, the leading advocate of neo-impressionism, with whom Matisse had worked just the year before. In January 1906, Signac wrote to the painter Charles Angrand, "Matisse, whose attempts I have liked up to now, seems to me to have gone to the dogs. Upon a canvas of two and a half meters, he has surrounded some strange characters with a line as thick as your thumb. Then he has covered

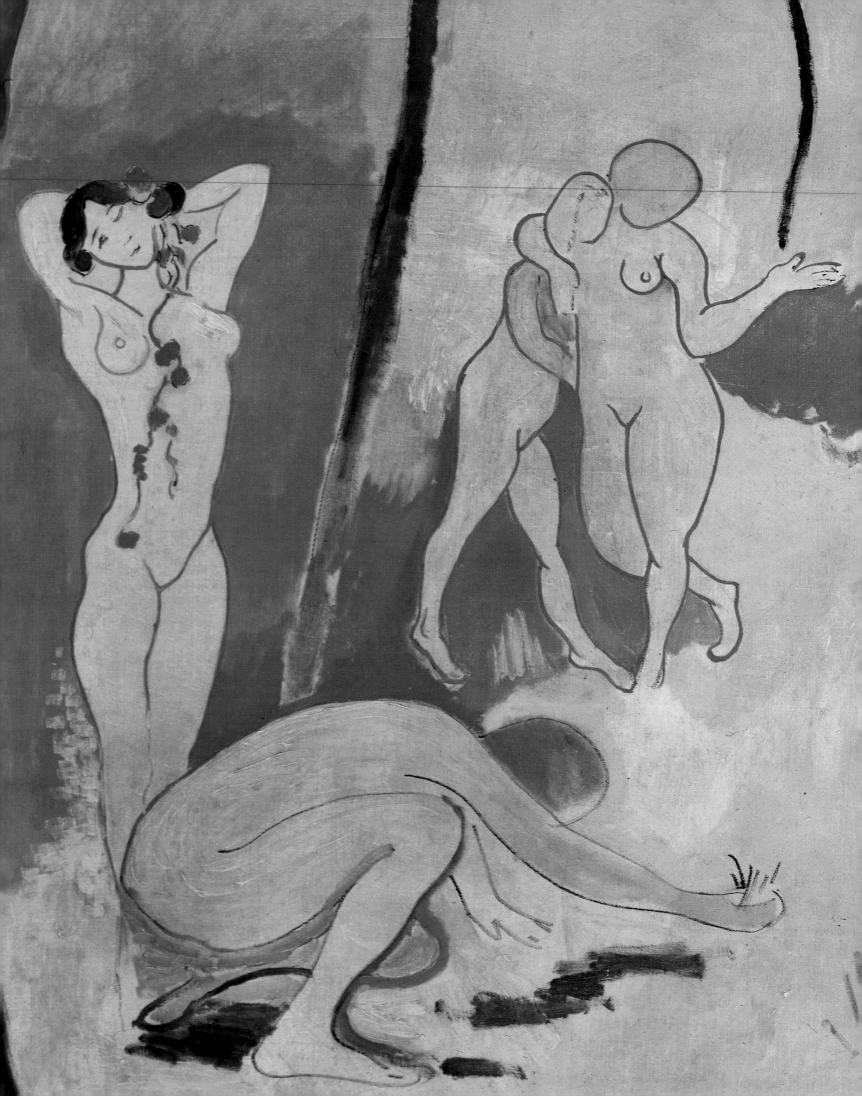

the whole thing with flat well-defined tints which — however pure — seem disgusting."[22] Even Leo Stein was puzzled when he first saw it. According to Maurice Sterne, it took Stein more than a week to make up his mind about it. Only after he had gone back to study it numerous times did he decide to buy it, feeling that it was "the most important painting done in our time."[23]

But perhaps the most important critique of Matisse's painting was the one implicit in Picasso's *Demoiselles d'Avignon* (fig. 8), done a year later, after Picasso had had ample time to study the *Bonheur de vivre* at Leo and Gertrude Stein's apartment. Picasso appears to have undertaken the *Demoiselles* in a spirit of competition with Matisse, although by 1907 the rougher, more sculptural, and more overtly primitivistic style of Matisse's *Blue Nude* must have been more immediately useful to him than the flat and brightly colored *Bonheur de vivre*. But the ambitious subject matter and sheer size of the *Bonheur* offered the most visible target for Picasso's competitive spirit, and the *Demoiselles* seems to be a clear attack on it. Although numerous points of comparison can be made between the two paintings — both of which have a common point of departure in Cézanne's bather paintings[24] — Picasso seems quite literally to deconstruct the *Bonheur*, in almost every way possible.

Whereas the *Bonheur de vivre* is curvilinear, exuberant, and brightly colored, the *Demoiselles d'Avignon* is angular, harsh, and monochromatic. Matisse's large picture presents a rather innocent erotic reverie in a bucolic setting, and is a celebration of life's pleasures. Picasso's even larger picture is a violent depiction of the harsh realities of a modern urban brothel, and has been understood as a confrontation with sexual trauma and death.[25] If Matisse's painting had in a way thumbed its nose at the grand tradition, Picasso's picture in effect declares that tradition — and Matisse's painting — to be irrelevant, even frivolous. The critics had accused Matisse of having gone too far; Picasso implies that he had not gone far enough.[26]

Although the *Bonheur de vivre* has not attracted as much critical attention as the *Demoiselles d'Avignon*, it remains even today a surprising and provocative picture, which only recently has led one scholar to wonder whether its contradictions should be characterized as "innocence, irony, or idiocy?"[27] In its lack of resolution between representation and abstraction, and its conflicts between subject and form, it posits a strikingly new kind of pictorial content that is in many ways as disturbing today as it was in 1906.

J F

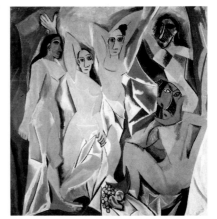

Fig. 8. Picasso, *Les demoiselles d'Avignon*, June-July 1907. Oil on canvas, 96 x 92″ (243.8 x 233.7 cm). Collection, The Museum of Modern Art, New York. Acquired through the Lillie P. Bliss Bequest.

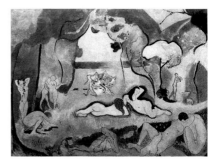

Fig. 9. *Le bonheur de vivre*.

View of the Sea, Collioure (La mer vue à Collioure)

1906
Oil on canvas
15 x 18⅛″ (38 x 46 cm)
Signed lower left: *Henri Matisse*
Inv. no. 73

Fig. 1. *Olive Trees at Collioure*, 1906. Oil on canvas, 17½ x 21¾″ (44.5 x 55.3 cm). The Metropolitan Museum of Art, New York. Robert Lehman Collection, 1975.

Fig. 2. *Seated Nude*, 1906. Oil on canvas, 13 x 16″ (33 x 40.6 cm). The Barnes Foundation, inv. no. 212.

This tranquil view of the sea from the Bois de Py, in the hills above Collioure, was painted during the late spring of 1906, shortly after Matisse returned to France from his brief sojourn in Algeria.[1] Its color and brushwork are closely related to *Olive Trees at Collioure* (fig. 1), done around the same time. Both pictures were bought by Leo Stein at the end of the summer of 1906, shortly after they were painted. As Stein later remembered, at this time Matisse brought back from Collioure the two versions of *The Young Sailor*, and "some landscapes in bright colors, which at first attracted me so strongly that I wanted the whole lot; but I could only get two of them, as the others were already promised."[2]

While Matisse's 1905 Collioure landscapes had been painted mostly in the pure, unmixed colors that grew out of his neo-impressionist palette, his 1906 landscapes are generally softer in color and give more attention to evoking atmospheric effects. After the strenuous imaginative synthesis of the *Bonheur de vivre* he seems to have been intent on exploring anew the possibilities of relatively direct perceptual painting. This is especially evident in a number of his depictions of female nudes in landscapes (fig. 2), painted from life, and in landscape studies such as this one.

View of the Sea, Collioure emphasizes the harmonious relationship between the gently curving forms of the landscape and the more angular lines of the houses that are nestled within it. Nature and architecture are further united by touch and color, and the overall effect is lyrical and tender. The soft pinks, blues, and greens evoke natural light and atmosphere; the placement of the tree on the right and the way that the arabesquelike movement of its branches and leaves frames the scene emphasize the picturesque qualities of the view. This sort of framing device, which at once asserts the surface of the picture and provides a point of reference for a view into deep space, recalls the similar use of trees by Cézanne.

View of the Sea, Collioure is a good example of how flexibly Matisse was able to use the "mixed" style that he had developed, which was characterized by the combination of different kinds of brushstrokes and was based on a byplay between arabesques, dabs, and scumbled areas that he so admired in Cézanne.[3]

Matisse was strongly drawn to the hills around Collioure, which he seems to have related to the ancient Mediterranean idea of the sacred grove. During the first three summers he spent there, he returned repeatedly to these hills as painting sites. As we have seen, a painting done in a similar locale had served as the inspiration for the *Bonheur de vivre*.

J F

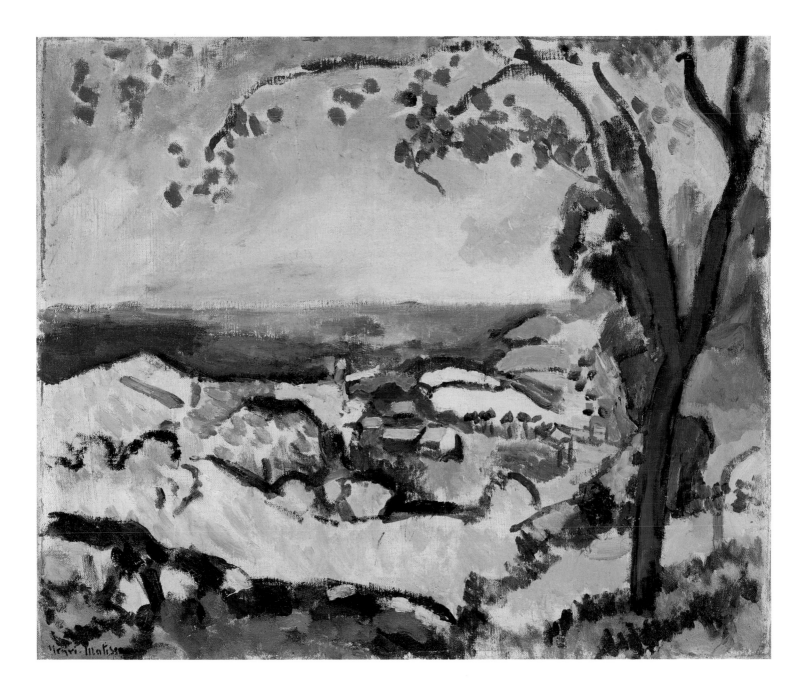

The Red Madras Headdress (Mme Matisse: Madras rouge)

Summer 1907
Oil on canvas
39⅛ x 31¼″ (99.4 x 80.5 cm)
Signed lower right: *Henri Matisse*
Inv. no. 448

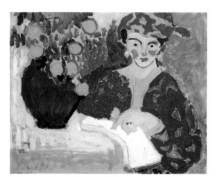

Fig. 1. *Red Madras Headdress*, 1907. Oil on canvas, 13 x 16″ (33 x 40.6 cm). The Barnes Foundation, inv. no. 878.

This rhythmically composed portrait of Matisse's wife coincides with an important turning point in his art, when he was moving away from the spontaneous, loosely brushed style of the fauve period and toward the flatter and more decorative manner that would characterize his most important paintings during the next several years.

This picture has traditionally been dated to the winter of 1907–1908, but it was actually done at Collioure early in the summer of 1907.[1] The painting is remarkable for its color and the boldness of its patterning. Although virtually no chiaroscuro modeling is used, the articulation of the woman's body in space is vividly indicated by the carefully modulated drawing and is further enhanced by the daring contrasts of green and red tints within the skin tones. The curving, rhythmic forms are made even more lively by the way they pivot around the straight arm of the chair. This effect is accented by the woman's brooch, which echoes the rosy pinks of her cheeks and engages the embellished trim around the neckline, sleeves, and belt within the complex counterpoint set up between the sprung rhythms of the differently decorated areas.

In 1907, Matisse was vacillating between sculptural and decorative styles, and this bright and boldly patterned picture stands in marked contrast to the more modeled, Cézannian paintings he did that year. The enameled surface, decorative flatness, and simplified drawing here evoke other paradigms, such as Byzantine enamels and Near Eastern art. This new, more synthetic kind of imagery also signaled a change in Matisse's symbolical means, as can be seen by comparing *The Red Madras Headdress* with the smaller and sketchier *Red Madras Headdress* (fig. 1), in which the symbolic relationship between the woman and the flowers is suggested by their juxtaposition. In *The Red Madras Headdress* the vitality of the woman is expressed directly by the floral patterning on her dress — in a way that recalls the similar use of decorative symbolism by van Gogh and Gauguin.

This extreme simplification of forms drew mixed reviews at the Salon d'Automne. Louis Vauxcelles praised the daring color harmonies constructed around the peacock blue of the background, but felt that the figure was a "caricature-like effigy" and expressed his horror at being reduced "to praising only the background in a portrait!"[2] Although Michel Puy felt that the painting "did not avoid a certain comic effect," he admired Matisse's subtle use of contour and color and "his gifts as a harmonist." Puy's only fear was that Matisse might push this kind of decorative abstraction too far and arrive at "deductions that were too absolute."[3]

In fact, spurred on by the very different direction that was then being taken by Picasso and Braque, during the next few years Matisse would push decorative painting even further. J F

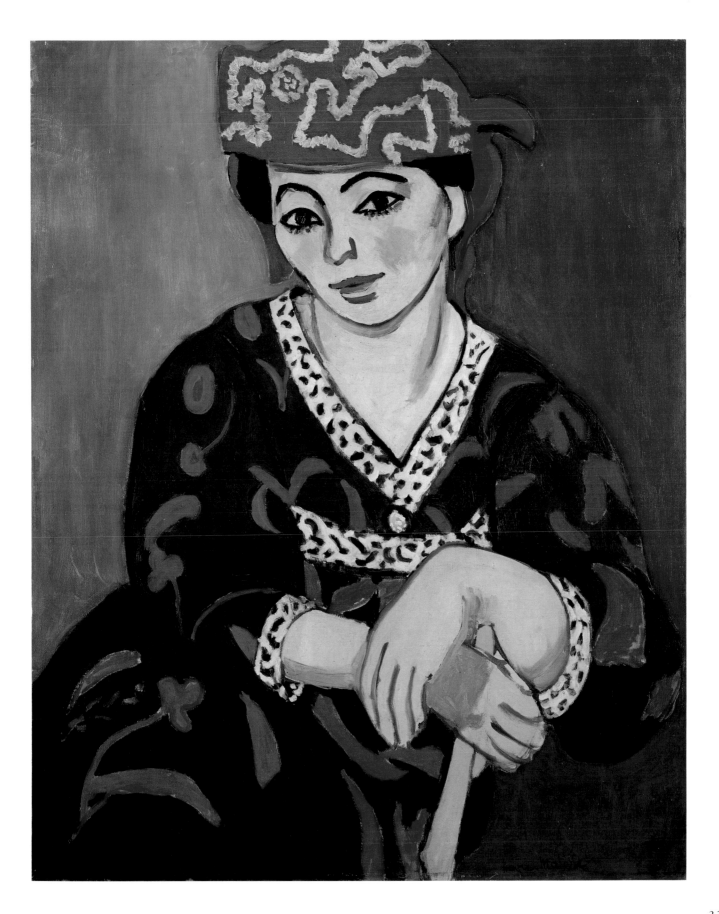

Blue Still Life (Nature morte bleue)

Late 1907
Oil on canvas
35¼ x 45⅞" (89.5 x 116.5 cm)
Signed lower right: *Henri Matisse*
Inv. no. 185

Fig. 1. *Vase, Bottle, and Fruit*, c. 1906. Oil on canvas, 28¼ x 36¼" (73 x 92 cm). The State Hermitage Museum, St. Petersburg.

Fig. 2. *Harmony in Red*, 1908. Oil on canvas, 70⅞ x 86⅝" (180 x 220 cm). The State Hermitage Museum, St. Petersburg.

The *Blue Still Life* is one of Matisse's most Cézannian compositions. But it is a strong affirmation of Matisse's own version of Cézannism rather than a mere imitation. The smoldering intensity of the brightly colored fruits in relation to the deep blues that surround them already prefigures the coloristic sophistication of Matisse's mature work.

In this painting Matisse makes especially effective use of the patterned *toile de Jouy* cloth on the table, which he would employ in a number of his still lifes in later years.[1] The relationship between the real fruit on the table and the blue basket of flowers that dominates the pattern on the tablecloth creates a powerful metaphor for the expression of *élan vital*, or vital force, that greatly enhances the strength of the painting. The metaphorical exchange of energy between organic and inorganic things is further emphasized by the way the tendrils of the real plant on the table extend the energy of the printed plant forms on the cloth below it across the brightly colored fruit. This vital flow is picked up by the floral pattern on the screen, in which the flowers seem almost literally to grow up out of the fruit on the far left side of the table. The right-hand side of the painting, by contrast, is heavily anchored by the majestic vase and the dark, stately verticals of the curtains and wall.

Just how far Matisse had come in exploring the plastic and symbolic possibilities of pattern and color can be seen by comparing his use of the cloth in this painting with that in *Vase, Bottle, and Fruit* (fig. 1), done a year or so earlier. During the next few years he would make a great effort to elaborate in an even more personal way the symbolic use of rhythmic patterning and plastic density that he so admired in the works of the great post-impressionists, such as Cézanne.[2]

In fact, the *Blue Still Life* seems to have formed the basis of one of Matisse's strongest moves to find an alternative to his Cézannism — *Harmony in Red* (fig. 2), in which many of the same elements are present, but in relentlessly flattened form. The perspective of the table, the use of the patterned tablecloth, and even the rectangular divisions and background floral motifs in the two paintings are so similar that one can see *Harmony in Red* as a recasting into a new pictorial language of many of the same elements that Matisse had used in the *Blue Still Life*.[3] During the next few years, he would articulate his new pictorial language in several different ways, as can be seen in *The Blue Tablecloth* of 1909 and in the large decorative interiors he painted in 1911.

Matisse exhibited this painting at the 1908 Salon d'Automne along with *Harmony in Red* and a number of other works — his largest representation at any Salon to date. Louis Vauxcelles, who was not enthusiastic about *Harmony in Red*, called the *Blue Still Life* "superb" and remarked that "The warm harmonies of blue and black combined with the glimmering red and yellow glints of the apples and lemons, are a match for a fine Cézanne."[4]

J F

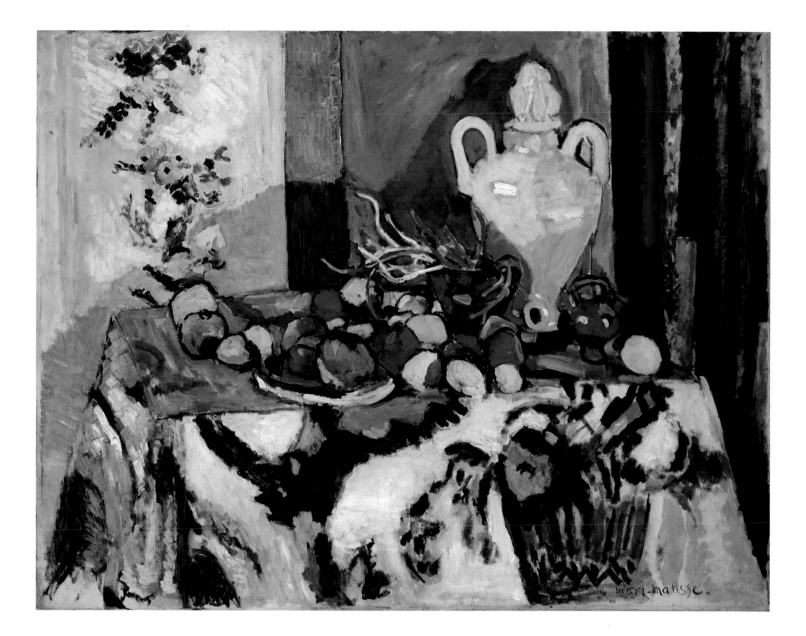

Interior with Goldfish (Poissons rouge: Intérieur)

1912
Oil on canvas
46⅜ x 39¾″ (117.8 x 101 cm)
Signed lower right: *Henri Matisse*
Inv. no. 569

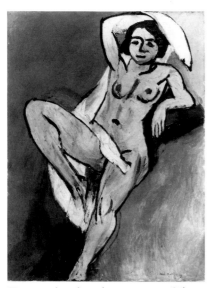

Fig. 1. *Nude with a White Scarf*, 1909. Oil on canvas, 45¼ x 35″ (116.5 x 89 cm). Statens Museum for Kunst, Copenhagen.

Fig. 2. *Zorah in Yellow*, 1912. Oil on canvas, 32 x 25″ (81.3 x 63.5 cm). Private collection.

Interior with Goldfish was painted in the spring of 1912, shortly after Matisse returned from his first trip to Morocco. The setting is the studio in the garden of his villa at Issy-les-Moulineaux, a suburb of Paris. On the table are a small bouquet of flowers, a bowl of goldfish, and a representation of his sculpture *Reclining Nude I* of 1907 (see page 258), a variation on the reclining figure in the *Bonheur de vivre*. On the far wall, two of Matisse's paintings are depicted, *Nude with a White Scarf* (fig. 1), which echoes the pose of *Reclining Nude I*, and *Zorah in Yellow* (fig. 2), a portrait of a Moroccan woman painted in Tangier.

Interior with Goldfish is built around contrasts between the tangible and the intangible, the real and the illusory. The dominant blues, rich and translucent like those of stained glass windows, suggest a disembodied, abstract space. But within this space a number of vividly concrete areas, such as the easel and the table, are inscribed with an insistent three-dimensionality. The pictorial structure of the painting reinforces its underlying theme: a complex meditation on the relationships between art and reality.

The still life on the table is a form of miniaturized nature in which plants, aquatic life, and the figure of the woman are brought together as a reduced and abstracted version of a landscape, "based on nature, but transformed to serve a decorative purpose...reduced to an artificial state, which is that of ornament or art."[1] The artificially contained life within the goldfish bowl is emblematic of the artificial combination of objects on the tabletop, which are in turn emblematic of the studio in which works of art are made. "Real" nature here is merely glimpsed through the doorway at the back of the room, where we see plants growing next to a shaded garden wall, under the green and blue stripes of an awning. As in the *Red Studio*, painted the previous fall, the window in *Interior with Goldfish* offers us no clear view of the outdoors, giving prominence instead to the themes of artifice and display — and leading us to contemplate the profound rapports that exist between the animate and the inanimate.[2]

The woman on the table is an inanimate representation of an animate being, the live flowers next to her have been cut from their roots and placed in an artificial setting, and the goldfish have been given an artificial home where they are constantly on display. In an extension of this metaphor, the arrangement on the table is itself blatantly artificial, and the room where it has been set up is a place where an artificer works, and where his pictures are displayed on the far wall. As in other paintings from this period, Matisse employs the pictures within the picture in a complex and provocative way — at once equating and differentiating between various kinds of framed views of other spaces. The view through the doorway is as intensely flattened as the paintings around it, as if it, too, were a picture rather than a real view. The two paintings, in turn, radiate as much light as the doorway, while the window is treated almost as opaquely as a wall.

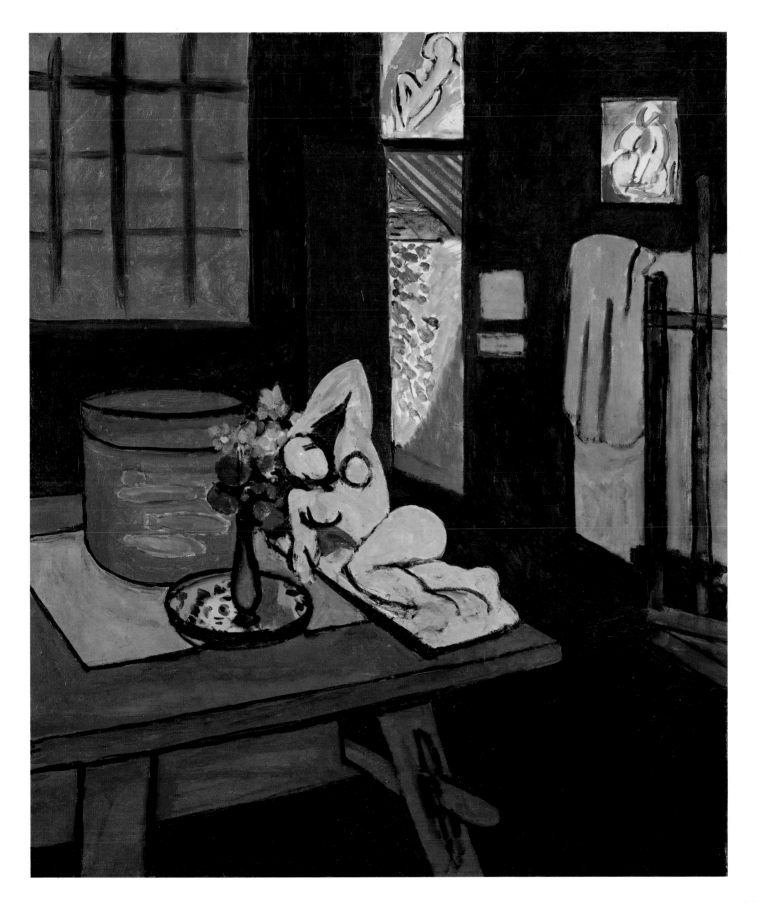

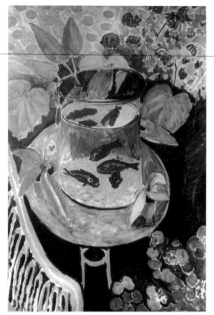

Fig. 3. *Goldfish*, 1912. Oil on canvas,
57⅞ x 38⅝" (147 x 98 cm). Pushkin State
Museum of Fine Arts, Moscow.

Fig. 4. *Still Life with Goldfish*, 1912. Oil on
canvas, 32¼ x 36¾" (82 x 93.5 cm). Statens
Museum for Kunst, Copenhagen.

The theme of the goldfish is related to Matisse's voyage to Morocco, where he had been deeply impressed by the way that goldfish were used as objects of contemplation.[3] A year later, recalling his recent experiences in a Moorish café, Matisse told Marcel Sembat, "I had my bowl of fish and my pink flower. That is what struck me! These great fellows who spend hours contemplating a flower and some goldfish."[4] The light in this painting also seems to refer to his trip to Morocco: the way the cool, dark interior is played against the glimpses of brilliant sunlight evokes the sharp contrasts between light and shadow that one experiences in North Africa.[5]

Interior with Goldfish is one of four compositions with goldfish Matisse did that spring. *Goldfish* (fig. 3), now in Moscow, is set outdoors, but in the other three paintings Matisse brings "nature" indoors and sets it on the tabletop. It is impossible to be certain about the exact order in which these three paintings were executed, but a good case can be made for the following sequence: Copenhagen (fig. 4); Barnes; New York (fig. 5). In the Copenhagen *Goldfish* (in which the flowers are slightly different from the other two), the elements of the still life are depicted without any reference to their specific setting; and the picture, although smaller than the other two, is considerably reworked. The Barnes and New York paintings, which are virtually identical in size, show the still life in the same environment, though in radically different ways. The Barnes painting has a strong sense of a specific time and place, whereas the New York *Goldfish and Sculpture* evokes an abstract, fluid environment. The Barnes picture is much more heavily worked than the New York picture, suggesting that the New York picture was painted later, in keeping with Matisse's usual practice at this time of following a more modeled, concrete image with a flatter and more synthetic one.[6]

In any case, the Barnes and New York paintings were probably painted within a very short time of each other, the second consciously done as a variation on the first. The still lifes are almost exactly the same, and the colors of the New York painting are essentially a lighter version of those in *Interior with Goldfish*. The space and setting in the New York painting, however, are so intensely dematerialized that they would be hard to read without the more descriptive depiction in the Barnes picture. In the New York picture, the light and shadow of the doorway are treated as abstract signs, in somewhat the same way that Matisse would depict the window view in the Museum of Modern Art's *Piano Lesson* of 1916 (to which the Barnes *Music Lesson* is a similar kind of pendant; see page 259).

Matisse returned to the goldfish theme in subsequent years, using the goldfish bowl as a focus for contemplation, as can be seen in the Barnes Foundation's *Woman with Goldfish Bowl* of 1921 (fig. 6). Indeed, the motif seems to have haunted him to the end of his life, appearing in a transformed, abstract way in the paper cutout *Chinese Fish* of 1951.

J F

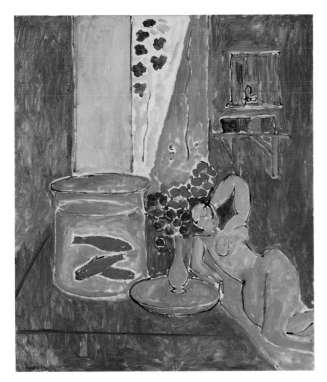

Fig. 5. *Goldfish and Sculpture*, 1912. Oil on canvas, 46 x 39⅜″ (116.2 x 100.5 cm). Collection, The Museum of Modern Art, New York. Gift of Mr. and Mrs. John Hay Whitney.

Fig. 6. *Woman with Goldfish Bowl*, 1921. Oil on canvas, 18¼ x 22¼″ (46.4 x 56.5 cm). The Barnes Foundation, inv. no. 963.

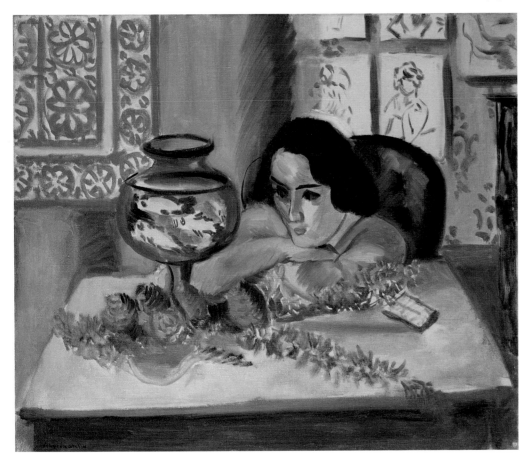

Seated Riffian (Le Rifain assis)

Late 1912 or early 1913
Oil on canvas
78¾ x 63″ (200 x 160 cm)
Signed lower left: *Henri Matisse*
Inv. no. 264

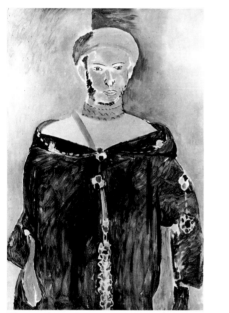

Fig. 1. *The Standing Riffian*, 1912. Oil on canvas, 57⅝ x 38½″ (146.5 x 97.7 cm). The State Hermitage Museum, St. Petersburg.

In the fall of 1912, Matisse returned to Morocco. That November, he wrote his family that he planned to do a picture of a young man from the Rif mountains, an area where some of the most colorful costumes in Morocco were worn, and which Matisse had visited the previous spring.[1] The painting referred to is *The Standing Riffian*, now in the State Hermitage Museum (fig. 1). Since the subject and coloring of that picture and the Barnes *Riffian* are virtually the same, it seems likely that both were painted within a fairly short time.

The *Seated Riffian* is remarkable for its size and sheer physical presence. The execution appears to have been very rapid and is something of a tour-de-force, considering the scale of the composition and the complex deployment of rhyming forms. The critic Waldemar George saw this painting as a typical example of Matisse's way of animating a picture through the extension of a "patch" of color, noting the way that Matisse quite arbitrarily "extended to the model's face, clearly split into two distinct parts, the color that belongs to the background."[2] And indeed, the composition of the painting, which has surprisingly little drawn contour, appears to have been determined by the inner energy of the various colors extending themselves in relation to each other.

In this larger than life-size image, Matisse has captured the legendary ferocity of the Rif tribesmen who were described by a contemporary as "haughty, fierce-looking dwellers of the mountains.... distinguished by their pride of bearing and by their imperious tones and gestures, as well as by their distinctive dress.... eternal rebels, they bow to no authority, and are restrained by no laws"[3] (see fig. 2). The pose of the Riffian, at once relaxed and commanding, expresses well his imperious bearing. The casual way that his ocher sling passes under his ornate green *djellaba*, and the sharp way that the rectangular block that he sits on is played against the forms of his legs and costume, evoke an aura of muted threat. In contrast to the stately vertical stripes of the background, he seems to float above the magenta floor. His open-legged pose and the way that his crossed hands and the decoration on his costume emphasize his genital area combine to produce an image that is at once aggressive and elegant. The sense of graceful virility is reinforced by the intense chromatic vibrations of the broadly brushed greens, magentas, and ochers that dominate the composition.

Male figures are relatively rare in Matisse's painting, and the pose and the subject here reflect his interest in Delacroix's watercolor studies of Moroccan men. The intensity of the Riffian's bearing and the pictorial treatment of his face also recall Matisse's own *Young Sailor I* of 1906 (fig. 3). These two works share common ground in the relative exoticness of their subjects, and in each painting Matisse appears to have been intrigued by a kind of feral intensity that radiates from a "primitive" man.[4]

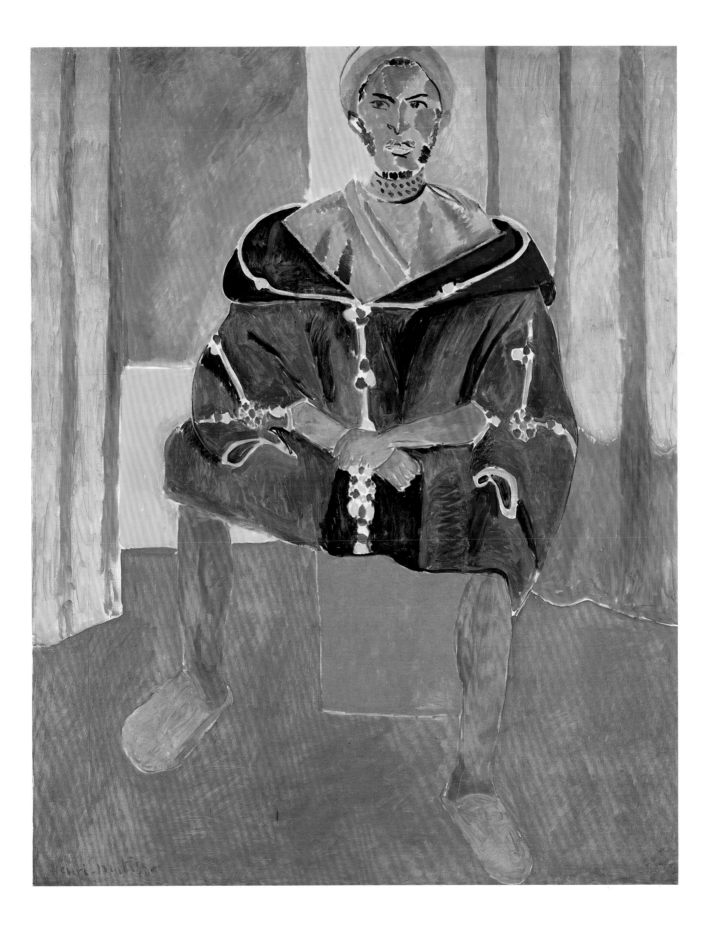

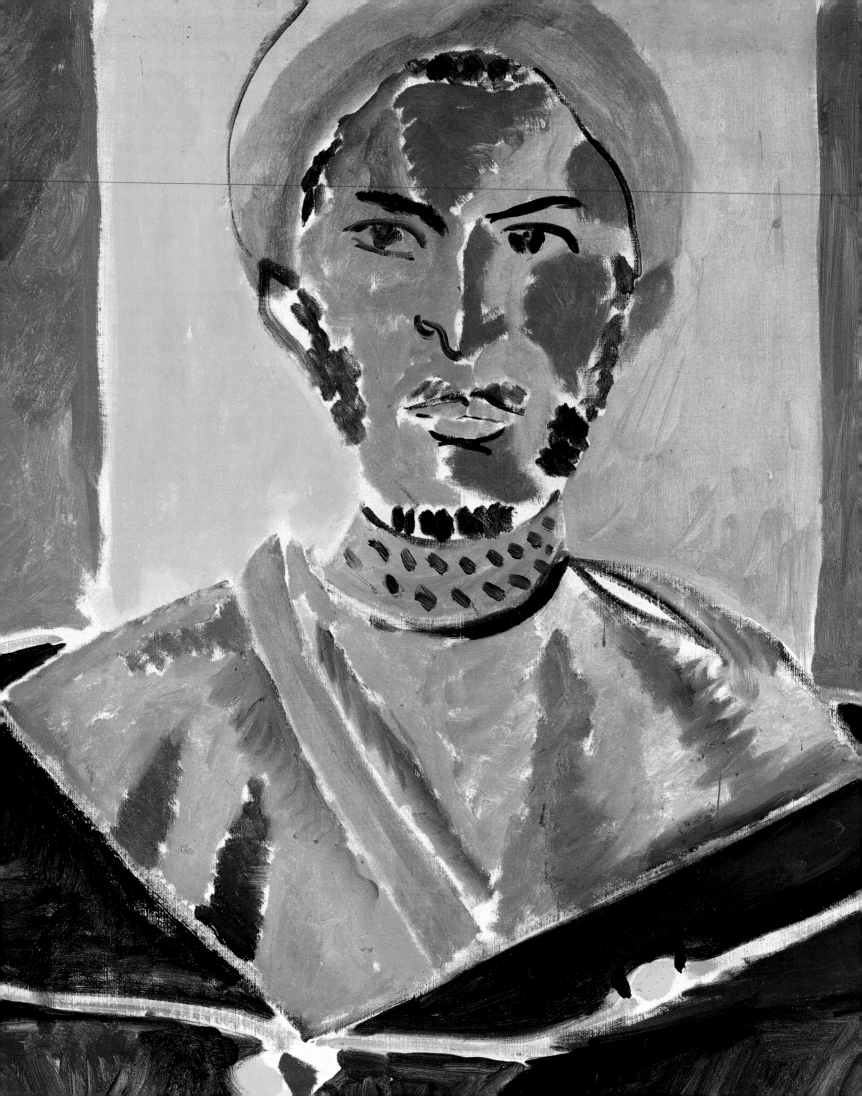

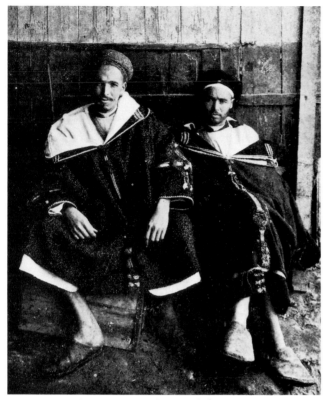

Fig. 2. *Two Merchants of Tangier*. Photograph from Vincent Sheean, *An American Among the Riffi* (New York, 1926).

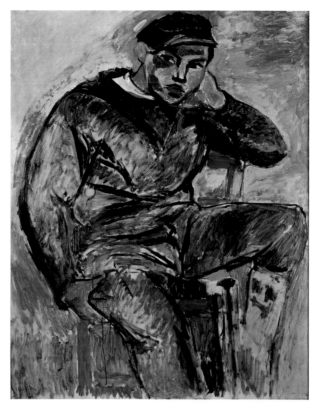

Fig. 3. *The Young Sailor I*, 1906. Oil on canvas, 39¼ x 32¼" (100 x 82 cm). Private collection, New York.

When the *Seated Riffian* was shown at Matisse's April 1913 exhibition of Moroccan paintings, Marcel Sembat singled it out for particular praise: "And the Riffian! Isn't he fine, this great devil of a Riffian with his angular face and ferocious bearing!

"Can you look at this splendid barbarian without dreaming of the warriors of yesteryear? The Moors of the *Chanson de Roland* had this wild look!

"In this Riffian, moreover...you will recognize this same effort to emphasize the dominant characteristics, the essential feelings, the large expressive lines; and to express them harmoniously, subordinating everything else to them, and sacrificing those who would be shocked by them."[5]

Despite Sembat's praise, the shocking quality and large size of this painting appear to have discouraged prospective buyers. Although Matisse offered the picture to his Russian patron Ivan Morosov, it remained unsold until it was eventually acquired by the Danish collector Christian Tetzen-Lund sometime around 1920.[6]

J F

Still Life with a Plaster Bust (Nature morte aux coloquintes)

Late spring 1916
Oil on canvas
39⅜ x 31⅞" (100 x 81 cm)
Signed lower right: *Henri Matisse*
Inv. no. 313

Fig. 1. *Jeanette, V (Jeanne Vadarin, 5th State)*, 1916. Bronze, 22⅞ x 8⅛ x 10⅝" (58.1 x 21.3 x 27.1 cm). Collection, The Museum of Modern Art, New York. Acquired through the Lillie P. Bliss Bequest.

Although long dated to 1912, *Still Life with a Plaster Bust* was actually painted in mid-1916. The painting was done shortly after Matisse finished the fifth and last version of the *Jeannette* busts — or perhaps while the sculpture was still in progress, since the plaster bust of *Jeannette, V* (fig. 1) that dominates the complex arrangement of fruit and flowers is set on a sculpture stand.[1] The space around the bust is quite complex, consisting of a series of overlapping rectangular surfaces that make the painting difficult to read and lend it a somewhat cubistic look.

Whereas most of Matisse's studio interiors, such as *The Red Studio* or *Interior with Goldfish*, are noteworthy for their sense of calm and order, *Still Life with a Plaster Bust* emphasizes instead the somewhat chaotic conditions behind artistic creation. (It may also reflect Matisse's unsettled state of mind about the war.) The plate of colocynths, bouquet of flowers, and empty basket that surround the bust are like detached studio props waiting to be placed within a coherent context. The two green rectangles in the background suggest the outdoors, but whether they are to be construed as windows or as segments of paintings is unclear. The pink rectangle at the lower left is similarly difficult to read. The empty gold frame in front of it (painted bright yellow) further complicates the spatial construction, while at the same time providing a solid anchor for the rich interplay between rectilinear and circular shapes. The color harmony of greens, pinks, and ochers played against deep grays is rather lyrical, in contrast to the cubist-inspired geometrical scaffolding of the composition. Even such a clearly legible object as the vase of flowers is surrounded by an unexpected aura of light and seems to float in a mist. The luminous whiteness that surrounds it also relates to the dotlike forms directly above, and to the general language of transparency that pervades much of the painting.

Matisse depicted his own sculpture in other paintings done around this time. That same year, he incorporated *Reclining Nude I* of 1907 (see page 258) into the two versions of *Sculpture and Vase of Ivy*, which are also composed in terms of circular and angular forms and employ unexpectedly transparent passages.[2]

A similar, cubist-inspired spatial complexity is also seen in *The Window* of 1916 (fig. 2), where a subtle interplay exists between luminous transparency and opaque patterning, and between a signlike shorthand and detailed description.

J F

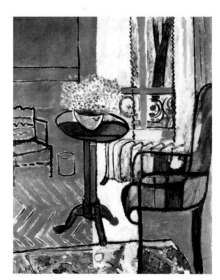

Fig. 2. *The Window*, 1916. Oil on canvas, 57½ x 46" (146 x 117 cm). The Detroit Institute of Arts, City of Detroit Purchase.

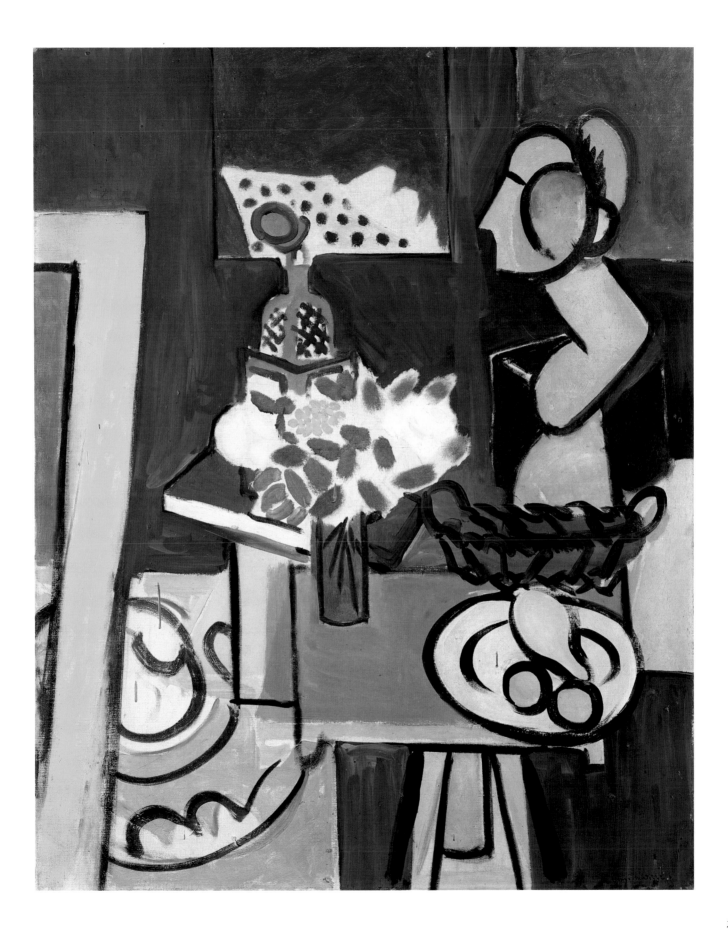

The Three Sisters Triptych (*Les trois soeurs, tryptique*)

1917

Oil on canvas

left: 77 x 38⅛″ (195.5 x 96.8 cm)
center: 76⅞ x 38⅛″ (195.2 x 96.8 cm)
right: 76¼ x 37⅝″ (193.8 x 95.7 cm)

Inv. nos. 363, 888, 25

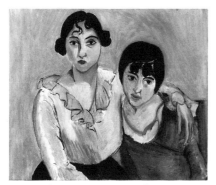

Fig. 1. *The Two Sisters*, 1917. Oil on canvas, 24 x 29⅛″ (61 x 74 cm). The Denver Art Museum.

Fig. 2. *Laurette with Turban, Yellow Jacket*, 1917. Wood, 24⅛ x 19½″ (61.3 x 49. 4 cm). National Gallery of Art, Washington; Chester Dale Collection.

Fig. 3. *Woman in Turban (Laurette)*, early 1917. Oil on canvas, 32⅛ x 25¾″ (81.3 x 65.4 cm). Baltimore Museum of Art, The Cone Collection, formed by Dr. Claribel Cone and Miss Etta Cone of Baltimore, Maryland.

Fig. 4. *The Three Sisters*, 1917. Oil on canvas, 36½ x 28¾″ (92 x 73 cm). Museé de l'Orangerie, Paris; Collection Walter-Guillaume.

In 1916 Matisse began to paint a young Italian model named Laurette, whom he depicted in so many different moods and circumstances that she seems like a character in a novel who reveals different parts of herself in different situations and in relation to different people. The paintings of Laurette also have a good deal of straightforward sensuality, a quality that had long been present in Matisse's drawings but quite rare in his paintings.

Along with this new sensuality, new thematic concerns began to emerge. For the first time Matisse began to do double and even triple portraits, having Laurette pose with another model or with one of her younger sisters (fig. 1). He also began systematically to explore different aspects of the model in relation to various exotic costumes, most especially those that evoked his recollections of Morocco (figs. 2 and 3).[1]

The most extraordinary of these multiple figure compositions is the Barnes *Three Sisters* triptych, which was probably begun in the spring of 1917.[2] In each of the three panels Laurette appears with two other women. In the left and central panels all three women are dressed in Moroccan costume; the turbaned Laurette's costume is different in these two pictures, while her companions are dressed in the same predominantly green and purple robes. The exoticism of the left panel is exaggerated by the Moroccan table in the foreground and by the presence of the African sculpture, probably a Bamana *Seated Figure* in Matisse's own collection.[3] In the right-hand panel, all three women are dressed in the same European garb that they wear in the Paris *Three Sisters* (fig. 4), suggesting that this panel was probably executed at the same time as the Paris *Three Sisters* and the Denver *Two Sisters*, (fig. 1), in which Laurette and the other women are similarly dressed.[4] On the wall behind them in the Barnes panel is a representation of Matisse's *Pink Marble Table*, which evokes his garden at Issy in early spring.[5] The left and central panels appear to have been painted

slightly later than the right one, in which the third woman is clearly an older, different person from the young girl in the other two. Despite the title, the women depicted are not all sisters; and there seems to be a total of four rather than three different women represented.[6] It is possible that the idea for a series of three related paintings came to Matisse after he had executed the right-hand panel.

In fact, Matisse did not originally insist on the pictures being exhibited together as a triptych. The three panels were dispersed and Dr. Barnes acquired them separately over a period of nine years. When Matisse visited the Barnes Foundation in December 1930, Barnes had only the two outside panels, and they were apparently not hung next to each other. It was Matisse himself who seems to have persuaded Barnes to acquire the central panel, which was available for sale in New York.[7] But initially, even Matisse could not remember which panel was supposed to be at the center of the composition. While he was in Merion that December, he did a rough pencil sketch of the triptych for Barnes, with the panels in the wrong order (fig. 5). What are now the left and right panels were drawn as the center and right respectively, and the center panel was mistakenly set at the left. It is clear from the way these sketches are drawn that Matisse was rendering what is now the central panel from memory; it is less tightly composed and less detailed than the other two. But, in a letter to Barnes written shortly afterward from the Plaza Hotel, New York, on the first of January 1931, Matisse said that he had been mistaken about the relative placement of the panels when he and Barnes had discussed them in Merion: "I was wrong in asserting that the panel of the 3 Sisters that is here [in New York] is not the central panel. While on the train [returning from Merion] all three came back to me in their order which is as follows." Matisse then sketched in the relative placement of the compositions (see fig. 6), noting the dominant colors reading from left to right as green, yellow, and red. He also did a sketch of what the general linear flow of the three pictures would be when they were properly placed (fig. 6).[8]

Matisse was eager to see the three paintings reunited. In a postscript to the same letter he wrote: "Let me repeat that I will be so happy if you are able to reunite these three things which work badly when separated. I am almost reluctant to say how well suited to your ensemble they are. That however is the goal that I wanted to attain when I made them"[9]

One can easily understand Matisse's desire to have the three paintings be together, since the ensemble as a whole has an impressive unity of color and design. The sweeping, V-shaped triangulation that unites the three panels is complemented by subtle rhymes of color and gesture. The contrapuntally deployed ochers, violets, and greens are resonantly played against the sharp black accents of such telling details as the African sculpture and Laurette's hair and legs in the left panel, and the broken rhythms of the hair and fan in the center. Similarly, the general theme of the curved arm and bent elbow runs through the three panels like a musical leitmotif.

Within the individual panels, each woman takes on a somewhat different look and seems to have a different character. Laurette, herself, who in the center panel has some of the austerity of a Byzantine saint, is presented quite erotically in the left panel, where she

Fig. 5. Sketch by Matisse indicating (incorrect) arrangement of *Three Sisters* triptych, 1930. Pencil on paper, 5¼ x 6⅜″ (13.3 x 16.2 cm).

Fig. 6. *The Three Sisters Triptych*, drawings by Matisse in a letter to Dr. Barnes, 1 Jan. 1931. The Barnes Foundation archives.

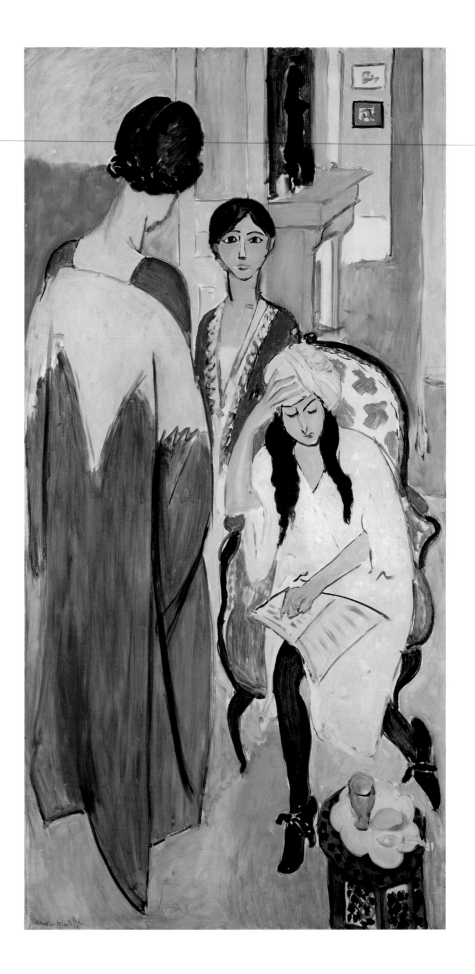

sits reading in an upholstered chair, the lovely curve of her black-stockinged leg rhyming with the dark vertical thrust of the Sudanese sculpture on the mantel behind her. In the right panel she is seen without a turban, the curves of her body played against the stark rectangle of her chair and the geometry of the table in the painting above her. Laurette's companions are also seen somewhat differently in each of the panels; their hair is variously arranged and their faces seem different each time we see them. (This aside from the fact that the standing woman in the right-hand panel is a fourth person who bears little resemblance to the young girl in the other two panels.)

For all its pictorial unity, the subject of the triptych is quite ambiguous and the ensemble is made puzzling, and even unsettling, by the wide range of art historical references that it incorporates. The eclecticism of the triptych reflects, among other things, Matisse's renewed interest in the brisk, flat, tonal rendering of Manet, and Manet's influence is also felt in the cool elegance of the women set against the flatly rendered backgrounds. The eclecticism of the *Three Sisters*, however, goes far beyond the nineteenth century and is an essential part of its expressiveness. As both Barnes and Barr have noted, the figures in the triptych allude to such diverse sources as African sculpture, Japanese triptych prints, and Byzantine and late gothic Sienese painting.[10]

The panels also evoke rather different, sometimes contradictory symbolical associations. The central panel is the starkest and most nearly symmetrical of the three. It functions like its counterparts in religious triptychs, which are also often triangular in compositional format and flanked by asymmetrical side panels that complete the symmetry of the ensemble. Both of the side panels, by contrast, are decidedly secular — the left one exotic and sensual, the right one quite *mondain* in a Parisian fashion.

The triptych format with three female figures in a domestic environment also clearly alludes to similar subjects in Japanese prints, with which the *Three Sisters* panels share an extreme verticality, lush color harmonies, crisp, flat patterning, and similar subject matter (fig. 7). Matisse certainly would have familar with such Japanese print triptychs, having based his 1907 *Le Luxe* on part of such a composition.[11] The contradictory references to Christian religious triptychs and secular Japanese print triptychs create a puzzling duality that contributes to the unsettling air of the ensemble. The synthesis of the sacred and the profane intrigues us, for the painting is at once solemn and charming, austere and sensuous.

Like the contemporaneous *Music Lesson*, the *Three Sisters* is a transitional work. It mixes the austerity and extreme vertical format of many of Matisse's 1913–1916 paintings with a new topicality and looseness of rendering. In this triptych, Matisse has achieved a grand composition without employing the intense modernist rhetoric that he had developed over the past several years. In its attention to surface details, in its relative naturalism, and in the subtlety with which the individual personalities are delineated, the *Three Sisters* triptych signals the beginning of a turning point in Matisse's art.

<div align="right">J F</div>

Fig. 7. Utamaro, *A Fanciful Picture of Utamaro's Studio with all the Artisans Represented by Women*, c. 1790. Woodcut.

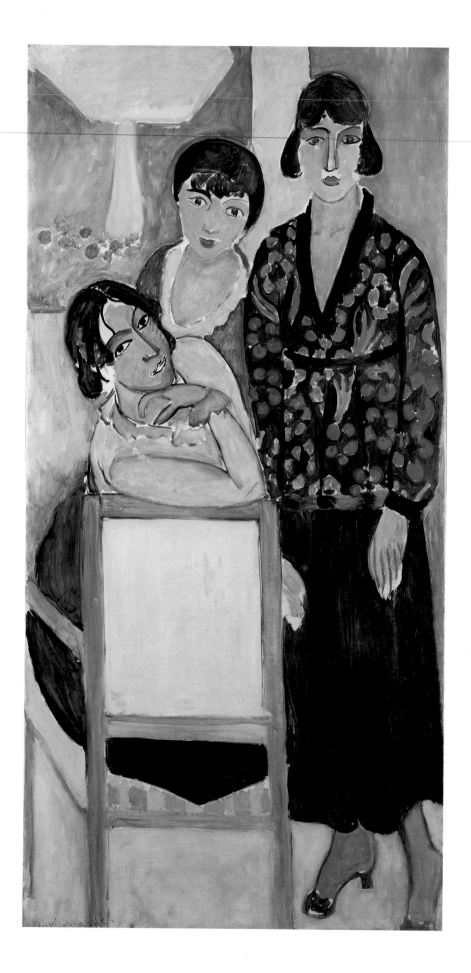

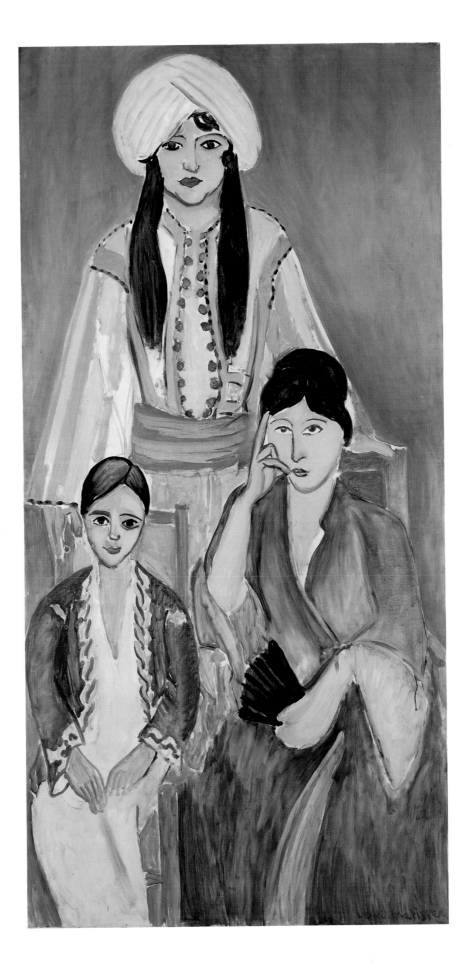

The Music Lesson (*La leçon de musique*)

1917
Oil on canvas
96⅜ x 79″ (244.7 x 200.7 cm)
Signed lower right: *Henri Matisse*
Inv. no. 717

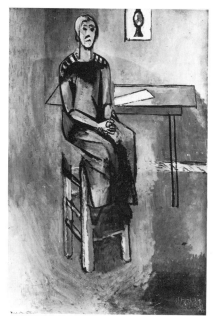

Fig. 1. *Woman on a High Stool (Germaine Raynal)*, early 1914. Oil on canvas, 57⅞ x 37⅝″ (147 x 95.6 cm). Collection, The Museum of Modern Art, New York. Gift of Florene M. Schoenborn and Samuel A. Marx (the former retaining a life interest).

Fig. 2. *Reclining Nude I [Aurore]*, 1907. Bronze (cast 6 of 10), 13⁹⁄₁₆ x 19⅝ x 11″ (34.5 x 49.9 x 28 cm). The Baltimore Museum of Art: The Cone Collection, formed by Dr. Claribel Cone and Miss Etta Cone of Baltimore, Maryland.

Matisse represented his whole family in a painting only twice — first in *The Painter's Family* of 1911, and later in *The Music Lesson*. The occasion for Matisse doing the painting seems to have been the imminent departure of his eighteen-year-old son Jean for military service at the height of World War I. But as it turned out, the picture was to be a valedictory statement in relation to the artist himself.

At the piano sit his daughter Marguerite, then twenty-three, and his seventeen-year-old son Pierre. To the left, Jean sits smoking a cigarette and reading a book, while just outside the window Madame Matisse sits sewing. Matisse's violin on the piano, its case open and ready to be played, acts as a surrogate for the painter, a devoted amateur violinist. Two of Matisse's own works are also represented in the painting, both in radically altered form. *Woman on a High Stool* (fig. 1), his 1914 portrait of Germaine Raynal, the wife of the critic Maurice Raynal, is set above the piano, its top cut off by its high placement; outside in the garden a greatly enlarged representation of Matisse's *Reclining Nude I* (fig. 2) dominates the pond and seems to animate, even personify, the luxuriant landscape.

The Music Lesson is a pendant to *The Piano Lesson* (fig. 3), done almost exactly a year earlier, during the summer of 1916.[1] Since the turn of the century, Matisse had created several pairs of paintings representing the same or similar motifs, the first usually more modelled and naturalistic, the second usually flatter and more abstract.[2] In this pair of paintings, however, Matisse has reversed his usual procedure and it is the earlier *Piano Lesson* that is flatter and more abstract.

The Music Lesson and *The Piano Lesson*, which are almost exactly the same size, sum up a pivotal moment in Matisse's career. While *The Piano Lesson* is one of his most severe and abstract paintings, *The Music Lesson* anticipates his imminent return to greater naturalism and a renewed interest in the particularities of specific people and ambiences as they appear in the flow of time.

In contrast to *The Piano Lesson*, *The Music Lesson* is rendered with airily transparent color and vibrant line, and its overall effect is that of a large, freely executed watercolor. A photograph taken of the painting while it was in progress (fig. 4) indicates that Matisse first executed a rather detailed line drawing for it, then colored it in quite rapidly with very few revisions.

On its surface, the scene depicted is one of bourgeois tranquility. Yet for all its apparent casualness, the painting exudes an unsettling sense of tension, effected in part by the nervous linearity of the rendering, in part by jarring dislocations in the spatial construction and in the relative sizes of the figures. These perspectival discrepancies are epitomized by the monumental statue next to the pond and the extravagantly oversized

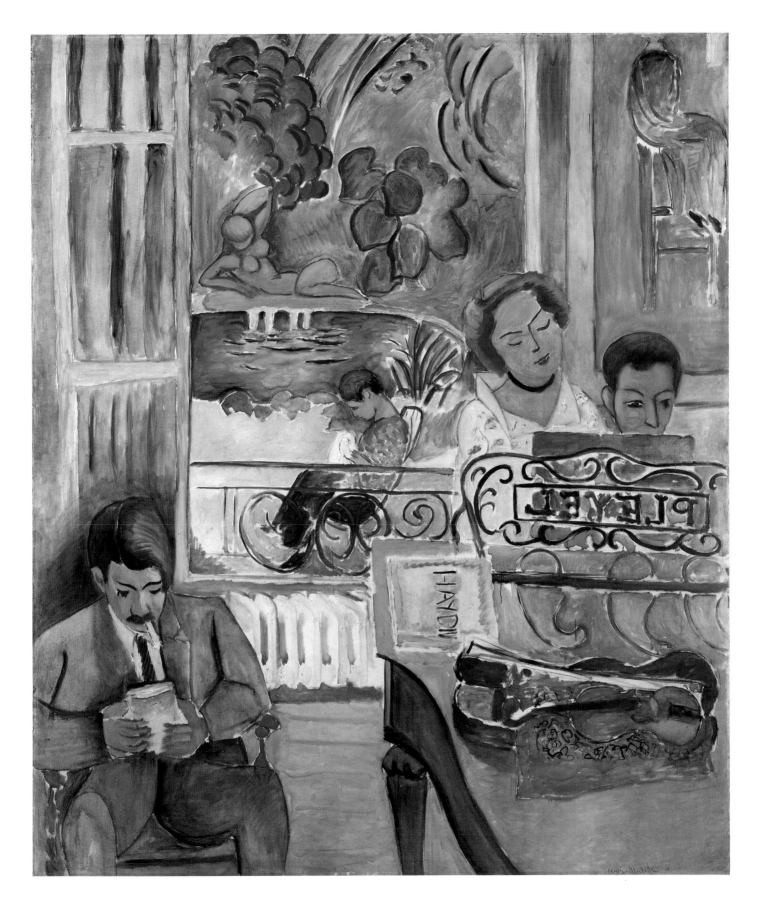

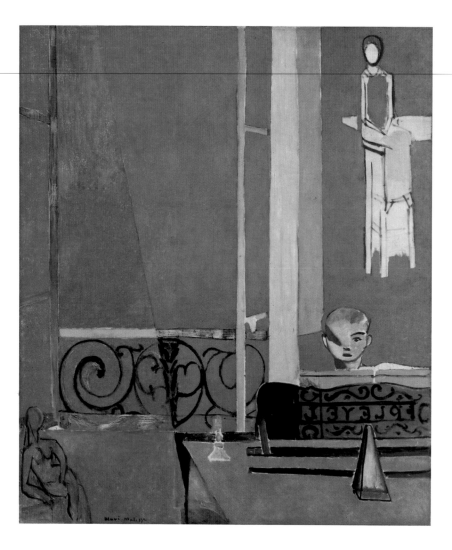

Fig. 3. *The Piano Lesson*, 1916. Oil on canvas, 96½ x 83¾″ (245.1 x 212.7 cm). Collection, The Museum of Modern Art, New York. Mrs. Simon Guggenheim Fund.

Fig. 4. *The Music Lesson* in progress, 1917.

foliage around it.³ They are further reinforced by the color harmony, in which the lively greens of the garden answer the vivid pink of the piano top, while everything else is rather dully colored.

The change of scale and the strategic deployment of color direct our attention to the nude and the landscape and invite us to contrast their sensuality with the rather banal interior, where everyone seems unaware of the splendid view. Indeed, everyone in the room is self-absorbed and engaged in some cultivated but routine activity. Playing the piano, sewing, and reading all represent the consumption of art rather than its creation. The artist, in removing himself from the picture, appears to be distancing himself from his family and his bourgeois life. "One can't live in a house too well kept," Matisse later observed. "One has to go off into the jungle to find simpler ways which won't stifle the spirit."⁴ The view through the window here is like an image of that "jungle."

The Music Lesson makes explicit the sexual tensions that were only implied in *The Piano Lesson*, where the voluptuous sculpture of a nude woman was contrasted with the austere teacherlike woman on the stool. In *The Music Lesson*, the overpowering nude in the lush

garden is contrasted to the cramped figure of Amélie Matisse and the complacent Margue-
rite seated at the piano. (The woman depicted on the stool has been literally cut off from
the activity around her.) If in *The Piano Lesson* we shared the painter's most rarefied and
synthetic vision, in *The Music Lesson* we observe the scene as if over his shoulder and we share
his sense of himself in relation to the outside world and to his family. The window view
beckons us to share his passionate vision of nature, and his sexual longing, just as the
analogous view in *The Piano Lesson* urged us to partake of his most abstract vision of nature
and of painting. In the earlier picture, nature was represented coolly as the raw material for
metaphysical speculation, but in *The Music Lesson* nature is intensely female and fraught
with desire.

Taken together, *The Piano Lesson* and *The Music Lesson* seem to allude to different
aspects of the formal, philosophical, and personal dilemma Matisse faced in the middle of
1917. *The Piano Lesson* was a kind of paradigm of the abstract musical possibilities of painting — a
probing of limits. *The Music Lesson* signals a return to sensuality, to elaborate description of
real light and real space, to sources — a new path for a painter who felt that his imagery had
moved too far away from direct contact with nature and become too synthetic. Two years
after he finished it, when he had taken the path suggested by *The Music Lesson*, Matisse
remarked that "when you have exploited the possibilities that lie in one direction, you
must, when the time comes, change course, search for something new If I had continued
down the other road, which I knew so well, I would have ended up as a mannerist. One
must always keep one's eye, one's feeling, fresh; one must follow one's instincts."[5]

As it turned out, only a few months after Matisse finished *The Music Lesson* he would
make a radical change by moving to Nice, where he would spend most of the rest of his life
apart from his family. It is tempting to see the voluptuous nude and the exuberant foliage as
harbingers of the sensuality and semitropical luxurance that he would find in Nice.

J F

Fig. 5. Sketch for *The Piano Lesson*, 1916.

Woman Reading at a Dressing Table (Intérieur, Nice)

Late 1919
Oil on canvas
29⅜ x 24″ (74.6 x 61 cm)
Inv. no. 394

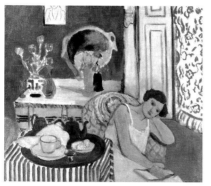

Fig. 1. *The Breakfast*, 1920. Oil on canvas, 25¼ x29⅛″ (64 x 74 cm). Philadelphia Museum of Art, The Samuel S. White III and Vera White Collection.

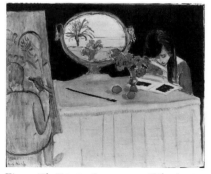

Fig. 2. *The Painting Session*, 1919. Oil on canvas, 29⅛ x 36⅝″ (74 x 93 cm). Scottish National Gallery of Modern Art, Edinburgh.

Shortly after Matisse arrived in Nice at the end of 1917, he had visited Renoir. And as if under the dual spell of the aged impressionist master and the intense but limpid light, he too began to concentrate on the sensuous rendering of women in luminous interiors.¹

Woman Reading at a Dressing Table depicts a woman seated in what is recognizably a hotel room. The theme of intimate self-absorption contrasted with an expanse of sea and sky is typical of Matisse's work at this time. (In fact, the original title of this picture was *Nice, la mer*.)²

On the table in front of the woman are a number of objects including the oval mirror that would become one of the most familiar props in Matisse's paintings of this period, and one of the most imaginatively used. It appears in the contemporaneous *The Breakfast* (fig. 1) as well as in the slightly earlier *The Painting Session* (fig. 2), in which a bouquet of flowers is magically seen both within the room and as if outdoors — at once solidly placed on the table and floating beside the palm tree in the mirror.³

The feeling of ennui, the sense of intimacy, and the emphasis on the psychological state of the model in these paintings mark a distinct departure from Matisse's earlier work. The very casualness with which the picture is painted reinforces the offhand quality of its psychological mood, and even the objects on the table evoke a certain sense of aimlessness and lassitude.

The painting is also full of sharply observed visual effects. On the translucent curtain, for example, a barely visible floral pattern is depicted with astonishing subtlety. Yet at the same time, close attention is also paid to the sheer painterliness of the rendering. The animated underdrawing, a combination of charcoal and thinned black paint, is played against broad, transparently brushed areas, while the tabletop is evoked largely by unpainted areas of canvas ground set against thinly painted washes. The vivid darks of the chair and hair, and the deep violet lines on the woman's dressing gown, give this otherwise apparently relaxed image an element of sharpness mixed with lyricism that recalls Japanese prints.⁴

In an essay written for an album of Matisse's drawings published in 1920, Charles Vildrac defended the recent change in Matisse's formal and expressive means with an implicit critique of high modernism, stating that "an overly exclusive concern for the relationships of lines, volumes, tones, is generally prejudicial to the necessary relationship between art and life." Vildrac went on to praise the way he felt Matisse had expanded the scope of his art. "It is no longer only the rhythm and external features of a figure that we see him capture, but the personality, the *moral character*. And now, following the example of the eternal masters, he fervently attunes his own style to the style of the model."⁵

J F

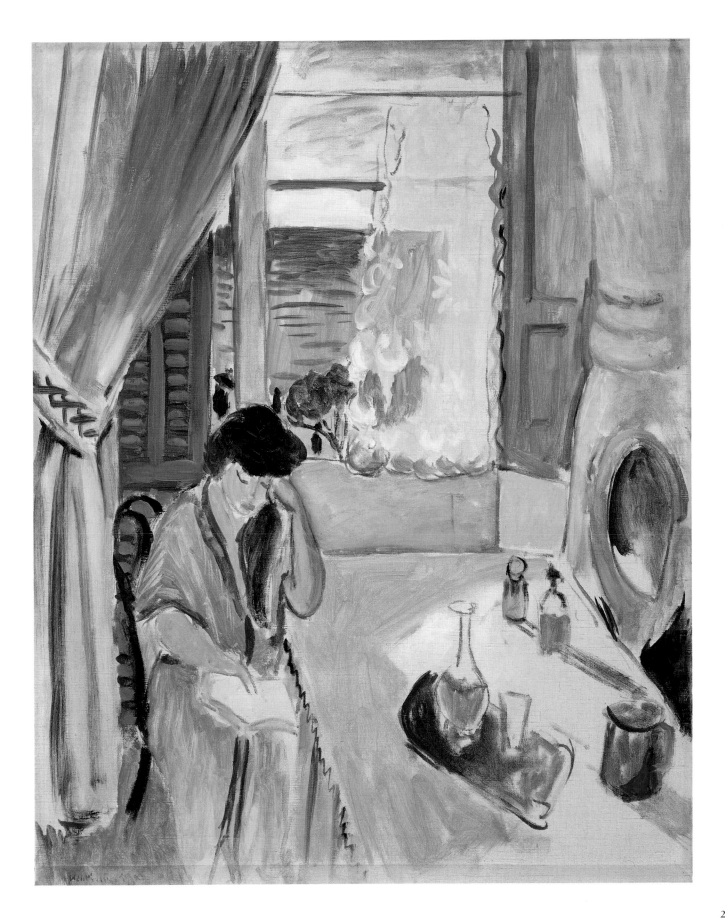

The French Window at Nice (Les persiennes)

Late 1919
Oil on canvas
51⅛ x 35" (130 x 89 cm)
Signed lower left: *Henri Matisse*
Inv. no. 897

The *French Window at Nice* was painted in Matisse's room at the Hôtel Mediterranée et de la Côte d'Azur. At this time he was both living and painting at the hotel in a rather small, oblong room with a high window and heavy draperies, whose cramped quarters were remarked on by several people who visited him at the time.[1]

This painting has, in a sense, a dual subject: the extraordinary light and color of the setting, with its strong contrasts between indoors and outdoors, and the sensuality of the woman — dressed in the transparent white blouse and red culotte of an odalisque — who looks up at us from an open book in front of the deep blue shutters of the window. At once austere and sensuous, the picture develops a counterpoint between the banality of the setting and the grandeur of the conception — a paradoxical contrast present in many of Matisse's paintings during the 1920s. This kind of tension is also reflected in the subject: an obviously French woman dressed in oriental costume, set within an imitation rococo interior. The theatricality of the subject may have been inspired in part by the theatricality of the hotel, which Matisse later remembered with amused affection: "And what lovely Italian ceilings! What tiles!...I stayed there four years for the pleasure of painting nudes and figures in an old rococo salon. Do you remember the way the light came through the shutters? It came from below like footlights. Everything was fake, absurd, terrific, delicious."[2]

As Barnes and de Mazia have noted, the figure occupies only a small proportion of the canvas, so that "the window as a whole may be regarded as the subject....It is this departure from conventional allocation of emphasis that establishes an effect of bizarreness, of dramatic contrast, which is carried out in the detailed employment of space, color, light and line."[3] This disproportion between the small, tightly curvilinear figure and the soaring, rhythmic architecture of the window emphasizes the picture's still atmosphere and timelessness.

In no other painting of this period is the marriage of depictive light and inventive color more fully realized than in *The French Window at Nice*. The contrast between indoors and outdoors had been dealt with in a number of Matisse's earlier works, but rarely in such a concentrated and poetical way. Also remarkable is the subtle mixture of carefully observed optical effects — such as the transparency of the top of the curtains — with the equally rich, abstract painterly qualities. Matisse's resonant rendering of the rosette form that hovers at the top of the window, amid the transparent sweep of the curtains, lends the window an almost gothic splendor. Similar effects are also created in the Art Institute of Chicago's *Interior at Nice* (fig. 1), painted around the same time as the Barnes picture, and in *Interior with Divan* (fig. 2), which was painted a little more than one year later.[4]

The French Window at Nice was first shown at Matisse's Galerie Bernheim-Jeune exhibition in the fall of 1920, at a time when the radical shift in his painting style was being

Fig. 1. *Interior at Nice*, c. 1919. Oil on canvas, 52 x 35" (132.1 x 88.9 cm). The Art Institute of Chicago, Charles H. and Mary F. S. Worcester Collection.

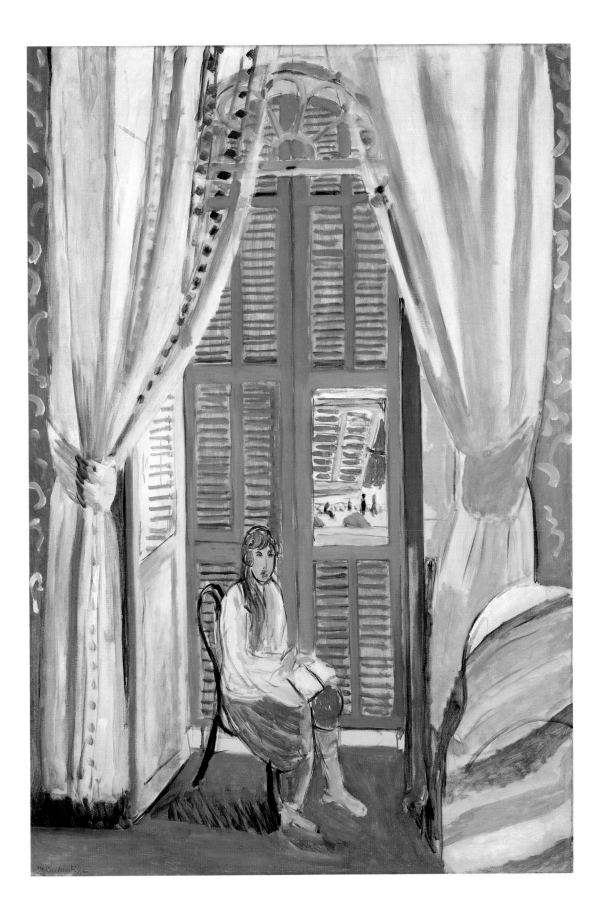

widely remarked among critics. In the exhibition catalogue, Charles Vildrac asserted that Matisse's recent paintings showed that he had "unity of vision, in the service of a prodigious 'quality of eye.'"[5] Other writers, however, were less enthusiastic about Matisse's recent pictures. In an ambivalent review of the exhibition, Fritz Vanderpyl wrote that Matisse, "with his superficial content and skin-deep taste, seems, in a somewhat puerile way, to defy the future."[6]

But most critics rose to Matisse's defense, in an outpouring of publications that followed his fiftieth birthday. In the first full-scale monograph published on Matisse, Marcel Sembat asserted, "In the latest works you will find a more perfect awareness of the artist's goal and of the skill he commands.... These years in Nice will mark a supreme moment in Matisse's work." Sembat goes on to describe precisely the sort of lighting effect that Matisse achieves in *The French Window at Nice*, which had been anticipated in a more severe form in *Interior with a Violin* of 1918 (fig. 3), in which the transition between the shaded interior and the sunlit world outside is also mediated by the luminous slit of a lifted shutter. Sembat asserts that that painting "enchanted everyone who knows what to look for. The new gift, the supreme expertise, is that Matisse's masterpieces are now perfect wholes."[7]

Matisse's work of this period was also defended as a revival of classicism, with strong nationalistic overtones. Jules Romains, for example, saw Matisse's recent paintings as part of a rediscovery of "classic dignity," and praised their equilibrium and maturity.[8] Around the same time, René Schwob spoke of Matisse's return to a greater realism. After asserting that Matisse's earlier painting, "without subject and seemingly relieved of the potential for accidental charms, was only an equilibrium of abstractions until today," Schwob goes on to praise Matisse for returning to nature and daring to be "excited to rediscover flesh and the play of shadows that accompanies the accidents of fleeting light."[9]

Although the orientalizing subject of *The French Window at Nice* is somewhat understated, it too indicates Matisse's shift toward a decidedly more conservative artistic position, which must be seen within the larger context of the increasingly conservative, colonialist and nationalistic political climate in France. Although paintings such as this one cannot be said to have an overt political content, and Matisse himself remained aloof from politics, many of the critics who supported him during the early 1920s held decidedly conservative and nationalist political views.[10]

J F

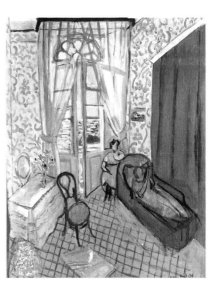

Fig. 2. *Interior with Divan*, 1921. Oil on canvas, 36¼ x 28¾" (92.1 x 73 cm). Musée de l'Orangerie, Paris; Collection Walter-Guillaume.

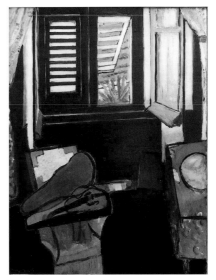

Fig. 3. *Interior with a Violin*, 1918. Oil on canvas, 45⅝ x 35" (116 x 89 cm). Statens Museum for Kunst, Copenhagen. J. Rump Collection.

Seated Odalisque (*Le genou levé*)

Late 1922
Oil on canvas
18¼ x 15″ (46.5 x 38.3 cm)
Signed lower left: *Henri Matisse*
Inv. no. 890

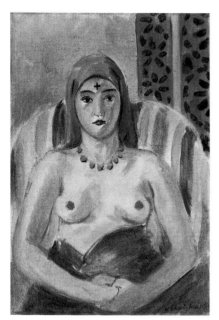

Fig. 1. *Odalisque, Half-Length — The Tattoo*, 1923. Oil on canvas, 14 x 9⅝″ (35.6 x 24.4 cm). National Gallery of Art, Washington; Chester Dale Collection.

S*eated Odalisque*, which transposes a Moorish theme into a specifically French bourgeois setting, combines the exotic and the familiar in a curious way. Set within an environment whose wallpaper is like a French version of all-over Moorish decoration and seated in a distinctly French armchair, the obviously French model is dressed in the provocative costume of a harem girl, complete with a small imitation tattoo mark on her forehead. (Such tattoos were employed as cosmetic and tribal markings and apparently also to ward off the evil eye.[1]) The same tattoo is present on the contemporaneous *Odalisque, Half-Length — The Tattoo* (fig. 1), and similar ones appear in some of Matisse's prints.[2]

In the hands of a lesser artist, such a picture might verge on the ridiculous. But here the intensity of our confrontation with the model and her provocative sexuality unite the disparate elements in a remarkably vivid and engaging image. The sultriness of the painting is further increased by the way the deep violets in the background lend heat and energy to the pale pinkish ochers of the woman's skin, and the way the green accents flicker against the muted warm tones behind them.

The contradictory nature of the subject is reflected in the rendering, which contrasts the flat, abstract background decoration with the extreme physicality of the woman. The vividly palpable quality of her breasts and the filmy transparency of her culotte are depicted with a breathtaking virtuosity. The forceful presence of the woman's body here can best be appreciated by comparing the picture to *Odalisque Seated with Arms Raised, Green Striped Chair* (fig. 2), which is similar in pose but somewhat more flatly rendered; the erotic charge of that painting is, so to speak, displaced to the startlingly forthright representation of the woman's armpit hair.

Ever since he had seen the Art Musulman exhibition at the Pavillon Marsan of the Louvre in 1903, Matisse had been fascinated by Islamic customs and by the decorative aesthetic of Islamic art. "My revelation came from the orient," he later said, and it may be further observed that taken together, the orient and the south exerted a powerful influence on the development of his mature painting.[3]

In 1917 Matisse had depicted Laurette and other models in oriental costume, as in the *Three Sisters* (see page 253 *et seq.*). But after World War I, he took up the theme with a new passion, and his representations of odalisques and harem girls — for almost all of which he used French models — became increasingly sensual. Although Matisse later explained his orientalizing fantasies by saying that he had seen odalisques in Morocco, this seems to be a rather deceptive (and self-deceptive) rationalization for the time-honored practice of creating psychic distance from erotically charged subject matter by removing it from the present

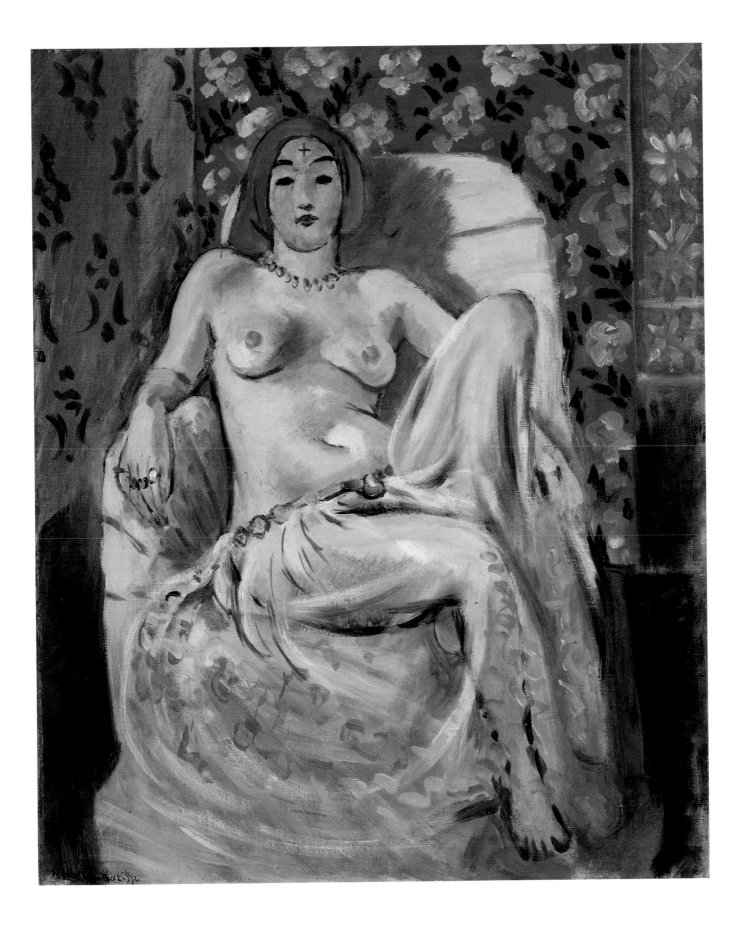

269

time and place. In particular, it was a persistent theme among some of the nineteenth-century artists whom Matisse most admired — Ingres, Delacroix, and Renoir.

Matisse's orientalism should also be situated within the larger cultural and political climate in France after the war. From April to November 1922, an enormous Exposition Coloniale was held in Marseille, France's traditional gateway to the east, and Matisse's personal interest in oriental subjects seems to have coincided with a growing interest in exotic cultures within French society as a whole. Although it would be superficial — even silly — to attribute Matisse's more accommodating postwar orientalism merely to financial opportunism, he was nonetheless aware of the marketability of such images. In 1922 the French government made its first purchase of a Matisse painting for a Parisian museum — the richly painted, almost Renoir-like *Odalisque in Red Trousers* of 1921 (fig. 3).[4]

At the same time, it is difficult to make a direct relationship between Matisse's orientalism and French colonialist concerns. In fact, the blatant fakeness in Matisse's depictions of oriental subjects suggests a self-consciousness that might well be characterized as a "post-colonialist" attitude. The elements of pastiche and simulacrum make Matisse's use

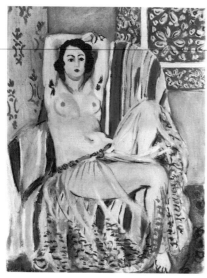

Fig. 2. *Odalisque Seated with Arms Raised, Green Striped Chair*, 1923. Oil on canvas, 25⅝ x 19¾" (65.1 x 50.2 cm). National Gallery of Art, Washington; Chester Dale Collection.

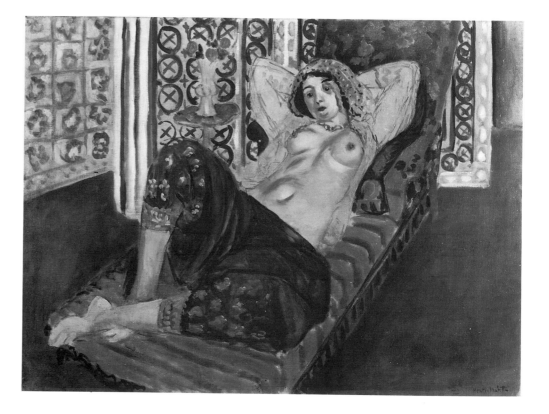

Fig. 3. *Odalisque in Red Trousers*, 1921. Oil on canvas, 26⅜ x 33⅛" (67 x 84 cm). Musée National d'Art Moderne, Centre Georges Pompidou, Paris.

of these themes potentially absurdist; and yet he avoids parody or even overt irony. It is precisely the ambivalence of his use of these oriental themes that makes paintings such as this one so emotionally haunting and so historically problematical.[5]

Toward the end of the decade, Matisse somewhat glibly defended his depiction of odalisques by saying, "I do odalisques in order to do nudes. But how does one do the nude without being artificial? And then, because I know that they exist. I was in Morocco. I have seen them."[6] Years later, he seems to have been closer to the truth when he told an interviewer that the odalisques were "the bounty of a happy nostalgia, of a lovely vivid dream, and of an experience lived almost in an ecstasy of days and nights, in the magic of a certain climate."[7]

A painting like the *Seated Odalisque* seems, in fact, to be an image of a profoundly personal erotic obsession. In it Matisse is able to give free reign not only to his nostalgia for the sensuality of Morocco; he is also able to express in a publicly acceptable way his desire for a local girl by transforming her into an exotic and mysterious creature.[8]

J F

Reclining Nude (Nu couché)

1924
Oil on canvas
23½ x 36¼" (59.8 x 92 cm)
Signed lower left: *Henri Matisse*
Inv. no. 199

Fig. 1. *Reclining Nude on a Sofa*, 1923. Oil on canvas, 18⅛ x 21⅝" (46 x 55 cm). Private collection.

Fig. 2. *Odalisque with Magnolias*, 1924. Oil on canvas, 25⅝ x 31⅞" (65 x 81 cm). Private collection.

Matisse had been painting nudes since the beginning of his career, but before World War I almost all of them had been studio nudes or figures in landscapes. The theme of what was later maliciously referred to as "the odalisque in the hotel bedroom"[1] was not developed until after the war, although certain earlier pictures of the model Laurette anticipated it.

Matisse seems to have been especially preoccupied with this theme in 1923–1924, and his various depictions of it cover a broad stylistic range, running from very loosely brushed paintings, such as *Reclining Nude on a Sofa* (fig. 1), to the tightly rendered and carefully modeled *Odalisque with Magnolias* (fig. 2). He also treated the subject in prints around the same time.[2]

The Barnes painting is remarkable for the amber glow that radiates from it. The finely calibrated color harmony sets the dense, warm yellows of the sofa against the rosy skin of the model and the transparent violet floral patterning on the screen behind her, which acts as a subtle metaphor for her femininity. (This kind of symbolism is more overtly stated in *Odalisque with Magnolias*.)

Reclining Nude was used as the catalogue frontispiece for Matisse's 1924 exhibition at the Galerie Bernheim-Jeune. This exhibition attracted a fair amount of attention and reinforced the already growing tendency to consider Matisse as an upholder of the classical French tradition. Philippe Marcel noted that Matisse's recent painting had arrived at "perfection." According to Marcel, although Matisse was being reproached for seeking "perfection to the detriment of profundity," his new style was really more refined, tasteful, and mature than that of his earlier works. "In effect, his pictures since 1916 breathe more sweetness; they charm by their musicality and seem made more for the delectation of the eyes than for the torment of the mind... the artist, having arrived at the peak of his form, aspires for more clarity, more simplicity, more sociability, not to say for more classicism, a term that cannot be exaggerated in defining the last phase of his production."[3] The critic Paul Fierens made an even grander claim for Matisse's recent work by stating, "Thanks to this painter, one will not accuse our epic of dryness.... Others interest us, crush us and move us. Henri-Matisse, in the very simplest way, brings us the latest novelties of the season, security, and happiness."[4]

The painter of the *Bonheur de vivre* was becoming for postwar France simply the painter of "*le bonheur*"! One is not surprised to learn that in a 1925 survey made by the influential magazine *L'Art Vivant*, Matisse was named the most popular artist in France.[5]

J F

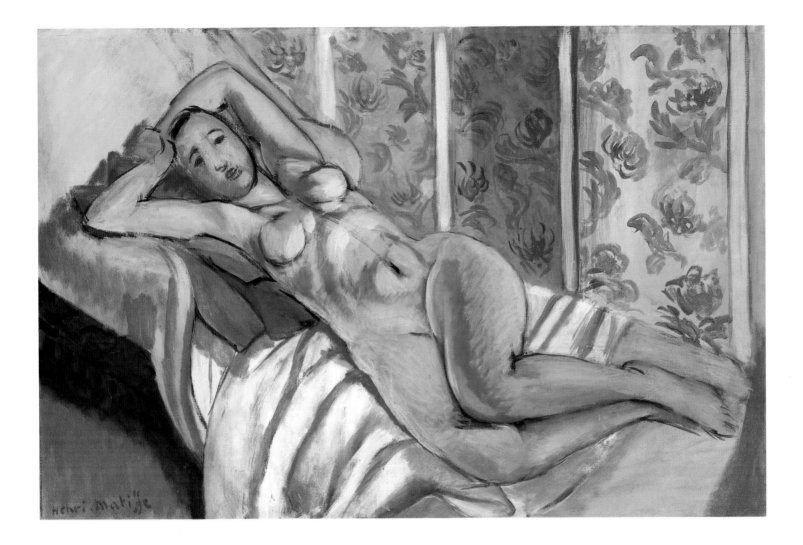

The Dance (Merion Dance Mural) (La Danse)

1932–1933 (first version begun 1931)
Oil on canvas
Left: 133¼ x 173¾″ (339.7 x 441.3 cm)
Center: 140⅛ x 198⅛″ (355.9 x 503.2 cm)
Right: 133⅜ x 173″ (338 x 439.4 cm)
Signed and dated lower right: *Henri Matisse. Nice. 1933*

Fig. 1. *Study for the Dance mural*, 1931. Pencil on paper, 19½ x 25⅝″ (49.5 x 65 cm). Pierre Matisse Foundation.

In the late 1920s Matisse went through a dry period in his painting; for the first time since the beginning of the century, he seemed to lack a clear direction. In 1930 he traveled to Tahiti, where Gauguin had painted, "to seek a new light." On his way, he passed through the United States, which he would later recall as more directly stimulating than the South Seas.[1]

When he returned to the United States that fall to serve on the jury of the Carnegie International Exhibition, he arranged to see the Barnes Foundation, which had the world's largest collection of his work. Much to Matisse's surprise, Dr. Barnes proposed that he paint a mural for the main hall of the Foundation.[2] Matisse was at first reluctant, as he was already committed to illustrate a selection of Mallarmé's poems for the Swiss publisher Albert Skira.[3] But he and Barnes discussed the matter again while Barnes was in Paris later that fall, and by mid-November Matisse had decided to accept the commission.[4] In order to study the space and work out other details, Matisse returned to the United States on 15 December; and by 20 December the letter of agreement had been drafted and the first of three scheduled $10,000 payments had been made by Barnes.[5] Matisse did some sketches while in Merion and he began work on small compositional studies for the mural shortly after he returned to Nice (fig. 1).[6] In order to have adequate space to work on such a large project, he rented a vacant garage at 8, rue Désiré Niel in Nice, not far from his apartment.[7]

According to the original agreement, the work "would take about one year to finish." As it turned out, Matisse did have the composition for the mural almost finished a year later, but only to find that a mistake had been made regarding the dimensions. He then started a second version, which was eventually installed in Merion. The two extant versions of the mural are usually referred to as *Dance I* and *Dance II* and are thought to have followed one another directly. The former, now in the Musée d'Art Moderne de la Ville de Paris, is generally supposed to have been executed in 1931–1932, just before Matisse began the version now in Merion; but the Paris version was extensively reworked in 1933, and was actually completed *after* the Merion mural had been installed.

The misunderstanding about the measurements arose from Matisse's apparent misuse of a paper template that was supposed to have been used to determine the size and shape of the canvases he worked on. In order to ensure that the murals would fit the space exactly, Barnes had had the template traced directly from the wall while Matisse was still in Merion. Matisse took this template with him when he returned to France, but he apparently overlooked two pieces of paper that were supposed to be attached to it and thus misjudged the width of the pendentives between the lunettes.[8]

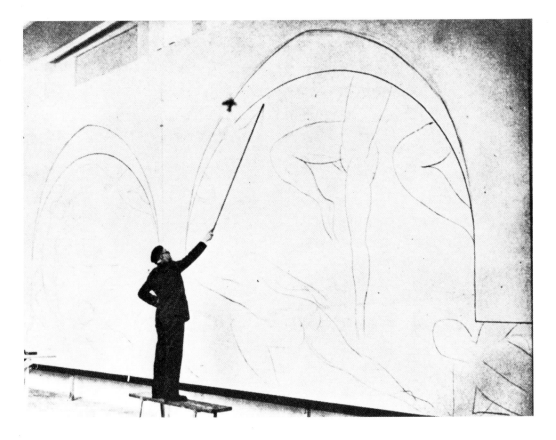

Fig. 2. Matisse drawing a *Dance* panel, 1931.

On 24 April, Matisse gave Barnes a progress report and sent two series of photographs of small studies for the mural — which he characterized as "first contact with the surface," and "second attack, more architectural, I believe."[9] Around the same time, he set up the large canvases on which he planned to execute the actual pictures, having decided to work full scale rather than from small sketches that would eventually be squared up.[10] Here, as in all the subsequent versions of the mural, Matisse worked on a set of three rectangular canvases on which he inscribed the irregular shapes of the spaces to be painted (fig. 2). When the pictures were finished, the excess canvas could be folded back and attached to stretchers built in the shape of the lunettes for which they were intended.

Barnes wrote to Matisse on 5 May, expressing both his satisfaction with the photographs and his doubts about whether the design allowed for enough canvas to be folded back over the stretchers.[11] On 15 May, Matisse replied to Barnes "to reassure you immediately." He explained that the borders would be large enough to stretch the pictures and included a diagram to explain which parts of the canvas he had left in reserve to be folded back. The pointed arches that Barnes had interpreted as sky, he explained, were "only done to help me in the composition — it is a fragment of canvas that will not be included on your wall...."[12]

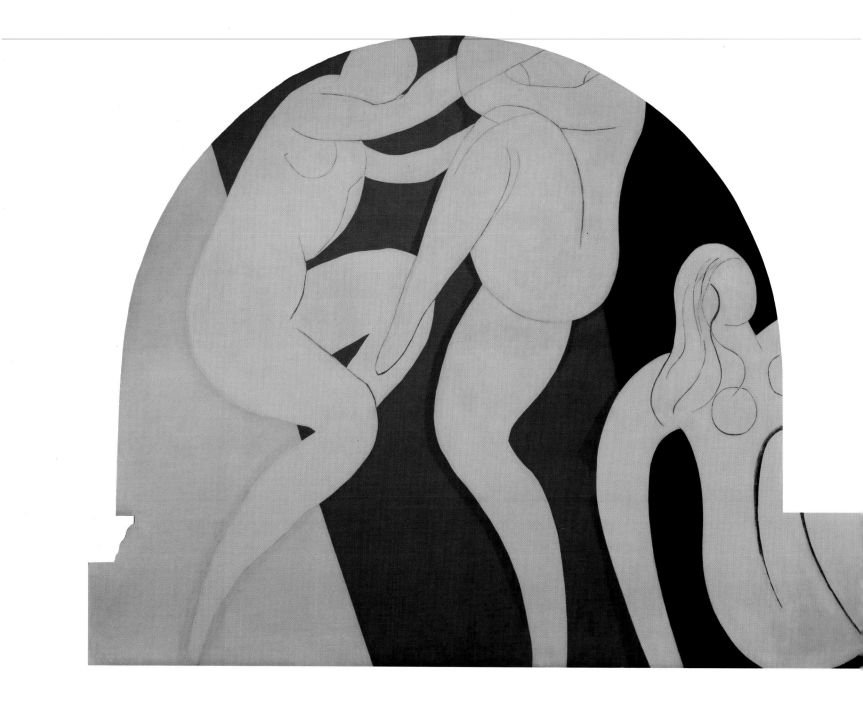

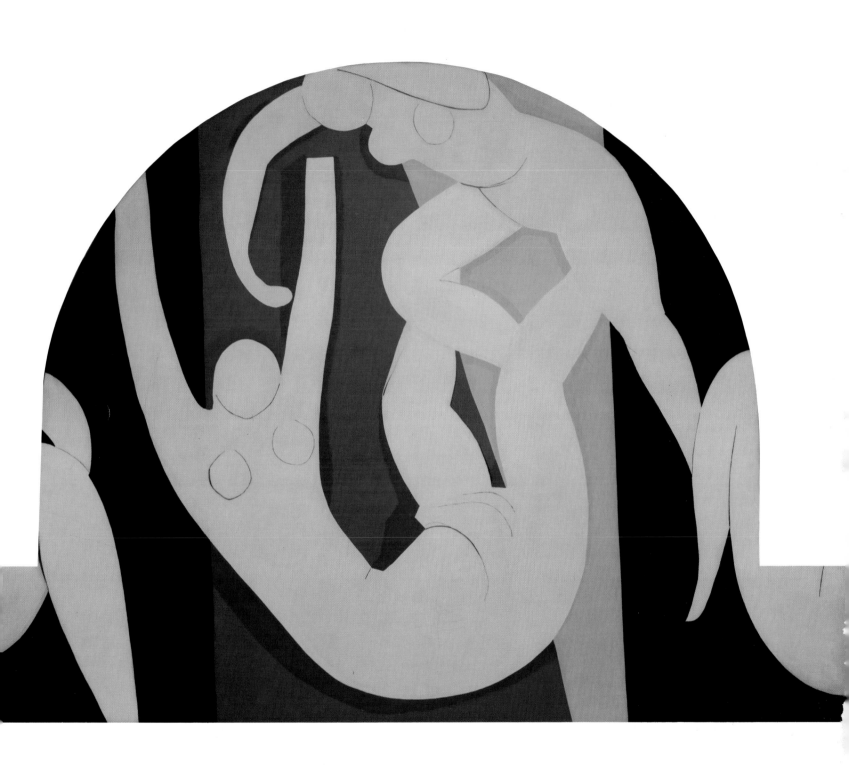

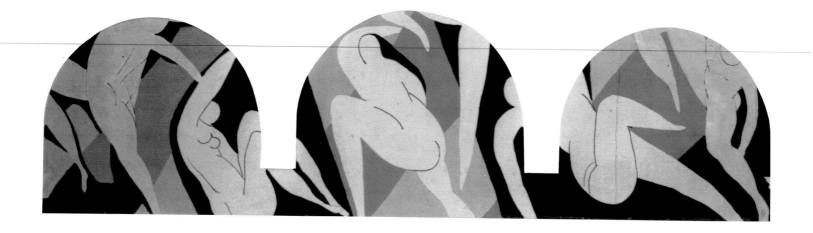

Fig. 3. *Study for the Dance mural*, 20 Feb. 1932. Gouache on paper, 10 x 24″ (25.4 x 61 cm). Private collection.

Barnes came to Paris in January, and met with Matisse to verify the dimensions of the decoration, which Matisse was planning to mount on temporary stretchers so that it could be shown at the Galeries Georges Petit prior to being sent to America. The exhibition of the work in Paris was very important to Matisse. According to a contemporaneous *New York Times* article, the galleries would be open until midnight "to enable all classes to view the canvas, and it will be specially lighted to insure losing none of its quality, both of these being daring innovations in gallery etiquette."[16] Matisse was therefore all the more disturbed to find an apparent discrepancy between the widths of the spaces left for the pendentives in his composition, which he thought conformed to the architect's plans, and those which Barnes said really existed in the building.

On 2 February, Matisse cabled Barnes from Nice to confirm this discrepancy and to request that the paper template, which had been returned to Merion, be sent to Nice as soon as possible so he could compare his composition with it.[17] Barnes responded immediately, repeating that the dimensions on the architect's plans were *not* the same as those of the template, and that Matisse should ignore the architect's plans completely; Barnes affirmed that the dimensions of the template had to be correct, since they were taken directly from the wall, and that if they had been properly followed, the dimensions would be correct.[18]

It soon became clear that Matisse had made a major mistake in the measurements. On 22 February, Barnes cabled Matisse confirming that the artist had been working from the wrong set of dimensions, not only because he had followed the architect's plans rather than the template, but because he had overlooked two strips of paper that were to have been attached to the template; in fact, the pendentives under the lunettes were twice as wide as Matisse had supposed them to be.[19] Barnes offered to come to Paris at once with the template, but Matisse realized that it was too late for anything to be done about the error.[20]

At this point, the work in progress was still executed entirely in cut paper (with the first, abandoned, painted version completely covered by the overlaid pieces of paper). What

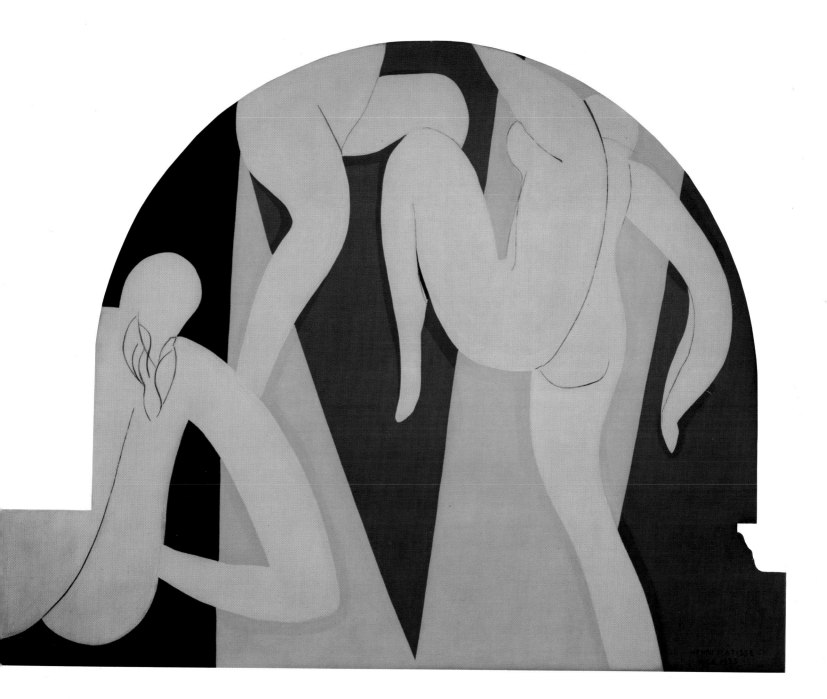

Barnes was confident enough about the progress of the work to make the second $10,000 payment to Matisse on 16 June 1931.[13] But he remained skeptical about the adequacy of the canvas borders and sent Edward Dreibelbies, an instructor at the Foundation, to visit the artist in Nice that summer in order to confirm that there would indeed be enough canvas to fold back behind the stretchers. Ironically, the amount of canvas was perfectly adequate, given the dimensions that Matisse was working with; but this issue drew attention away from the larger issue of whether those dimensions were themselves correct. When Dreibelbies wrote to Barnes on 2 August, he included a detailed drawing of Matisse's layout for the canvases, complete with dimensions. "The mural as laid out by Matisse is on three rectangular canvases," he explained to Barnes, indicating their general shape with dotted lines on his drawing. Dreibelbies then went on (fatal sentence!), "Matisse says the architectural measurements are exact — the figures given locate the divisions [between the three separate canvases]," and he assured Barnes that "a generous width of canvas has been allowed on all four sides and Matisse is painting about two inches of canvas on 'turned in' edges where the two divisions occur."

According to Dreibelbies, "Matisse was interested in checking the measurements as they were taken and wishes to say that two or three months prior to the completion of the painting he will send complete and detailed information...."[14]

The matter of the dimensions was apparently settled — even though the diagram in Dreibelbies' letter indicates the width of the pendentive bases as being around twenty-one inches each; this is clearly wrong, since the pendentive bases in the building are actually about one meter wide, or nearly twice as wide as those indicated in the diagram. As far as we know, Barnes did not notice this discrepancy at the time.

After Matisse had worked on this canvas for a while, he realized that he could not create the kind of architectural effect that he wanted by using his usual painting technique, which employed subtly nuanced brushwork, with figures conceived as moving within an illusionistic space. He also found that the enormous scale of the mural required frequent and extensive changes — which would be very difficult to achieve by constant repainting. He therefore developed the technique of using sheets of painted paper to try out compositional changes without having to do extensive repainting. The sheets of paper were painted and stacked in piles, like a palette that would supply the limited number of colors that Matisse had decided to use in the composition — gray for the figures; blue, pink, and black for the background. The pieces of paper could be pinned to the surface of the canvas and easily altered by moving and cutting. Matisse could thus make changes in the composition without having to rub out, paint over, or build up a thick surface filled with pentimenti.

He planned, when the composition was finalized, to lift the areas of cut paper and fill in the canvas below with the same color oil paint that had been used on the sheets of paper. This was a radical departure from Matisse's previous technique; it not only permitted him to make large changes quickly, it also depersonalized his relationship to the surface of the picture, in accordance with his notion of creating an "architectural" rather than an "expressive" surface.[15]

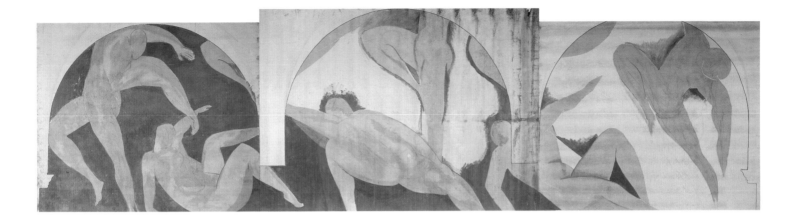

Fig. 4. *Unfinished Dance Mural*, the recently discovered first version, 1931. Oil on canvas, left: 162⅕ x 139¾″ (412 x 355 cm); center: 200¼ x 142⁹⁄₁₀″ (510 x 363 cm); right: 162⅕ x 139¾″ (412 x 355 cm).

the composition looked like at this time is indicated in a gouache copy of it that Matisse made on 20 February 1932 (fig. 3) and gave to Barnes when he saw him in early March, apparently to reassure him about the aesthetic value (and existence!) of the work.[21]

A few months later, Matisse began another, entirely different version of the mural on a set of three new canvases.[22] This new version was finished in April 1933 and installed at Merion in mid-May, with Matisse himself present to supervise. Despite the difficulties, both Matisse and Barnes said they were extremely pleased with the final product, which Matisse saw as a significant advance in the general development of his painting and which Barnes considered a major addition to the Foundation and its collections.[23]

Later that year, Matisse began to rework the first set of canvases, on which the still unfinished cut-paper composition was pinned above the long-abandoned underpainting.[24] He reworked the composition extensively that fall; and eventually he transferred the cut-paper design onto a third set of three canvases. The three canvases with the unfinished painting on them were then abandoned — rolled up and stored away — and remained forgotten until the spring of 1992.[25]

Because of the chronological overlapping between the various versions of the mural, it would be well to give them descriptive rather than sequential titles. The recently discovered unfinished painting will hereafter be referred to as the *Unfinished Dance Mural* (fig. 4); the version in Merion will be called the *Merion Dance Mural*; and the version now in the Musée d'Art Moderne de la Ville de Paris (fig. 5) will be referred to as the *Paris Dance Mural*. Although this latter picture is usually designated as *Dance I* and has "Nice 1932" inscribed on its righthand panel, it was in fact the *last* version to be completed, as Matisse was still working on it late in the fall of 1933.[26]

At the time Matisse was given the commission by Barnes, he was also given free choice of subject, and it was he who decided on the theme of the dance. This had been the theme of his first major mural commission, for the Moscow home of Sergei Shchukin in 1909–1910,

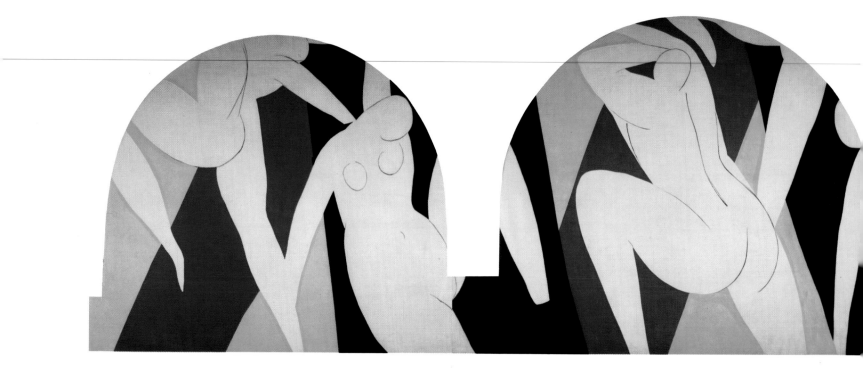

and it had been originally depicted in the *Bonheur de vivre* (see page 227), which Barnes had already owned for nearly a decade.

Matisse used the Shchukin *Dance* as his point of departure for the composition as well as the subject of the Barnes mural, which was to be his first painting of figures in motion since he finished the 1910 *Dance*. When he began work on the first small studies for the mural he had reproductions of his 1909 full-size oil sketch for the *Dance*, and of a charcoal drawing he had done for the 1910 version, pinned to a nearby wall (fig. 6). In some of the earliest small drawings he did for the Barnes *Dance*, the composition follows the 1909–1910 composition quite closely, with the pendentives of the architecture functioning merely as "interruptions" of the round of dancers rather than as a structural component (fig. 7).[27]

The poses of the figures in the early small oil studies (figs. 8 and 9) also derive from those in the 1909 painting — although with modifications that take into account the non-rectangular, architectural context of the Barnes commission. The rendering in these early oil sketches involves a certain amount of modeling, and the poses and facture recall the figures in the Cézanne *Three Bathers* that Matisse himself owned. The background is still conceived as a simplified landscape and the composition is rather stiff.

In the early oil sketches, Matisse had experimented with ocher, yellow, red, and blue — but for the first full-scale rendering of the mural itself, he reduced his colors to blue and gray. This *Unfinished Dance Mural* (see fig. 4) follows quite closely the composition of the small oil sketches. The drawing and the brushwork in it are remarkably fresh and its surface is very matte. Its marked resemblance to early Renaissance fresco underpainting

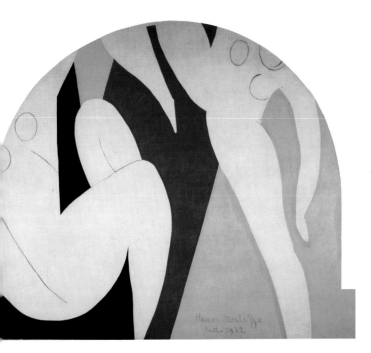

Fig. 5. *Paris Dance Mural*, 1931–32; finished 1933 [though signed and dated 1932]. Oil on canvas, left: 133⅘ x 152⅖" (340 x 387 cm); center: 139⁷⁄₁₀ x 196" (355 x 498 cm); right: 131¹⁄₁₀ x 153⁹⁄₁₀" (333 x 391 cm). Musée d'Art Moderne de la Ville de Paris.

indicates that from the beginning Matisse sought a paint surface that would harmonize with the architecture. But the rendering of the figures in this version is still much more pictorial than architectural — the view of the dancers in space takes precedence over the architectural surface design. In essence two systems are in conflict here — the one pictorial, descriptive, and painterly; the other flat, decorative, and architectural.

After Matisse abandoned this first try, probably in the late summer or early fall of 1931, he decided to take a very different approach. It was then that he began to work with cut and pinned paper, which more or less forced him to reduce his range of colors and to suppress modeling and the illusion of deep space.[28] He emphasized the architectural function of the mural not only by flattening the space but by increasing the size of the figures in relation to the total image, so as to give the panels the commanding presence that their setting required. Although the poses of the figures in the early studies for the mural were similar to those in the Shchukin panel, they were necessarily more fragmented. In order to deal with the lunettes and the vaulted ceiling, Matisse later said, "I made my figures larger than life-size, larger than the surfaces could contain. Thus there is half a body coming down from above. Another is half-length. Over an area which was not very wide, only thirteen meters, I permitted the observer to see a much larger dance, because I used fragments."[29] Matisse made a great effort to envisage how the picture would look when mounted at the Foundation. "My aim," he told an interviewer, "has been to translate paint into architecture, to make of the fresco [*sic*] the equal of stone or cement."[30]

In order to harmonize with the gray limestone of the building, the figures in the subsequent versions of the mural were rendered in a cool, stony gray, while the background

Fig. 6. Matisse with oil sketches for the *Dance* mural, 1931. Photograph by Pierre Matisse.

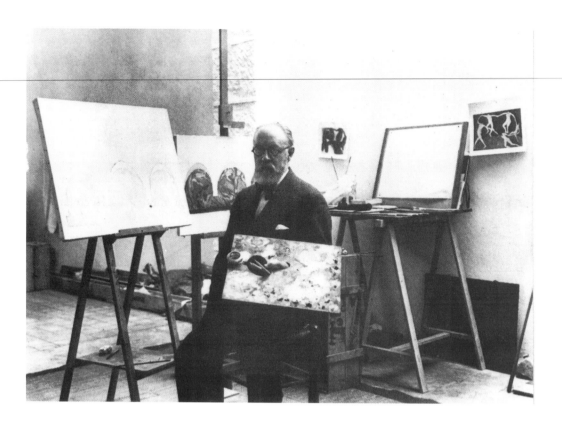

was reduced to broad bands of black, pink, and blue. The essentially vertical rhythmic banding recalls the austere black bands in the 1916 *Bathers by a River* (fig. 10), one of Matisse's most abstract early paintings. The effect of the banding, the flatness, and the suppression of modeling is to allow the painting itself to become an architectural element within the broader architectural complex of the building.[31]

Matisse had based the general movement of the figures in the early stages of the mural on the clockwise, right-to-left motion of the Shchukin painting. This is apparent not only in a number of the drawings he did for the composition but also in small gouaches which appear to reflect various stages of the composition in progress (fig. 11) and in which the evolution from a flowing horizontal movement to a more geometrical and vertical division of the compositional elements is evident.

Although in the past Matisse had sometimes photographed his works while they were in progress, with the *Merion Dance Mural* he did this more systematically than ever before, and it is thus possible to study its evolution quite closely (fig. 12). This is a practice that he would frequently employ later. It reflects his new self-consciousness about the act of creation, also evident in the numerous drawings he did later in the decade which depict him in the act of creating the picture we are looking at.[32]

When Matisse discovered that the dimensions of the first version of the mural were incorrect, he reconceived not only the physical composition but also the expressive feeling of the work.[33] As he had done on the first set of full-size canvases, he began what would be the

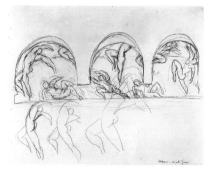

Fig. 7. *Study for the Dance mural*, 1931. Pencil on paper, 10¼ x 13″ (25.9 x 33 cm). Musée Matisse, Nice.

Merion Dance Mural by drawing directly on the large canvases with charcoal. The drawing style is extremely free and vigorous. The figures are highly simplified and have a linear purity similar to that of the Mallarmé etchings that he had been working on for the past year or so.

Although Matisse began work on the new set of large canvases during the summer of 1932, he did not give them his full attention until after the publication of the Mallarmé book on 25 October. Shortly after he turned his attention to the mural again, he hired Lydia Delectorskaya as his studio assistant, an event that was to have great importance for him; in the ensuing years, she became by turns his principal model and secretary, and remained his close companion for the rest of his life.[34]

Right from the beginning (State I), Matisse conceived this version of the decoration in terms of eight rather than six figures. In the earliest stage, the figures under the pendentives were composed as part of an overall arabesquelike motion that was set in counterpoint to, rather than in direct structural accord with, the architectural design. Eventually, however (State IV), the organization became more clearly segmented. The pairs of leaping figures within the lunettes were distinctly separate from the reclining figures fixed under the downward thrust of the pendentives. It is at this stage that the pendentive figures are clearly turned in opposite directions, one seen from the front, the other from behind — a direct echo of the two reclining figures in the *Bonheur de vivre*.

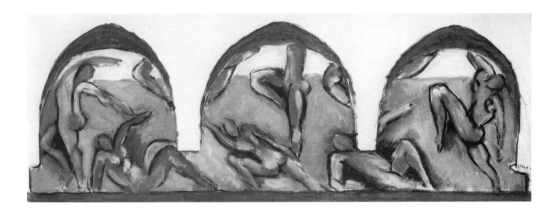

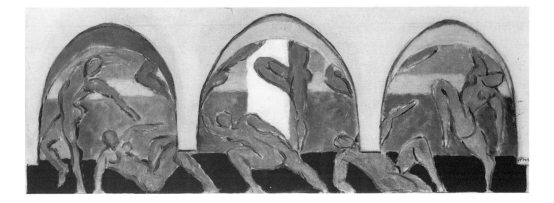

Figs. 8 and 9. *Studies for the Dance mural*, 1931. Each, oil on canvas, 12⅝ x 34 1/16″ (32 x 86.5 cm). Musée Matisse, Nice.

Shortly afterward (State VII), Matisse made the pairs of dancing figures within the lunettes even more violently active. At this stage of the composition, the dance begins to verge on a *lutte d'amour*, or battle of love. The physical violence of the figures in the next few stages is remarkable, and quite unprecedented in Matisse's earlier work. This is especially marked in the center panel, where the figures seem virtually to be spinning in a kind of Dionysian frenzy (State X). The composition of the central panel at this stage clearly anticipates the figures in one of Matisse's most violently sexual images, *Nymph in the Forest* (*La verdure*), which was begun a few years later and reworked for several years.[35]

As Matisse worked on this version of the mural, he experimented with a number of different kinds of poses, including intensely foreshortened ones (States IX–XII). At one point he even added leaf forms in the background (States XIV–XV), similar to those in an early stage of the 1916 *Bathers by a River*.

By 24 November, he had finished the drawing proper and covered the entire surface of the picture space with colored papers (State XVI). He then began to emphasize the black vertical movements in the background, which became increasingly complex as the work progressed. By 14 December he was already close to what would be the final composition (State XIX); and after 20 December, when the figures were fairly well resolved (State XX), he devoted increasing attention to adjusting the forms in the background. In January 1933 he broadened the poses of the pendentive figures, in order to relate them better to their architectural function of seeming to bear some of the weight of the arches (State XXIII).

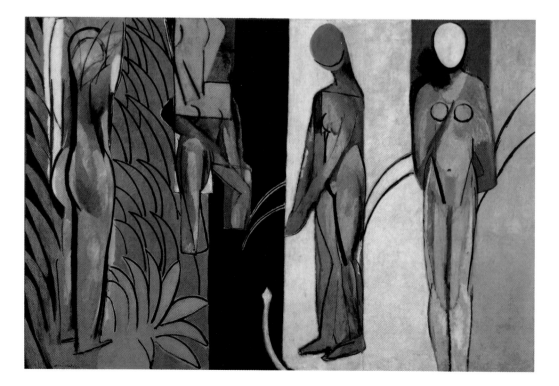

Fig. 10. *Bathers by a River*, c. 1916–17. Oil on canvas, 102¼ x 153½″ (259.7 x 389.9 cm). The Art Institute of Chicago, Charles H. and Mary F. S. Worcester Collection.

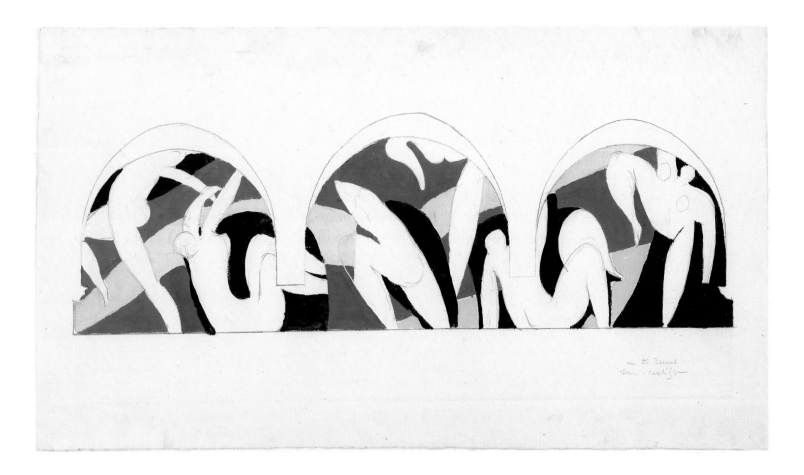

At this time, Dr. Barnes had not yet seen the actual mural and still did not know that Matisse was working with painted paper rather than directly with paint. On 24 January, Barnes came to Nice to see the actual work in progress. He was enthusiastic about what he saw and told Matisse that he liked the composition so much that it could be finished as it was.[36] Matisse, however, continued to revise the composition until the beginning of April.

Although Matisse had planned to exhibit the *Merion Dance Mural* at the Galeries Georges Petit in Paris, just as he had planned to do with the earlier version the year before, he was unable to finish the work in time to do so. On 30 March 1933, he wrote to his daughter Marguerite that the actual painting of the panels was taking longer than he had expected and that they would not be dry enough to ship until the end of April. He also said that the effect of the paint on the paper had been more matte than it was on the canvas and that he would have to add accents in charcoal.[37] In fact, when the mural was finished, he felt that the surface was too impersonal and he also repainted the contours and added areas of shadow to enliven the composition.[38] Matisse himself planned and supervised the crating of the three canvases and he took them with him when he sailed for New York on the "Rex" in early May. He arrived in New York on 11 May and was driven to Merion the next day by his son Pierre; the crates with the canvases arrived in Merion that same afternoon. On

Fig. 11. *Study for the Dance mural*, 1931. Gouache on paper, 14 x 25¼″ (35.6 x 64.1 cm). The Barnes Foundation, inv. no. 1091.

(Overleaf)
Fig. 12. Photographs taken by Matisse, showing successive stages of the *Merion Dance Mural* in progress; identified by Matisse as States I, IV, VII, X, XI, XII, XIV, XV, XVI, XIX, XX, XXIII, 1931–32. The Barnes Foundation archives.

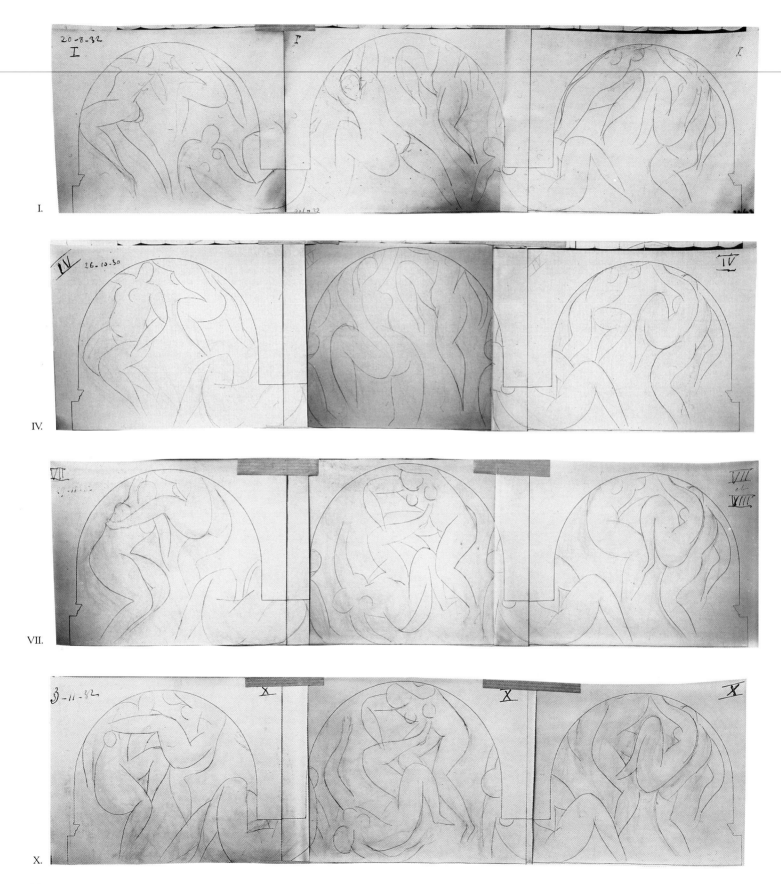

I.

IV.

VII.

X.

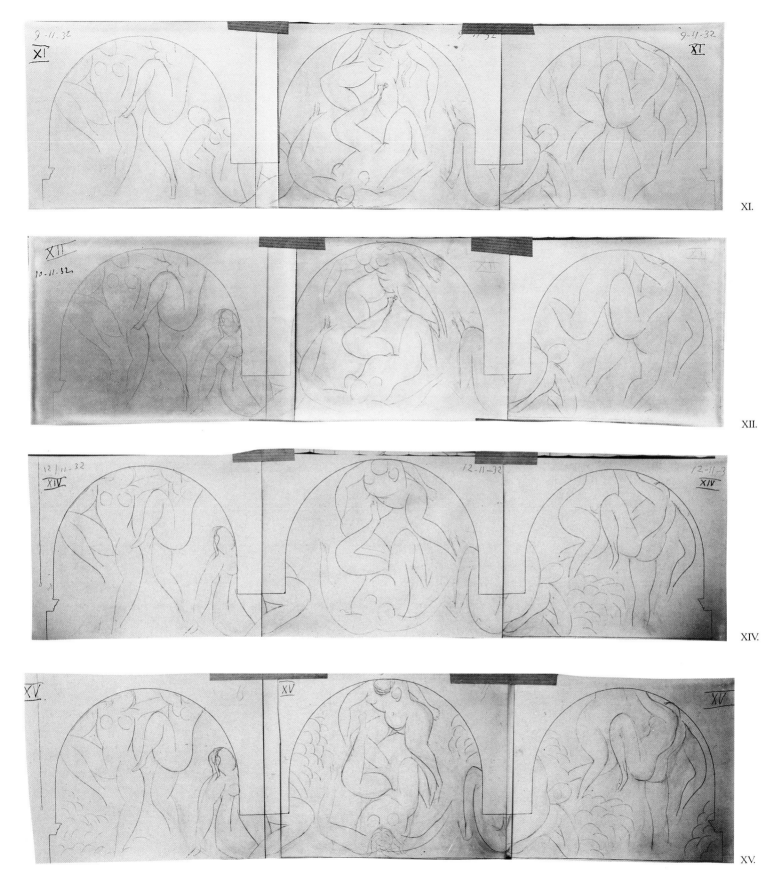

XI.

XII.

XIV.

XV.

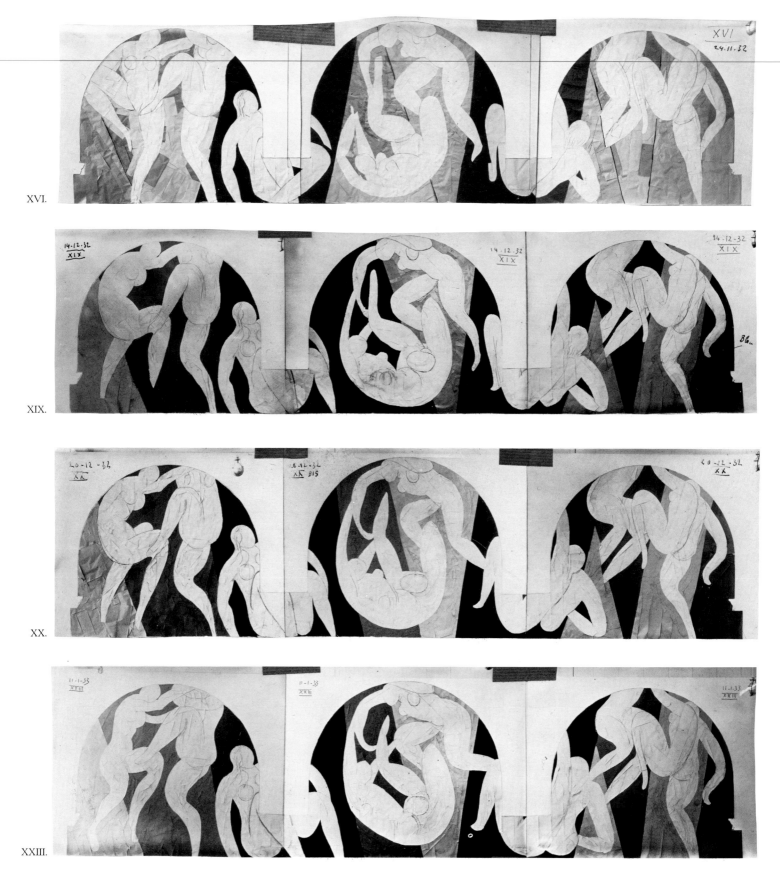

XVI.

XIX.

XX.

XXIII.

Friday the 13th, the crates were unpacked; Matisse supervised the stretching and installation of the canvases over the weekend.[39]

In the end, Matisse said he was pleased with the mural. "*J'étais ravi,*" he told Dorothy Dudley. "As soon as I saw the decoration in place, I felt that it was detached absolutely from myself, and that it took on a meaning quite different from what it had had in my studio, where it was only a painted canvas. There in the Barnes Foundation it became a rigid thing, heavy as stone, and one that seemed to have been spontaneously created at the same time with the building." Dr. Barnes told Matisse that the painting was "like the rose window of a cathedral," and Matisse himself referred to it as being "like a song that mounts to the vaulted roof."[40]

Although after the mural was installed Dr. Barnes bought very few Matisses, the two men seem to have mutually benefited from their relationship. As a result of his direct contact with Matisse, Barnes was later able to criticize scholars and museum directors with a stronger sense of authority about what the artist thought and felt. And Matisse was finally prepared to find out just what it was he had been looking for when he went to Tahiti — which turned out to be much closer to home than he had thought.

J F

Two Girls in a Yellow and Red Interior
(Deux fillettes, fond jaune et rouge)

1947
Oil on canvas
24 x 19⅜″ (61 x 49.8 cm)
Signed and dated lower right: *H. Matisse 47*
Inv. no. 2075

In 1943, Matisse moved to Vence, where he rented a villa called *Le rêve* (The Dream) on the outskirts of the town. (Nearby, his friend André Rouveyre lived in a house called *La joie de vivre!*[1]) During the years Matisse spent there, he worked on both paintings and cutouts, and his paintings became even more freely brushed and brightly colored.

Two Girls in a Yellow and Red Interior is one of a series of small but powerful paintings Matisse did in 1947, based on the theme of two girls seated in front of a window. In this picture, indoors and outdoors are conflated by the unifying expansiveness of the ochers and by the rhyming forms of the flowers and tree. Although distances are indicated by drawing, the large flat areas of color compress and flatten the space. The mood of this painting, like others in the series, is celebratory. There is a vivacious exchange of energy between the different orders of beings and things, and all seem to share a common source of vitality, which is transmitted in part by our awareness of the electric movement of the artist's brush. The painting is also noteworthy for the way that the light on the figures is suggested through opposing colors, with very little variation in tonal value.

The overall space is quite ethereal and the various entities within it — girls, flowers, fruit, and tree — are translated into a kind of sign language that is the painterly equivalent of the disembodied, abstract space of the late cutouts. The undulating curves and abstract dynamism of the blue shape reflected on the window pane seem to be especially indebted to the fluid movement that the artist's hand had acquired while cutting into paper with a pair of scissors.

In a related picture, also in the Barnes Foundation (fig. 1), most of the composition is given over to the view through the dark blue window, and the interior space is confined to an L-shaped area of bright coral into which the girls and their immediate surroundings are cramped. Outdoors, the nocturnal scene is illuminated by an eerie yellow glow, very likely an abstract Matissian translation of the actual reflected light on the trees — and a brilliantly different way of conflating indoors and outdoors.

The bleached-out light on the figures and the general theme of our painting recall similar compositions by Pierre Bonnard, who had died at the beginning of 1947.[2] Matisse may quite possibly have intended a painting like this one as an homage to Bonnard, with whom he had been especially close during the war years. In 1940 he had written to Bonnard that he was paralyzed "by something conventional that prevents me from expressing myself as I would like to in painting. My drawing and my painting are separating."[3]

In this painting, Matisse has reunited drawing and color in a strikingly original and ebullient way.

J F

Fig. 1. *Two Girls in a Coral Interior, Blue Garden*, 1947. Oil on canvas, 25½ x 19¼″ (64.8 x 48.9 cm). The Barnes Foundation, inv. no. 2092.

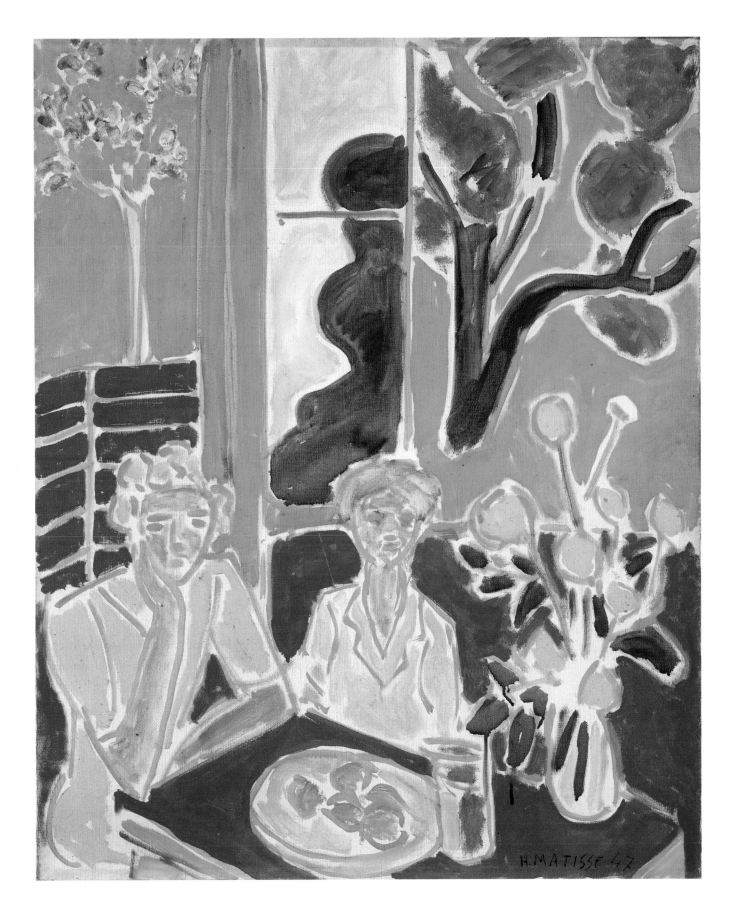

NOTES AND INDEX

Notes

DR. BARNES IN PARIS

1. Paul Guillaume, "Le Docteur Barnes," *Les Arts à Paris*, no. 7, January 1923, 1.

2. William Schack, *Art and Argyrol, The Life and Career of Dr. Albert C. Barnes* (New York and London, 1960); Henry Hart, *Dr. Barnes of Merion, An Appreciation* (New York, 1963); Howard Greenfeld, *The Devil and Dr. Barnes: Portrait of an American Collector* (New York, 1987).

3. Archives Vollard, Paris, Bibliothèque des musées nationaux, MS 421 (5,8) 1912 diary [10 December]: "10 1/2 Barnes rue de Grammont"; [11 December]: "sold to M. Barnes Cézanne painting *Bathers* before 1885 25 x 34 15,000 Cézanne painting still life 21 x 37 before 85 5,000 [total] 20,000 sold to M. Barnes and delivered 2 Renoir for 30,000 rec'd." On 13 December Vollard remitted to the painter Maurer a check for 4,500 francs "for commission Barnes sale," confirming the role of Maurer as adviser to Dr. Barnes. Number 3809 corresponds, moreover, to the Vollard account book (Archives Vollard, MS 421, 4,5: "*Portrait of Mme Cézanne*, 100 x 81 [bought] from Cézanne 300 francs". John Rewald, *Cézanne and America* (London, 1989), 263, using the Durand-Ruel archives, explains that Barnes paid Vollard through Durand-Ruel. This type of operation can be explained by the fact that Durand-Ruel had a branch in New York, thus facilitating payments on both sides of the Atlantic. John Rewald suggests as well that the *Portrait of Mme Cézanne* is the painting now in the Detroit Institute of Arts (V 528), and the *Still Life*, rm. 2, no. 18, in the Barnes Foundation (V 352); both hypotheses are confirmed by the dimensions supplied by Vollard. We suggest that the *Bathers* is rm. 5, no. 96, in the Barnes Foundation (V 270).

4. *Collection de M. X.*, sale catalogue, Paris, Hôtel Drouot, 7 December 1912, no. 16, Daumier, *Imaginary Invalid*, 25 x 32, 10,000 francs [Barnes Foundation Rm. 1, no. 75]; no. 35, Pissarro, *The Marketplace*, 1888, 46 x 38, 2,400 francs; no. 36, Renoir, *Woman Crocheting*, 38 x 32, 17,000 francs [Barnes Foundation rm. 11, no. 108]; no. 42, Renoir, *Women with Bouquet*, 58 x 71, 24,000 francs [Barnes Foundation Rm. 13, no. 289], are still at the Barnes Foundation with the exception of the Pissarro.

5. *Collection Henri Rouart, première vente, tableaux anciens . . . modernes . . . composant la collection de feu M. Henri Rouart*, sale catalogue, Paris, Galerie Manzi-Joyant, 9, 10, 11 December 1912: no. 92, *Bathers*, 40 x 42, 18,000 francs [Venturi 383; Barnes Foundation, rm. 8, no. 93]; no. 94, *Still Life, Peach and Grape on a Plate*, 16.5 x 29, 7,000 francs [Venturi 192; Barnes Foundation, rm. 9, no.

241]; no. 96, *Still Life, Three Apples*, 16.5 x 10, 2,000 francs [Venturi 202; Barnes Foundation, rm. 3, no. 57]; *Gazette de l'Hôtel Drouot*, 10 December 1912. Dr. Barnes also bought no. 160, Daumier, *Water Carrier*, 25 x 15, 1,300 francs (Barnes Foundation, rm. 8, no. 127).

6. Schack 1960, 73–7.

7. The collection bequeathed in 1911 by Isaac de Camondo was not exhibited to the public until several weeks before declaration of World War I. All the works of his impressionist friends and of Manet bequeathed by the painter Gustave Caillebotte in 1894 were still in the Musée du Luxembourg, reserved for contemporary artists. The gift of Etienne Moreau-Nélaton, including Manet's *Luncheon on the Grass*, had been exhibited since 1907 at the Musée des Arts Décoratifs, connected to the Louvre buildings.

8. Barnes was in Paris when the collection was dispersed in 1913; his order to Durand-Ruel to buy was canceled at the last moment (see Rewald 1989, 265). It was on this occasion that he saw Renoir's *The Sketching Lesson* (inv. no. 949) for the first time.

9. Rewald 1989.

10. Letter from W. Glackens to his wife, Paris, 16 February 1912, in Ira Glackens, *William Glackens and the Ashcan Group* (New York, 1957), 158, cited by Schack 1960, *Art and Argyrol*, 78, and Rewald 1989, 161. For today's values in dollars we suggest that the reader consult the price indexes proposed by Rewald 1989, flyleaf; according to the French I.N.S.E.E. tables it is also possible to multiply values in francs of 1911-1914 by 14.68 to obtain equivalent in 1990 francs; after the war, the factor varies between 4 and 5 until 1925, then between 2 and 3 during the years following until World War II.

11. Barnes Foundation, rm. 2, no. 51. Archives Durand-Ruel, Paris. I would like to express my warm gratitude once again to Caroline Godfroy-Durand-Ruel for having kindly confirmed the figures of the Glackens purchases.

12. *View of Montmartre*, still at the Barnes Foundation (rm. 5, no. 144), and *Leaving the Bath*, a small seated nude, which is no longer in the collection. I would like to thank Aminata Diallo and Lynn Fleming for verifying this information at the Foundation.

13. 1912 diary (see n. 3 above) [28 February]: "sold to M. Glackens 1 Picasso *Young Woman holding a cigarette* for 1,000 F rec'd."

14. Rewald 1989, 161. Venturi 424 Barnes Foundation rm. 14, no. 300.

15. I would like to thank Guy-Patrice Dauberville, director of Bernheim-Jeune, for having assisted me in

clarifying Dr. Barnes' activity in Paris. On 3 June 1912, "E." Barnes bought a Gauguin, 7,000 francs (probably *Haere Pape*) (page 167), a Delacroix, 10,000 francs, and a van Gogh, no. 17.762R which relates to *Factories à Asnières* (La Faille no. 318, Barnes Foundation, rm. 6, no. 303, sold to Dr. Barnes 12 October 1919). On 2 August 1912, he bought a Vallotton, 1,000 francs, and on 30 August 1912, three Bonnards: Jean and Henry Dauberville, *Bonnard, Catalogue Raisonné de l'Oeuvre peint*, vol. 1 (Paris, 1965), no. 287, *Evening, Lamplight*, about 1903, Barnes Foundation, rm. 10, no. 275; vol. 2 (Paris, 1968), no. 527, *Young Woman Writing*, 1908, Barnes Foundation, rm. 6, no. 346; no. 555, *Handcart* or *Rag Pickers*, 1909, Barnes Foundation, rm. 3, no. 309.

16. On the first Matisses purchased by Dr. Barnes from Leo Stein through Durand-Ruel, in December 1912," see Matisse, *View of the Sea, Collioure* (pages 236 and 308).

17. Rewald 1989, 276, 279 n. 9; over the years Barnes bought several works from Leo Stein (248–249, 252, 255, 256).

18. Rewald 1989, 263.

19. Venturi no. 605, Barnes Foundation, rm. 1, no. 7; Rewald 1989, 263–264.

20. Rewald 1989, 266–267. Vollard noted in his diary (see n. 3 above) [2 June 1913]: "2 p.m. shop Mr. Barnes"; 10 June, he sold to Durand-Ruel: "392 Cézanne, Picasso *Blue child* 5250 Picasso *The Bulls* [here exhibited as *Composition: The Peasants*] Renoir *Head of a Child*," all for 57,000 francs. No. 3392 corresponds to a Vollard stock number (Archives Vollard, MS 421 [4,5]): "Cézanne, *Houses among trees*, [bought] 200 F from Cézanne"; the number assigned to the Picasso cannot be traced.

21. 1913 diary (see n. 3 above), 18 June 1913.

22. Bill of sale of Levesque et Cie, 11 June 1913 (Barnes Foundation archives); Barnes exchanged a van Gogh and a Renoir to buy *The Luncheon* by Renoir (page 55) and *Woman with Cape* by Renoir, and a *Still Life* by Cézanne. Exchanging paintings was a current practice though it indicates that Barnes was a client who had to be accommodated. On the Lawson and Burroughs exhibition, see article by Guillaume Apollinaire, "Art moderne Américain," *Paris-Journal*, 10 July 1914, republished in Apollinaire, *Oeuvres en prose complètes*, vol. 11 (Paris, 1991), 818–819.

23. According to the Durand-Ruel account books, Barnes bought the following works on 14 May 1914: stock no. 7907, *Seated Woman*, 1875 (no longer in the Barnes Foundation); no. 7509, *Woman Fixing Her Hair*, 1887 (no longer in the Barnes Foundation); no. 8717, *View of Cagnes*, 1908 (ex-coll. Mary Mullen); no. 4613,

Landscape with Figure, 1894 (no longer in the Barnes Foundation); no. 7380, *Study of a Head of a Girl* (Barnes Foundation, rm. 14, no. 474); no. 4451, id. [*Study of a Head of a Girl*] (Barnes Foundation, rm. 23, no. 475); no. 10.463, *Study, Woman Torso* (Barnes Foundation rm. 1, no. 157, fig. 8); no. 10.131, *Bather Reflected in Water* (Barnes Foundation rm. 16, no. 217, fig. 9). All of the above works were identified with the help of Caroline Godfroy-Durand-Ruel, Aminata Diallo, and Lynn Fleming.

24. *Collection Herbert Kullmann de Manchester*, sale catalogue, Paris, Hôtel Drouot, 16 May 1914, no. 18, 42,350 francs, *Bather* of 1895, Barnes Foundation, rm. 7, no. 301. On August 26 1914 Barnes bought two more Renoirs at Durand-Ruel: *Landscape with Figures near Cagnes* (Barnes Foundation, rm. 9, no. 257) and no. 10.550, *Head of a Woman*, unidentified.

25. Paris, Archives Durand-Ruel; Barnes also bought a drawing by Puvis de Chavannes, a Hoffermann [sic], and two landscapes by Vignon. See also Rewald 1989, 267.

26. Rewald 1989, 268.

27. Albert C. Barnes, "How to Judge a Painting," *Arts and Decoration*, vol. 5, no. 6, April 1915, 217–220, 246–250. Barnes again invoked his fifty Renoirs in a letter to Durand-Ruel, of 25 January 1915, cited by Rewald 1989, 268, when he hoped to convince Renoir, whom he had not met, to part with a self-portrait, using Durand-Ruel as a go-between.

28. Letter from Barnes to Durand-Ruel, 9 June 1914, cited by Rewald 1989, 267. Oddly enough such an intention used to foretell the sale of a collection.

29. Letter from Barnes to Durand-Ruel, 25 January 1915, cited by Rewald 1989, 268.

30. On Paul Guillaume, see Anonymous, "Paul Guillaume, *Arts*, 5 October 1934; Waldemar George, *La Grande Peinture contemporaine à la collection Paul Guillaume* (Paris, n.d. [1929]), and Michel Hoog, introduction to *Musée de l'Orangerie, Catalogue de la collection Jean Walter et Paul Guillaume* (Paris, 1984), 5–11.

31. In *Les Arts à Paris*, no. 4, 15 May 1919, Paul Guillaume wrote that he saw his first work of "negro art" at a Montmartre laundry in 1904, when he was thirteen years old, implying that he already then knew Apollinaire, which seems unlikely. Apollinaire mentioned the name of Paul Guillaume for the first time in "Exotisme et Géographie," *Paris-Journal*, 10 September 1912, republished in Apollinaire, *Oeuvres*, 473 and 476. George [1929] recalled Guillaume's interest in ethnology at the time of his military service, "two years before the war," that is, in 1912.

32. When he married in 1920, to Juliette Lacaze, his marriage contract, which listed his worldly goods, included a collection of 265 "negro" sculptures, and works by Matisse, Derain, Vlaminck, Marie Laurencin, and others that remain unidentified, as well as 39 paintings, 250 drawings, and 2 works of sculpture by Modigliani. I would like to thank Maître Lacourte Notary, M. Aubron's successor, for allowing me to consult his archives.

33. It is tempting to see a connection with Dr. Barnes, when, in *Les Arts à Paris*, no. 1, 15 March 1918, before the war had ended, Guillaume included a paragraph concerning "a foreign collector in Paris," who is said to be purchasing works by Renoir, Manet, Cézanne, Toulouse-Lautrec, van Gogh, Gauguin, Pissarro, Sisley, Daumier, and Matisse, although this sort of notice is too common a procedure to be specifically linked to Barnes. There is also the announcement made by Picabia in 1919: "Paul Guillaume, financed by a rich American, grows larger" (Picabia, "New York, Paris, Zurich, Barcelone," *391*, no. 8, February 1919, 8, republished in Picabia, *Ecrits 1913–1920*, vol. 1, ed. Olivier Revault d'Allones and Dominique Bouissou [Paris, 1975], 129). I would like to thank Sylvie Maignan, who referred me to the article in *Comoedia*, 30 January 1923, in which René Jean lists the purchases of Dr. Barnes, some fifty works, he says, by Daumier (*Les Ribaudes*), Manet, van Gogh, Renoir, Redon, Derain, Utrillo, Pascin, Gritchenko, Soutine, Zadkine, and Lipchitz, and announces the creation of the Barnes Foundation and its goals. There seems not to have been a catalogue for the exhibition. As for the exhibition in Philadelphia, see *Catalogue of an Exhibition of Contemporary European Painting and Sculpture*, Philadelphia, The Pennsylvania Academy of The Fine Arts, with preface by Albert C. Barnes; seventy-five entries, mostly by artists still living at that time, include the works of Soutine, Modigliani, Segonzac, Lipchitz, Gritchenko, Perdriat, Derain, Matisse, Picasso, Zadkine, Kisling, Laurencin, Lagut, de Chirico, Lotiron, Kars, Utrillo.

34. Cited by Pierre Cabanne, *Le Roman des grands collectionneurs* (Paris, 1961), 188–189. Schack 1961, 140–141, gives a slightly different version in English.

35. Albert C. Barnes, "Le Temple," *Les Arts à Paris*, no. 10, November 1924, 11.

36. Paul Guillaume, "Ma visite à la Fondation Barnes," *Les Arts à Paris*, no. 12, May 1926.

37. In 1992, there are 180 works by Renoir, 69 by Cézanne, 60 by Matisse, including all techniques.

38. Felix Fénéon, "Le Ring," *Bulletin de la vie artistique*, 15 November 1921.

39. Picabia, "Vues de dos," *Paris-Journal*, 6 April 1923, reprinted in Picabia, *Ecrits 1921-1953*, vol. 2, ed. Olivier Revault d'Allones and Dominique Bouissou (Paris, 1978), 117–118.

40. Paul Guillaume, "Le récent voyage du Dr. Barnes à Paris," *Les Arts à Paris*, no. 8, October 1923, 14.

41. Jacques Villeneuve, "Echos et actualités," *Les Arts à Paris*, no. 13, June 1927, 3.

42. Letter from Etienne Bignou to Dr. Barnes, 13 April 1935 (Barnes Foundation archives), and letter from Bignou to Andry-Farcy, curator of the Musée du Grenoble, 1 June 1935, from the Mayor of Grenoble to Dr. Barnes, 11 September 1935, and Dr. Barnes' answer 26 September 1935 (Grenoble, Municipal Archive).

43. Letter from Dr. Barnes to Etienne Bignou, Madrid, 7 June 1934 (Barnes Foundation archives).

44. Archives Vollard, Paris, Bibliothèque des musées nationaux, MS 421 (4,6) Cashier's ledger 1920–1921: "1 July 1921, payment received from Barnes at Philadelphia (omitted 27 June 1921) 1 painting by Renoir *The Embroiderers*, 1 painting by Cézanne *Woman in a Red-Striped Dress, Peasant Standing* total 575,000 francs". MS 421 (4,7) Cashier's ledger 1922–1928: "29 December 1924 payment received from Barnes Foundation at Philadelphia 1 canvas Cézanne no. 1361 228,000 francs, 1 canvas Renoir no. 1298 190,000 francs, 1 canvas Picasso no. 1549 95,000 francs" (stock numbers not recorded elsewhere); "24 July 1925 payment received from Barnes Foundation at Philadelphia 1 painting Cézanne *The Planter* no. 82 250,000 francs"; "23 December 1925 payment received from Barnes at Philadelphia 1 painting Cézanne *Cabaret Scene* no. 4808 1,000,000 francs."

45. Ambroise Vollard, *Souvenirs d'un marchand de tableaux* (Paris, 1937), 383; though discreet about his client, Vollard related the following story: after Vollard fell at Merion, Barnes is supposed to have said: "Ah! Vollard, if you had killed yourself, I would have had you buried in the Foundation."

46. Letter from Jean Renoir to George Durand-Ruel, Cagnes, 14 December 1921 (Paris, Archives Durand-Ruel).

47. Jean Renoir, *Pierre Auguste Renoir, mon père* (Paris, 1981), 505.

48. See the photograph of *Bonheur de vivre* at Michael and Sarah Stein's, reproduced in Rewald 1989, 65.

49. Interview with Tériade, *L'Intransigeant*, 19, 20, 27 October 1930, republished in Henri Matisse, *Ecrits et propos sur l'art*, ed. Dominique Fourcade (Paris, 1972), 111. In an interview with the American journalist Dorothy Dudley (see n. 66), Matisse paid tribute to Barnes' "eye" and to his "340" Renoirs and "80" Cézannes, his beautiful Seurats, and his "marvelous" El Greco.

50. Letter from Matisse to the director of the Museum of Western Art, Moscow, Nice, 1 Place Charles Félix, 20 June 1935, in Matisse 1972, 151.

EDOUARD MANET

Tarring the Boat

1. 1869, Neue Pinakothek, Munich; Rouart-Wildenstein 1975, no. 135.

2. 1868–1869, Musée d'Orsay, Paris, Caillebotte Bequest; Rouart-Wildenstein 1975, no. 134.

3. Rouart and Wildenstein 1975, no. 193. The work has belonged successively to the collections of Dollfus, Mme. Besnard, and Georges Viau in Paris, then Hansen in Copenhagen.

4. 1873, Musée d'Orsay, Paris, J. J. Dubrugeaud Bequest; Rouart-Wildenstein 1875, no. 188.

5. Respectively, 1863, Musée d'Orsay, Paris, given to the state by public subscription undertaken by Monet; Rouart-Wildenstein 1875, no. 69; and 1864, National Gallery of Art, Washington, J. Widener Bequest; Rouart-Wildenstein 1975, no. 72.

6. Henri Matisse, in *Ecrits et propos sur l'art*, edited by D. Fourcade (Paris, 1972), 2–3, English trans. from Jack D. Flam, *Matisse on Art*, New York, 1973, 107.

7. He departed from Le Havre for Rio de Janeiro on 9 December 1848, arriving 4 February 1849, and returned to Paris on 13 June, leaving the Ecole Navale for good in order to devote himself to the study of painting.

8. 1864, Philadelphia Museum of Art, J. G. Johnson Bequest; Rouart-Wildenstein 1975, no. 76.

9. *Fishermen at Sea* (*Laborers of the Sea*); Rouart-Wildenstein 1975, no. 192.

PIERRE-AUGUSTE RENOIR

Torso

1. Daulte 1971, no. 144.

2. Merete Bodelsen, "Early Impressionist Sales 1874–1894 in the light of some unpublished 'procès-verbaux,'" *Burlington Magazine*, 110, no. 783 (June 1968), 333, 336.

3. *Tableaux et pastels composant la collection de M. Théodore Duret*, sale catalogue, Paris, Galerie Georges Petit, 19 March 1894, sold for 4,900 francs to Durand-Ruel.

4. I would like to thank Caroline Godfroy-Durand-Ruel for kindly locating the bill of sale for this purchase involving Dr. Barnes, 13 April 1912 (Archives Durand-Ruel, Paris).

Jeanne Durand-Ruel

1. Daulte 1971, no. 179, repr.

2. Renoir painted portraits of the Durand-Ruel children on various occasions (Daulte 1971, nos. 408–411, 549), and of Paul Durand-Ruel in 1910 (Durand-Ruel, Paris). When Durand-Ruel died in 1922, the painting went to his other daughter, Marie Thérèse (Madame Aude); it remained in her possession until 1935, when it was sold — through the intermediary of the New York branch of Durand-Ruel — to Dr. Barnes, who had long coveted this picture, and was delighted to purchase it for the sum of $50,000.00. "Dr. Barnes Buys Two Renoirs; He Now Has 175," *Art Digest* (15 April 1935); and Carl W. McCardle, "The Terrible-Tempered Dr. Barnes," *Saturday Evening Post* (4 April 1942), reprinted in John Rewald, *Cézanne and America*, London, 1989, 276–277.

3. Edmond Renoir, "Cinquième exposition de La Vie Moderne," *La Vie Moderne*, no. 11 (19 June 1879), in Lionello Venturi, *Les Archives de l'Impressionisme*, vol. 2, Paris and New York, 1939, 337.

Leaving the Conservatoire

1. Georges Rivière, *Renoir et ses amis*, Paris, 1921, 151, repr. 149.

2. Vollard 1918, vol. 1, 81, no. 323; Daulte 1971, no. 245, repr.

3. The work is mentioned for the first time with this title in 1896, in the Chabrier sale catalogue (see n. 6). Albert Barnes and Violette de Mazia, *The Art of Renoir*, Merion, Pennsylvania, 1935, 449, no. 73, repr. 252, entitled *After the Concert*.

4. See the portraits of Rivière by Renoir, dated 1877, National Gallery of Art, Washington, and by N. Goeneutte, repr. in Gilbert de Knyff, *Norbert Goeneutte, sa vie, son oeuvre*, Paris, 1978, 33.

5. Georges Rivière, "A M. le Rédacteur du Figaro," *L'Impressioniste*, no. 1 (6 April 1877), in Venturi 1939, vol. 2, 309.

6. *Tableaux, pastels . . . composant la collection Emmanuel Chabrier*, sale catalogue, Paris, Hôtel Drouot, 26 March 1896, no. 22, *La Sortie du Conservatoire*, sold for 1,500 francs to Durand-Ruel.

7. Archives Durand-Ruel, Paris and Archives Berthier-Wagram (Archives nationales, Paris).

8. Acquired from the Berlin dealer Paul Cassirer, received and paid for on 14 March 1929; the painting was relined on its arrival in the United States.

The Luncheon

1. Daulte 1971, no. 303, repr.

2. Eugène Blot, *Histoire d'une collection*, Paris, n.d. [1932], 42.

3. Archives Berthier-Wagram (Archives nationales, Paris) and Barnes Foundation archives.

Mother and Child

1. Daulte 1971, no. 381, says that Durand-Ruel bought the painting from Renoir on 6 July 1881, but this must be a misprint for 1882.

2. Quoted in Barbara Ehrich White, *Renoir, His Life, Art, and Letters*, New York, 1984, 115.

3. Quoted in White 1984, 115.

4. Daulte 1971, no. 380. Rivière 1921, 27, illustrates a pen and ink drawing of the girl and baby, present location unknown.

5. Ambrose Vollard, *Renoir, An Intimate Record*, trans. by Harold L. Van Doren and Randolph T. Weaver, New York, 1925, 103, indicates that Renoir called the painting 'Woman with a Child on Her Knees.'

6. White 1969 and A. Callen, *Renoir*, London, 1978, both argue that the ring on the finger of Aline Charigot in the painting *Bather I* of 1881 (Sterling and Francine Clark Art Institute, Williamstown), was added for the sake of propriety.

7. Jean Renoir 1962, 225.

8. For a discussion of the myth, see E. H. Gombrich, "Raphael's *Madonna della Sedia*," in *Norm and Form: Studies in the Art of the Renaissance*, London and New York, 1966, 64–80.

9. Vollard 1925, 102.

10. The painting was bought from Durand-Ruel by the Chicago collector Mrs. Potter Palmer as early as 1892, but was returned to the dealer in 1894. It entered Dr. Barnes' collection from Durand-Ruel in 1920 — at a cost of $31,500. Writing in 1935, Barnes and de Mazia stated that they considered the work to be one of the best of Renoir's pictures from the period 1880–1883, demonstrating the "assimilation of light and color as organic parts of his form." Barnes Foundation archives.

Sailor Boy

1. The letter is partially published in White 1984, 133.

2. In a letter of 20 July, 1881, Jacques-Émile Blanche reported: "Mother kept him [Renoir] for dinner. We were at the table for a little less than three quarters of an hour (usually it takes us fifteen or twenty minutes)"; quoted in White 1984, 107.

3. Quoted in White 1984, 133.

4. Quoted in *Renoir* [exh. cat. Galeries nationales du Grand Palais], Paris, 1985, 224.

5. Daulte 1971, cat. nos. 446, 447.

6. According to Daulte, Dr. Barnes acquired *Sailor Boy* from Durand-Ruel on 19 October, 1914. A month later, on 19 November, he acquired *Girl with Parasol*. The former painting had been paid for by 29 April 1915, when it received a Barnes Foundation inventory number, 325, while *Girl with Parasol* was given the number 189. That the numbers were not consecutive suggests that Barnes was not primarily interested in the paintings as pendants and likely intended to hang them in different rooms of his home. At the Barnes Foundation today, *Sailor Boy* centers a carefully composed wall rather than balancing another work, further suggestion that Barnes regarded it as an independent painting. The portrait of Aline remained at the Foundation until at least 1935, when Barnes and de Mazia discussed it in *The Art of Renoir*, but at a later date Barnes sold the painting, thus separating Renoir's two sweet-faced "brats." Barnes Foundation archives.

Beach Scene

1. Letter of 5 September 1883, to Paul Bérard, quoted in White 1984, 133.

2. Letter of 27 September 1883, quoted in White 1984, 133.

3. Venturi 1939, vol. 1, 193, 125–126; quoted in Paris 1985, 239.

4. Barnes Foundation archives.

Garden Scene

1. On the painting, see C. Riopelle, "Renoir: The Great Bathers," *Bulletin of the Philadelphia Museum of Art*, vol. 86, nos. 367–368 (Fall 1990), 5–41.

2. Renoir also painted a slightly smaller preparatory study in oil, Daulte 1971, no. 504.

3. Barnes and de Mazia 1935, 95.

4. Vollard 1925, 123.

5. Barnes Foundation archives. A letter from Durand-Ruel, New York, dated 17 May 1916, reads: "I received your letter of May 16th and will keep the Renoir, Madame Renoir in the Garden, until I hear further from you." I have found no other documents relating to the painting in the archives.

6. The correspondence is in the Barnes Foundation archives. By the 1930s, the two had reconciled their differences, and indeed in 1936 Vollard lectured at the Foundation.

7. The story of how Barnes acquired Cézanne paintings from Vollard via Durand-Ruel is told by J. Rewald, *Cézanne in America*, Princeton, 1989, 263–268.

Noirmoutiers

1. Denis Rouart, ed., *Correspondance de Berthe Morisot*, Paris, 1950, Engl. trans. by Betty W. Hubbard, New York, 1957, 195.
2. Rouart 1957, 195.
3. White 1984, 196.
4. Albert André, *Renoir*, Paris, 1919, 26.
5. The painting was acquired by Barnes from Durand-Ruel in 1916. Barnes Foundation archives.

Reclining Nude

1. Vollard 1925, 24.
2. Jean Renoir, *Renoir, My Father*, trans. by Randolph and Dorothy Weaver, Boston and Toronto, 1962, 64.
3. The letter of 27 April 1893 to Paul Bérard is quoted in White 1984, 196; from excerpt in Drouot sale cat., 22 June 1979, no. 110. While Barnes dates the painting to c. 1897–1898, White suggests that Renoir might have been referring to it in the letter to Bérard and so dates *Reclining Nude* to c. 1893.
4. Renoir 1962, 392.
5. Renoir 1962, 392.
6. Renoir 1962, 65.
7. Barnes Foundation archives.

Artist's Family

1. Renoir 1962, 270.
2. Renoir 1962, 271.
3. In the caption to a photograph of *The Artist's Family* in Renoir 1962, 278, the girl is identified as Marie Isembart, the daughter of another neighbor at the Château des Brouillards. Jean Renoir is recalling an event of his infancy some sixty-five years earlier.
4. White 1984, 205.
5. Renoir 1962, 273.
6. Richard Thomson, "Representing Montmartre," *Toulouse-Lautrec* [exh. cat. Hayward Gallery], London, 1991, 228.
7. Renoir 1962, 373.
8. Quoted in Rewald 1989, 268.
9. Barnes Foundation archives.
10. Barnes Foundation archives. A penciled annotation on the painting's stretcher reads: *Arrived Feb 17 1927*.

Bather and Maid

1. Barnes and de Mazia 1935, 424.
2. *Cézanne and the Impressionists*, November 1935, no. 7; *Renoir*, December 1935, no. 7.
3. In a letter dated 11 December 1935, Bignou confirmed the previous day's sale (Barnes Foundation archives).
4. Letter of 22 January 1942, from Barnes to Herbert H. Elfers, Durand-Ruel, Inc., New York. Barnes Foundation archives.
5. Letter of 15 November 1933, from Barnes to Etienne Bignou. Barnes Foundation archives.
6. In Bignou's letter of 11 December 1935 (see n. 3 above) Bignou indicated that Barnes would pay $44,000 in cash for *Bather and Maid* plus one painting in exchange, Henri Matisse's *Boy with a Butterfly Net* of 1907 (Minneapolis Institute of Arts). When he en-

tered the Renoir in the Foundation inventory on 2 January 1936, Barnes gave the price as $50,000, the Matisse being valued at $6,000 in exchange! (Barnes Foundation archives).
7. On which see Steven Z. Levine, "To See or Not to See: The Myth of Diana and Actaeon in the Eighteenth Century," in *The Loves of the Gods: Mythological Painting from Watteau to David* [exh. cat. Kimbell Art Museum, Fort Worth], 1992, 73–95.

The Promenade

Barnes purchased the painting from the Galerie Barbazanges, Paris, for $28,000 on 5 January 1926. Barnes Foundation archives.
1. Renoir 1962, 373. Adrienne, apparently wearing the same patterned mauve blouse, posed for the painting *Girl Tatting* in the Philadelphia Museum of Art.

Caryatids

The works were acquired from Jean Renoir via Etienne Bignou in 1933 for $4,200 each.
1. Paul Fierens, "Renoir classique," *L'Art vivant* 174 (July 1933), 286.
2. Vollard 1934, 25.
3. See *Clodion 1738–1814* [exh. cat. Musée du Louvre], Paris, 1992, 265–275.
4. Renoir 1962, 98.
5. For a discussion of these issues see Debra L. Silverman, *Art Nouveau in Fin-de-Siècle France: Politics, Psychology, and Style*, Berkeley, Los Angeles, and London, 1989.
6. Vollard 1934, 25.

Bathers

1. Vollard 1925, 215.
2. On this process see Riopelle 1990, 17–20.
3. On this question, see Tamar Garb, "Renoir and the Natural Woman," *The Oxford Art Journal*, vol. 8, no. 2 (1985), 3–15; and Marcia Pointon, "Biography and the Body in Late Renoir," chapter four of *Naked Authority: The Body in Western Painting 1830–1908*, Cambridge, 1991, 83–97.
4. Correspondence in 1923 between Barnes and Paul Guillaume, who was representing the collector in Paris, and with Guillaume Lerolle, both of whom tried to arrange the sale of the painting, are found in the Barnes Foundation archives.
5. Barnes wrote to Paul Guillaume about the proposed gift on 13 April 1923: "I want that painting if the Louvre does not accept it. I offered 500,000 francs because I believe no dealer would pay that much for it unless he expected to sell it to me, the only collector who buys expensive, late Renoirs." Barnes Foundation archives.
6. Barnes Foundation archives.

CLAUDE MONET

Madame Monet Embroidering

1. Daniel Wildenstein, *Claude Monet: Biographie et catalogue raisonné*, Tome I: 1840–1881, Lausanne and Paris,

1973, 270 (no. 366), and John Rewald, *The History of Impressionism* (4th, rev. ed.), New York, 1973, 354.
2. Albert Wolff, "Masque de Fer" in *Le Figaro* (quoted in Gustave Geffroy, *Claude Monet, sa vie, son oeuvre*, Paris, 1924, vol. 1, chap. 13), 77, as quoted in Rewald 1973, 351.
3. Also see Robert Herbert, "Method and Meaning in Monet," *Art in America* (September 1979), 97: "In the mid-1870s at Argenteuil, some paintings were done very quickly, in large buttery strokes, but more numerous are canvases . . . which were worked on repeatedly, with drying time between the sessions. Their brushwork is varied to suit the imagery . . . Monet applied his paint quite frankly in strokes of one color, but frequently he wanted to change or enrich the color while retaining the underlying texture of 'spontaneity.' He therefore added thin surface colors."
4. Philippe Burty, introduction to *Vente du 24 mars 1875 – Tableaux et acquarelles par Cl. Monet, B. Morisot, A. Renoir, A. Sisley*, Hôtel Drouot, Paris, as quoted in Rewald 1973, 351, 354.
5. *Madame Claude Monet Reading*, c. 1872, The Sterling and Francine Clark Art Institute, Williamstown; *Madame Renoir Reading "Le Figaro,"* c. 1874, Calouste Gulbenkian Foundation, Lisbon; and *Madame Monet*, c. 1874, Collection Arturo Peralta-Ramos, New York. François Daulte (*Auguste Renoir*, vol. 1, Lausanne, 1971, nos. 73, 77, and 78) ascribes all to 1872; however, Rewald 1973, 344, assigns the works in the Gulbenkian Foundation and the Peralta-Ramos collection to c. 1874. The Sterling and Francine Clark Art Institute currently dates *Madame Monet Reading "Le Figaro"* to c. 1872.
6. Ronald Pickvance, "Monet and Renoir in the Mid-1870s," in *Japonisme in Art, An International Symposium*, Tokyo, 1980, 161–162.

The Boat Studio

1. Paul Tucker, *Monet at Argenteuil*, New Haven and London, 1982, 9. Tucker's study of Monet's life and work in Argenteuil is indispensable to a full understanding of the artist's achievement.
2. François Thiebault-Sisson, "About Claude Monet," *Le Temps*, 8 January 1927, as quoted in Charles F. Stuckey, ed., *Monet: A Retrospective*, New York, 1985, 346.
3. Wildenstein 1973, vol. 1, nos. 323 and 390.
4. For a discussion of the self-portrait in the Kröller-Müller painting, see Tucker 1982, 112–113.

PAUL CÉZANNE

Bathers at Rest

1. Quoted from Gerstle Mack, *Paul Cézanne*, New York, 1989 211; reprint of 1935 edition.
2. Renoir, as executor of Caillebotte's estate, haggled with the curators for two years over the bequest, in what was one of the darker chapters in the gradual acceptance of progressive painting into the mainstream of French public institutions. The art dealer Bignou, who sold the picture to Dr. Barnes in 1933

(in collaboration with Galerie Georges Petit), claimed that it was among the works rejected in 1896 and that "fifteen years later, in 1911, the French State, in the person of Minister Clementel, solicited from the Caillebotte family the donation of this picture, but he met with a refusal." Barnes Foundation archives.

3. Richard Brettell makes the observation that the picture shown in 1877 may actually have been the sketch (Lionello Venturi, 1936, no. 273; now in Geneva, illustrated above), not the Barnes picture. His evidence is the red signature of that work, usually associated with Victor Choquet, who lent many pictures to the show. However, the amount of criticism leveled against this work, far more than any other shown by Cézanne in 1877, firmly suggests that it was the larger, more important work that was shown. It is quite possible that Cézanne, worried that the larger work would not be ready in time, listed the sketch in the exhibition brochure, making the switch after it was printed. See Richard Brettell in *The New Painting: Impressionism 1874–1886* [exh. cat. National Gallery of Art], Washington, 1986, 196.

Leda and the Swan

1. Venturi 1936, no. 111.
2. Venturi 1936, no. 551. Meyer Schapiro speculates elegantly on the sensual and erotic role fruit would play in Cézanne's work. "The Apples of Cézanne: An Essay on the Meaning of Still-life," *Modern Art, Nineteenth and Twentieth Centuries, Selected Papers*, New York, 1982, 11.

Gardanne

1. Venturi 1936, nos. 431–432.
2. Adrien Chappuis, *The Drawings of Paul Cézanne, A Catalogue Raisonné*, Greenwich, Connecticut, 1973, vol. 1, no. 902.

Boy in a Red Vest

1. John Rewald, *Paul Cézanne: The Watercolors*, Boston, 1983, no. 375.
2. Venturi 1936, no. 681.
3. Gustave Geffroy, *La vie artistique, ser. VI*, Paris, 1900, 218.

Potted Plants

1. Rewald 1983, no. 194.

The Card Players

1. Paul Alexis, 1847–1901, a successful novelist and playwright who grew up in Aix with Cézanne and Zola. His letter is quoted in John Rewald, *Paul Cézanne*, trans. by M. H. Liebman 1950, 142–143.
2. Theodore Reff, "Cézanne's 'Card Players' and their Sources," *Arts Magazine*, vol. 55, no. 3 (November 1980), 114.
3. Venturi 1936, vol. 1, 59, and vol. 2, nos. 556–560.
4. For the related drawings and watercolors see Rewald 1983, nos. 377–381, and Chappuis, 1973, nos. 1092–1095.
5. The daughter was interviewed in 1955. See Robert

Ratcliffe, "Cézanne's Working Methods and Their Theoretical Background," University of London, 1961, 19–20. See also Reff Ph.d. diss., 1980, 105 n. 10.
6. Many have attempted to endow these men with animation, Meyer Schapiro, for example, speaking of the Louvre picture, in which one figure is "the more habitual player, relaxed and cool," while his competitor "has a bright mind and sluggish body," his pose "more strained in deciding." See Meyer Schapiro, *Paul Cézanne*, New York, 1952, 88.
7. Quotations attributed to Cézanne are famously secondhand and vulnerable to doubt; however, his insistence to Emile Bernard in 1904 on the importance of remaining true to the motif before him has considerable reinforcement from others who knew Cézanne, just as his notion, first mentioned in a letter to Renoir, of certain works as "souvenirs of the Museum" takes on, particularly in terms of his figurative works, a sound validity. For a summation of these points and references, see Reff 1980, 104.
8. Joachim Gasquet, *Cézanne: A Memoir with Conversations*, trans. by Christopher Pemberton, London, 1991, 48.

Well

1. Mack 1989, 323.
2. Rewald 1983, nos. 425 and 531.

House and Trees

1. Rewald 1883, 123, no. 178.

Mont Sainte-Victoire

1. In 1990 an exhibition took place in Aix that examined the role of the mountain in local culture and traced its image through the works of Cézanne and into the twentieth century. See exh. cat. Musée Granet, Aix-en-Provence, *Sainte-Victoire: Cézanne: 1990*, 1990.
2. Rewald 1989, 272.

Woman in a Red-Striped Dress

1. Albert C. Barnes and Violette de Mazia, Barnes found the reds ineffectively integrated into the picture overall; "the drawing and modeling of the garment suffer an appreciable loss in expressive power." The rigor of his criticism is not untypical; in an earlier passage analyzing the composition, he perceptively states: "This pattern is quite as obvious as in Hals, but it is more colorful and luminous, and by its greater simplification it eliminates surface-detail and accentuates three-dimensional solidity more effectively: its primary purpose is expressive rather than illustrative and decorative". *The Art of Cézanne*, Merion, Pennsylvania, 1939, 384.
2. From the Barnes archives we know a considerable amount about the means by which Dr. Barnes acquired this picture. In 1912 the American painter Alfred Maurer was working in France. Barnes encouraged his art and asked him to serve as an agent for his acquisitions. On 29 September 1912, Maurer wrote from Pont de Try ("Normans"): "Went to Paris yesterday and saw Vollard . . . He asks 35,000 fr. for

Cézanne's *Woman in Striped Dress*, which I think is about the real market value, it's a fine picture and Vollard tells me it was painted in 1896 . . . it's as Cézanne as Cézanne can be. It has the quality of some of his fine still life, that solid quality." On 2 October he was back in Paris: "Druet has a Cézanne of an old woman perhaps of a canvas of about no. 49 [a commercially available canvas size, 85 x 65 cm]. Vollard [has a woman in a] striped dress which I think finer . . . Do you want Vollard to send it on approval." The *Old Woman* (see fig. 1) is a portrait of a defrocked nun whom Cézanne seems to have taken in out of charity and painted saying her rosary.

Maurer's instincts were remarkably keen; the *Old Woman* ranks with the *Woman in a Striped Dress* in expressive force. Barnes instructed Maurer on 9 October to get Vollard to adjust the price. Maurer replied on 15 October that he'd been to see Vollard again and "he assures me he sent photos I wanted him to send among them you will find Cézanne's *Woman in Striped Dress* . . . in the Cézanne you will find a small touch over the mouth which is not finished or left as Cézanne did in so many of his works, don't let this bother you, after you are accustomed to the painting you don't notice it at all. This Cézanne has all the qualities of the best Cézanne and resembles very much those fine solid still lifes." Barnes cabled with shipping instructions on the twenty-first and Maurer wrote a day later, reassuring him that all was in order. However, as would often happen with Vollard, negotiations collapsed. Fortunately Barnes persisted and finally purchased the work for 5,000 francs more in 1915, Durand-Ruel acting as his agent. Barnes Foundation archives: Alfred Maurer file and inventory ledger.

Woman in a Green Hat

1. Barnes Foundation archives: Durand-Ruel file for 1915.
2. Rewald 1989, 268.
3. Ambroise Vollard, *Paul Cézanne, His Life and Art*, trans. by Harold van Doran, New York, 1923, 80.
4. Geffroy in *Journal*, 16 November 1895, quoted from Gerstle Mack, *Paul Cézanne*, New York, 1935, 342.

Table, Napkin, and Fruit

1. Meyer Schapiro, "The Apples of Cézanne," op. cit., p. 27.
2. Reff: "Pictures within Cézanne's Pictures," op. cit., p. 100, fig. 35.
3. Schapiro, "The Apples of Cézanne," op. cit., p. 27.

Still Life with Skull

1. V.V. 61 and V. 68, 1865–68: V. 734, 751, 753, 759, 1567.

Boy with Skull

1. Venturi 1936 vol. 1., no. 679.
2. Rewald, *Cézanne: A Biography*, New York, 1986, 189–90.
3. Reff, "Cézanne; the Severed Head and the Skull," *Arts Magazine* (October 1983), 84–100.

Chrysanthemums

1. Gasquet 1991, 128.
2. Rewald dates the Moscow picture to 1902–1904, the ~~Barnes flowers to c. 1900. See *Cézanne: The Late Works*~~ [exh. cat. The Museum of Modern Art, New York] 1977, plates 161, 163.
3. Alfred Robaut records three Delacroix watercolors of *Chrysanthemums*, at least one of which was in Choquet's collection. See Robaut, *L'oeuvre complète d'Eugène Delacroix*, New York, 1969, (reprinted from the 1885 Paris edition), nos. 1823, 1824, 1825.

Bibémus Quarry

1. Rewald in exh. cat. New York 1977, 93.

Nudes in a Landscape

1. See Mary Louise Krumrine, *Paul Cézanne: The Bathers*, Basel, 1989; this publication was done in connection with an exhibition at the Basel Kunstsammlung 10 September–10 December 1989.
2. Venturi 1936, vol.1, 62.
3. The arguments have been summarized by Theodore Reff in exh. cat. New York 1977, 38-44. Dr. Krumrine expands upon this, with more specific reference of other bather subjects: See Krumrine 1989, 207–210.
4. Dr. Krumrine's observation that the figure was, in its first manifestation, a male bearing the features of Cézanne himself, has not been reinforced by others. See Krumrine 1989, 209–210.
5. Footnote, Rewald, The Museum of Modern Art, 398 quoting Sir Herbert Read, *The Meaning of Art*, London, 1931, sect. 73.

PAUL GAUGUIN
Mr. Loulou

1. Henri Mothéré, who communicated with Chassé by letter, quoted in Charles Chassé, *Gauguin et le groupe de Pont-Aven*, Paris, 1921, 52.
2. Although children frequently appear in Gauguin's Breton paintings, they are generally included as anonymous bathers or genre figures. One of the few other formal portraits of children Gauguin made at this time is the *Double portrait d'enfants* in the Ny Carlsberg Glyptothek, Copenhagen. Though dated to 1895 in Georges Wildenstein, *Gauguin*, eds. Raymond Cogniat and Daniel Wildenstein, Paris, 1964, vol. 1, no. 530, most scholars agree on a date of c. 1889. See for example, Merete Bodelsen, "The Wildenstein-Cogniat Gauguin Catalogue," *Burlington Magazine*, 108, no. 754 (January 1966), 38, and Ronald Pickvance, *The Drawings of Gauguin*, London, New York, Sydney, Toronto, 1970, no. 55. The children in this portrait have not been identified. It is possible that the older of the two children represents Louis Le Ray at a slightly younger age.
3. All that is known of Louis Le Ray is that he was the younger brother of Jules Le Ray, born c. 1874 in Nantes, who was working as a painter in Le Pouldu by 1894. For information about the Le Ray family I wish to thank Jean-Marie Cusinberche whose essay,

"L'Itinéraire de Paul Gauguin en Bretagne," in *Gauguin et ses amis peintres — La collection de Marie Henry — Buvette de la Plage, Le Pouldu, Bretagne*, Yokohama, 1992, is the most recent published account of Gauguin in Le Pouldu. Given Jules' profession and Gauguin's friendship with the family, it is possible that the boys' father was also an artist. According to Wildenstein 1964, the portrait of M. Loulou remained in the Le Ray family until 1923. Judging from Gauguin's inscription and his reputed closeness to the family, the portrait must have been a gift from the artist to Louis' father.
4. See Gauguin's letters in Maurice Malingue, *Lettres de Gauguin à sa femme et à ses amis*, Paris, 1946, nos. 82 and 83.
5. See, for example, Richard Brettell in *The Art of Paul Gauguin* [exh. cat. National Gallery of Art], Washington, 1988, nos. 165 and 216.
6. See Charles F. Stuckey in Washington 1988, nos. 8 and 13.

Haere pape

Haere pape is no. 464 in Wildenstein 1964 and no. 41 in Richard Field, *Paul Gauguin: The Paintings of the First Trip to Tahiti*, Ph.D. diss., Harvard University, Cambridge, 1963, New York and London, 1977, 328.

1. Field places this work on stylistic grounds in the summer or fall of 1892 (Field 1977, 160–162; 324–325; and 328 no. 41). *Haere pape* probably was among the sixty-six paintings Gauguin brought back with him to Paris in June of 1893, but it was not among the works he chose to exhibit at Durand-Ruel that December (see *Exposition d'oeuvres récentes de Paul Gauguin* [exh. cat., Galeries Durand-Ruel], Paris, 1893).
2. Bengt Danielsson, "Gauguin's Tahitian Titles," *Burlington Magazine*, 9, no. 760 (April 1967), 231, no. 17. Field translates the title as an invitation, "Come into the Water," Field 1977, 328.
3. In the Metropolitan Museum of Art, New York. See Wildenstein 1964, no. 428.
4. Bernard Dorival, "Sources of the Art of Paul Gauguin from Java, Egypt and Ancient Greece," *Burlington Magazine*, 93, no. 577 (April 1951), 118.
5. On this work see Kunio Motoe in *Paul Gauguin* [exh. cat. The National Museum of Modern Art], Tokyo, 1987, 172, no. 69. The figure appears in other Tahitian paintings such as *Parau Parau*, 1892 (Wildenstein 1964), no. 472. There is also a sketch of this figure in the artist's Tahitian sketchbook, Bernard Dorival, *Carnet de Tahiti*, Paris, 1954, 72v.
6. For sketches of the dog see Dorival 1954, 28r.
7. See, for example, *Mahana no atua*, 1894 (Wildenstein 1964, no. 513).

VINCENT VAN GOGH
Joseph-Etienne Roulin

1. Long before moving to Paris in February 1888, van Gogh had developed strong but not entirely accurate

preconceptions about the people of Provence; he seems to have been strongly influenced by Alphonse Daudet's *Tartarin of Tarascon* novels. For an excellent discussion of this subject, see Judy Sund, *True to Temperament: Van Gogh and French Naturalist Literature*, Cambridge University Press, 1992, 172–173.
2. Vincent van Gogh, *The Complete Letters of Vincent van Gogh*, vol. 3, Greenwich, 1959, 148 (letter 583).
3. Van Gogh [1959], vol. ?, 439 (letter W 5).
4. Van Gogh [1959], vol. 2, 623 (letter 516).
5. The five versions are reproduced in J.-B. de la Faille, *The Works of Vincent van Gogh*, Amsterdam, 1970, 224, nos. F 504–508, and Jan Hulsker, *The Complete van Gogh*, New York, 1977, 380 (no. 1655), 385 (no. 1669), and 386 (nos. 1670–1672).
6. Hulsker 1977, 388.

Although most authorities assign the three portraits of Roulin to approximately the same period as the five versions of *La Berceuse*, Florence E. Coman, assistant curator, National Gallery of Art, has recently noted that one of them appears in the background of the version of *The Bedroom* in the Rijksmuseum Vincent van Gogh in Amsterdam. The presence of the portrait of Roulin in that composition poses a problem, because the canvas in Amsterdam is firmly dated October 1888; see Evert van Uitert, Louis van Tilborgh, and Sjraar van Heugten, *Vincent van Gogh: Paintings* [exh. cat. Rijksmuseum Vincent van Gogh], Amsterdam, 1990, 172. Additional discrepancies are evident in the drawings of *The Bedroom* that van Gogh included in letters 554 (16 October 1888) and B22 (17 October 1888), including the painting on the wall behind the head of the bed (letter 554) and at least one of the paintings hanging to the right of the bed (letters 554 and B22). A possible explanation for the portrait of Roulin in the October 1888 version of *The Bedroom* is that when Theo returned it to Vincent in September 1889 to be copied (Vincent made two variants), the artist may have retouched the original version, which had suffered moisture damage months earlier (van Uitert 1990, 138), and added the portrait of Roulin.
7. Van Uitert 1990, 138, n. 1: "Ronald Pickvance expressed the view, in a lecture given at the Metropolitan Museum of Art in New York on 17 November 1984, that the version of Roulin's portrait exhibited in the Kröller-Müller Museum at Otterlo may be a forgery."
8. Van Gogh [1959], vol. 2, 623 (letter 516).
9. Van Gogh [1959], vol. 3, 126 (letter 573): "... he had put on his brand-new uniform which he had received that very day, and every one was making a great deal of him."
10. Van Gogh left most of his work unsigned, but he did sign many of the paintings he gave away as gifts, such as the portrait of Dr. Felix Rey. Some are also inscribed to the recipient, especially those given or traded to other artists.

For a different analysis of the sequence and interrelationships of the portraits of Roulin, see Jan

Hulsker, "Van Gogh, Roulin, and the two Arlésiennes, a re-examination: Part II," *Burlington Magazine*, 134, no. 1076 (November 1992), 709–711; Hulsker thoroughly discusses the portraits of Roulin and proposes that Roulin did not pose for the examples now in Merion, Otterlo, and New York, but that van Gogh used the portrait now in Boston (fig. 1) as the "model" instead of Roulin himself.

11. Van Gogh [1959], vol. 3, 211 (letter 605, 10 September 1889). For a discussion of the significance of this passage in connection with *La Berceuse*, see Jan Hulsker, "Van Gogh, Roulin, and the two Arlésiennes: Part I," *Burlington Magazine*, 134, no. 1074 (September 1992), 576–577.

GEORGES SEURAT
Entrance to the Port of Honfleur

1. See R. L. Herbert, "Marines; Grandcamp et Honfleur, Port-en-Bessin et Gravelines," in *Seurat 1859–1891* [exh. cat. Grand Palais, The Metropolitan Museum of Art], Paris, 1991, 271, 274, 361, 398.
2. On *La Maria, Honfleur*, now in the National Gallery, Prague, see E. Darragon, "Seurat, Honfleur et la Maria," *Bulletin de la Société de l'Histoire de l'Art français*, 1984, 263-280.
3. Stem and rigging: in *Corner of the Harbor*, de Haucke, *Seurat et son oeuvre*, Paris, 1961, no. 163, Rijksmuseum Kröller-Müller, Otterlö; anchors: in *Le canal de Gravelines, un soir*, 1890, de Haucke 1961, no. 210; mooring post: in our fig. 1, *Channel of Gravelines, Petit Fort Philippe*, 1890, Indianapolis Museum of Art.
4. Félix Fénéon, in *Les Impressionnistes en 1886*, reprinted in Joan U. Halperin, ed., *Oeuvres plus que complètes, Chronique d'arts*, 1970, vol. 1, 56.
5. Fénéon, in *L'Emancipation sociale*, April 1887, reprinted in *Oeuvres*, 1970, vol. 1, 67.
6. Fénéon, in *L'art moderne*, 1 May 1887, reprinted in *Oeuvres*, 1970, vol. 1, 93.
7. Dorra-Rewald 1959, no. 162; C. M. de Haucke, *Seurat et son oeuvre*, Paris, 1961, no. 171. Fénéon probably exchanged it in 1890 for a smaller, more recent work that had excited his enthusiasm: *The Model Seen from the Front* (today in the Musée d'Orsay, Paris), a highly finished study for the central figure in *Models (Poseuses)* (page 175). Before it was bought by Dr. Barnes, it belonged to Karl E. Osthaus, Alfred Flechteim, and Rolf de Maré.

Models

1. Dorra-Rewald 1959, no. 178; de Haucke 1961, no. 185. See also Françoise Cachin, in *Georges Seurat 1859–1891* [exh. cat. Musée d'Orsay, the Metropolitan Museum of Art], Paris, New York, 1991, 309–319.
2. Arsène Alexandre, "Un vaillant," obituary, Paris, 1 April 1891.
3. August 1887; letter published in Dorra-Rewald 1958, CXI; trans. in Paris 1991, Engl. ed. (New York, 1991), 278.
4. Fénéon, in *L'art moderne*, 15 April 1888, reprinted in *Oeuvres*, 1970, vol. 1, 84.

5. To Octave Maus, 17 February 1894, in M. O. Maus, *Trente années de lutte pour l'art*, 1926, 87; trans. in Paris 1991, Engl. ed. (New York, 1991) 409.
6. Journal of Paul Signac, 2 January 1898, published by J. Rewald in *Gazette des Beaux-Arts*, April 1947.
7. According to Dorra-Rewald, it had been cut and used to frame other paintings by Seurat.
8. Roger Fry, *The Dial*, September 1926.
9. Fénéon 1888, in *Oeuvres*, 1970, vol. 1, 84.

HENRI DE TOULOUSE-LAUTREC
"A Montrouge" — Rosa La Rouge

1. The last reference to Lautrec in the studio of Cormon dates from the spring of 1887, when Cormon's students presented their teacher with a "ridiculous silver palm" on the occasion of his having been awarded a medal of honor at the Salon. Herbert Schimmel, *The Letters of Henri de Toulouse-Lautrec*, Oxford, 1991, letter 141, 1887, to his mother. The studios of Lautrec (after 1886 on the rue Caulaincourt), Cormon, and Rachou were located in Montmartre.
2. He often went to Le Chat Noir (Schimmel 1991, letter 129, July 1886, to his mother) and became a regular at Le Mirliton, which was opened by Bruant in 1885, at 84 boulevard Rochechouart; there, the singer performed irreverent songs written in *argot*, or street slang.
3. M. G. Dortu, *Toulouse-Lautrec et son oeuvre*, New York, 1971, vol. 2, 305.
4. François Gauzi, *Lautrec mon ami*, Paris, 1992, 133; "In particular, she possessed the exceptional distinction of being a redhead. To tell the truth, she had her hair dyed yellow but Lautrec was no stranger to artifice; he all but preferred that to the real" (169).
5. As early as 1884, in a group of paintings representing Carmen Gaudin, he made a portrait of a "woman who has an absolutely golden head" (Dortu 1971, 243-246, 305, 345). She is the *Pierreuse* (352).
6. Gauzi 1992, 136. At that time she was not a professional model, though she also posed for Cormon, Stevens, and Besnard.
7. Dortu 1971, 206, 307, 308.
8. This painting first belonged to Aristide Bruant, who exhibited it in his cabaret; it was entered in the Bruant sale in Paris, April 1905, no. 2 (4,500 francs, unsold).
9. Published in Bruant's review *Le Mirliton*, 1 February 1886.
10. Gale Murray has shown that a barely perceptible transition of this kind can be observed across a group of paintings that include *La Grosse Maria* and *La Blanchisseuse*, which she dates from 1886. Murray, *Toulouse-Lautrec: The Formative Years, 1878-1891*, Oxford, 1991, 94–96.
11. The unusual forelock made enough of an impression for the painting to be entered in the inventory of the Barnes Foundation under the title *Laundress — Woman with Wisp of Hair*.

12. The drawing (D.3090) was published in *Courrier Français*, no. 22, 2 June 1889, after which the painting could not have been made.
13. Maurice Joyant, *Henri de Toulouse-Lautrec*, Paris, 1926–1927, vol. 1, 98, 264, repr. 68; vol. 2, 145.
14. Schimmel 1991, letter 153, 1887, to his mother.

Reclining Nude

1. Dortu, 1971, vol. 3, 396, no. P.648, repr. 397.
2. Daniel Halévy, *Degas parle . . .* , Paris, 1960, 14.
3. Joris Karl Huysmans, "L'exposition des Indépendants en 1881," up-dating Baudelaire's remarks on the occasion of the Salon of 1846.
4. In the Barnes Foundation files, this painting is identified as "Nude — Blue" and "Reclining Nude on Blue Couch," titles that distinctly recall Matisse.
5. Dortu 1971, vol. 3, 649.
6. "Un five o'clock milk," *La Vie Parisienne*, 22 May 1897, 304.
7. *Toulouse-Lautrec* [exh. cat. Hayward Gallery and Grand Palais], London and Paris, 1991, 460.
8. Schimmel, 1991, no. 487.
9. Especially those on the rue des Moulins and the rue d'Amboise in Paris; Anne Roquebert, *Le Paris de Toulouse-Lautrec*, Paris, 1992, 34, 35, 41. In *Elles*, his album of lithographs from 1896, Lautrec revealed the ease and virtuosity with which he recorded the intimate routines of the women he had been able to observe there.
10. Yvette Guilbert, *La chanson de ma vie*, Paris, 1927, 228.
11. The dealer Etienne Bignou had acquired the painting from Eugène Blot, according to the Bignou records that are preserved in the Musée d'Orsay.

HENRI ROUSSEAU
Unpleasant Surprise

1. *Unpleasant Surprise* appears in Dora Vallier, *Tout l'oeuvre peint de Henri Rousseau*, Paris, 1982, no. 122; and in the biography and catalogue raisonné by Henri Certigny, *Douanier Rousseau en son temps*, Tokyo, 1984, vol. 2, no. 170.
2. Dora Vallier, *Henri Rousseau*, New York, 1961, 313.
3. Jean Béral, *Art et littérature*, 10 May 1901.
4. La Belle Jardinière was a department store in Paris known for its ready-to-wear clothes.
5. Ambroise Vollard, *En écoutant Cézanne, Renoir, Degas*, Paris, 1938.
6. Vallier 1982, 101.

Scout Attacked by a Tiger

1. Vallier 1982, no. 211a.
2. Roch Grey, *Henri Rousseau*, Paris, 1943, 51.
3. Vallier 1982, no. 151.
4. Vallier 1961, 313.
5. Sandra E. Leonard, *Henri Rousseau and Max Weber*, New York, 1970, 50–51.

Woman Walking in an Exotic Forest

1. Vallier 1982, no. 217.
2. Vallier 1982, no. 202.

PABLO PICASSO

Woman with a Cigarette

1. *Woman with a Cigarette* is listed in the following catalogues: Christian Zervos, *Pablo Picasso*, Paris, 1932–1978, 33 vols.; vol. 1, no. 99; Pierre Daix and Georges Boudaille, *Picasso: The Blue and Rose Periods*, Greenwich, 1966, no. VI. 26; Josep Palau i Fabre, *Picasso vivant (1881–1907)*, Paris, 1981, no. 667.

2. Zervos 1969, vol. 21, no. 134.

3. One of the most provocative and sumptuous being *The Hetaera* (Zervos 1932, vol. 1, no. 42; Daix-Boudaille 1966, no. VI. 17, in a large hat with feathers and a gemstone necklace, which is almost contemporary with *Woman with a Cigarette*.

4. The other women of 1901 tend to be more archetypal than the Barnes smoker, but a distinct resemblance can be observed in *The Woman with a Chignon* (Zervos 1932, vol. 1, no. 96; Daix-Boudaille 1966, no. VI. 23); *The Aperitif* (Zervos 1932, vol. 1, 98; Daix-Boudaille 1966, no. VI. 24); and *The Absinthe Drinker* (Zervos 1932, vol. 1, no. 100; Daix-Boudaille 1966, no. VI. 25).

5. Une foule de portraits . . .
Miroir de toute vérité . . .
Au bord de deux yeux innocents
Portraits sensibles et confiants.

Paul Eluard, *A Pablo Picasso*, Geneva and Paris, 1944, 153–154; repr. 142.

6. Félicien Fagus, in *La Revue blanche*, 15 July 1901, vol. 27, 464–465: "Apart from the great precursors, it is easy to detect numerous likely influences: Delacroix, Manet, . . . Monet, Van Gogh, Pissarro, Toulouse-Lautrec, Degas, Forain, and Rops perhaps"; trans. Kenneth Lyons, in Josep Palau i Fabre 1981, 514–515. The exhibition at Ambroise Vollard, 6 rue Laffitte, took place from 25 June to 14 July 1901. The catalogue contained sixty-four titles, with an unnumbered series of drawings listed as item no. 65.

7. Fagus 1901, 464–465.

The Ascetic

1. *The Ascetic* is listed in the following catalogues: Zervos 1932, vol. 1, no. 187; Daix-Boudaille 1966, no. IX. 33; Palau i Fabre 1981, no. 923.

2. Picasso to Pierre Daix, in *La Vie de peintre de Pablo Picasso*, Paris, 1977, 47. While we may be right to retain this psychologizing justification, we ought not lose sight of the chronology of events: Picasso was not there when Casagemas committed suicide in Paris, on 17 February 1901. When Picasso returned to Paris in May, he stayed in the studio of his departed friend, where he worked for several more weeks to prepare his exhibition for Vollard. It was only in the fall that this dramatic event emerged in his painting, with several portraits of the deceased (Zervos 1969, vol. 21, nos. 177, 178, 180; Daix-Boudaille 1966, VI. 5, 6, addendum A.6); and a first exorcism canvas, the *Evocation* (Zervos 1932, vol. 1, 55; Daix-Boudaille 1966, VI. 4). And it is in 1903, with *La vie* (Zervos 1932, vol. 1, no. 179; Daix-Boudaille 1966, IX. 13), one of the masterworks of the blue period, that Picasso finally brought his work of mourning to an end.

3. Daix-Boudaille 1966, 154.

4. Carl Gustav Jung, "Picasso," *Neue Zürcher Zeitung*, 13 November 1932.

5. Jaime Sabartés, *Portraits et souvenirs*, Paris, 1946, 73.

6. See, for example, *Le Roi de Boétie*, Paris, 1980, 193. Max Jacob met Picasso at the time he was exhibiting at Vollard in 1901.

7. Respectively, Zervos 1932, vol. 1, no. 175; Daix-Boudaille 1966, IX. 30. Zervos 1932, vol. 1, no. 168; Daix-Boudaille 1966, IX. 32. Zervos 1932, vol. 1, no. 202; Daix-Boudaille 1966, IX. 34.

8. John Richardson, *A Life of Picasso*, London, 1991, 279.

9. No. 2 in *Picasso peintre-graveur*, vol. 1, catalogue raisonné of the engravings and lithographs, compiled by Bernhard Geiser, new edition revised by Brigitte Baer (Berne, 1990), in which Picasso conjured up the body, if not the face, of the ascetic, though he appears younger here. It is not known if these archetypal figures of misery were drawn from models (though *The Ascetic* and *The Old Guitar Player* might be identified as the same sitter). As for the titles that have been assigned to these paintings, it is hardly surprising that we frequently encounter a religious connotation — asceticism, frugality — that clearly evokes the representation of figures that John Richardson refers to as "latter-day martyrdoms"; Richardson 1971, 277.

Acrobat and Young Harlequin

1. The *Acrobat and Young Harlequin* appears in Daix-Boudaille 1966, no. XII. 25; in Palau i Fabre 1981, no. 1043; and in Zervos 1932, vol. 1, no. 301.

2. The best survey of sources for this theme in Picasso's early work is still Theodore Reff, "Harlequins, Saltimbanques, Clowns and Fools," *Artforum* (October 1971), 30–43. See also Marilyn McCully, "Magic and Illusion in the Saltimbanques of Picasso and Apollinaire," *Art History* (December 1980), 425–434; and Richardson 1991, 336–340.

3. *Un clown imaginatif, un parfait mime, un gymnaste audacieux, un jongleur précis, en quoi est-il inférieur au poète, au musicien? Les uns et les autres ils puissent aux mêmes sources et les mêmes lois régissent leur art. . . . Mais l'oeuvre de ceux-ci, dira-t-on, demeure, tandis que celle de ceux-là est passagère. Eh! qu'importe, les choses les plus belles et les plus délicieuses ne sont-elles pas les plus fugitives . . .* Gabriel Mourey, *Fêtes Foraines de Paris*, Paris, 1906, 83–84.

4. E. A. Carmean, *Picasso: The Saltimbanques* [exh. cat. National Gallery of Art], Washington, 1980, 37–39.

5. See the catalogue entry on Picasso's *Strolling Player and Boy*, (National Museum of Art, Osaka) by Núria Rivero and Teresa Llorens in exh. cat. Museu Picasso, *Picasso 1905–1906: From the Rose Period to the Ochers of Gósol*, Barcelona, 1992, 244.

6. For a discussion of such theaters, see Jacques Garnier, *Forains d'hier et d'aujourd'hui*, Orléans, 1968, 339–362; in the context of Picasso's work of 1905, see Michèle Richet, "Bateleurs et cirque dans l'oeuvre dessiné de l'époque rose," [exh. cat. Musée Picasso], Paris, *Picasso, jeunesse et genèse: Dessins 1893–1905*, Paris, 1991, 111–112.

7. See Reff, 1971 38–40.

8. The identity of the painting that Picasso sent to the international pavilion of the Venice Biennale remains uncertain, though it was probably a large *saltimbanque* picture of 1905. For an extended study of the matter, see Jean-François Rodríguez, "Picasso à la Biennale de Venise (1905–1948). Sur deux lettres de Picasso à Ardengo Soffici," *Atti dell'Istituto Veneto di Scienze, Lettere ed Arti*, vol. 143 (1984–1985), 27–55. Rodriguez believes that Picasso actually submitted the second — ultimately overpainted — version of the *Family of Saltimbanques* (National Gallery of Art), though the evidence is tenuous. Richardson names the Barnes picture; see Richardson 1991, 357. Richardson also posits (pages 299 and 506 n. 14) that *Acrobat and Young Harlequin* itself is painted over a lost work of 1904, the *Beggar with Basket of Flowers*; since the canvas has not yet been x-rayed, this hypothesis cannot be confirmed.

The Girl with a Goat

1. *The Girl with a Goat* is listed in the following catalogues: Zervos 1932, vol. 1, no. 249; Daix-Boudaille 1966, no. XV.35; Palau i Fabre 1981, no. 1260. The chronology of the trip to Gósol had not been clearly established when Zervos published the first volume of his catalogue, and this accounts for his having dated the work 1905.

2. They stayed at Gósol from the end of May to mid-August.

3. For example: the large version of *Two Brothers* (Zervos 1932, vol. 1, no. 304; Daix-Boudaille 1966, no. XV.9); *Two Adolescents* (Zervos 1932, vol. 1, no. 305; Daix-Boudaille 1966, no. XV.10); and *Adolescents* (Zervos 1932, vol. 1, no. 324; Daix-Boudaille 1966, no. XV.11).

4. She is undoubtedly the model for *Grand nu rose* (Zervos 1932, vol. 1, no. 327; Daix-Boudaille 1966, no. XV.27), and the smaller gouache *Nu couché au mouchoir de tête* (Zervos 1932, vol. 1, no. 317; Daix-Boudaille 1966, no. XV.47).

5. So called ("flesh period") in particular by André Level in *Picasso* (Paris, 1928), 26. André Salmon, for whom the rose period actually begins after the *saltimbanque* pictures, refers to it as the period of "mirrors" and "nude figures" (*L'Art vivant*, Paris, 1920, 171).

6. Zervos 1932, vol. 1, no. 321; Daix-Boudaille 1966, no. XV.40.

7. Zervos 1932, vol. 1, no. 325; Daix-Boudaille 1966, no. XV.34.

8. Zervos 1970, vol. XXII, no. 425.

9. Published in facsimile with text (preface and notes) by Douglas Cooper, Paris, 1958.

10. In the sketchbook MP. 1857, Musée Picasso, Paris, especially pages 46 for the child, 47 and 48 for the goat, 64 for the girl, and 50 (fig. 2) for the entire group. Another sheet (45) depicts a nude with her arms raised above her head; the drapes are similar to those in *The Girl with a Goat*, and foreshadow the *Demoiselles d'Avignon*.

11. In addition to *The Source* and *The Turkish Bath*, which are commonly cited, John Richardson also proposes a comparison with the small *Vénus anadyomène* sur-

rounded by winged cupids in the Louvre (Richardson 1991, 447).

12. See Phoebe Pool, "Picasso's Neoclassicism, First Period," in *Apollo*, vol. 81 (February 1965), 122-127. One of the Eros figures is reproduced on page 122. They are small terra-cotta figures approximately 12 inches high, which date from the second century B.C. We know that Picasso visited the antiquities collections at the Louvre on a regular basis.

13. For example, two drawings show a more direct confrontation between the female figure and the child: one (Zervos 1970, vol. XXII, no. 423), in which he is seen holding up a mirror to the woman as she fixes her hair, echoes numerous depictions of Venus and Cupid; in another, fascinated and uneasy, he passively attends a woman's toilette (Zervos 1954, vol. VI, no. 846).

14. Sexuality is evidenced by a drawing that dates slightly later than the *Girl with a Goat*. The scene has changed: the animal is transformed into a satyr with a ripely sensual body (it might otherwise be taken for the representation of Satan) who dances before the nude woman, while a Cupid behind brandishes his bow with a conquering air.

Composition: The Peasants

1. *Composition: The Peasants* appears as catalogue no. XV.62 in Daix-Boudaille 1966; no. 1329 in Palau i Fabre 1981; and no. 384 (Supplément) in Zervos 1932, vol. 1.

2. *Composition* is the title inscribed on the Barnes Foundation purchase invoice of 1913, and on the original label from the Grafton Galleries exhibition, which is still attached to the stretcher. There, Vollard is listed as the owner of the work, and we can speculate that the title reflects firsthand information — through Vollard — from Picasso. In a letter of December 1944 to Alfred Barr (copies of which are held by the Barnes Foundation and the Museum of Modern Art), Barnes reported Picasso's confirmation of this title; also quoted in Alfred Barr, *Picasso: Fifty Years of His Art*, New York, The Museum of Modern Art, 1946, 256. We adopt the composite title *Composition: The Peasants* from Daix-Boudaille 1966.

3. See exh. cat. Museu Picasso, Barcelona 1992, 352–354, for a summary of the literature concerning the chronology of sketches. Most recent authors, including Daix and Palau i Fabre, agree that the picture was conceived in Gósol.

4. Only Patrick O'Brian has proposed a possible subject, the return of cattle from a summer in the high pastures of mountain country, a festive occasion in which the animals are sometimes decorated with flowers; see O'Brian, *Picasso*, New York, 1976, 147. But the author fails to support the claim or specify that it is even an indigenous period custom of Gósol, and without further evidence, the matter remains unresolved.

5. See Barr 1946, 47–48; Daix-Boudaille 1966, 100–101; John Richardson, "Picasso's Apocalyptic Whorehouse," *The New York Review of Books* (23 April 1987), 42; William Rubin, "La Genèse des Demoiselles d'Avig-

non," in Hélène Seckel, ed., *Les Demoiselles d'Avignon*, Paris, 1988, vol. 2, 402–403; and Richardson 1991, 448. We should note that Barnes may have preceded Barr in describing the painting as "Grecoesque," which he does in his letter to Barr of December 1944.

6. Richardson 1991, 429–430.

7. See Paul Lafond, "Domenikos Theotokopuli, dit Le Greco," *Les Arts* (October 1906), 4–6. Barr first noted a group of publications on El Greco in 1906 with which Picasso may have been familiar; see Barr 1946, 256.

Head of a Woman and *Head of a Man*

1. The *Head a Woman* and *Head of a Man* appear respectively as catalogue nos. 34 and 49 in Pierre Daix et Joan Rosselet, *Le Cubisme de Picasso: Catalogue raisonné de l'oeuvre peint 1907–1916*, Neuchâtel, 1979, where they are identified as Kahnweiler cliché nos. 97 and 78; as nos. 1551 and 1547 in Palau i Fabre 1981; and nos. 12 and 11 in Zervos 1942, vol. 2.

2. The crucial literature on the stylistic development of the *Demoiselles d'Avignon* (on which my own discussion is based) is: William Rubin, "Picasso," in William Rubin, ed., *"Primitivism" in 20th Century Art: Affinity of the Tribal and the Modern, Volume 1* [exh. cat. The Museum of Modern Art], New York, 1984, 241–296; and Hélène Seckel, ed., 1988, vol. 2 (especially William Rubin, "La Genèse des Demoiselles d'Avignon," 367–487) and Pierre Daix, "L'Historique des Demoiselles d'Avignon révisé à l'aide des carnets de Picasso," 489–545).

3. See Daix in Seckel, ed., 1988, vol. 2, 514–517, in which both Barnes pictures are situated within a sequence of sixteen sketchbooks for the *Demoiselles d'Avignon* that are now in the collection of the Musée Picasso, Paris. Daix matches the two heads to sketches from *carnet* no. 8, which he dates in May–June. The *Head of a Woman* also appears as no. 80 in vol. 1 of the exhibition catalogue, page 98, where it is dated in June. All works by Picasso related to the *Demoiselles* are catalogued and reproduced in Seckel, ed., 1988, vol. 1.

4. The heads from Cerro de los Santos were sold to Picasso by Géry Pieret, a shady acquaintance of the Picasso-Apollinaire circle who stole the sculptures from the Louvre. See Rubin in Seckel, ed., 1988, vol. 2, 400 n. 11.

5. The role of African tribal art in the stylistic development of the *Demoiselles d'Avignon* and related works is a subject of some recent controversy. For our purposes, it is sufficient to note that the schematic geometry and scoring in both Barnes heads demonstrate a stylistic kinship to certain African masks — such as examples from the Etoumbi region of the People's Republic of the Congo — which are now believed to have been unavailable to Picasso in 1907, though certain related features are found in Kota and Hongwe reliquary figures, long accessible by that time. The full argument concerning the documentable relationship between tribal objects and Picasso's work on the *Demoiselles* is in Rubin 1984, 250–266, and Rubin in Seckel, ed., 1988, vol. 2, 470–476. For one of several

dissenting opinions, see Patricia Leighten, *Re-Ordering the Universe: Picasso and Anarchism, 1897–1914*, Princeton, 1989, 92, where the Barnes *Head of a Man* is taken to represent an explicit conflation of Iberian and Etoumbi-style African features.

6. Daix has proposed that this figure may be a "primitivist" reconfiguration of the sailor; see Daix in Seckel, ed., 1988, vol. 2, 514. For a discussion of the sailor and consecutive illustrations of his changing face, see Rubin in Seckel, ed., 1988, vol. 2, 409–415. On the evidence of the forelock, Leighten believes the figure to be a self-portrait, though the moustache would seem to contradict this; see Leighten 1989, 92.

GEORGES BRAQUE

Napkin, Knife, and Pears

1. *Napkin, Knife, and Pears* appears as catalogue no. 28 in Nicole Worms de Romilly and Jean Laude, *Braque Cubism 1907–1914*, Paris, 1982. Romilly assigns Kahnweiler *cliché* no. 1145 to the work, and tentatively identifies it as catalogue no. 5 in the first 1921 Galerie Kahnweiler sale at the Hôtel Drouot in Paris. Our title is a translation from Romilly, though the picture appears to be listed simply as *Serviette* (no. 41) in the early catalogue of Braque's oeuvre compiled by George Isarlov, who probably copied titles from the Kahnweiler archive. See Isarlov, "Georges Braque," *Orbes* no. 3 (Spring 1932), 81.

2. William Rubin, "Cézannisme and the Beginnings of Cubism," in Rubin, ed., *Cézanne: The Late Work* [exh. cat. The Museum of Modern Art], New York, 1977, 178.

3. Isabelle Monod-Fontaine et al, *Donation Louise et Michel Leiris: Collection Kahnweiler-Leiris* [exh. cat. Musée National d'Art Moderne, Centre Georges Pompidou], Paris, 1984, 24. Monod-Fontaine matches *Napkin, Knife, and Pears* to catalogue no. 26 (listed as "Nature Morte") of the Braque exhibition.

The Pitcher

1. *The Pitcher* appears as catalogue no. 31 in Romilly and Laude 1982. Romilly assigns Kahnweiler *cliché* no. 1082 to the work, and notes that it was reproduced as catalogue no. 7 in the first 1921 Galerie Kahnweiler sale at the Hôtel Drouot in Paris.

2. Braque's pun on *le broc* was first conjectured by Alvin Martin in an iconographical interpretation of the artist's *Violin and Pitcher* from 1909–1910 (Kunstmuseum, Basel); see Martin, "Georges Braque and the Origins of the Language of Synthetic Cubism," in Isabelle Monod-Fontaine with E. A. Carmean, Jr., *Braque: The Papiers Collés* [exh. cat. National Gallery of Art], Washington, 1982, 67. He notes that the pun was cited by the dealer Berthe Weill, with reference to Braque in 1909; see Weill, *Pan! . . . dans l'Oeil!* Paris, 1933, 153. The original title of the Barnes picture may have been *Le Broc*; it seems to appear this way (as no. 65) in the Braque catalogue compiled by George Isarlov; see Isarlov 1932, 82.

ROGER DE LA FRESNAYE
Married Life

1. The Minneapolis and Barnes versions of *Married Life* are *catalogue raisonné* nos. 131 and 132 respectively in Germain Seligman, *Roger de la Fresnaye*, Greenwich, 1969. For the most extensive discussion of the two works, see Robert Mead Murdock, "Elements of Style and Iconography in the Work of Roger de la Fresnaye, 1910–1914," M. A. thesis, Yale University, New Haven, Conn., 1965, 53–56.

2. For example, Louis Vauxcelles, "Les Arts — Exposition La Fresnaye," *Gil Blas* (22 April 1914), 4.

3. In *Married Life*, an allegorical convention of nature/culture is bolstered by the apparent still-life polarity of books and fruit. We might also instructively compare the enigmatic picture to sketches by La Fresnaye from 1913–1914 for an unrealized composition in which the juxtaposition of a clothed man and a nude woman is more formal — far less suggestive of a domestic narrative; see Seligman 1969, nos. 206 and 207. For a feminist critique of issues in gender and allegory that are relevant to the iconography of this picture, see Marcia Pointon, "Guess who's coming to lunch? Allegory and the body in Manet's *Le Déjeuner sur l'herbe*," in *Naked Authority: The Body in Western Painting 1830–1908*, Cambridge, 1990, 113–134. The only other pre-war modernist work that juxtaposes the dressed and undressed in a domestic context (albeit highly oblique) is Marcel Duchamp's parodic *The Bride Stripped Bare by Her Bachelors, Even*, which was conceived in 1912.

4. The Barnes picture is catalogue no. 35 from the Galerie Levesque exhibition; the Minneapolis version appears to be no. 1176 at the 1913 Salon des Indépendants, where it is simply titled *Intérieur*. For exhibition history on the two works, see Seligman 1969, 154. See also Seligman, *Roger de la Fresnaye*, New York, 1945, 25–27, for a complete transcription of the Levesque exhibition catalogue.

5. For an anthologized sampling of the debate, see John Grand-Carteret, *Les Trois formes de l'Union sexuelle à travers les Ages. Mariage, Collage , Chiennerie*, Paris, 1911, 249–410.

6. In André Warnod, "Le Salon des Indépendants: I. Fauves et Cubistes," *Comoedia*, (18 March 1913), 1.

CHAIM SOUTINE
The Skinned Rabbit

1. Albert C. Barnes, *The Art in Painting*, Merion, Pa., 1976, 374.

2. Barnes 1976, 374.

The Little Pastry Cook

1. Pierre Courthion, *Soutine peintre du déchirant*, Paris, 1972, 214a.

2. *Arts à Paris*, January 1923, no. 7, 5–7.

AMEDEO MODIGLIANI
Reclining Nude from the Back

1. The *Reclining Nude from the Back* is no. 45/1917 in Christian Parisot, *Modigliani catalogue raisonné*, vol. II, Rome, 1991; no. 207 in Osvaldo Patani, *Amedeo Modigliani: Catalogo Generale, Dipinti*, Milan, 1991; no. 203 in Ambrogio Ceroni, *I dipinti de Amedeo Modigliani*, Milan, 1970; no. 390 in J. Lanthemann, *Modigliani 1884–1920. Catalogue raisonné, sa vie, son oeuvre complète, son art*, Barcelona, 1970; and no. 332 in Arthur Pfannstiel, *Modigliani et son oeuvre. Etude critique et catalogue raisonné*, Paris, 1956. Parisot, Patani, and Ceroni date the work 1917; Lanthemann and Pfannstiel previously assigned the picture to 1919. Curiously, the Barnes nude does not appear in Angela Ceroni, *Modigliani: Les Nus*, Paris, 1989.

2. Werner Schmalenbach makes a similar point; see Schmalenbach, *Amedeo Modigliani: Paintings — Sculptures — Drawings*, Munich, 1990, 47.

3. For an account, see Berthe Weill, *Pan! . . . dans l'oeil!*, Paris, 1933, 227–229.

4. Schmalenbach believes that such comparisons serve only to point up Modigliani's putative renunciation of context and ideology in the nudes; see Schmalenbach 1990, 47.

Portrait of Jeanne Hébuterne (Seated in Profile)

1. The Barnes *Portrait of Jeanne Hébuterne* is no. 42/1918 in Parisot 1991; no. 274 in Patani 1991; no. 261 in Ceroni 1970; and no. 360 in Lanthemann 1970. The work is dated 1918 by Parisot, Patani, and Ceroni, and 1919 by Lanthemann. The corresponding profile portrait of Jeanne Hébuterne (Private collection, Paris), is Patani no. 276, and Ceroni no. 260, though it does not appear in the Parisot catalogue raisonné.

2. For Modigliani and Jeanne Hébuterne in the south of France, see Jeanne Modigliani, *Modigliani, une biographie*, Paris, 1990, 109, 115–119.

3. According to Félicie Cendrars, while Hébuterne was in the south of France, she wore her hair in "plaits around her head, like a crown" ("nattes autour de la tête, comme une couronne"); quoted in Modigliani 1990, 115.

4. Edith Balas, "The Art of Egypt as Modigliani's Stylistic Source," *Gazette des Beaux-Arts* (February 1981), 87–94. Balas quotes from the memoirs of the Russian poet Anna Akhmatova, a friend of Modigliani's, who remembers being sketched by the artist "in the headdress of an Egyptian princess."

Portrait of Jeanne Hébuterne (Left Arm Behind Head)

1. The *Portrait of Jeanne Hébuterne* is no. 27/1919 in Parisot 1991; no. 319 in Patani 1991; no. 307 in Ceroni 1970; and no. 358 in Lanthemann 1970. All date the work 1919.

2. For an affinity between depictions of the body in Modigliani and Picasso, see Schmalenbach 1990, 16–17.

3. For the exhibition of the *Demoiselles* at the Salon d'Antin in 1916, see Hélène Seckel, ed., *Les Demoiselles d'Avignon*, vol. 2, Paris, 1988, 570–578.

4. The comparison was first made in Lanthemann, 1970, 131.

5. For the phallic transformation of the female body as a sexual trope in the elastic morphology of twentieth-century art, see Adam Gopnik, "Caricature," in Kirk Varnedoe and Adam Gopnik, *High and Low: Modern Art and Popular Culture*, New York, 1990, 140–143.

Girl with a Polka-Dot Blouse

1. The *Young Girl with a Polka-Dot Blouse* appears as no. 13/1919 in Parisot 1991; no. 309 in Patani 1991; no. 298 in Ceroni 1970; and no. 273 in Lanthemann 1970. The work is dated 1919 by Parisot, Patani, and Ceroni, 1918 by Lanthemann.

2. For Modigliani's primitivism, see Allan G. Wilkinson, "Paris and London: Modigliani, Lipchitz, Epstein and Gaudier-Brzeska," in William Rubin, ed., *"Primitivism" in 20th Century Art*, vol. II, New York, 1984, 417–423.

HENRI MATISSE
Le bonheur de vivre

The title of this celebrated painting has undergone a number of transformations. It was originally exhibited as *Le bonheur de vivre*, but over the years generally has come to be known as *La joie de vivre*, in part because of Dr. Barnes' preference for that title.

Dr. Barnes purchased the painting from the Danish collector Christian Tetzen-Lund, through Paul Guillaume, Paris, in December 1922, for 45,000 francs. In a letter of 1 December 1922 to Guillaume, Barnes referred to it as "the Bonheur de Vie," and described it as "a large canvas of a number of nudes dancing in a circle." In his telegram of 3 December confirming the order to buy, Barnes used his own version of the title: "ACHETEZ JOIEVIVRE CINQUANTE." Guillaume's cabled reply on 10 December used the original title: "ACHETE MATISSE BONHEUR VIVRE QUARANTECINQ MILLE." (Barnes Foundation archives.) But the painting had a previous history of being called by other than its original title. When the Galerie Bernheim-Jeune photographed it in March 1914, it was listed as "*Les joies de la vie*," and in a 26 November 1914 letter to Gertrude Stein, Felix Fénéon referred to it as "La Joie de vivre" (Stein Archives, Yale University). Matisse himself frequently referred to the picture as *La joie de vivre*.

Probably the first published use of the English title as "The Joy of Life" was in the *Glasgow Herald*, 23 March 1906, which further noted that the meaning of the picture "remains a mystery," even though "it is not devoid of talent." The painting, which for many years has been hung in the stairwell at the Barnes Foundation, was not always exhibited there. In a 2 March 1927 letter to Guillaume, Barnes describes the "Joie de Vivre" as having been hung in a room [currently room 14] "converted into a repository for the pearls of old, modern and contemporary art" (Barnes Foun-

dation archives).

The composition is analyzed by Albert C. Barnes and Violette de Mazia, *The Art of Henri Matisse*, New York, 1933, 369–373; for extended analyses see also Alfred H. Barr, Jr., *Matisse, His Art and His Public*, New York, 1951, 81–82, 88–92; Pierre Schneider, *Matisse*, New York, 1984, 241–275; Jack Flam, *Matisse: The Man and His Art, 1869–1918*, Ithaca and London, 1986, 151–164.

1. See Thomas Puttfarken, "Mutual Love and the Golden Age: Matisse and 'gli Amori de' Caracci,'" *Burlington Magazine* 124 (April 1982), 202–208.

2. Although the picture evokes the primal innocence of the Golden Age of the ancient Greeks and Romans, it also incorporates incongruent pastoral imagery. The Golden Age preceded human labor, the domestication of animals, and the consumption of wine. Hence the shepherd and his flock, the bacchanalian ring of dancers, and the woman with the wreath of ivy (a plant sacred to Dionysos/Bacchus) are not consistent with Golden Age imagery. See Barr 1951, 88–89. On the iconography of the Golden Age, see James B. Cuno, "Matisse and Agostino Caracci: A Source for the 'Bonheur de Vivre,'" *Burlington Magazine* 122 (July 1980), 503–505; Puttfarken 1982, 202–208.

3. Lawrence Gowing, "The Modern Vision," in Robert C. Cafritz, Lawrence Gowing, and David Rosand, *Places of Delight: The Pastoral Landscape* [exh. cat. The Phillips Collection and National Gallery of Art], Washington, 1988, 238. Significantly, in the summer of 1905 Matisse had visited Daniel de Monfreid, who had an extensive collection of paintings and writings by Paul Gauguin. See Judy Freeman, *The Fauve Landscape* [exh. cat. Los Angeles County Museum of Art], New York, 1990, 76.

4. For these and other literary parallels, see Barr 1951, 88–89; Schneider 1984, 242–244.

5. On the intermingling of the Golden Age and the idea of the sacred, see the complex and interesting discussion in Schneider 1984, 245–273. For a provocative interpretation that considers the painting to encompass "a catalog of infantile fantasies, a sequential imagining of a mythic infantile sexuality, with the fantasies of seduction, castration, and primal scene . . . auto-eroticism, narcissism, and exhibitionism" see Margaret Werth, "Engendering Imaginary Modernism: Henri Matisse's *Bonheur de vivre*," *Genders* 9 (Fall 1990), 49–72.

6. For detailed discussion of the relationships between the painting and the Mallarmé poem, see Flam 1986, 156–163.

7. The painting is a good example of the historical self-consciousness that underlies what Gowing describes as the combined tradition of "the pastoral of primitiveness and the pastoral of sophistication. The apparent dichotomy in this single tradition accounts for the richness that has been open to modern painters, as well as the puzzlement." Washington 1988, 243.

8. André Derain to Maurice Vlaminck, 28 July 1905.

André Derain, *Lettres à Vlaminck*, Paris, 1955, 154–155. In the same letter, Derain stated his (and presumably Matisse's) main goal as finding a new conception of light that would entail ridding himself of the neo-impressionists' divisionist technique and the negation of shadow.

9. Matisse's impatience with neo-impressionist practice and his anticipation of working with flat planes of color are apparent in his 14 July 1905 letter to Signac, in which he criticized his own *Luxe, calme et volupté* (which Signac had recently bought) for its lack of harmony between "the character of the drawing and the character of the painting." Saying that the divisionist painting had destroyed the eloquence of the drawing, Matisse remarked that "It would have sufficed if I had filled in the compartments with flat tones such as Puvis [de Chavannes] uses." Freeman 1990, 73. For a complex and interesting discussion of this opposition in Matisse's work, see Yve-Alain Bois, "Matisse and 'Arche-Drawing,'" in *Painting as Model*, Cambridge, Massachusetts, 1990, 3–63.

10. See Barr 1951, 88. Leo Stein recalled having met Matisse not long after he bought the *Woman with the Hat* at the Salon d'Automne, and already "Matisse was at work on the *Joie de Vivre*, his first big decoration, and it was giving him no end of trouble." Leo Stein, *Appreciation: Painting, Poetry and Prose*, New York, 1947, 160.

11. For reproductions of other studies, see Barr 1951, 320–321; Schneider 1984, 241–245; Flam 1986, 158–160. In order to work on such a large canvas — the biggest he had yet undertaken — Matisse rented space in an expropriated convent, the Couvent des Oiseaux at 56, rue de Sevres, which he would use as a studio until 1908.

12. *Luxe, calme et volupté* had been based on *By the Sea (Golfe de Saint-Tropez)*. See John Elderfield, *Matisse in the Collection of the Museum of Modern Art*, New York, 1978, 36–37; Flam 1986, 114–121.

13. See Barr 1951, 135; also Georges Duthuit, *The Fauvist Painters*, New York, 1950, 91.

14. This sexually provocative pose is associated with Titian's *Bacchanale* in the Prado and was also frequently employed by Ingres. It has a long history, going back at least to ancient Roman art. Matisse returned to the motif the next year in *Reclining Nude I* and the *Blue Nude*.

15. The probable use of a cartoon is reflected in contemporary discussions of the painting. Louis Vauxcelles wrote that "to enlarge a lovely sketch by squaring it up is an error" ("Le Salon des 'Indépendants,'" *Gil Blas*, 20 March 1906). Charles Morice remarked that "The canvas seems empty. . . . There is perhaps enough here for a very reduced sketch" ("Le XXII Salon des Indépendants," *Mercure de France*, 15 April 1906, 535–536).

Careful examination of the surface of the painting indicates that most of the major elements of the design were set in charcoal before Matisse began to paint. In some places, the black charcoal is reinforced by thinly applied black paint; in areas such

as the kneeling figure in the left foreground almost the entire drawing of the figure was definitively set at this stage. The schematic nature of some of the underlying charcoal lines indicates that they were transferred from a cartoon.

Matisse altered the cartoon composition somewhat as he worked, as can be seen especially in the pentimenti of tree trunks in the upper part of the painting. The general thinness of the paint film and the extensive use of the canvas ground, especially on the left side of the picture, make it possible to get a fairly good idea of how he proceeded. The thick lines around the reclining figures at the center foreground appear to have been added quite late in the painting's evolution.

A crayon study of the painting (ill. Schneider 1984, 245), dated 1907 by Matisse's daughter (auction catalogue, Sotheby Parke-Bernet, New York, sale of 22 May 1981, no. 832) and supposed to have been done after the picture was finished, may actually represent an intermediary stage between the San Francisco oil sketch and the cartoon for the painting. Although the figures are quite close to those in the final painting, the landscape in the background is very close to the San Francisco oil sketch. Since different parts of the crayon drawing clearly relate to different aspects of the oil sketch and the final painting, one wonders how it could be a "copy" after either.

16. Pierre Courthion, unpublished interview with Matisse, 1941, as communicated to the author, December 1979.

17. See for example, Barr 1951, 88–92; Flam 1986, 157–162. See also Cuno 1980, and Puttfarken 1982.

18. See Bois 1990, 53, who considers the *Bonheur* as "at once the end of fauvism and the birth of the 'Matisse system,'" and for his discussion of the significance of Matisse's apparent distancing from the picture, which in fact continued to play a significant role throughout his life. Matisse did not directly follow up on the style-subject innovations of the *Bonheur*, or on his overt subversion of the pastoral tradition. The small, lyrical and more traditional *Pastoral*, now in the Musée d'Art Moderne de la Ville de Paris, was almost certainly done after he finished the *Bonheur*; and later he did not address the pastoral theme itself in quite so traditional or literary a way, even in his other pictures of nudes in landscapes, such as the 1908 *Bathers with a Turtle*, the 1909–1910 *Dance*, or the 1913–1916 *Bathers by a River*.

19. On the day before the opening of the Salon, the Galerie Druet opened a large Matisse show, which included numerous early works (to make clear the nature of his development) as well as recent paintings and sculptures, including the San Francisco oil sketch for the *Bonheur de vivre*, entitled "*Etude du tableau exposé aux 'Indépendants'*" ("Study for the picture at the 'Indépendants'"); Galerie Druet, *Exposition Henri-Matisse* [19 March–7 April 1906], Paris, 1906, cat. no. 13.

20. Morice 1906.

21. "Where art is concerned, theories, system, and the abstract must be avoided like the plague." Vauxcelles 1906.

22. Signac to Angrand, 14 January 1906, translated in Barr 1951, 82. Signac's reference to the thick outlines — which appear to have been added late in the execution of the painting — suggests that the painting may have been largely finished by mid-January. Matisse's decision to exhibit this painting at the Salon des Indépendants, of which Signac had been a founder in 1884, seems to have been part of his public repudiation of neo-impressionism. Signac was so upset that he picked a fight with Matisse at a café after the opening of the Salon.

23. Barr 1951, 82. Sterne's account is given in Charlotte Leon Mayerson, ed., *Shadow and Light: The Life, Friends and Opinions of Maurice Sterne*, New York, [n.d.], 52–53. In fact, the Steins did not buy the painting outright when they first took possession of it, as they were uncertain of their financial position in the aftermath of the San Francisco earthquake. In the late spring of 1906 Matisse wrote to Manguin that the *Bonheur* was hanging in Leo and Gertrude Stein's studio at a height of twelve to fifteen feet (in the same room with Picasso's 1905–1906 *Boy Leading a Horse*). According to Matisse, Gertrude had told him that "if our situation does not change, we will take the painting." Freeman 1990, 92.

24. For a discussion of parallels and differences between the two works, see Carla Gottlieb, "*The Joy of Life*: Matisse, Picasso and Cézanne," *College Art Journal* 18, 2 (Winter 1959), 106–116.

25. See, for example, the exemplary discussion of the *Demoiselles* in Leo Steinberg, "The Philosophical Brothel," *October* 44 (Spring 1988), 7–74. This is a revised version of Steinberg's groundbreaking essay originally published in *Art News*, September and October 1972.

26. Picasso's monochromatic and angular picture in effect "feminizes" Matisse's colorful and curvilinear one. This sort of machismo assertiveness runs through Picasso's entire career. He referred to his collaborator during his cubist period, Georges Braque, as "*ma femme*" ("my wife"), and reportedly compared Matisse's work to "a colored necktie."

27. Werth 1990, 69. See also Schneider 1984, 241, who asserts that the painting "was not meant to be understood."

View of the Sea, Collioure

Information in the Barnes Foundation archives reveals that this painting belonged to Leo Stein, and was thus one of two 1906 landscapes owned by Stein (see n. 2 below). This was one of the first Matisses acquired by Dr. Barnes. It was purchased from Leo Stein, through Durand-Ruel, in December 1912, for 900 francs, frame included (888 francs for the painting and 12 francs for the frame), along with *Still Life with a Statuette and Melon*, Barnes Foundation 64 (which cost 3,500 francs, with an 80-franc frame included).

1. The identification of the exact site was made by Wanda de Guébriant, Matisse Archives, Paris (telephone conversation, 13 May 1991), who says that the

nude studies of Mme Matisse done that summer were also painted in the Bois de Py. Matisse was in Algeria between 10 and 26 May. His fascination with the North African landscape, reflected in his letters, may have contributed to his desire to paint more descriptively when he returned to Collioure. For a summary of the letters, see Freeman 1990, 90.

2. Stein 1947, 192. The two landscapes are clearly the Barnes *View of the Sea, Collioure* and *Olive Trees at Collioure*, which was exhibited as *Paysage aux Oliviers* at the 1908 Salon d'Automne, cat. no. 894. The circumstances surrounding the events described by Stein make it certain that he was correct in remembering the year to be 1906. Both landscapes were exhibited at Matisse's 1910 retrospective at the Galerie Bernheim-Jeune, *Exposition Henri-Matisse du lundi 14 au mardi 22 février 1910*, Paris, 1910, [the actual dates of the show were from 14 February to 5 March], as cat. nos. 43 and 45, dated to 1906. On a Bernheim-Jeune label still affixed to the rear stretcher support of the Barnes landscape, with the number 16143R, the title is handwritten as *La Mer vue à Collioure*. The Lehman Collection landscape also has a 1910 Bernheim-Jeune label on it. One of the landscapes was shown at the first Post-Impressionist Exhibition at the Grafton Galleries in London later in 1910 (cat. no. 70), but it is not possible at present to determine which one.

Olive Trees at Collioure has been incorrectly published with a firm date of 1905. It has even been identified as one of the paintings exhibited in Matisse's Galerie Druet show in March 1906 — Paris 1906, cat. no. 11, *Promenade dans les oliviers* — which would place it firmly in the summer of 1905, since Matisse did not return to Collioure again until after that show opened. See George Szabo, *French Masterpieces, XIX and XX Century Paintings and Drawings From the Robert Lehman Collection of the Metropolitan Museum of Art*, New York [exh. cat. Ordrupgaard Museum], Copenhagen, 1986, cat. no. 62, where the title is given as *Promenade among the Olive Trees*. This identification, however, is incorrect; there is no reason for calling the scene a *Promenade*, since no one is walking in the painting. Almost certainly, the painting actually shown in 1906 is the one now known as *Madame Matisse in the Olive Grove*, which indeed does include a *promeneuse* (see illustration in Flam 1986, 127), or a related, more freely brushed version now in a private collection.

3. Matisse spoke of his early discovery of "the force, the song of the arabesque working together with color" in Cézanne's paintings. See Gaston Diehl, *Henri Matisse*, Paris, 1954, 17. In "Confrontations," *Formes* 1 (January 1930), 11, Matisse characterized his own technique as consisting of combinations of "patches and arabesques" ("*de taches et d'arabesques*").

The Red Madras Headdress

The title comes from the red madras that Mme Matisse wears on her head. "Madras" in this context refers both to a kind of brightly colored cloth, usually a mixture of silk and cotton, and to a type of kerchief

made from this cloth and worn on the head as a turban. This painting was reproduced in the first serious interview-article about Matisse, Guillaume Apollinaire's "Henri Matisse," *La Phalange* 2, 18 (December 1907), 481–485. It was exhibited at the second Post-Impressionist Exhibition at the Grafton Galleries, London, in 1912 (cat. no. 26) and at the 1913 Armory Show in New York, where it was the most frequently reproduced and most discussed picture of the eight Matisses shown. Responses to it were usually quite negative. Frank Jewett Mather, Jr., wrote that "The torso is swung in with a quite magnificent gesture that ignores all details; for the rest, a coarse emphasis of the intentness of the face, raw color, mean surfaces — a prodigal expenditure of violent means to achieve a passing and negligible effect" ("Old and New Art," *The Nation* [6 March 1913], 241). In another review, Mather referred to the picture's "wilful if powerful distortions, a childish symbolism, fairly appalling ugliness" ("Newest Tendencies in Art," *The Independent* [6 March 1913], 509). It was also caricatured as being by "Gyp the Futurist" (see Archives of American Art *Journal* 27, 2 [1987], 24, and Jo Davidson, "The Extremists: An Interview," *Arts & Decoration* [March 1913], 170–71, 180).

The painting, which had originally been owned by Michael and Sarah Stein, was purchased by Dr. Barnes from Tetzen-Lund through Paul Guillaume in January 1925 for 70,000 francs (Barnes Foundation archives). Its composition is analyzed at length by Barnes and de Mazia 1933, 379–382.

1. Matisse referred to it as "*Tête d'expression*" ("Expressive head") in a 13 July 1907 letter to Felix Fénéon, director of the Galerie Bernheim-Jeune (Bernheim-Jeune archives, Paris). It was exhibited under that title at the 1907 Salon d'Automne, where it stood out from the other, distinctly sketchier works that Matisse submitted. On 7 September 1907, Fénéon wrote to Leo Stein, asking him to give his opinion of the Barnes Foundation's small *Red Madras* to the American Byzantinist Thomas Whittemore, who was thinking of buying it (Stein archives, Yale University).

2. Louis Vauxcelles, "Le Salon d'Automne," *Gil Blas*, 30 September 1907, 3. "Why this hateful contempt for form?" Vauxcelles asked rhetorically, reprimanding Matisse for having reduced painting "to an abstraction."

3. Michel Puy, "Les Fauves," *La Phalange*, 15 November 1907; reprinted in *L'Effort des peintres modernes*, Paris, 1933, 65.

Blue Still Life

The painting was shown at the 1908 Salon d'Automne as "*Nature morte au camaieu bleu*", which might be more accurately translated as "*Still Life in Blue*". But in exh. cat. Paris 1910, cat. no. 52, it was listed simply as *Nature morte bleue*, and dated 1907. Its composition is analyzed in detail in Barnes and de Mazia 1933, 373–379. It was purchased from Tetzen-Lund through Paul Guillaume in January 1925 for 70,000 francs (Barnes Foundation archives).

1. For a photograph of the actual cloth, see Barr 1951, 344.

2. In his early years, Matisse had been accused of painting too much like Cézanne. In fact, around the turn of the century, the dealer Durand-Ruel had declined to handle his work because it looked too much like Cézanne's; see François Fosca, *Simon Bussy*, Paris, 1930, 5–6. At the time, Matisse seems to have been particularly impressed by Cézanne's deep blue still lifes, and he later recalled having seen "two very beautiful still lifes by Cézanne, biscuits and milkbottles and fruit in deep blue" at Durand-Ruel's. Matisse, "Observations on Painting," 1945, translated in Jack D. Flam, *Matisse on Art*, London, 1973, 101. In the same text, Matisse recalls Pissarro's admiration for Cézanne's *Still Life with Peppermint Bottle*, now in the National Gallery of Art.

3. The tablecloth in *Blue Still Life* was originally painted a pinkish color, still visible beneath the blue. The winter fruit on the table — apples, oranges, and lemons — suggest a date late in 1907, a few months before Matisse started *Harmony in Red*. (For more on the date, see Barr 1951, 123–125; and Flam 1986, 232–233, where it is misdated to early 1908.) In its first state, *Harmony in Red* had also been painted in blues (the early state is generally referred to as *Harmony in Blue*), and the proportions of *Harmony in Red* are almost exactly the same as those of *Blue Still Life* (*Harmony in Red* is approximately twice as large).

What appears to be the same cactus family plant — possibly a Rhipsalis clavata — appears in the 1907 *Still Life with Asphodels* now in Essen (ill. Flam 1986, 203).

4. Louis Vauxcelles, "Le Salon d'Automne," *Gil Blas*, 30 September 1908.

Interior with Goldfish

The painting was reproduced in the first monograph about Matisse, Marcel Sembat's *Henri-Matisse*, Paris, 1920, 39, where the title was given as *Intérieur (L'Atelier)*. It is listed in the 1926 Barnes Foundation inventory. Its composition is analyzed in Barnes and de Mazia 1933, 382–386.

1. Theodore Reff, "Meditations on a Statuette and Goldfish," *Arts Magazine* 51 (November 1976), 112.

2. On the symbolism of the *Red Studio*, see Elderfield 1978, 86–89, and Flam 1986, 318–322.

3. Marcel Sembat, "Henri Matisse," *Cahiers d'Aujourd'hui* (April 1913), 192; Jean Puy, "Souvenirs," *Le Point* 21 (1939), 24, likened Matisse himself to a "goldfish who intensely exalts in the iridescence of colors and forms through the dematerializing globe of his bowl and who . . . would show the world, without regard to the material representation of things, nude women, landscapes, still-lifes, stripped of their real matter and signification and made into agreeable ghosts for his enchanted eye."

4. Sembat 1913, 191–193.

5. In a more public way, the goldfish theme had exotic overtones and was generally associated with the Orient. Claude Debussy, for example, had based one of his *Images* (composed in 1907) on a Japanese lacquered tray decorated with fish, and the faddish orientalism of goldfish was reflected in Apollinaire's 1911 complaint that "An awful lot of goldfish" were to be seen at current exhibitions. "People say cyprinids are in fashion this year because of the Chinese exhibitions." See Reff 1976, 113–114; Elderfield 1978, 198 n. 6; Flam 1986, 500 n. 37.

6. It is not unthinkable that the New York *Goldfish and Sculpture* was painted directly from the Barnes painting rather than from the actual still life. Matisse worked this way with other pairs of paintings, such as *The Young Sailor* of 1906, the second version of which was painted from the first painting rather than directly from the model. See Stein 1947, 192, who states that the second version was "a free copy" from the first, "with extreme deformations."

Seated Riffian

The painting, which had belonged to Tetzen-Lund, was purchased from Paul Guillaume in January 1925, for 70,000 francs. Because of its unwieldy size, Dr. Barnes for a while thought of returning it to Paris. On 6 October 1926, he wrote to Guillaume, "I don't believe I can find a place for the Riffain [sic] by Matisse, because it is so large. If that is the case I shall have to sell it in Paris." But on 2 March 1927 he wrote to Guillaume, "I found a good place for Matisse 'Riffain' [sic], so I will not have to send it back to Paris; but there are a number of other pictures, not so valuable, which I will probably send to Paris this spring" (Barnes Foundation archives). Its composition is analyzed in Barnes and de Mazia 1933, 387–389.

1. The letter is referred to in Jack Cowart, Pierre Schneider, et al., *Matisse in Morocco: The Paintings and Drawings, 1912–1913* [exh. cat. National Gallery of Art] Washington, 1990, 96. Matisse had made a mule trip to the Rif town of Tetouan on 27–28 March (see exh. cat. Washington 1990, 259). Matisse planned to visit Tetouan again in the fall but may not actually have gone. See exh. cat. Washington 1990, 259.

2. Waldemar George, "Psychanalyse de Matisse: Lettre à Raymond Cogniat," *Chroniques du Jour* 11, 9 (April 1931), 7; trans. in Jack Flam, ed., *Matisse, A Retrospective*, New York, 1988, 274. By 1931 George had become somewhat critical of Matisse's departures from nature and disapproved of what he saw as Matisse's lack of "the slightest concern for verisimilitude."

3. Henry Collins Walsh, "The Rifs in Morocco," *The Travel Magazine* 14 (November 1908), 67; as cited by Jack Cowart in Washington 1990, 130.

4. The man who posed for the *Young Sailor I* was a Catalan fisherman — very different from the models Matisse had been using at the time — "six feet tall and of athletic build," considered even by the local people to have a "primitive air" ("*cet air primitif*") about him. See Sabine Rewald, in William S. Lieberman and Sabine Rewald, *Twentieth-Century Modern Masters: The Jacques and Natasha Gelman Collection* [exh. cat. The Metropolitan Museum of Art], New York, 1989, 89.

5. Sembat 1913, 194.

6. See Washington 1990, 96, 264. The Bernheim-Jeune exhibition of Matisse's Moroccan paintings ran from 14–19 April 1913. The *Seated Riffian* is listed in the catalogue, *Exposition Henri-Matisse: Tableaux du Maroc et Sculpture, du 14 au 19 avril 1913*, Paris, 1913, cat. no. 1, *Le rifain assis*, and it was certainly shown, since it appears in installation photographs of the exhibition. On the back of the painting's stretcher support is a label from the "Prima Esposizione Internazionale d'Arte della Secessione, Roma 1913," with the number 647 on it. This exhibition ran from March to June 1913. Although the *Seated Riffian* is not listed in the catalogue for the Rome exhibition, it may have been sent there after the show opened.

Still Life with a Plaster Bust

The painting is listed in the 1926 Barnes Foundation inventory.

1. The painting came to be misdated because Matisse himself mistakenly dated it to 1912, in a small pencil sketch did of it while he was in Merion in December 1930. See Christie's, New York, *Impressionist and Modern Drawings and Watercolors* [auction cat., 11 May 1989], New York, 1989, no. 168. The incorrect date has also been given some credence by confusion about the title. The painting was shown at Matisse's Galerie Bernheim-Jeune exhibition in 1919, *Oeuvres Récentes de Henri Matisse Exposées du 2 au 16 mai 1919*, Paris, 1919, cat. no. 3, not illustrated, under the title *Nature Morte aux Coloquintes* (*Still Life with Colocynths*; the colocynth is a spongy fruit that grows on a Mediterranean herbacious vine [Lat: *Citrullus colocynthis*], related to the watermelon, and from which a powerful cathartic is prepared). In the catalogue, comprising works from between 1914 and 1919, its size is given as 100 x 81 centimeters, and its date as 1916. (The painting was photographed by Bernheim-Jeune, archive photo 1185, in August 1916, a time when Matisse's paintings were photographed shortly after they were done.) As the Barnes Foundation later called the picture *Still Life with Bust* and gave its measurements as 99 x 79 cm, scholars came to think that the 1919 catalogue referred to the Museum of Modern Art's *Coloquintes*, or *Gourds* (65 x 81 cm), despite the appreciable discrepancy in size. For more about the date of the painting and of the sculpture represented in it, see Barr 1951, 157–158; Flam 1986, 504 n. 31.

2. These still lifes are illustrated in Flam 1986, 426–427.

The Three Sisters Triptych

Right: *Three Sisters with "Pink Marble Table,"* left: *Three Sisters with Negro Sculpture*, center: *Three Sisters, Gray Background*, The Barnes Foundation, inv. nos. 25, 363, 888. The three panels were purchased separately over a period of years. The right panel was bought from Paul Guillaume in August 1922, for 22,500 francs; the left panel, which had belonged to Tetzen-Lund, was bought from Guillaume in January 1925 for 80,000 francs; the center panel, which had belonged to Alphonse Kann,

was bought from the Valentine Gallery, New York, for $15,000. The purchase of the latter (sometimes confused with the purchase of the whole ensemble) was a matter of some controversy. As the story is usually told, R. Sturgis Ingersoll had wanted to purchase the picture for the Philadelphia Museum of Art but Dr. Barnes bought it out from under him. This story has been recounted many times, but always without the knowledge that Matisse himself seems to have played a role in Barnes' decision to purchase the center panel and hang the three individual pictures as a triptych (see notes below). For standard accounts of the controversy, see William Schack, *Art and Argyrol*, New York, 1960, 230–233; Henry Hart, *Dr. Barnes of Merion*, New York, 1963, 121–123; Howard Greenfeld, *The Devil and Dr. Barnes*, New York, 1987, 164–167. The three paintings are analyzed as a triptych ensemble in Barnes and de Mazia 1933, 399–404. Barr 1951 (192–193), Schneider 1984 (436, 478–479), and Flam 1986 (443–445) all consider the three pictures together as a triptych.

1. Earlier he had painted his wife in Japanese and Spanish costumes but not in extended series, as with Laurette. These paintings of Laurette anticipate Matisse's later odalisques.

2. Although the triptych is usually said to have been started in late 1916, and finished during the later part of 1917, Matisse painted all three panels during the spring and summer of 1917. The styles of all three panels are similar, and a companion painting, the Paris *Three Sisters* (fig. 4), from around the same time, was photographed by Bernheim-Jeune in May 1917 (archive photo number 1777). None of the Barnes panels was photographed by Bernheim-Jeune, which indicates that in any case all three pictures were completed before Matisse renewed his contract with the gallery on 19 October 1917; his 1912 contract had lapsed on 15 September 1915 and although he continued to sell through them, he no longer did so exclusively until 1917, when the contract was renewed. For the texts of the contracts, see Barr 1951, 553–554.

3. The Bamana sculpture is reproduced in Flam 1986, 421.

4. It seems likely that the right-hand panel was painted earliest, around the same time as the Denver and Paris pictures, in April or May 1917.

5. Elderfield 1978, 116–118, dates *The Pink Marble Table* to the summer of 1917; but since the Denver *Two Sisters* and the Paris *Three Sisters* were photographed by the Bernheim-Jeune Gallery in April and May of 1917 respectively (archive photos number 1705 and 1777) *The Pink Marble Table* was very likely painted in the late spring rather than the summer of 1917.

6. In fact, only the young girl seems actually to have been Laurette's sister; the other women may have been Laurette's friends, or simply other models. See Washington 1986, 42 n. 10. In this context, it is interesting to note that the 1922 invoice for the right panel lists it as "*Trois femmes*," not "*Trois soeurs*." The 1925 invoice for the left-hand panel, though, lists the

title as "*Les 3 Soeurs*." The 1926 Barnes Foundation inventory lists both of these paintings as "Three Sisters" (Barnes Foundation archives).

7. Barnes in fact initially hesitated to do so, and over a month after Matisse made the suggestion, he was apparently undecided about purchasing the third panel. This indecision appears to have led to the contretemps with R. Sturgis Ingersoll.

8. At the beginning of his letter, written from the Plaza Hotel in New York, Matisse complains about mental confusion caused by a severe nasal problem at the time, and gives it as the reason why he could not remember the proper sequence of the paintings: "*C'est aussi pourquoi je me suis trompé en vous affirmant que le panneau des 3 Soeurs qui est ici n'est pas le panneau central. Dans le train ils me sont revenus tous trois dans leur ordre qui est celui-ci* [illustration] *la composition fait ceci* [illustration]" (Matisse to Barnes, 1 January 1931; Barnes Foundation archives).

9. Matisse had already discussed the price of the picture and felt somewhat awkward about pressing Barnes to buy it: "(I should add that Dudensing knows that the price that he gave me is for you) Why not get in touch with him about it?" The original French for the entire postscript is as follows: "*Laissez-moi vous repeter que je serai si content que vous puissiez réunir ces trois choses qui vivent mal séparément. J'en suis presque à regretter qu'elles soient si bien faites pour votre ensemble. Ce qui'est pourtant le but que j'ai voulu atteindre en les faisant — (Je dois ajouter que Dudensing sait que le prix qu'il m'a fait est pour vous) Pourquoi ne lui demandez vous pas en communication?*"

Valentine Dudensing was the owner of the Valentine Gallery. Dr. Barnes purchased the picture on February 25th for $15,000 — considerably more than he had paid in 1925 for the left-hand panel (80,000 francs or $4,336.04). On 26 February 1931, Barnes sent Matisse a note with a diagrammatic drawing of the new arrangement of the three panels, flanked by four other works by Matisse (Matisse Archives, Paris). On 20 March 1931, Barnes wrote to Matisse saying, "You would be very much pleased to see the wall on which hangs your three different versions of the 'Three Sisters.' It is as fine as any wall I have ever seen in any gallery. At first we hung the three pictures close together, and to the right and left of them we hung four others of your paintings; but the wall was too crowded and we removed the four small paintings and found that the best results were obtained by having the three large pictures by themselves." (Barnes Foundation archives.) In an undated draft of a response to this letter Matisse wrote that he was not surprised by the effect that the triptych made and that is why "I insisted that you buy the last picture which reestablished the triptych. [*Ce que vous me dites du mur des trois soeurs ne m'étonne pas trop et c'est pourquoi j'ai insisté pour vous faire acheter le dernier tableau qui rétablissait le triptique*]" (Matisse Archives, Paris).

10. See Barr 1951, 192–193, and Barnes and de Mazia 1933, 399–404; also Barnes and de Mazia 1933, 273, for interesting visual comparisons with Manet and Afri-

can sculpture.

11. See Robert Reiff, "Matisse and Torii Kiyonaga," *Arts* 55, 6 (February 1981), 164–167. As Reiff points out, the crouching figure at the left of the *Bonheur de vivre* may also have been based on a figure in this print. Barr 1951, 192–193, also draws parallels with Japanese prints.

The Music Lesson

Both this painting and the related *Piano Lesson* were done in the interim period between Matisse's Bernheim-Jeune contracts, and neither seems to have been handled by the gallery. The picture was purchased by Dr. Barnes in 1923; although the bill of sale has not been located, Barnes evidently acquired the painting at a low price because of its unwieldy size. In a letter of 6 October 1926, he wrote to Paul Guillaume, who was then trying to sell *The Piano Lesson* and *Bathers by a Stream*: "I fear that you will have trouble in selling them to a private collector. You remember the reason that I bought The Music Lesson so cheap was because it was too big for an amateur" (Barnes Foundation archives). When Matisse visited the Barnes Foundation, he did small pencil sketches of a number of his paintings, next to which he noted titles and (frequently incorrect) dates. His sketch of this painting is titled, *La famille* (The family). The composition is analyzed in detail in Barnes and de Mazia 1933, 389–398.

1. On the dates of the two paintings, see Barr 1951, 193–194; Elderfield 1978, 114–116; Flam 1986, 452.

2. As in the two versions of *The Young Sailor* and in the Barnes and New York *Goldfish* paintings.

3. *Reclining Nude I*, on which it is based, is actually only 13½" high. In a drawing related to *The Piano Lesson* (fig. 5), Matisse had also included a representation of *Reclining Nude I*, but in its true scale. There he had placed it next to a flower pot — an intriguing echo of the motif in the Barnes *Interior with Goldfish* of 1912. In that same drawing Matisse also represented the radiator and the book of Haydn's music on the piano. Indeed, given the loose rendering and greater naturalism of the drawing, it appears that it may have been done after *The Piano Lesson* was finished. If so, this drawing might have been done as a study for the painting that became *The Music Lesson*, before Matisse decided to alter the composition and include the other members of his family.

4. Matisse interviewed by E. Tériade, "Visite à Henri Matisse," *L'Intransigeant*, 14 and 22 January 1929; trans. Flam 1973, 58. For a discussion of Matisse's family in relation to his art, see Schneider 1984, 330–331.

5. Matisse interviewed in 1919, by Ragnar Hoppe, in "Pa Visit Hos Matisse," *Städer och Konstmärer Resebrev och Essäer om Konst*, 1931; trans. Flam 1988, 171.

Woman Reading at a Dressing Table

The painting was photographed by Bernheim-Jeune in February 1920 (archive photo 3026). Although it is possible that it was executed in January 1920, the late

1919 date seems much more likely. There was always a delay between the time that the paintings were executed in Nice and shipped to Paris to be photographed, and in January 1920 Matisse went to London to work on the costumes for the ballet *Le Chant du Rossignol*. The painting is listed in the 1926 Barnes Foundation inventory. The composition is analyzed in Barnes and de Mazia 1933, 415–417.

1. Letter from Matisse to Charles Camoin, 23 May 1918; trans. Flam 1988, 170.
2. This is the title given in the Bernheim-Jeune inventory; it is also hand-lettered on a sticker attached to one of the stretchers.
3. The mirror and some of the other props had been in use for some time. *The Painting Session*, then entitled *La séance de peinture dans le cabinet de toilette*, was photographed by Bernheim-Jeune in July 1919 (archive photo 2598). The *Petit Déjeuner* was photographed in May 1920 (archive photo 3201).
4. Matisse seems to have been deeply inspired by the imagery and style of Japanese prints at this time. This is especially evident in the intimate subjects of his pictures, their tilted perspectives, and the use of deep black accents played against variously patterned areas.
5. Charles Vildrac, *Cinquante Dessins par Henri-Matisse*, Paris, 1920; trans. Flam 1988, 198. Many of the ideas in Vildrac's essays of this time directly reflect his conversations with Matisse.

The French Window at Nice

The painting was photographed by Bernheim-Jeune in February 1920 (archive photo 3027). Like *Woman Reading at a Dressing Table*, it almost certainly dates to late 1919. The picture was first reproduced as *Les persiennes* in the Bernheim-Jeune catalogue, *Exposition Henri-Matisse du 15 Octobre au 6 Novembre 1920*, Paris, 1920, cat. no. 19, where it was listed under the category of pictures done at "Nice 1919." At the time, the painting was listed as having been bought outright by the gallery and was prominently reproduced in the catalogue. It was included in the 1931 Matisse retrospective at the Museum of Modern Art, *Henri Matisse Retrospective Exhibition* (3 November–6 December 1931), New York, 1931, cat. no. 49, and was purchased by Dr. Barnes from Galeries Georges Petit, Paris, in December 1931, for $15,750.00. The composition is analyzed in Barnes and de Mazia 1933, 412–415.

1. See, for example, Charles Vildrac, *Nice 1921: Seize Reproductions d'Après les Tableaux d'Henri-Matisse* [exh. cat., Galerie Bernheim-Jeune], Paris, 1922; trans. Flam 1988, 202: "I recalled as well the high window and its drapes, the red rug and its patterns, the low armchair in which Matisse has often posed the nude model or which he has positioned, empty, beside the window, enhancing this affable and roly-poly seat with a lace antimacassar. . . . First, this room was smaller than I had supposed: From certain of his pictures I had formed the impression that, in it, one could walk freely, with long strides, or dance with ease . . . the window occupied the greater part of its width."

2. Francis Carco, "Conversation avec Matisse," *L'ami des peintres*, Paris, 1953; trans. Flam 1973, 85–86. The interview dates to 1941 and was originally published in *Die Kunst-Ziettung*, Zurich, August 1943.
3. Barnes and de Mazia 1933, 412.
4. Matisse's family nicknamed the Barnes painting "The Cathedral." Schneider 1984, 452. On the date of the Chicago painting, see Washington 1986, 294. The Paris painting was photographed by Bernheim-Jeune in May 1921 (archive photo 3761.)
5. Charles Vildrac, "Henri-Matisse," *Exposition Henri-Matisse du 15 Octobre au 6 Novembre 1920*, Paris, 1920; trans. Flam 1988, 198.
6. Fritz Vanderpyl, "Salons et Expositions," *Le Petit Parisien*, 14 November 1920.
7. Marcel Sembat, *Henri Matisse*, Paris, 1920, 11–12.
8. Jules Romains, "Opinions," in Elie Faure, Jules Romains, Charles Vildrac, and Léon Werth, *Henri-Matisse*, Paris, 1920, 19–20; trans. Flam 1988, 181–182.
9. René Schwob, "Henri-Matisse," *L'Amour de l'Art* 6 (October 1920), 192–195; trans. Flam 1988, 191–193.
10. For a good discussion of the ambivalent nature of Matisse's art in relation to politics, see Kenneth E. Silver, *Esprit de Corps: The Art of the Parisian Avant-Garde and the First World War, 1914–1925*, Princeton, 1989, 258–264.

Seated Odalisque

The painting was photographed by Bernheim-Jeune in February 1923 (archive photo 4513); it was first exhibited at the gallery in 1923 and reproduced in their catalogue, *Seize Tableaux de Henri-Matisse, 1922–1923*, Paris, 1923, cat. no. 11, under the title *Le genou levé* ("The Raised Knee"); in the same catalogue, *Odalisque Half-Length — The Tatoo* (cat. no. 10, which was photographed at the same time, archive photo 4512), drew attention to the tattoo with the title *"Le tatouage."* The National Gallery's *Odalisque Seated with Arms Raised* was photographed in April 1923 (archive photo 4562) but was not included in the exhibition catalogue. All three of these paintings, however, were illustrated in the second edition of Elie Faure, Jules Romains, Charles Vildrac, and Léon Werth, *Henri-Matisse*, Paris, 1923, where the Barnes painting, no. 37 is again titled *"Le genou levé."* Dr. Barnes purchased the picture from Galeries Georges Petit, Paris, in July 1931 for $6,000. The composition is analyzed in Barnes and de Mazia 1933, 419–421.

1. Tattooing or marking with henna is fairly common in the Near East and in North Africa. Matisse may have invented the cruciform tattoo represented here, though somewhat similar ones may be seen in photographs of Arab, Persian, and North African women. For discussions and pictures of various related types of tattoos and henna decorations, see H. R. P. Dickson, *The Arab of the Desert*, London, 1949, 164–167, 170, 425; Malek Alloula, *Le Harem colonial*, Paris, 1981, 66, 67, 77 (where a similar forehead tattoo is shown); Alev Lytle Croutier, *Harem: The World behind the Veil*, New York, 1989, 84; Angela Fischer, *Africa Adorned*, New York,

1984, 238, 246, 251 (where a similar forehead tattoo is shown); Thierry Maujer, *The Bedouins of Arabia*, Paris, 1988, 89, 99.
2. The prints date mostly from 1929. See for example, Marguerite Duthuit-Matisse and Claude Duthuit, *Henri Matisse: Catalogue raisonné de l'oeuvre gravé établi avec la collaboration de Françoise Garnaud*, Paris, 1983, vol. 1, nos. 154, 158 (where the tattooed cruciform is on the chest); vol. 2, nos. 505–507, 518.
3. See Matisse, "Le chemin de la couleur," *Art Présent* 2 (1947), 23; trans. Flam 1973, 116.
4. For details on this acquisition, see Isabelle Monod-Fontaine, Anne Baldassari, and Claude Laugier, *Matisse* [Collections du Musée national d'art moderne], Paris, 1989, 66–69. As Silver, 1989, 264, points out, the picture was purchased just three weeks before the opening of the Exposition Coloniale in Marseilles. For a stimulating discussion of Matisse's orientalism at this time see Kenneth E. Silver, "Matisse's Retour à l'ordre," *Art in America* 75, 6 (June 1987), 111–122, 167–169.
5. Matisse was not unaware of the potential absurdity of such subjects. See, for example, the mid-1920s photograph of Bonnard parodying a "Matisse odalisque" pose in Matisse's studio; Washington 1986, 31.
6. Interview with Tériade, 1929; trans. Flam 1973, 59. In a later version of what seems to be the same interview, less accurately recounted, Tériade gives the text as, "I had seen them in Morocco, and so was able to put them in my pictures back in France without playing make-believe." E. Tériade, "Matisse Speaks," *Art News Annual*, 1952, reprinted in Flam 1973, 135.
7. André Verdet, *Entretiens Notes et Ecrits sur la Peinture*, Paris, 1978, 124. Verdet interviewed Matisse between 1948 and 1951. It is hard to imagine where in Morocco Matisse might actually have seen "odalisques," except in brothels. If so, the odalisques of the 1920s may evoke a more specifically sexual nostalgia than Matisse liked to discuss.
8. The model for this painting, and for many odalisque pictures, was Henriette Darricarrère, born in 1901. When she met Matisse in 1920, she lived with her family in Matisse's neighborhood; she modeled for him regularly until 1927. See exh. cat. Washington 1986, 26–27.

Reclining Nude

The painting was photographed by Bernheim-Jeune in May 1924 (archive photo 5047). It was exhibited that May and published in Galerie Bernheim-Jeune, *Exposition Henri-Matisse du mardi 6 mai au mardi 20 mai 1924*, cat. no. 27, where the title is given simply as *Nu*. Dr. Barnes purchased it in January 1925 from Paul Guillaume, Paris, for 10,000 francs. The composition is analyzed in Barnes and de Mazia 1933, 421–425.

1. The phrase is from Thomas Craven, *Modern Art: The Men, the Movements, the Meaning*, New York, 1940, 168. Matisse's first postwar depictions of a nude reclining on a bed were done in 1921. Both were photographed

by Bernheim-Jeune in June 1921, *Reclining Nude* and *Reclining Nude with a Turban* (archive photos 3807 and 3814); the first is reproduced in Alexandre Romm, *Henri Matisse*, Moscow, 1937, ill. no. 31; the second in Mario Luzi and Massimo Carrà, *L'opera di Matisse dalla rivolta 'fauve' all'intimismo, 1904–1928*, Milan, 1971, no. 338.

2. See Duthuit 1983, vol. 2, nos. 432, 435, 436.

3. Philippe Marcel, "Henri Matisse," *L'Art d'aujourd'hui*, Spring-Summer 1924, 46.

4. Paul Fierens, *Paris-Journal*, 16 May 1924; reprinted in *Bulletin de la vie artistique*, 1924, 246–247.

5. Matisse topped the list of artists considered most worthy to be included in a museum of modern French art. See Christopher Green, *Cubism and its Enemies: Modern Movements and Reaction in French Art, 1916–1928*, New Haven and London, 1987, 138. His prices were accordingly high. On 2 October 1926, Barnes wrote to Paul Guillaume, "It is astounding how his paintings have advanced in price and how the desire to own them has spread to people who formerly would not buy them." (Barnes Foundation archives.)

The Dance (Merion Dance Mural)

Commissioned by Dr. Barnes in 1930. Paris version worked on 1931 to early 1932; extensively reworked autumn 1933. Merion version started summer 1932, completed April 1933, and installed at the Barnes Foundation, 12–15 May 1933 with the participation of the artist. Contemporaneous accounts are given in Louis Gillette, "'La Danse' d'Henri Matisse à Pittsburg [sic]," *Beaux-Arts: Chronique des arts et de la curiosité* 72, 21 (26 May 1933), 1, 6; Dorothy Dudley, "The Matisse Fresco in Merion, Pennsylvania," *Hound & Horn* 7, 2 (January-March 1934), 298–303; Matisse, letters written in 1934 and 1935 to Alexandre Romm, translated in Flam 1973, 67–70.

1. Matisse discussed his trips to Tahiti and New York in an interview with E. Tériade, "Entretien avec Tériade," *L'Intransigeant*, 20 and 27 October 1930; trans. Flam 1973, 60–64. In 1929, while he was still planning the trip, he told Florent Fels that he was going to the Pacific islands to see a light that had "another density." Florent Fels, *Henri-Matisse*, Paris, 1929, 50.

2. Matisse cabled Barnes on 20 September 1930, asking permission to visit the Foundation. He met Barnes on 27 September and returned to Merion on October first.

3. Matisse had been commissioned by Skira early in 1930 and the book was published on 25 October 1932. The actual contract seems to have been confirmed in April, in Matisse's absence. See Claude Duthuit, *Henri Matisse: Catalogue raisonné des ouvrages illustrés établi avec la collaboration de Françoise Garnaud*, Paris, 1988, 16–17.

4. Matisse and Barnes met in Paris on 3 November; Matisse agenda, Matisse Archives, Paris. On 16 November, the artist's daughter, Marguerite Duthuit, wrote to Etta Cone in Baltimore saying that her father had just accepted a large decoration for the Barnes Foundation (Cone Archives, Baltimore Museum of Art).

5. On 8 December 1930, Matisse cabled Barnes to say that he would be arriving in New York on the "Mauretania" with the intention of going straight to Merion if possible. On 13 December, Barnes sent a cable to the ship, informing Matisse that John Dewey would meet him; Dewey brought Matisse to Merion directly from the pier on 15 December. The date of the commission is usually given as January 1931 (see Barr 1951, 220, and Washington 1986, 39), but the actual letter of agreement is dated 20 December 1930. It fixes the price for the murals at $30,000, to be paid in three installments of $10,000 each. The first payment was included with the letter. The second payment was to be made when the work was half-finished, and the third was to be forthcoming when the paintings were installed at the Foundation, approximately a year later.

6. In a 22 December letter to his wife, Matisse said that he had already done a sketch "before the surface to be decorated"; Matisse Archives, Paris. For the early studies, see *Henri Matisse Dessins: Collection du Musée Matisse* [exh. cat. Musée Matisse], Nice, 1988, 222–247.

7. This building is often identified as a film studio, but when Edward Dreibelbies visited Matisse there in August 1931, he described it clearly as a garage (Barnes Foundation archives). See Washington 1986, 39–42, for photographs of the building and a discussion of its function.

8. In a 26 December 1930 letter to his wife, Matisse mentions that he helped work on a template that was being made for "the panel and the ceiling which is not easy because it is round" (Matisse Archives, Paris). Matisse had initially forgotten to bring the architect's blueprints and had Barnes send them to him in March 1931 (Barnes Foundation archives).

9. Matisse to Barnes, 24 April 1931 (Barnes Foundation archives).

10. As we have seen, Matisse had used a cartoon for the *Bonheur de vivre* (and had very possibly done the same for the final version of the Shchukin *Dance*). Flam 1986, 495 n. 41.

11. "According to the photos, it seems that the canvas containing the figures is joined to the piece representing the sky without any border to allow for mounting the canvas with the figures on the stretcher. Now, our intention being to place them on the stretchers by folding back the excess, it is necessary to leave a rather large border all around the painting, a border of at least three or four centimeters which would be folded back around the stretchers." Barnes to Matisse, 5 May 1931 (Barnes Foundation archives).

12. Matisse to Barnes, 15 May 1931. (Barnes Foundation archives.) This letter also contains a diagram of shapes in the borders, which are apparently related to the pieces of the template that had been made. Similar shapes are also drawn in the borders of the recently discovered, unfinished version of the mural.

13. Barnes Foundation checkbook, 1931 (Barnes Foundation archives).

14. Dreibelbies to Barnes, 2 August 1931.

15. This account of Matisse's technique is taken from my interview with Lydia Delectorskaya (Paris, 12 June 1992), who worked as Matisse's assistant on the Merion mural in 1932–1933, and from the published account by Lisette Clarnète as given in interviews with C. de Pesloüan, published in "Matisse Photographe," *Jours de France Madame*, 27 November 1989.

16. "Matisse Finishing Mural for America," *The New York Times*, 9 February 1932.

17. Matisse to Barnes, 2 February 1932 (Matisse Archives, Paris).

18. Barnes to Matisse, 2 February 1932 (Matisse Archives, Paris).

19. These cables and Barnes' letter of 2 February 1932 are in the Matisse Archives, Paris.

20. See Hahnloser in Washington 1986, 272.

21. Barnes and Matisse met in Paris on 4 March 1932. At this time Barnes had apparently not seen the actual mural. Pierre Matisse saw this gouache when he dined with Barnes in Merion in mid-April; Pierre Matisse to Henri Matisse, 19 April 1932 (Pierre Matisse Archives).

22. Although Barr 1951, 220, says that Matisse did not begin the second version until the fall of 1932, the studies for it seem to have been begun early that summer. On 1 July Barnes wrote a detailed letter to Matisse from Brides-les-Bains, in which he discussed the dimensions of the new canvases that Matisse already had installed in his studio; Matisse Archives, Paris. On 7 July 1932, Pierre Matisse wrote to Barnes saying that his father had begun "the sketch for the new decoration, which is off to a magnificent start" ("*Il a commencé l'esquisse de la nouvelle décoration qui est magnifiquement partie.*") (Barnes Foundation archives). The first photograph taken of the full-size work in progress dates from 20 August 1932, but it seems to have been begun in late June or early July.

23. On 25 May 1933, Matisse wrote to Etta Cone: "I arrived on May 11th and I leave the 29th — after having installed the decoration in Merion, which was marvelously received — Dr. Barnes is very happy.... I am very tired and have to return to rest...." (Cone Archives, The Baltimore Museum of Art). On 17 May 1933, Matisse wrote to his friend the painter Simon Bussy, saying that the mural was a great success and that Barnes had compared the effect to the stained-glass windows of a cathedral: "My decoration is installed. It is of a splendor that one can't imagine unless one sees it — because the ceiling and the lunettes together become alive through radiation and the same effect continues down to the floor. My collector rightly said, 'It is like a cathedral' (The Stained Glass of a cathedral)."

Some doubt has been raised, however, about how just how satisfied Barnes really was. Although Barnes praised the mural at the time — he was not in any case a man who liked to admit to mistakes — after its installation his enthusiasm for acquiring more Matisses fell off sharply. In a biography com-

missioned by Mrs. Barnes, who was presumably privy to her husband's thoughts, Henry Hart flatly states that Barnes was disappointed with the mural: "Barnes was never completely satisfied with it, but he never told the artist so" (See Hart 1963, 120).

24. Just before he left to install the mural in Merion, Matisse wrote to his wife (5 May 1933), asking her to re-pin some of the pieces of paper that were not securely fastened to the still unfinished earlier version (Matisse Archives, Paris).

25. For circumstances of its discovery, see Pierre Schneider, "Henri Matisse: 'La Danse' resuscitée," *L'Express*, 8 May 1992, 156–162. The surface of this set of canvases is full of thousands of pinholes, evidence of the constant reworking with cut and pinned paper.

26. On 5 May 1933, Matisse wrote his wife telling her that some of the pieces of paper on the "decoration panel that remains" ["*panneau de la décoration qui reste*"] were about to fall and should be pinned more securely to the canvas. The reference here is clearly to the still unfinished cut paper version of what would become the *Paris Dance Mural*, which was at that time still pinned to the canvas of the *Unfinished Dance Mural*. On 25 August 1933, Matisse wrote Simon Bussy that he had begun to rework the remaining decorative panel. On 16 October 1933, he wrote Bussy that he was hard at work on it, and that he was making tracings to be applied to a new set of canvases that had been ordered from Guichardaz. On 29 October 1933, Matisse wrote Bussy that he was still hard at work on it. (Matisse Archives, Paris).

27. See, for example, Schneider 1984, 615.

28. Matisse had apparently not begun to work in paper when Dreibelbies visited him in August; he began to do so in the fall.

29. Georges Charbonnier, "Entretiens avec Henri Matisse," *Le Monologue du peintre*, Paris 1960, vol. 2; trans. Flam 1973, 139.

30. Dudley 1934, 299.

31. The murals, for example, would be seen against the light, but in the end Matisse felt that he had made the most of the situation: "The spaces between the doors are about two meters wide. I made use of the contrast created by these spaces; I used them to create correspondences with the forms in the ceiling. . . . Thus I displaced the contrast. Instead of making it between the bright doors and the spaces in between, I put it up in the ceiling so that my very strong contrast united the whole panel, doors and spaces" (Charbonnier 1960; trans. Flam 1973, 139).

32. For a fascinating collection of in-progress photographs, and of relevant drawings, see Lydia Delectorskaya, *Henri Matisse, Peintures de 1935–1939 . . . l'apparente facilité . . .*, Paris, 1986. According to Delectorskaya (interview with the author, Paris, 12 June 1992), the panels were photographed when Matisse felt that he had brought them to a decisive stage in their evolution.

33. As has been mentioned, he later reworked the composition of what is now the *Paris Dance Mural* quite extensively. Just how much that composition was subsequently reworked can be seen by comparing the *Paris Dance Mural* with the small gouache done on 20 February 1932 (fig. 3), which reflects what the picture looked like at the time Matisse discovered that the dimensions were wrong.

34. See Delectorskaya 1986, 14.

35. See Schneider 1984, 299, where it is dated "1936, 1942–3." See also the related drawings (Schneider 1984, 258).

36. Matisse to Pierre Matisse, 2 February 1933; Pierre Matisse Archives. It was probably during this encounter that Matisse arranged to give Barnes the photographs of the work in progress now at the Barnes Foundation, the last of which is dated 25 January 1933. Three further photographs are published in *Cahiers d'Art* 10, 1 (1935); repr. in Diehl 1954, pl. 103; the last of these is dated 7 April 1933.

37. The letter is in the Matisse Archives, Paris. The first coats of paint had been applied by a housepainter named Goyo.

38. Lydia Delectorskaya interview with the author, Paris, 12 June 1992.

39. Matisse described the process in some detail in letters to his wife (Matisse Archives, Paris).

40. Dudley 1934, 298–303. On 3 February 1934, Matisse wrote to Barnes, asking how the canvases had fared physically during the extreme change of climate during the summer months, and what effect his mural had had on "the spiritual life of the Foundation." On the second matter he had been somewhat assured by a card he had received from Barnes. In the same letter, Matisse speaks of having reworked the first version of the Barnes mural and of other recent paintings (Barnes Foundation archives).

Two Girls in a Yellow and Red Interior

This painting is reproduced in color in *Verve* 6, 21–22 (1948), n.p. Dr. Barnes purchased the painting in April 1948 from Pierre Matisse. This and the other 1947 interior were the last Matisses that he purchased. The timing of the purchase is specially interesting, since it coincided with the height of Dr. Barnes' battles with the Philadelphia Museum of Art over issues related to their 1948 Matisse retrospective (see Greenfeld 1987, 265–273).

1. Schneider 1984, 273 n. 12.

2. The theme of figures seated near a window runs throughout Bonnard's work; in his later paintings such as *The Studio and Mimosa, Le Cannet*, 1939–1946, indoors and outdoors also tend to be conflated (see Sasha M. Newman, ed., *Bonnard: The Late Paintings* [exh. cat. The Phillips Collection], Washington, 1984, cat. no. 65).

3. The French phrase is "*Mon dessin et ma peinture se séparent.*" Matisse to Bonnard, 13 January 1940 (see Jean Clair, ed., "Correspondance Matisse-Bonnard, 1925–1946," *La Nouvelle Revue Française*, 1 July 1970, 92; for other letters, see Clair 1970, 1 July 1970, 82–100; 1 August 1970, 53–70.

Index of Illustrations

A NOTE ON THE TYPE

The text of this book was set in Centaur, the only typeface designed by Bruce Rogers, the well-known American book designer. A celebrated penman, Rogers based his design on the roman face cut by Nicolas Jenson in 1470 for his Eusebius. Jenson's roman surpassed all of its forerunners and even today, in modern recuttings, remains one of the most popular and attractive of all type faces.

The italic used to accompany Centaur is Arrighi, designed by another American, Frederic Warde, and based on a Chancery face used by Lodovico degli Arrighi in 1524.

Composed by U.S. Lithograph, typographers, New York
Printed and bound by Amilcare Pizzi, S.P.A., Milan
Designed by Bruce Campbell and Lisa Tremaine